ALONG THE ANCIENT SILK ROUTES

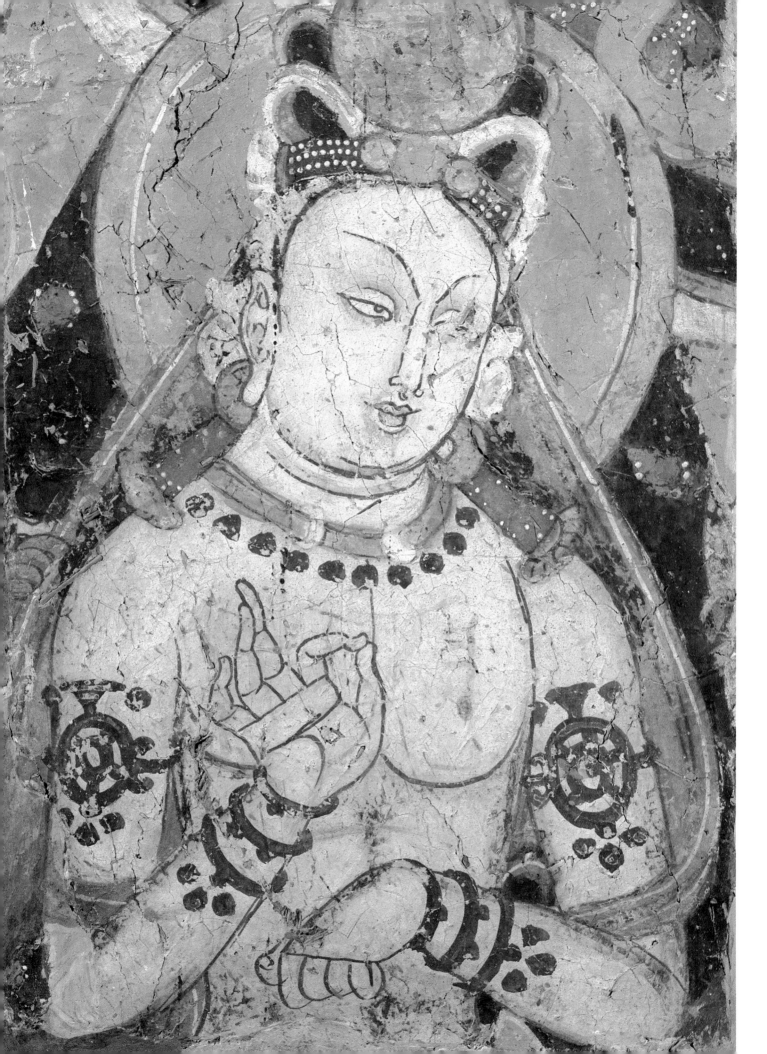

ALONG THE ANCIENT SILK ROUTES

Central Asian Art

FROM THE WEST BERLIN STATE MUSEUMS

An exhibition lent by the Museum für Indische Kunst, Staatliche Museen Preussischer Kulturbesitz, Berlin, Federal Republic of Germany

The Metropolitan Museum of Art

NEW YORK

This volume is published in conjunction with
the exhibition "Along the Ancient Silk Routes:
Central Asian Art from the West Berlin State Museums"
held at The Metropolitan Museum of Art,
New York, April 3–June 20, 1982.

The exhibition and publication were made possible
by a grant from IBM.

PUBLISHED BY
The Metropolitan Museum of Art, New York
Bradford D. Kelleher, Publisher
John P. O'Neill, Editor in Chief
M. E. D. Laing, Editor
Peter Oldenburg, Designer

COVER/JACKET ILLUSTRATIONS
Front: King Ajatashatru, and His Wife (?);
 detail of No. 24. Kizil, 600–650
Back: Seated Buddha; No. 47. Tumshuk, 5th century

FRONTISPIECE
King Ajatashatru; detail of No. 24. Kizil, 600–650

Produced by Kunstbuch Berlin Verlagsgesellschaft m.b.H., Berlin
Printed and bound in the Federal Republic of Germany

ISBN 0-87099-300-3 (paper MMA)
ISBN 0-8109-1800-5 (cloth HNA)

LIBRARY OF CONGRESS CATALOG CARD NO. 82-80801

CONTENTS

Unless otherwise stated all the illustrations are from the archives of the Museum für Indische Kunst, Berlin.
The maps on pages 14, 16–17, 19, and 38 were drawn especially for this volume by Kathleen Borowik (© 1982 The Metropolitan Museum of Art).
The translation was by Ian Robson, with contributions by John Gabriel.

NOTE Transliterated words and names are printed without diacritical marks.
The spelling of place and proper names has been adjusted for phonetic convenience.

FOREWORD

ONE OF THE GREAT rewards of a visit to the Museum für Indische Kunst in Dahlem, West Berlin, is the opportunity to see its extraordinary holdings in the art of Central Asia. With only a handful of important collections of Central Asian art in the world, Berlin's remains unrivaled, particularly in the magnificent assemblage of wall paintings. Acquired in the first quarter of this century as the result of four pioneering expeditions to the remote and inhospitable region of Chinese Turkestan, the Berlin collection has led the way to a greater understanding and appreciation of the ancient cultures of Central Asia.

It is in the context of our exchange agreements with the Stiftung Preussischer Kulturbesitz that we are able to present in New York a generous selection of the Berlin holdings. Through this unparalleled collection visitors to The Metropolitan Museum of Art will discover the wonders of early Buddhist painting and sculpture in Central Asia, as well as some rare examples of the little-known art of the Manichaeans and Nestorian Christians. The exhibition, it should be noted, is the first of any consequence of the art of Central Asia to be presented in this country.

I would like to express my thanks to Professor Dr. Stephan Waetzoldt, Director General of the Staatliche Museen Preussischer Kulturbesitz, who was on the German side the architect of this exchange of exhibitions; it has already featured in Berlin an exhibition of treasures of Islamic art from the Metropolitan Museum, as a counterpart to "Along the Ancient Silk Routes." I take pleasure in acknowledging as well the unfailing cooperation of Professor Dr. Herbert Härtel, Director of the Museum für Indische Kunst, who, with the able assistance of Dr. Marianne Yaldiz of the Museum für Indische Kunst, wrote the text for this volume. Martin Lerner, Curator of Indian and Southeast Asian Art at the Metropolitan Museum, was responsible for the selection of the exhibition and its organization in New York. In addition, Mr. Lerner has contributed the Gandharan entries to the catalogue, and has acted as general editor and consultant for this publication.

Because of the fragility of the objects the exhibition will not travel. We are

all the more grateful and honored to have been entrusted with these masterpieces by the Stiftung Preussischer Kulturbesitz.

Finally, I wish to express my profound appreciation to IBM for its generous support of the exhibition and catalogue. Very simply, if IBM had not recognized the singular importance of the project and provided the necessary funding, it could not have been undertaken, and a unique opportunity for us to experience these works of art at first hand would have been lost.

Philippe de Montebello
Director
The Metropolitan Museum of Art

FOREWORD

THE EXHIBITION "Along the Ancient Silk Routes" from the holdings of the Museum für Indische Kunst, Staatliche Museen Preussischer Kulturbesitz, Berlin, is our response to the splendid show of masterpieces of Islamic Art from The Metropolitan Museum of Art, New York, that we were privileged to mount in 1981.

In Germany—and indeed in Europe—the Museum für Indische Kunst is the only self-contained collection specializing in the art of India and of Central and Southeast Asia. In establishing such a museum, based on the old collections of the Museum für Völkerkunde—the Ethnological Museum—as well as on new acquisitions, the trustees of the Stiftung Preussischer Kulturbesitz were aiming not only to expand their services to the public but also to honor the great cultural and aesthetic values which that art represents for the world.

In the Berlin State Museums we take pride in the scope of our collections. They embrace, as do those of the Metropolitan Museum, works of art and cultural history from all parts of the world and all epochs. We are glad, therefore, to offer our visitors the chance to see masterpieces from other collections, and in turn to send some of our own treasures abroad, where they can be enjoyed by many who might otherwise have been denied that opportunity.

It is in this spirit that a program of exchange exhibitions has been set up between the Metropolitan Museum in New York and the Staatliche Museen Preussischer Kulturbesitz in Berlin. In the realization of this program I am deeply indebted to Mr. Philippe de Montebello, Director of the Metropolitan Museum, and for their organization of this exhibition to Professor Dr. Herbert Härtel and Mr. Martin Lerner in Berlin and New York respectively.

Historical circumstances have made the Museum für Indische Kunst, of the Staatliche Museen Preussischer Kulturbesitz in Berlin, a repository of the art of Central Asia. Now, through the Metropolitan Museum, we share this heritage of a distant land with the American public.

Stephan Waetzoldt
Director General
Staatliche Museen Preussischer Kulturbesitz

PREFACE AND ACKNOWLEDGMENTS

REPORTS OF A GREAT Buddhist civilization, dating from the first millennium A.D. and buried for centuries beneath the drifting desert sands of Central Asia—what could have been more provocative to late nineteenth- and early twentieth-century explorers and archaeologists? Drawn by this startling news, those who braved the hazards of fabled Turkestan found a reality that far exceeded their expectations. What they discovered was indeed a missing chapter in the history of Asian art: the lost cities and Buddhist communities which had graced the ancient Silk Routes once connecting Rome to China.

For centuries these routes were the avenues along which the great caravans carried goods between East and West. Inevitably also they were channels for the communication of ideas, beliefs, and art styles. People of different races and professions—merchants, monks, soldiers, pilgrims, official emissaries from far-off lands—stopped at the cities along the way. Many languages could be heard there; many cultures blended to create an intellectual climate of high order. In the large cosmopolitan centers, where Jews mingled with Hindus and Zoroastrians traded with Muslims, valuable commodities from China and India, Rome and Persia changed hands no doubt many times before they reached their final destination. In all this traffic perhaps the single most significant and lasting treasure transmitted along the Silk Routes was the Buddhist faith.

That Buddhism, and with it Buddhist art and iconography, spread from its homeland in India to China is now well known, although the precise chronology and sequence of its movement have still to be worked out. To understand the complex nature of that movement, partly by sea but primarily overland, requires an appreciation of the richness and diversity of the cultures of Central Asia. In addition, the Buddhist art of Central Asia is crucial to an understanding of the dissemination of styles throughout the whole of the Far East.

Travelers who reached the oasis cities and garrison towns along the Silk Routes found thriving schools of Buddhist learning and art. Under the patronage of local rulers and the religious community, great programs of Buddhist subject matter were painted in glorious colors on the walls of cave temples hollowed out from cliffs and in the interiors of freestanding temples and monasteries. There were Buddhist sculptures fashioned from clay, wood, and more precious

materials, and painted temple banners to enhance places of worship. Donors could commission works of art to accrue merit in this world and purchase icons to bring home. Nor was Buddhism the only religion of ultimately foreign origin to be found in Central Asia. The Manichaeans and Nestorian Christians had communities in the Turfan area, evidence of the diversity of cultures that flourished in that remote part of the world.

The archaeologists whose discoveries and publications first revealed the existence of this forgotten civilization sent their finds back to their own countries: to Germany, France, Russia, England, India, and Japan. Unless one traveled abroad, therefore, the visual impact of what they found was hard for Americans to imagine. This lack of first-hand experience of the great artistic remains of Central Asia could hardly be corrected through the few examples which have entered the collections of American museums. Now, for the first time, a major exhibition of the art of Central Asia—one of the most fascinating chapters in the history of Asian art—has been brought to this country.

My warmest thanks go to Professor Dr. Herbert Härtel, Director of the Museum für Indische Kunst at Dahlem, who so generously permitted me to make a selection far beyond my original expectations, and to Dr. Marianne Yaldiz, who very graciously shepherded me through the wealth of Central Asian art in the museum. We are fortunate to have in this volume the fruits of their expert knowledge of the collection. Acknowledgments are also due to Dr. Raoul Birnbaum, of Cornell University, and to Dr. Willibald Veit, of the Museum für Ostasiatische Kunst in Berlin, for their contributions to the catalogue.

I would like to record my gratitude to Dr. Stephan Waetzoldt, whose unstinting advocacy of the exchange program between the Berlin museums and the Metropolitan was crucial to the success of this project, and to Philippe de Montebello, whose enthusiastic support has ensured its fruition.

Countless people in Berlin and New York have contributed their skills and efforts to the realization of the project, and I am deeply grateful to them all. A special word of thanks is due to the exhibition designer, Jeffrey Daly, whose innovative installation has preserved the integrity of a very complex body of material; and to the catalogue editor, Mary Laing, whose constructive intelligence and dedicated care have been so important in shaping this volume.

Martin Lerner
Curator of Indian and Southeast Asian Art
The Metropolitan Museum of Art

INTRODUCTION

Herbert Härtel

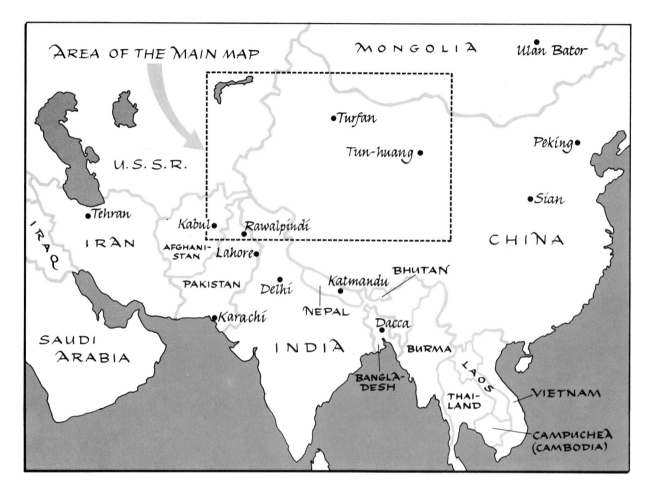

Part of the Eastern Hemisphere, showing the area of the main map (see pages 16–17)

pages 16–17
Map of Chinese Turkestan and adjoining areas, with insets showing the main regions
explored by the German Expeditions between 1902 and 1914

At the end of the nineteenth century and in the first few decades of the twentieth, scientific and archaeological expeditions to the regions along the so-called Silk Routes in Chinese Turkestan led to the discovery of numerous cave temples and monastery ruins on the slopes of the Tien Shan and Kunlun ranges. Members of the expeditions were amazed by the art treasures and documents that they found there, and soon their detailed reports captured the attention of an interested public around the world, in both West and East. The news—and it was no exaggeration—was of the rediscovery of a culture which had disappeared without trace centuries ago. Who, apart from one or two scholars, would ever have guessed that this inhospitable area of Central Asia was once a link between China and the Western Lands, with its own rich culture?

Central Asia and the Silk Routes

The geography of the area would suggest that nature had expressly designed a forbidding no-man's-land between the great cultures of the world. In the east are the Lop and Gobi deserts, to the north and south the long chains of the Tien Shans and the Kunluns, to the west the Pamirs, which are linked to the Kunluns by the Karakoram ranges; together these mountains form a pair of pincers around the heart of Chinese Central Asia. This, in turn, is for the most part covered with the sands of the Taklamakan desert, whose deadly perils have been dramatically described both by the early Chinese travelers and by courageous Western explorers. The only solid ground in this hollow is to be found along the foothills of the mountain slopes in the north and south; here water from the occasional glacier-fed rivers and streams, the most notable being the Tarim River on the northern rim, have made human habitation possible. This is where since ancient times the great connecting routes between East and West have run, aptly christened "Silk Roads" or "Silk Routes" by the German scholar Ferdinand von Richthofen in the last century. One of China's chief mercantile commodities thus became the keyword for the general trade and transport routes of Chinese Central Asia. For centuries the main traffic between China and the West circulated along these Silk Routes, creating a need for stopover stations, which sprang up in the shape of oasis towns and city-states on the mountain rivers and enjoyed their periods of prosperity.

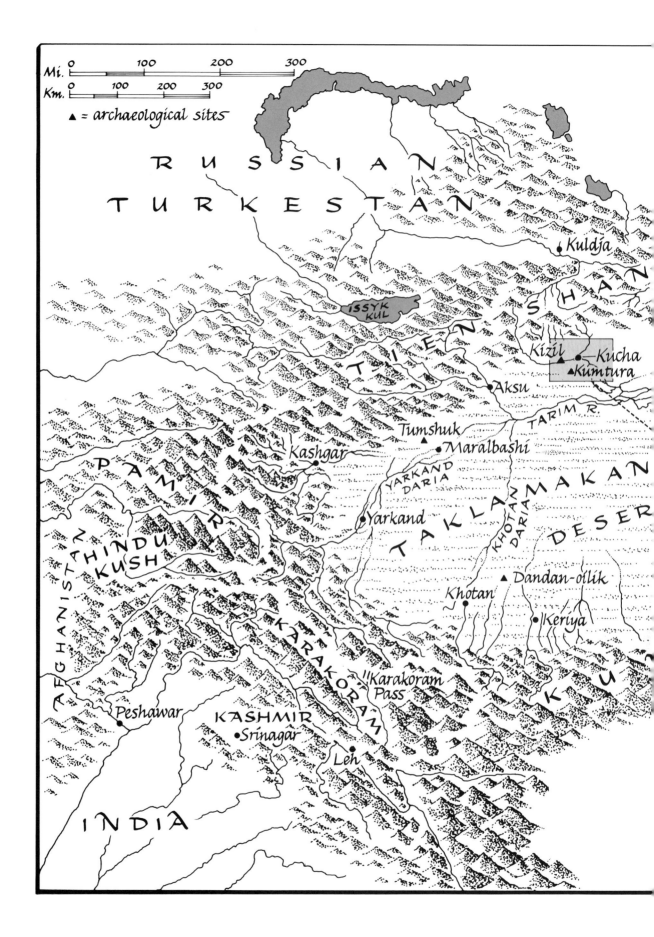

Mi.

Km.

▲ = archaeological sites

R U S S I A N

T U R K E S T A N

• Kuldja

ISSYK KUL

T I E N S H A N

Kizil ▲ • —Kucha
▲Kumtura

• Aksu

TARIM R.

• Tumshuk
• Maralbashi

Kashgar

YARKAND DARIA

P A M I R

• Yarkand

T A K L A M A K A N

D E S E R

HINDU KUSH

KHOTAN DARIA

▲ Dandan-oilik

A F G H A N I S T A N

• Khotan

• Keriya

K U N

K A R A K O R A M

Karakoram Pass

• Peshawar

KASHMIR
• Srinagar

• Leh

I N D I A

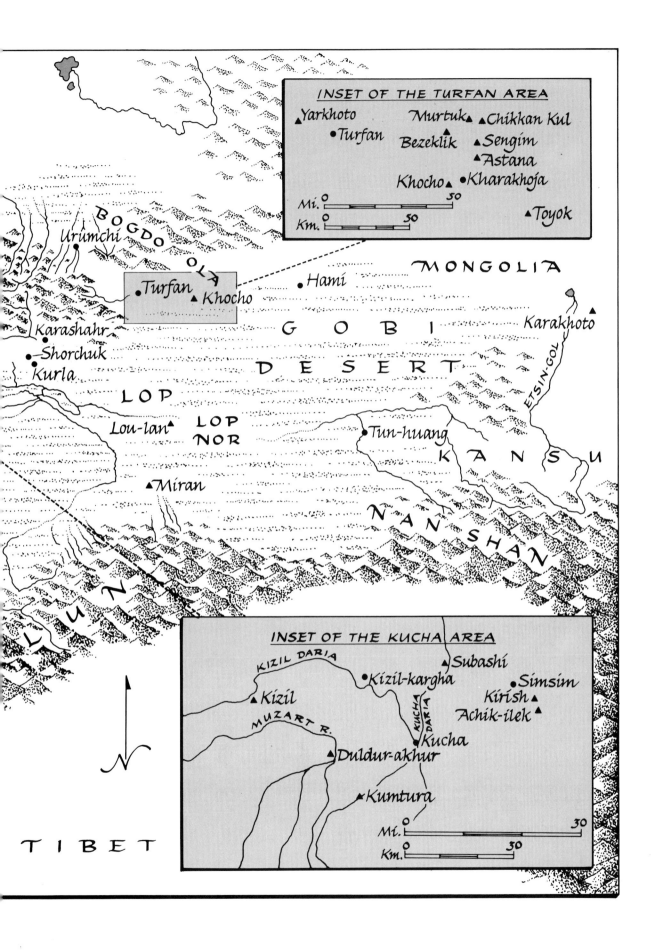

INSET OF THE TURFAN AREA

▲Yarkhoto ▲Murtuk ▲Chikkan Kul
•Turfan Bezeklik ▲Sengim
▲Astana
Khocho▲ •Kharakhoja

Mi. 0 50
Km. 0 50 ▲Toyok

BOGDO OLA

Urumchi

Turfan ▲Khocho •Hami MONGOLIA

G O B I

Karashahr

Shorchuk D E S E R T ▲Karakhoto

Kurla

L O P

LOP
Lou-lan▲ NOR

•Tun-huang K A N S U

▲Miran

N A N · S H A N

K'UN · LUN

INSET OF THE KUCHA AREA

KIZIL DARIA

•Subashi

•Kizil-kargha

▲Kizil •Simsim

MUZART R. Kirish▲

 Achik-ilek▲

•Kucha

▲Duldur-akhur

▲Kumtura

Mi. 0 30
Km. 0 30

T I B E T

The route started from the capital Ch'ang-an (present-day Sian) in the province of Shensi and crossed the Gobi desert to the oasis of Tun-huang where, as it approached the Taklamakan desert, it divided in two: the northern route via Hami, Turfan, Karashahr, Kucha, Aksu, Tumshuk, and Kashgar to Samarkand, and the southern route via Miran, Cherchen, Keriya, Khotan, and Yarkand to Herat and Kabul. In the course of its history, the part of Central Asia thus opened up—now officially designated the Sinkiang Uighur Autonomous Region of the People's Republic of China—has been known under several names: Chinese Tartary, Chinese Turkestan, Eastern Turkestan, Kashgaria, Serindia, Sinkiang, and, as a general term, Chinese Central Asia.

Chinese Turkestan did not enjoy a history of peace. Most of the time it was the object of expansionist policies of ambitious neighboring powers, who sought to bring the important routes along the mountain slopes into their sphere of influence. Huns, Tocharians, and Hephthalites, followed by Turks, Tibetans, and Uighurians, competed to dominate the area and were every now and again subjugated by the Chinese.

In the seventh century A.D., when the Arabs began their conquest of the Sasanian empire in Persia, China attained the zenith of her power under the first T'ang emperors. By about 647/648 all the states of the Tarim basin were under Chinese hegemony. As early as 680, however, the eastern Turks founded an empire independent of China, before they were finally overthrown in 745 by the Uighurians, a related race. From then on the capital of the Uighurian empire was Khocho. The Tibetans also took part in the power struggles of those years; toward the end of the seventh century they invaded the Kucha and Turfan regions, and in 763 they even sacked the Chinese capital, before making peace with China in 822. In the ninth century Chinese Central Asia was predominantly controlled by the Uighurians, although the Arab foe was already threatening the frontiers. In fact, Khotan, on the southern route, had been attacked more than once in the eighth century. The decisive victory of Islam, however, had to wait until the tenth century, when the Uighurian ruler of Kashgar converted to Muhammadanism. This marked the death knell of Buddhism, hitherto the prevailing religion of the region: monasteries and temples were desecrated and destroyed wherever the Muslim armies encountered them. The people of the Tarim basin have remained Muslim to the present day.

With Buddhism went the spiritual basis of the culture of Chinese Turkestan, which had lasted for nearly a thousand years. So complete was its eclipse that not until the archaeological expeditions of the late nineteenth and early twentieth

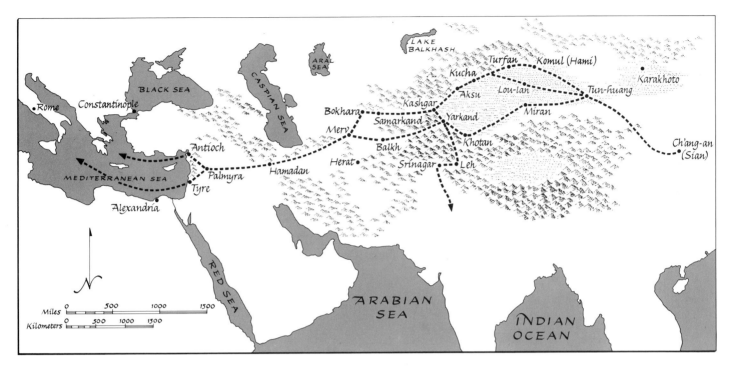

The ancient Silk Routes between China and the West

centuries was its one-time existence rediscovered. How did Buddhism gain its foothold in such a remote part of the world, and what forms of expression did this religion develop in these out-of-the-way places?

Buddhism in Central Asia

The foundation of early Buddhism is the teaching of Gautama Buddha (ca. 563–483 B.C.), who was born in northeast India as Prince Siddhartha of the Shakya clan. His precepts originated in a critical appraisal of the Vedic–Brahmanic religion and the schools of philosophical thought then current in northern India. The term Buddhism also comprises later interpretations which, after the Buddha's death, were propagated by the different schools that had developed from schisms. The two most important of these were the so-called Hinayana (Small or Lesser Vehicle) and Mahayana (Great Vehicle). Hinayana closely followed the original, strict teaching of Buddhism, which preached redemption for only a few indi-

19

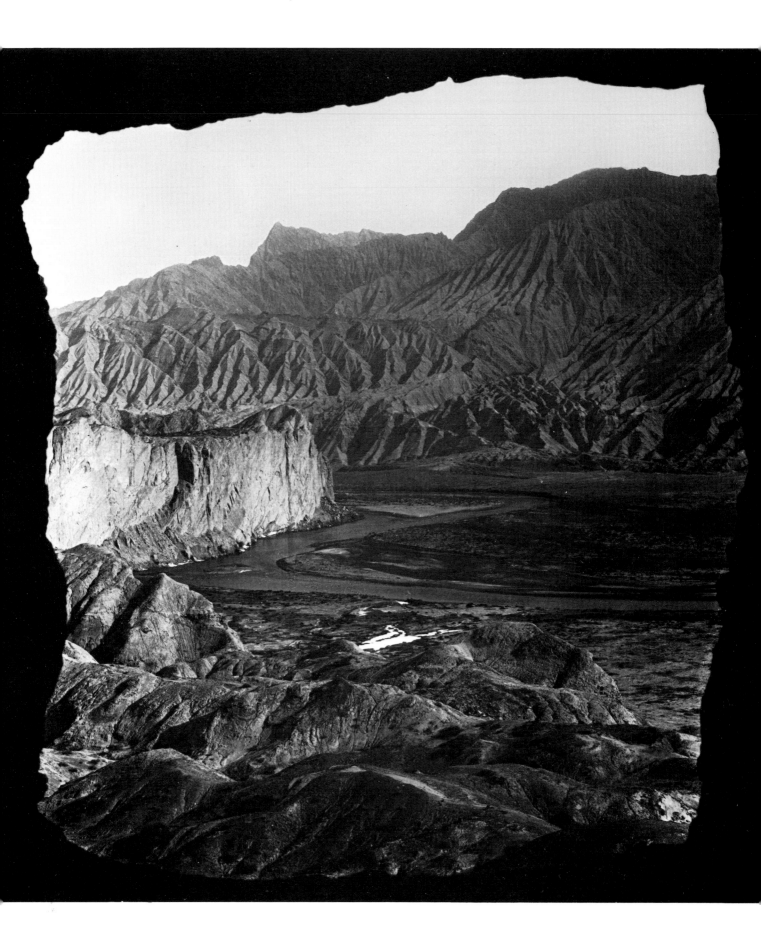

viduals of strong character, while the mass of followers would gain no lasting satisfaction. According to Mahayana, the weak could also attain to the blessed state of nirvana, provided only they had the will thereto and strove toward the goal of enlightenment by worship of the Buddha and the practice of compassion, charity, and self-denial.

Buddhist teachings were at first current only in the Buddha's native land, Magadha (now Bihar). It was the patronage of the emperor Ashoka in the third century B.C. that led to the expansion of Buddhism throughout the northern half of the Indian subcontinent and its growth to become the country's predominant religion. The decision of a Buddhist council in favor of extensive missionary work outside India and the dispatch of monks to Afghanistan and Kashmir launched Buddhism's development into a world religion. Thus it was that at the beginning of our era Buddhist monks were wandering as missionaries through Central and Far East Asia. They carried with them manuscripts of the sacred texts, preached Buddhist doctrines, and instituted Buddhist communities abroad, thus laying the foundation for the prevalence of the Buddhist religion in Asia.

At the same time, Buddhist art also crossed the borders of its land of origin, for from its early days Buddhism had used the language of art as a means of expression and communication. We may well assume that the inhabitants of distant lands acquired their first knowledge of the new religion from the pictorial language of temple banners which were carried around, depicting scenes from the life of the Buddha. Wherever Buddhist communities sprang up in the wake of the missionaries, monasteries and temples were soon built, and wealthy believers donated wall paintings and sculptures to honor the Buddha and to earn religious merit for themselves. With their love of seclusion, Buddhist monks habitually seek out remote spots in valleys and on hills. Along the Silk Routes, the nearness of the mountains with their gorges induced the local Buddhists and their patrons to carve the community buildings and halls of worship out of the cliff walls—in other words they built and decorated cave temples accessible via man-made steps. It was the discovery of hundreds of these caves at the beginning of this century that caused such a sensation. Toward the eastern stretch of the northern route, around the oasis of Turfan, conventional edifices of clay bricks were also built.

Wherever the communities existed, the monks lived their religious life in the midst of nature, ruled by the teachings of the Buddha, in solitude but certainly not as recluses; for they subsisted on the gifts of the laity, with whom they came in contact as they journeyed collecting alms, as was their custom, or

21

View from a monk's cell, overlooking the Muzart River at Kizil

when somebody brought them a donation. In the cave temples and cult buildings they heard and recited the familiar texts of the Buddhist scriptures and walked in veneration round the shrine, whose niches were filled with statues. The walls and vaulting of the cult chamber and ambulatories were everywhere painted with scenes from the life of the Sublime One and with illustrations of episodes from his previous incarnations. In the monasteries, too, copies of Buddhist texts were made from old Indian manuscripts, so that entire libraries were built up, essential for community life.

Works of art and documents from these complexes, which have been abandoned for over a thousand years, have given us invaluable information about their contemporary culture. In addition, the subjects of the pictures and the versions of the texts from the two centers of Buddhist community life on the northern Silk Route, Kucha and Turfan, have had quite another, unexpected impact on Buddhist research. The findings show clearly that Kucha was a center of Hinayana Buddhism, Turfan a center of the Mahayana school. As Khotan in the south has also been shown to have been Mahayanist, we must, it seems, assume that the missionaries of the two denominations took different paths in their travels. The few late cave temples of the Mahayanist faith in the Kumtura region are advance posts created in times of Uighurian and Chinese rule, a small enclave in Hinayana territory. There was no time for the Mahayanists, who by then considered themselves superior and were bent on expansion, to mount an organized crusade from east to west.

Manuscripts, more than any other finds, reveal that Buddhism did not have the field entirely to itself in Chinese Central Asia. The Nestorian version of Christianity and Manichaeism also gained a foothold. In and around the old Uighurian capital, Khocho, and only here, priceless relics of the literature of the Manichaeans have been found, including a number of celebrated book miniatures (Nos. 114–118). That such finds were possible is due in the final analysis to the fact that in the eighth century the Uighurian ruler Bugug Khan (759–780) was converted to Manichaeism, a syncretistic world religion driven out of Western Asia by the Arabs (for a fuller discussion of this religion and its founder, see the Catalogue, text preceding No. 112). From this time onward the Uighurian princes were zealous disciples of the Manichaean faith. Buddhism, however, continued to be the religion of the masses.

As already noted, the conversion of the population to Islam, beginning in the tenth century, consigned the multifaceted culture of Chinese Central Asia to oblivion. The story of its rediscovery is a dramatic one.

Cave temples at Toyok, seen from above

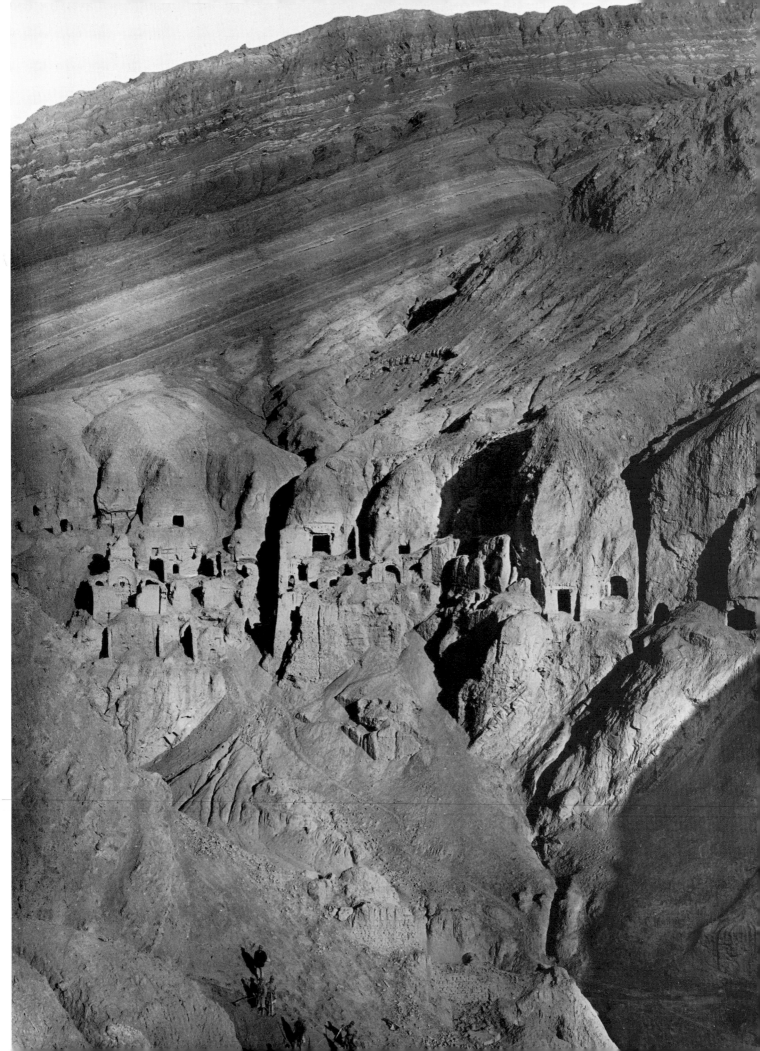

The Discovery and Exploration of Chinese Central Asia by Western Scholars

The modern exploration of Chinese Central Asia took place within a period of less than a hundred years, and at its peak assumed almost the aspect of a scientific race between scholars from many lands. Experts were dispatched from British India, Sweden, Russia, Germany, France, and Japan: alone or in teams they visited Central Asia to survey the land and to study archaeological sites whose existence had hitherto been known only through vague or exaggerated reports.

First in the field were the British officials Montgomerie, Forsyth, and Johnson, whose adventurous expeditions from India between 1860 and 1875 brought back the first serious information on the politics, life, and culture of the area. Their reports were supplemented by the findings of the Russian Nikolai Prejevalsky from his exploration of Central Asia between 1875 and 1880, and of the Russian botanist Albert Regel: they reported having found numerous temples and "Buddhist idols." Regel was the first foreigner to set eyes on the ruins of the old city of Khocho, near Karakhoja.

Between 1889 and 1899 the interest of Indologists all over the world was aroused by a fragmentary manuscript brought to India from Kucha, for the texts, written on birch bark in Sanskrit and an ancient Indian script, dated from the fifth century A.D. and were thus older than any manuscript then known in India. Was it possible that the culture and language of ancient Central Asia derived from India? While controversy still raged about the authenticity of the texts, the Swedish geographer and explorer Sven Hedin had at the end of 1895 begun the first of a series of planned expeditions to "the lost cities of the Taklamakan" from a base in India. Though not an expert in archaeology, art history, or religion, he recognized the immense significance for the world of Oriental studies of the ruins and art treasures he found. In 1900 the British archaeologist Aurel Stein set out from Kashmir on his first expedition to Central Asia. A native of Hungary, Stein was later to be knighted by his adopted country for his contribution to Central Asian studies. He became famous above all for his research in Khotan on the southern Silk Route, the discovery of Tun-huang (1906–09), and the excavations in "innermost Asia" (Lou-lan and Turfan, 1913–15).

In 1898, while Aurel Stein was planning his first expedition and Sven Hedin his third (1899), a Russian scholar, Dimitri Klementz, began the first investigations of a truly archaeological nature for the Academy of Sciences in St.

Petersburg. It was really the results of his work that triggered the great German, French, and Japanese expeditions, which began in 1902 and went on till about 1915. Klementz was the first to photograph the ruins and to bring back manuscripts, fragments of wall paintings, and other items. These finds mark the beginning of the story of the German "Turfan" expeditions, a story that can be traced in some detail with the help of the original records.

The German Expeditions (1902–14)

Prelude

The investigations of the St. Petersburg Academy of Sciences had been preceded by excellent preparatory work on the part of Russian and German scholars. It is not surprising, then, that after Klementz's return the Russian experts engaged in this project quickly established contact with their German colleagues. At the end of September 1899 they stopped in Berlin on their way to the International Congress of Orientalists in Rome to confer with Albert Grünwedel, director of the Indian department of the Museum für Völkerkunde, or Ethnological Museum. A study of the records shows clearly that this meeting sparked off German activities in Central Asia and led, not unexpectedly, to further meetings with the Russians. The preliminary reports in the records throw an interesting light on the state of research, the scientific attitude toward the discoveries in Central Asia, and the political situation at that time. We shall therefore quote from some original documents that have never before been published to conjure up the intellectual atmosphere at the time the great expeditions were being conceived.

Professor Albert Grünwedel, highly regarded by experts all over the world as a scholar in the field of Indo-Tibetan Buddhism and the iconography and mythology of India and Tibet, wrote the following memorandum, dated September 26, 1899, after the visit of the Russian researchers:

> Yesterday Professors Radlov and Salemann brought to Berlin samples of the cave paintings found in Turfan (plus manuscripts and woodcuts) which they intend to present to the congress in Rome. They inquired whether the Prussian government would be prepared to cooperate in an expedition on a larger scale being planned by the Academy, and in the last resort were desirous of at least moral support for the project by our attestation of the scientific importance of the whole thing.

Albert Grünwedel
(1856–1935)

On their way back from Rome the Russians again stopped in Berlin, and Grünwedel made a comprehensive report of their talks. Thus we find under October 17, 1899:

With reference to the visit to the Ethnological Museum of the Russian professors Radlov and Salemann...I have the privilege of adding to my report as follows.

Near Turfan, north of the River Tarim in the eastern foothills of the Tien Shans (Central Asia), the Keeper of the Ethnological Museum of the Imperial Academy of Sciences in Petersburg, Mr. Klementz, and his wife made discoveries of extraordinary significance both for Buddhist archaeology and for the ethnography and philology of Central Asia. Russian merchants having reported to the Academy on unusually interesting relics of ancient times, Mr. Radlov commissioned the sinologist Professor Hirth, resident in Munich, to compile comprehensive material from Chinese sources on Buddhist cities in Central Asia, and dispatched Mr. Klementz therewith to Central Asia. Equipped with this literature, the said gentleman and his self-sacrificing spouse found a whole series of cave temples from the Buddhist era, the entrances to which had been blocked up by sand drifts, but which

were accessible via small openings made by the present inhabitants. All these cave temples are full of wall paintings (frescoes), the preservation of which is now greatly endangered by the fact that the Muhammadan population of the neighboring villages has got into the habit of breaking off pieces thereof to fertilize their fields. Thanks to the foresight of the Imperial Academy, about 50 lb. of such detached fragments of murals have already been brought to Petersburg, and a painter has been sent to make copies on the spot. I have seen a dozen or so such pictures, which were shown to me by the aforementioned gentlemen on their way to the Congress of Orientalists in Rome, on the basis of which they requested my opinion about certain aspects of style and interpretation. It was easy to see that the copies must be truly excellent, for they showed types of frescoes characteristic of ancient Indian, ancient Iranian, and Buddhist Chinese styles. Among the pictures figured a bodhisattva (perhaps Maitreya) in pure Indian style and in the soft matt colors of the wall paintings of Ajanta, now made accessible by Griffith.

There is no doubt, therefore, that we are confronted with a Central Asian sister school of the Buddhist painting of ancient India—everything pointed to the existence of such a school.

Among the pictures of Buddhist Chinese character were Buddha portraits with inscriptions and a Garuda portrayed as the god of thunder.

By and large we may be justified in making a comparison with the paintings of the "King's Road" in Bamiyan, reported by Ritter and Talbot, even though the repercussions of this magnificent discovery can hardly be assessed adequately at the present time. This is all the more true in that manuscripts were found, including bilingual ones (Turkish with Sanskrit glosses in Vartula script), and more discoveries can be expected.

At the same time, it must be stressed that any delay will increase the grave risk of losing for ever these priceless documents of the history of Central Asia.

The Russians' suggestion of a combined project is not mentioned again here. The files reveal that it was examined in depth but could not in the end be realized.

In connection with this report by Grünwedel we may cite the famous sinologist F. W. K. Müller, who stressed above all the significance of the manuscripts, more and more of which were being discovered, and the threat to the documents of Central Asian culture "in a Central Asia dominated by fanatic Muhammadan philistinism and iconoclastic narrow-mindedness." He concludes his remarks with the sentence: "Should it prove possible to make new discoveries of this nature in cave temples, it would throw a whole new light on the entire religious and, what it amounts to, cultural history of Central Asia."

In addition to the Russian samples, the 1899 Congress of Orientalists in

Rome evidently saw British finds, brought out by way of India. Anyone who knows what such international conferences are like can imagine the sort of impression it created among the assembled experts—whether philologists, historians of religion, archaeologists, or art historians—to be presented with two public demonstrations of the existence of a hitherto practically unknown culture. The Turfan file in Berlin contains an eyewitness report by a conference delegate which conveys the prevailing atmosphere:

At the last International Congress of Orientalists in Rome, 1899, a great stir was caused by the presentation of a magnificent collection of relics from the western part of Eastern Turkestan, in the possession of the British government, and by the report of the discoveries of a Russian expedition in the east of the same area. These finds and investigations brought home to us the astonishing fact that Eastern Turkestan possessed a rich and flourishing culture right up to the end of the first millennium, reflecting in its extraordinarily varied aspects the influence of the neighboring Chinese, Indian, and Greek–Western Asian cultures.

The British collection comprises manuscripts and woodcuts, coins and seals, terracottas and other figures, which were found in tombs, towers, and other edifices, or dug up on sites buried in sand drifts.

The most important discovery of the Russian expedition (1898) was the finding of no less than 160 man-made cave complexes (some linked with constructions in the open), being imitations of the world-famous Buddhist monastery and temple complexes of India, which often have subterranean elements. Many of these temples are adorned with Chinese, Indian, and Turkish inscriptions, and above all with magnificent frescoes of religious and secular character.

The greatest significance among the discoveries attaches to the manuscripts, *most of which are in totally unknown scripts and tongues*, presenting Orientalists overnight with a number of *fascinating problems of the greatest import, the solution of which would constitute a great leap forward in the study of Central Asian scripts, languages, and history.*

Of great importance also are the sculptures and paintings, as they illustrate *extremely interesting associations with the art of China, India, and Persia, and indeed with that of Greece, Rome, and the Near East, of incalculable scientific significance.*

For all the quantity and value of the British and Russian finds, they are but a drop in the ocean compared with what could be brought to light in the way of specimens of writing, painting, and sculpture by a *large-scale, methodical, and well-funded* investigation of the sites, in particular by the *excavation of the cities buried beneath the sand.* If it were possible to send a scientific expedition to Eastern Turkestan on such a mission of research, the field of Oriental studies would be enormously enriched.

The First Expedition (December 1902–April 1903)

Grünwedel, with the enthusiastic backing of the Berlin Orientalist and *Privatdozent* Dr. Georg Huth, was now possessed by the idea of undertaking research of his own in Central Asia. Unfortunately, the willingness to finance a German expedition in no way matched the enthusiasm of the experts. The files tell of the endless exertions, interminable correspondence, even begging, entailed in the realization of the project. Especially depressing for Grünwedel must have been the aloof attitude of the Berlin Academy of Sciences, which was prepared to lend moral support only. The first expedition was in fact financed to the tune of only about 25 percent from public funds, namely from the budget of the Ethnological Museum itself, the rest being made up by donations from a private art-lover and a wealthy industrialist, along with a grant from the Berlin Committee for the Advancement of Ethnology, which was made available with a surprising lack of red tape. The first expedition, which with the traveling involved lasted nearly one year, had at its disposal the total sum of 36,000 marks.

The securing of funds, the ratification by the cultural authorities in Berlin, and the applications for the various travel documents had taken a very long time. The scientific preparations had also been under way for some time. Contacts between experts of the interested nations were surprisingly good. Although a joint German–Russian expedition could not be realized, the professors in St. Petersburg assisted their colleague Grünwedel in every possible way, above all in facilitating the expedition's transit through Russia and in securing the necessary papers. Stein, whose first expedition had been reported in the London *Times* on March 30, 1901, visited Berlin at the beginning of October 1901 en route to Central Asia for the second time. He related his expedition experiences and gave important advice on local conditions in Chinese Turkestan. The question was, though, would such commendable cooperation between rivals in the same field prove to be more than temporary?

Reading through the files we can appreciate the nervousness of those involved in the preparations, eager to get the expedition under way, and how their patience was tried by the constantly recurring hindrances. Without a doubt, in view of reports reaching them from other travelers about the cultural vandalism of the local Muslim inhabitants, they were worried that they might arrive too late to forestall irreparable damage to what remained. Thus it is virtually with a sigh of relief that we read under August 12, 1902, the entry: "Professor

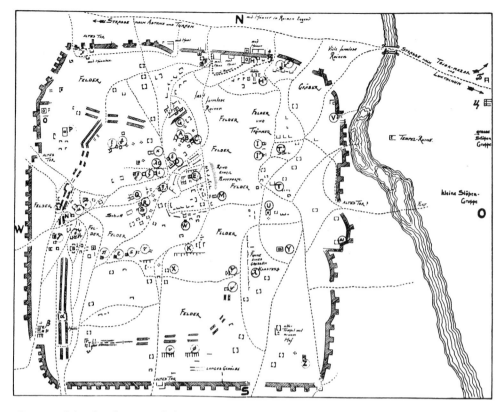

Grünwedel's sketch map of the ancient city of Khocho

Grünwedel and Dr. Huth departed for Central Asia last night." A third member of the expedition was Theodor Bartus, a museum handyman whose adventurous career as a sailor had equipped him with numerous talents which would no doubt come in useful in such a venture. The three-man team was headed for the oasis of Turfan on the eastern stretch of the northern Silk Route. This destination led to the term "Turfan expedition" being applied to all four ventures, though the later expeditions also worked in other locations.

Not until late November 1902 did the team arrive at their destination, after a strenuous journey of over three months. From the beginning of December 1902 to early April 1903 they worked dedicatedly at several sites in the Turfan oasis, notably in the ancient city near Karakhoja (the one-time Khocho), Sengim, and Murtuk. Grünwedel's first task was to draw a reliable plan of the extensive area around Karakhoja, which he found full of ruins and described in a letter as follows:

> This is without doubt a forgotten Asian city of extraordinary interest. The size of it alone is remarkable: the inner, holy city, consisting only of temples and palaces, measures 7,400 feet at the widest point of the still standing walls. Hundreds of

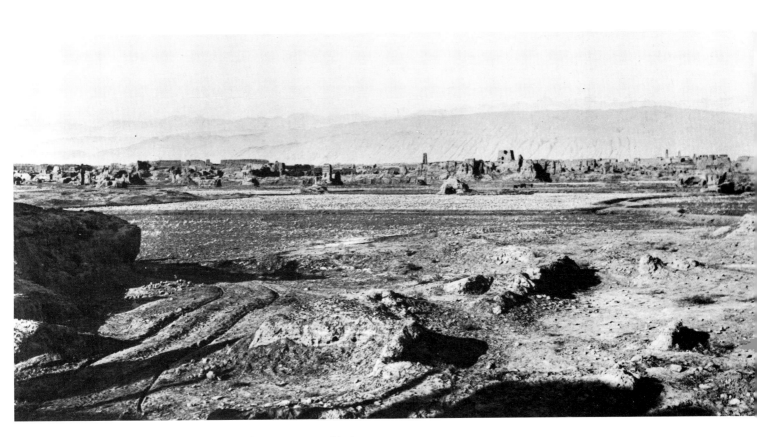

View of the ruins of Khocho, near Karakhoja

tiered temples and grandiose vaulted edifices cover an extensive area of land, where the present-day inhabitants lay their irrigation canals.

Their fears had not been unfounded; with dismay, Grünwedel records:

The city serves as a quarry for materials to build the modern houses, as a gold mine for those who dig for treasures, as a place of amusement where one can smash frescoes and statues of the Buddha to the glory of Allah—not to mention the practical benefit of being able to use the fragments to fertilize the sugarcane, cotton, and sorghum fields among the ruins. There is no police force, so we can only look on as the demolition process takes its traditional course all around where we are working. It is extremely provoking and depressing to work in such circumstances, as we are even obliged to pay the vandals for the fruits of their looting and gradually try to convince them to adopt a more responsible attitude.

Grünwedel published detailed information on the work of the expedition in his *Bericht über archäologische Arbeiten in Idikutschari und Umgebung im Winter 1902–1903* (1906); Idikutschari was his name for Khocho, the great ruined city adjoining Karakhoja. This locality and its surroundings did in fact turn out to

31

be a Buddhist city, but it had, to everyone's surprise, more to offer: manuscripts in many languages and scripts—Sanskrit, Uighurian, Mongolian, Ancient Turkish, Chinese, Tibetan; relics of the Manichaean religion and, as was to be established later, of the Nestorians, a Christian community which will be discussed below. The results of the expedition surpassed all expectations: forty-four crates were filled with the finds—figures of clay and wood, woodcuts, manuscripts, and wall paintings rescued from the rubble of the temple ruins; all were carefully packed and transported by camel and boat to St. Petersburg, and thence to Berlin. Grünwedel had returned with Bartus to Berlin in July 1903, Huth having left the expedition to pursue philological studies in Osh (Kirghizia). At the end of his long, handwritten report in August 1903 Grünwedel draws the following conclusions:

> I consider the organizing of new expeditions to be absolutely essential. The country, which I have now come to know well, is full of ruins of the most interesting nature. Murtuk especially, and Kucha even more so, should be worthy of our attention. Topographic surveys and the measuring of the temples and caves should take priority. In this respect I have done what my modest abilities permitted me, but much more needs to be done in this field before excavations are begun!...As far as the frescoes are concerned, it is high time that energetic measures were taken, as the natives break them off to fertilize their fields. These pictures have a tremendous significance for the history of art in Eastern Asia, as they undoubtedly represent the missing link between ancient Chinese art and the so-called Greco-Buddhist art of the Gandhara region.

The crates of finds arrived in Berlin in November 1903. Shortly afterwards the material was available for examination by the experts. Greatly impressed by the results, the Committee for the Exploration of Central Asia, which had been constituted in the meantime by a number of prominent Orientalists under the chairmanship of Professor Pischel, resolved to equip a new expedition to Turkestan as soon as possible. Thanks to the unreserved support of the scientific bodies, this time there were no problems of finance. The German Kaiser provided the money for the second expedition from his discretionary fund. The Prussian parliament approved without debate the allocation requested by the Ministry of Education and Culture for the third expedition, which was planned to follow without delay.

Orientalists around the world had also been showing more and more interest in the activities and findings of the expeditions to Chinese Central Asia. At the International Congress of Orientalists held in Hamburg in the autumn of 1902,

when Grünwedel was on his way to Turfan, Stein presented examples of his finds from Khotan. In view of the vast and entirely new field of studies offered by Central Asia, the congress resolved to take up a proposal made by the Russians in 1899 and to found a society for the exploration of this area on an international basis. Thus was born the Association Internationale pour l'Exploration de l'Asie Centrale et de l'Extrême-Orient, with a central committee in St. Petersburg and national committees in the various countries of Europe and in the United States. The committees were to work entirely independently of one another, the central committee serving only to facilitate a systematic development of scientific research and to smooth out conflicts of interest. One of the main objectives was also to "check the senseless destruction of the remains being caused not only by the local inhabitants but also by dilettantish travelers." Thus, the serious scientific ventures prompted by anxiety about the survival of the magnificent relics of a great, lost culture had aroused an international echo. A new era had begun for the majority of specialties studied in the Oriental faculties of Western universities. China, however, the land most directly affected, was obviously totally unconcerned—how else to explain her failure to curb the excesses of the local Muslims and the lack of interest shown by Chinese scholars in the world-shaking discoveries being made on what was, after all, Chinese territory?

The Second Expedition (November 1904 –August 1905)

The German committee of the international association, under the chairmanship of Professor Pischel and later of Professor Heinrich Lüders, was a national body as envisaged by the Hamburg conference. The founding of a commission of experts also meant that in future projects would not depend on the initiative of one individual but would be realized by resolutions of this body. As the plan was to dispatch a new expedition as soon as possible, and as Grünwedel would for health reasons not be able to travel before 1905, it was decided to place the Second Royal Prussian Turfan Expedition under the leadership of Albert von Le Coq, who had been working latterly as an unpaid volunteer in the Indian department of the Ethnological Museum.

Von Le Coq's background was quite unlike that of Grünwedel, who after a regular course of university studies had come to Berlin in 1881 and two years later, while still a young man, had been appointed keeper of the Indian collections at the museum. He had risen thus to become one of the most prominent scholars in his field, winning international recognition with his early work on Buddhist

Albert von Le Coq (1860–1930)

art in India (Grünwedel 1893), later translated into English. Albert von Le Coq, on the other hand, who came of a Berlin Huguenot family, had originally studied commercial subjects in London and America before entering his father's trading firm; only at the age of forty did he decide to change his career, beginning the study of Oriental languages in Berlin in 1900. At the same time he worked without pay in the Afro-Oceanic department of the Ethnological Museum, moving to the Indian department in 1902. It is hard to imagine two more contrasting personalities than those of Grünwedel and von Le Coq: the serious, quiet scholar, who tended to keep out of the limelight and was indeed sometimes difficult to get on with, and the refined man of the world, full of vitality and fun, whose attractive personality made him popular with his fellows. It was obvious that the dissimilarity of characters would produce moments of tension, but to judge from the enterprise shown by von Le Coq and its results, we must commend the commission for having chosen the right counterpart to Grünwedel.

Von Le Coq, accompanied by the factotum Bartus (who was the only one to take part in all four German expeditions), arrived in Turfan in November 1904. This expedition was regarded as a preparatory one, intended to join forces

with the main expedition under Grünwedel which was due to arrive in the course of the following year. The study area was again the ruined city near Karakhoja, designated by Grünwedel Idikutschari and by von Le Coq Khocho (Chotscho). For three months von Le Coq with Bartus methodically investigated the ruins on this site. His letters during the period reveal disappointment with the scant results, and on terminating his stay in Khocho he was less than satisfied with the fruits of his work. Nevertheless, alongside the continuation of the systematic inventory and sketching of the temple complexes, important manuscripts were discovered, written in no less than twenty-four scripts with texts in seventeen languages, some of them entirely unknown at the time, so that the philologists in Berlin had a real job to decipher them. There were not only Buddhist texts but also some pertaining to other religions. Especial interest was aroused by the discovery of sacred writings of the Manichaeans, till then thought to have been lost without trace, among them pages from illuminated books (Nos. 114–118), which are the first pictorial records we possess of this religious community. From a Nestorian temple, also, were salvaged the only surviving, faded wall paintings (No. 95).

Like his predecessors, von Le Coq was struck by the unbelievable brutality with which the treasures of an ancient culture were treated by the local inhabitants. In his popular account of the second and third Turfan expeditions (Le Coq 1926), which later appeared in an English translation entitled *Buried Treasures of Chinese Turkestan*, he writes:

> Our expeditions reached Khocho too late—if they had arrived sooner, more of these remarkable paintings could have been saved. We could also have salvaged more of the Manichaean literature, important for the history of religion and language alike: one of the peasants told me that five years before the first expedition arrived he had found five large wagon-loads of the manuscripts so valuable to us, those with the "small characters," i.e., the Manichaean script, in a temple which was being demolished to make way for a field. Many of them, he related, were illustrated with pictures in colored ink and gold paint. But he had been fearful... of the sinister nature of the writings... and without more ado had thrown the entire library into the river!

Von Le Coq was also very depressed, as Grünwedel had been, by another experience:

> Everywhere great havoc has been wrought by the constant digging of the natives. For the ruined city is a source of various things of practical use to the present-day

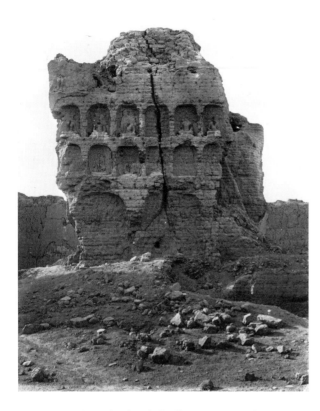

Ruins of a brick-built stupa, Turfan region *Defaced wall painting of Mahakashyapa, Kizil*

inhabitants. First of all there is the loess dust which has accumulated in the ruins over the centuries, constituting together with the broken and trodden-down fragments of statues lying beneath it a valuable fertilizer. Even more sought after as fertilizer are the murals painted on the clay coating of the walls; these pictures are for the Muslim anathema, and consequently, whenever he comes across one he disfigures at least its face. The belief prevails that pictures of men and animals, if you don't destroy at least the eyes and mouth, will come to life at night, descend from the wall, and perpetrate all kinds of mischief to the detriment of man, cattle, and crops! In the neighborhood of the villages, however, they hack these pictures, which are painted in various tempera colors, from the walls and use them to fertilize fields that have been overcultivated. The Chinese officials who govern the land couldn't care less about these ravages; they are all Confucians and despise Buddhism as the religion of the "lower classes." As the population grew, whole sections of the [ancient] city were gradually cleared of ruins by this process of depredation; the ground was leveled, irrigation canals were dug to bring in water, and thus the door was opened for the ravages of damp to get at the remaining ruins.

In March 1905, von Le Coq broke off the work in Khocho and directed his attention to the temple complexes of Sengim, Bezeklik, near Murtuk, and Toyok to the north of Karakhoja. Here were found not only conventional buildings but also cave temples cut in the soft stone or, as in the Sengim gorge, a combination of both systems, in that the cave temples were given a projecting porch of bricks or wood. The archaeologists' luck had now changed, for Bezeklik especially turned out to be a repository of caves, many of them intact, with the wall paintings preserved. In the various groups of caves the paintings were of different styles (Nos. 81–85) and testified to a vigorous activity over a long period of time on the part of Buddhist monks. Bartus, the experienced handyman, was able to rescue numerous murals from these temples; they were dispatched to Berlin, where they were soon to become the object of scientific study and publication. It is a tragedy that a number of the larger paintings from these temples, after having been removed from the reach of the local vandals, were

Southern end of the main terrace at Bezeklik

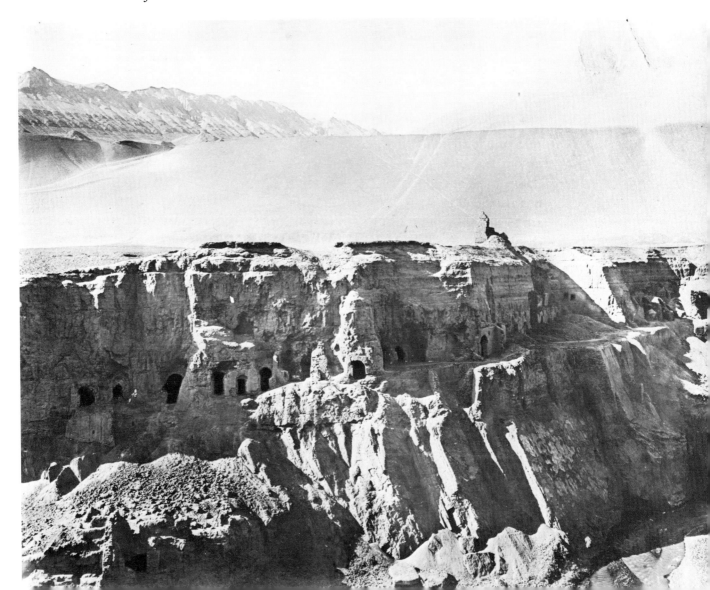

destroyed when bombs fell on the Ethnological Museum in Berlin during the Second World War. Large-scale reproductions of these pictures are, however, contained in von Le Coq's book *Chotscho* (1913).

To escape from the burning heat, in August 1905 von Le Coq retreated to the cooler region of Komul (Hami), higher up in the eastern foothills and reached by crossing the inhospitable edges of the Gobi desert. There too he searched for ancient ruins, but the prevailing climate seems to have been much less favorable for buildings and works of art than in the Turfan oasis, as is indicated by von Le Coq's remarks on the investigation of two Buddhist temples: "We promptly got down to work, but found to our dismay that the snowfalls frequent here in the foothills had made the earth so moist that the sculptures and other relics that we found buried, and there were plenty of them, had lost all shape and form." But in any case there was no time for a lengthy stay in Komul, as a telegram from Berlin brought the news that Grünwedel had decided to travel to Turkestan again and wished to be met in Kashgar. Since Grünwedel's arrival in Kashgar had been announced for October 15, 1905, von Le Coq and

Itinerary of the German Expeditions

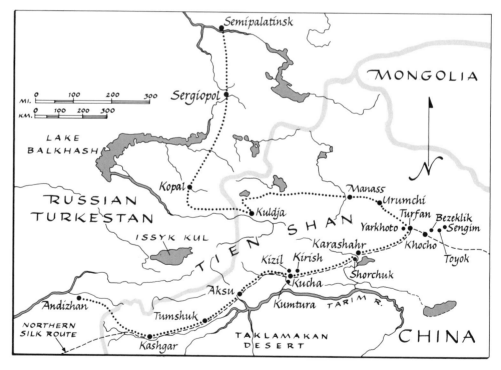

Bartus broke camp without delay, rode back to Turfan, and marched at top speed via Kurla to Kucha, whence they proceeded after a short rest via Aksu to Kashgar, arriving shortly before October 15. What a disappointment it was, then, for them to learn that Grünwedel had lost his baggage in Russian Turkestan, and then to have to wait weeks before he finally arrived in Kashgar on December 5, accompanied by a new member of the expedition, a junior civil servant by the name of Pohrt. During their long wait it was a great relief for von Le Coq and Bartus to be able to enjoy the generous hospitality of the British consul-general, George—later Sir George—Macartney, and his wife, who were also to prove good friends in a later time of need. It was Grünwedel's arrival that marked the start of the third expedition.

The Third Expedition (December 1905–April 1907)

It was really not Grünwedel's fault that he was so late in reaching Kashgar. In 1905, following a report by von Le Coq on Russian interference in Turfan, a heated exchange of letters had taken place between Berlin and St. Petersburg, which had resulted in such a cooling off of the hitherto friendly relations between the parties that Grünwedel planned to travel this time to Central Asia via India instead of Russia. However, as the funds allocated for the main, that is, the third, expedition were not made available until the end of May 1905, and as a considerable sum had to be deducted therefrom and sent off to relieve financial problems that had befallen the earlier, second expedition, Grünwedel was forced to change his plans and to travel, however reluctantly, by way of Russia after all. In St. Petersburg, like the gentleman that he was, he sought to reach an agreement with his Russian colleagues on the areas to be excavated, though it soon became clear that he was the only one who respected the role of St. Petersburg as international coordinating center—not even the Russians kept to the rules. Still, Grünwedel seems to have obtained ratification from the Russian committee for his plan to study the Kucha region as well as the Turfan oasis. Grünwedel was probably alone in thinking it fair to consult his colleagues; his conscientiousness as a researcher is also documented in all his reports—he can indeed be described as the most painstaking archaeologist, with the most scientific attitude, to work in Central Asia. For him, drawing, measuring, and photographing took precedence over the collecting of finds. Grünwedel's second great report, entitled *Altbuddistische Kultstätten in Chinesisch-Turkistan* (1912), is evidence of his thoroughness as an archaeologist. The photographic archive

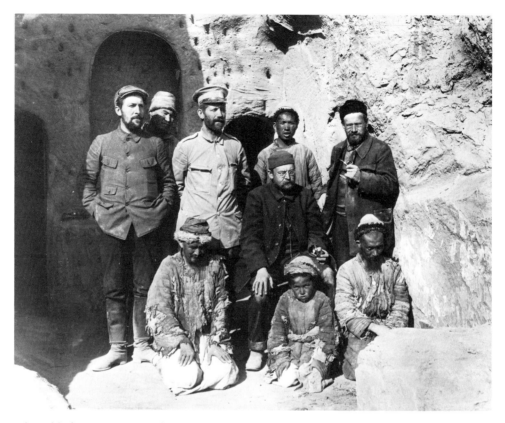

The Third German Expedition
Center row, left to right: Pohrt, Bartus, Grünwedel, von Le Coq

of the Berlin expeditions to Turfan, which still exists today, is unsurpassed in the wealth of valuable material it offers and is still consulted by many experts.

After Grünwedel's late arrival owing to the delays experienced in Russia, the expedition spent a short time exploring Tumshuk (where a few months later the first French expedition to Central Asia under Paul Pelliot started work), and then set off for Kucha. The team worked for nearly four months in the environs of the city: first in Kumtura, a small locality to the west of Kucha, near which there was an extensive complex of ancient Buddhist cave temples, and then in Kizil, like Kumtura situated on the Muzart River, where a multitude of Buddhist temples were found hewn in the mountainsides; the local name for this site, Ming-oi ("1,000 cells" or "chambers"), obviously referred to a vague figure of great magnitude. The work was crowned with success. The wall paintings in many caves exemplified quite a different style—more "Western," as it were, and older (Nos. 9, 10) than those in the Turfan oasis. Only in Kumtura were there

a few caves with murals in a Buddhist Chinese style and coloration (Nos. 59–64), suggesting that this area had experienced more vicissitudes of history, the repercussions of which had carried as far as the monasteries.

In view of the great number of caves, it was necessary to devise a scheme of identification: it was decided not to number them, but to give them names suggestive of their distinguishing characteristics. Thus, for example, we have the Cave of the Sixteen Sword-Bearers, from the groups of knights painted on its walls; the Rockfall Cave, because a great block of stone fell in front of the entrance while it was being explored, narrowly missing von Le Coq; the Cave of the Seafarers, alluding to the seafaring legends illustrated therein; and the Cave of the Red Dome. In the last of these a particularly interesting find was made, namely, the remains of a library of very old manuscripts on palm leaf, birch bark, and paper, together with inscribed wooden tablets. This cave was also the source of leaves from the oldest Sanskrit manuscript, which at the same time is one of the oldest Indian manuscripts ever found.

Von Le Coq, in the book he wrote for the general public, has given us a lively account of the work of the expedition and the many eventful experiences that the team had while in Kumtura and Kizil, including three earthquakes. The work in Kizil was an eye-opener for Grünwedel. In a letter dated April 2, 1906, he writes:

> For years I have been endeavoring to find a credible thesis for the development of Buddhist art, and primarily to trace the ancient route by which the art of imperial Rome, etc., reached the Far East. What I have seen here goes beyond my wildest dreams. If only I had hands enough to copy it all, [for] here in the Kizil area are about 300 caves, all containing frescoes, some of them very old and fine.

In May 1906 the expedition transferred its attentions further eastward to the site of Shorchuk, near Karashahr. Here the most interesting finds were clay figures mostly of Buddhist deities and often with peculiarly rotund faces (e.g., Nos. 65–68); designed to fit into niches, the figures are left unmodeled at the back. At the end of June 1906, an illness of increasing severity made it impossible for von Le Coq to continue. It was about this time that the team heard that Stein was on his way to Turfan and that Pelliot had left Paris for Central Asia. Von Le Coq told Grünwedel he should immediately head for Turfan; he himself returned to Kashgar and, accompanied by a British officer, Captain Sherer, began the hazardous journey to India across the Karakoram mountains. They passed

Entrance to the Nakshatra Cave, Shorchuk

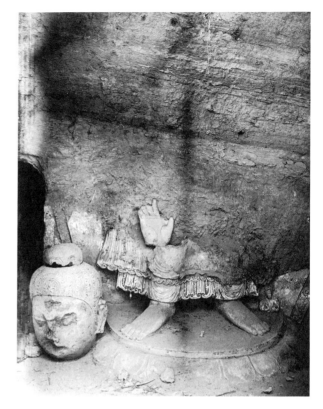

Remains of a standing Buddha, Shorchuk

through many dramatic situations, during which von Le Coq saved the life of his British traveling companion. He finally reached Berlin in January 1907.

Grünwedel, Pohrt, and Bartus continued to work in Khocho and Komul well into the year 1907. Numerous crates were packed with fragments of wall paintings, Buddhist figures of clay, wood, and bronze, paintings on cloth and paper, and a quantity of manuscripts, and these were dispatched to Berlin. Despite the worsening political situation, the finds were sent by way of Russia. Grünwedel and his colleagues traveled home in May 1907 via Urumchi and Semipatalinsk.

The Fourth Expedition (June 1913–February 1914)

The wealth of material that had now accumulated in the so-called Turfan collection in Berlin was enough to occupy the experts and museum personnel for some time. So it is no wonder that six years elapsed before the fourth German expedition to Central Asia was fitted out. One quite unintended advantage of this pause was that there was no chance of a face-to-face encounter with Pelliot,

42

Stein, the Japanese archaeologists Tachibana and Nomura under the aegis of Count Otani, or the Russians, who had suddenly become active and who were now represented by Colonel Koslov and the foremost Russian Buddhist expert of his time, Sergei Oldenburg—all of whom traveled the northern Silk Route between 1907 and 1911. In 1912, when both von Le Coq and Stein were planning new expeditions, the political situation in Chinese Turkestan became so precarious that the Foreign Office in Berlin advised postponing the departure of the German team. The German envoy in Peking had in fact been informed that "the Chinese Government considers the situation in Chinese Turkestan at the moment to be so unsettled that it can accept no responsibility for the safety of members of the expedition." As a result of this, the Foreign Office would give its leave only if von Le Coq expressly declared that he was embarking on the expedition at his own risk. Both he and Bartus signed such a declaration and departed on March 31, 1913, for Kashgar by way of Russia. Their main goal was the further exploration of the area around Kucha visited by the third expedition. They worked there from June to September 1913, and with the Peacock

Icon niche and ambulatory, Kizil

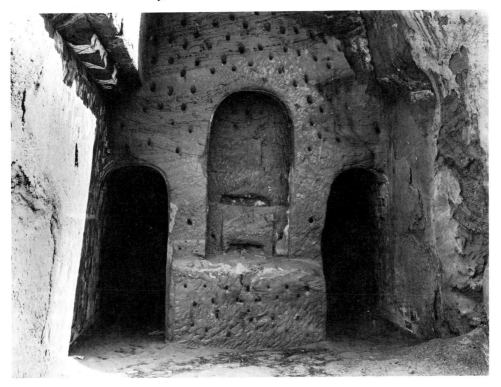

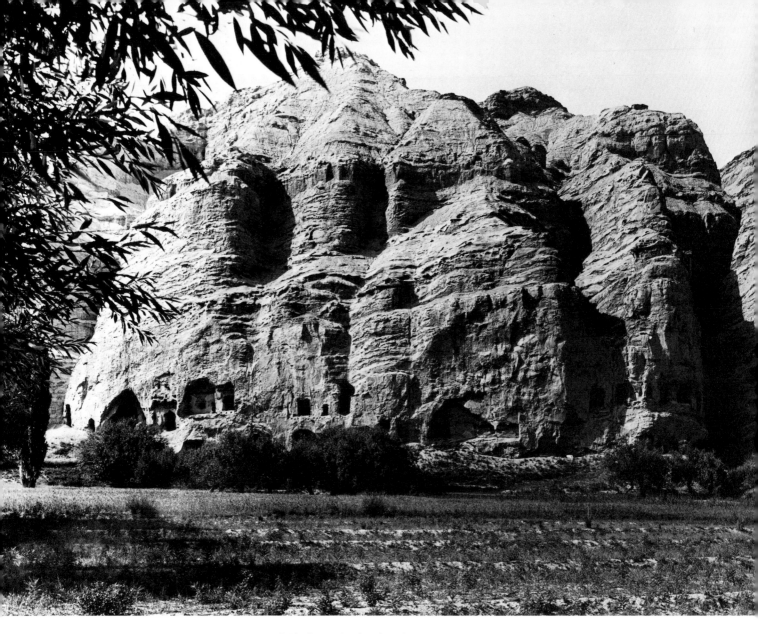

Cave temples at Kizil, from the banks of the Muzart River

Cave, the Cave of the Ring-Bearing Doves, and the Cave of the Sixteen Sword-Bearers they discovered Buddhist temples of outstanding architectural and artistic importance. This expedition gave us the wall paintings of the knights (No. 107) and various Buddhist subjects and legends (Nos. 21–30). During this time excursions were made to Achik-ilek and Subashi Langar, before the scene of operations was transferred for a few weeks to Kirish–Simsim, fifteen miles northeast of Kucha. Not many cave temples were found there, but some, when cleared of debris, revealed unusual architectural features, both in ground plan and in their details. One of the temples had a high dome in seven segments, each painted

with a Buddha image. A few temples with large wall paintings were heavily coated with soot; when cleaned the paintings salvaged from these caves, depicting stories from the preexistences of the Buddha, revealed very individualistic, harmonious color schemes (No. 37).

The fourth expedition also visited Kumtura, where it worked until November excavating the caves with Chinese-style paintings that had been discovered previously, and Tumshuk, which was the object of investigation from December 1913 to mid-January 1914. Numerous crates of finds were packed off under great difficulties, and in March 1914 von Le Coq and Bartus left Kashgar to head back to Berlin via Russia.

This expedition had encountered a very different state of affairs locally; the disturbances in the land had put the inhabitants on their guard and cooled the hospitality they had shown to the members of previous expeditions. Von Le Coq gives a detailed account of the conditions he met with in a book written for the general public, *Von Land und Leuten in Ostturkistan* (1928). We read that Macartney, the consul-general, sent a telegram in September 1913 warning him that fresh disturbances had broken out in Kashgar, and advising him to retreat to Russian territory. Von Le Coq also tells of an attempt to murder Bartus in the night, which was foiled only by the latter's alertness. There was evidently an almost complete breakdown of law and order in Chinese Turkestan at this time, making it a near-miracle that the crates of finds dispatched via Russia arrived in Berlin undamaged by the end of May 1914.

This was the last German expedition; the French and the Japanese also discontinued their activities. Only Sir Aurel Stein, who was already in Central Asia upon the outbreak of the First World War, proceeded with his explorations until February 1915. After the war, expeditions were organized by Langdon

View of the ruins at Subashi

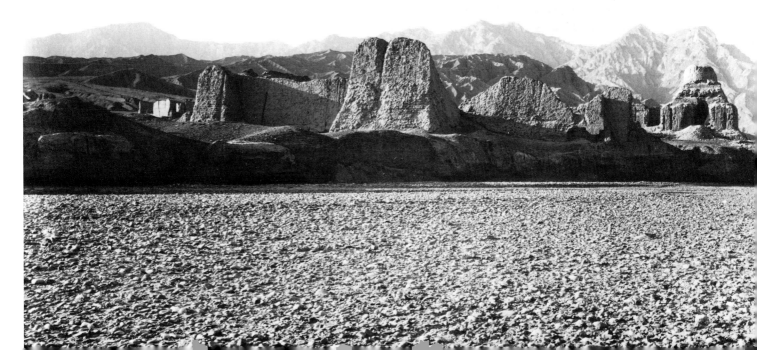

Warner of the Fogg Art Museum at Harvard (1923–25), Sven Hedin from Sweden (1926), and finally Stein under the auspices of the Fogg Art Museum (1930). Then the doors to Chinese Central Asia closed.

Evaluation of the Finds

The relics of a vanished Asian culture recovered from caves along the Silk Routes ended up in a number of museums throughout the world—in Leningrad, Berlin, Paris, New Delhi, Seoul, Tokyo, London, and Cambridge (Massachusetts). Generations of experts have been and still are occupied with the evaluation of the wall paintings, sculptures, temple banners, wooden figures, archaeological miscellanea, and above all of the manuscripts in seventeen languages and twenty-four scripts. Faced with the hundreds of scientific publications on this material, we may well ask what progress would have been made in the field of Oriental studies had this unique cultural enclave in the heart of Asia not been rediscovered. Chinese scholars were at the time pursuing other goals and took no part in the exploration of Central Asia. Thus, when the time came, the field was open to interested Orientalists from all parts of the world. Today, Central Asian studies are an established Orientalist discipline.

Philologists are unanimous in stressing the immense importance of the manuscripts found in the cave temples of Chinese Turkestan. Religious experts have found a fruitful field of study in the texts and pictures. Art historians, however, are mainly interested in the wall paintings, pictures on cloth, miniatures, sculptures, and miscellaneous finds. These relics are chiefly of Buddhist origin, only a small fraction giving testimony of the Manichaeans and the Nestorian Christians, and as the Buddhist works of art are the only ones to have been found at all the sites, a comprehensive survey of stylistic and iconographic interrelations and developments can be based on these alone. The scientific evaluation of the materials collected in Berlin soon led to important results with regard to questions of style.

Central Asian Art—Style and Date

Albert Grünwedel, the leader of the first and third German expeditions, became convinced even during his studies in the field that the paintings in different

localities were of different styles and ages. Inspired by his preliminary findings, Ernst Waldschmidt later classified the paintings as belonging to three principal styles (Le Coq & Waldschmidt 1928–33, VII). A recent attempt to reassess the various styles has found little favor through its failure to take into account the relevant archaeological context and compositional aspects; we may continue, therefore, to go by the old, well-researched analyses. According to these, there were two clearly distinguished spheres of artistic influence in the area of the northern Silk Route: an older, western school (about A.D. 500–700) around Kucha, and an eastern school of later date (about A.D. 650–950) in the region of the Turfan oasis. The styles of the western school are especially well exemplified by the numerous wall paintings from the cave monasteries of Kizil, near Kucha. They betray Indian and Iranian influences and have therefore been designated "Indo-Iranian." The Indian element is seen in the way the subjects from the Buddhist canon are composed and in the serene, tranquil portrayal of the Buddha. The Iranian influence, though less obvious, is to be found in the pictorial details, especially of dress. Crowns and other ornaments worn by bodhisattvas and deities, and many decorative ribbons and borders are of Sasanian origin; numerous decorative features can be traced back to patterns from the Sasanian school of silk weaving. In the eastern sphere, on the other hand, the Chinese influence is predominant, revealing itself quite clearly in the physiognomy of the persons portrayed, in dress, and in accoutrements. There is, however, also a significant sprinkling of ancient Turkish elements. The striking differences between the eastern and western spheres along the northern Silk Route are well exemplified in the two groups of patrons (Nos. 107, 108).

The use of motifs from other lands helps us to place a culture in its historical perspective and to trace its origins, but it is of little value in defining the style of a work of art. Nor, unfortunately, can the names of the artists aid us in establishing stylistic criteria in Central Asian art; we have no personal data for the painters and sculptors whose genius transformed the traditional patterns and elements evolved from the hybrid culture of their homeland into works of art stamped with an individual style. With a few exceptions in which the name of the artist has come down to us, Buddhist art is characterized by anonymity. The artist, who often enough was himself a Buddhist monk, saw his task as being to make manifest in visual form the ideals of the Buddhist faith. Works of art were intended to stimulate the religious feelings of the believer and motivate him to a higher level of moral conduct, thus bringing him closer to the goal of his spiritual aspirations. The work of art is paramount, the artist fades into the

background. Even though his personality is of course contained in an abstract way in his work, it remains impossible, when we review the wealth of pictures from several centuries that has come down to us, to attribute this or that piece to a particular, if nameless, artist. The best we can do is to seek to identify the distinguishing stylistic features of the works, especially of the paintings.

The characters of an inscription in the Cave of the Painters in Kizil support a dating of the oldest paintings in the Kucha region to the period around A.D. 500. There are only a few caves painted in the same style as the Cave of the Painters: between them they represent the oldest group of temples. The Cave of the Statues in Kizil is one of them, and depictions of a cowherd listening to a sermon by the Buddha (No. 9) and of Vajrapani (No. 10) from this cave typify what has been designated the first Indo-Iranian style. Here we see a very specific choice of colors. Note the use of finely distinguished shades of the same basic hue, passing in a variegated scale from whitish yellow through brownish and reddish nuances to deep brown, sometimes merging into black. This color scale is disrupted by only one contrasting color, a very bright green. The second distinguishing characteristic of this style is the line. Fine strokes of the brush give contour to surfaces, objects, and persons. Employed in the rendering of clothes that fall into folds, they create the effect of a three-dimensional modeling of the fabric. This effect can be observed even in such short garments as the cowherd's loincloth: the semicircular concentric lines in the region of his right thigh convey the impression that the material is clinging to the contours of the body. In paintings of this style the coloring of the lines is almost always determined by the ground color, being one shade darker. In areas of flesh the lines form the rough contour and are complemented by portions of shading.

The first Indo-Iranian style evolved via intermediate stages (e.g., No. 17) into the second. Typical examples of this style, which is to be found in a much greater number of caves than the first, are Nos. 21 and 22. The greater use of vividly contrasting colors is striking. We find a new contrast color, a really bright lapis lazuli blue. Nor are the artists afraid of unnatural skin and hair coloring (No. 20). The contour lines are noticeably stiffer and less logical, and there is a starker contrast between the shaded areas. The background of the pictures is often adorned with flowers, leaves, and fruits. Jewelry and headdress have become more extravagant and complicated. The color range is not nearly so monotone as in the first style. The paintings on the vaulted ceilings, for example, are not infrequently of a more graphic character. Stylized mountain landscapes, which often serve as the background for narrative scenes from Buddhist legends, are

frequently divided up into black and white fields, with patches of natural green. These variants are also to be associated with the second Indo-Iranian style, which incidentally is represented by a few examples to the east, in the Turfan region (No. 90).

The western school, which is here illustrated by the pictures from Kizil, reveals no influences from East Asia. At another site near Kucha, however, in Kumtura, alongside caves with paintings in the Indo-Iranian style, were others decorated in quite a different, unrelated manner. The finely detailed representation of deities, for example, part of a wall painting from the Apsaras Cave in Kumtura (No. 60), betrays a free, casual, and individualistic technique. The artist needs only a few brushstrokes to create a lifelike effect. Note also the appearance of new shades; the color scheme is always harmoniously composed.

This is a characteristic of the most outstanding works of the third main style of painting in Eastern Turkestan, the Buddhist Chinese style, which was predominant in the eastern sector of the northern Silk Route, in the Turfan oasis. The Chinese influence can also be seen in the facial characterization of the persons portrayed, and in their costume, jewelry, and ornament. The existence of Buddhist Chinese paintings in a complex as far west as Kumtura is due to a temporary change of political rule; but the fact that these are some of the most beautiful and vivid paintings to have been produced in this style makes Kumtura one of the most important centers of art in Central Asia. The Buddhist Chinese paintings in Kumtura are not, however, merely representatives of the eastern style of art, but also heralds of Mahayana Buddhism in the Hinayana domain of the west.

The sculptures of wood and clay in the Berlin collection permit only a very rough line to be drawn between the western or Indo-Iranian and the eastern or Buddhist Chinese styles. Within these spheres of influence there is such a variety of styles and forms that it is simplest to classify them according to place of origin. Buddhas and devatas (Buddhist deities without names) constitute the main body of the carved wood statues and the clay figures, the latter molded around a wooden framework. Sometimes they formed part of the original decoration of the niches and ledges in the caves, but more often they were pious donations to the monasteries from lay believers and visitors.

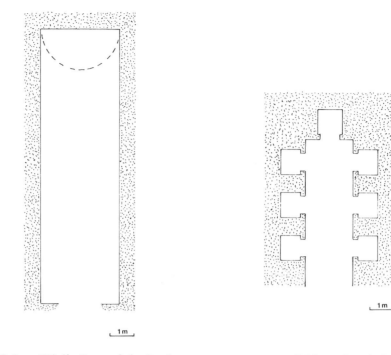

FIG. I:1a *Kizil, Cave of the Seafarers* FIG. I:1b *Shorchuk*

The Architecture

I. Cave Temples

The architecture of the caves in the complexes around Kucha is characterized on the whole by only a few basic forms. Alongside the individual rooms for the high-ranking Buddhists there were simple cells and communal rooms for the monks and utility rooms of various types. These secular structures were only seldom adorned with paintings or sculptures. A different picture is presented by the assembly halls and places of worship of the monastic communities: very often they were almost totally decorated with paintings and sculptures. According to the plans drawn during the expeditions, von Le Coq recognized four basic types.

1. The simplest construction is a long, narrow, rectangular hall, surmounted by a barrel vault resting on an inner corbel (Fig. I:1a). This type occurs mainly in the caves of later date, and only very rarely in the older ones. Sometimes a small room is built on to the rear wall of the cella or several chapels face each other along the side walls (Fig. I:1b). This variant is also found mainly in the more recent caves.

50

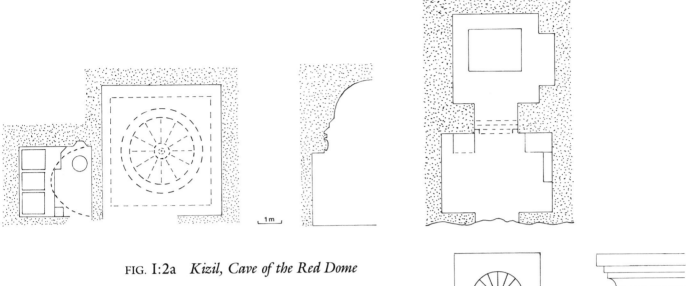

FIG. I:2a *Kizil, Cave of the Red Dome*

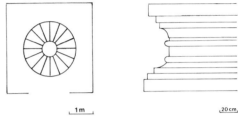

FIG. I:2b *Kizil, Peacock Cave*

2. The caves of the second architectural type consist of a square room whose walls project inward at the base of the ceiling to form a cornice that supports a hemispherical dome (Fig. I:2a). In several of these domed temples (e.g., in the Peacock Cave) a large profiled pedestal stood in the rear half of the room, where the stupa pillar is situated in Type 3 (Fig. I:2b). This kind of cave temple may therefore have marked a transitional stage in the evolution of the third type.

3. The architectural type most often found in Chinese Central Asia is the pillar or stupa temple (Fig. I:3a). It consists of a square or rectangular cella whose rear wall is formed by the central core-pillar. Two low, narrow passages to the right and left of the pillar lead to a usually higher chamber behind it. These ambulatories were used for the solemn processions around the stupa pillar or devotional image; they are always barrel-vaulted. The back wall of the stupa pillar is sometimes curved to form an arch over the rear passage. The cella is usually surmounted by a barrel vault; sometimes it is domed (Fig. I:3b) or fitted

51

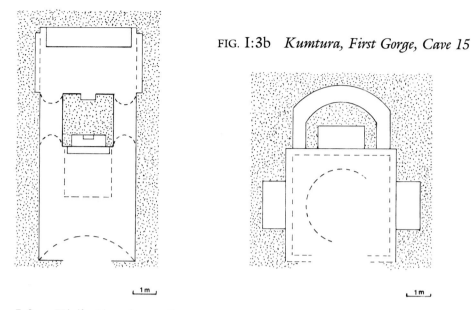

FIG. I:3b *Kumtura, First Gorge, Cave 15*

FIG. I:3a *Kizil, Ajatashatru Cave*

with an imitation lantern-roof as derived originally from wooden edifices (Fig. I:3c). In a later period, apparently, the niche made in the front of the stupa pillar to accommodate the cult image was more deeply cut.

4. The caves of Type 4 consist of a transverse rectangular cella with a barrel vault (Fig. I:4a). The door is located in the center of one of the long walls and is sometimes flanked by a window on each side. A sort of open terrace runs along the front of the cella and explains the presence of windows, which are found in hardly any of the other caves and would indeed have served no purpose there, as most of the temples have dark vestibules; these, however, have practically everywhere caved in as a result of earthquakes.

Similar to this fourth type of temple are the small grottoes that were the cells in which the monks lived. They are transverse vaulted chambers, with a window in the outer wall, reached by a tunnellike, angled side-passage (Fig. I:4b). The fireplace is installed next to the door. Often there is a stone sleeping-bench (lacking in this example).

The architecture of the Turfan area, like its art, differs greatly from that of the more westerly regions. There are indeed cave temples here, though considerably fewer in number. The most extensive group of caves carved out of the rock has been found outside Khocho in Bezeklik, near Murtuk; though in other respects similar to the cave temples in the Kucha region, these are usually provided with separate porches in the open or are fronted by terraces or portals.

52

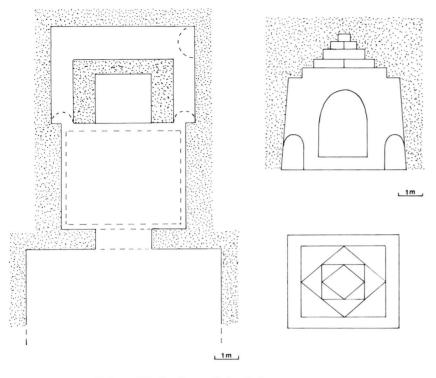

FIG. I:3c *Kizil, Cave of the Painters*

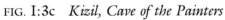

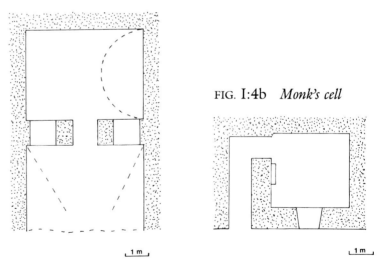

FIG. I:4b *Monk's cell*

FIG. I:4a *Kizil, Cave of the Hippocampi*

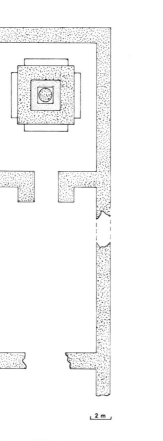

FIG. II:1a *Khocho, Temple* γ

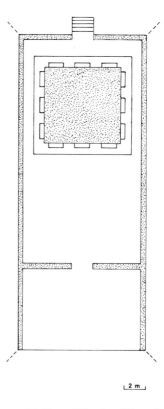

FIG. II:1b *Khocho, Temple A*

FIG. II:2 *Khocho, Temple V*

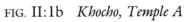

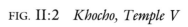

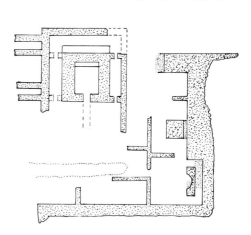

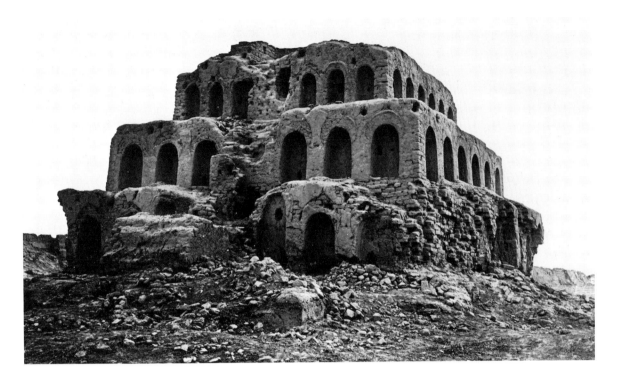

FIG. II:3 *Khocho, Temple Y*

II. Freestanding Temples

In the actual urban areas of Yarkhoto and Khocho there are temples built in the open. They are, however, in a very dilapidated state, as the construction materials—for lack of stone, sun-baked bricks—have been used by the Turkish peasants to fertilize their fields or have fallen prey to the ravages of climate and earthquake. As not only stone but also timber was hard to come by, roofing was a big problem, which the architects attempted to solve by constructing domes and vaulted ceilings.

1. The commonest type of conventional freestanding temple, of which no intact example survives, is the stupa temple. It is surrounded by a right-angled wall, inside which are a forecourt or porch and a stupa (Fig. II:1a). The stupa stands on a square platform which on all four sides often has one or more pedestals or niches for statues (Fig. II:1b).

2. The temples of Type 2 consist of an ambulatory, which in this case encloses not a stupa but a cella (Fig. II:2).

3. The third type of freestanding architecture is the tiered stupa, a tall tower with stepped tiers resting on a square base. Each tier contains niches for statues, usually on all sides (Fig. II:3).

following page
Wall paintings in the Cave of the Painters, Kizil. Scenes of the Buddha Preaching; lower right, figure of a painter at work (see No. 14)

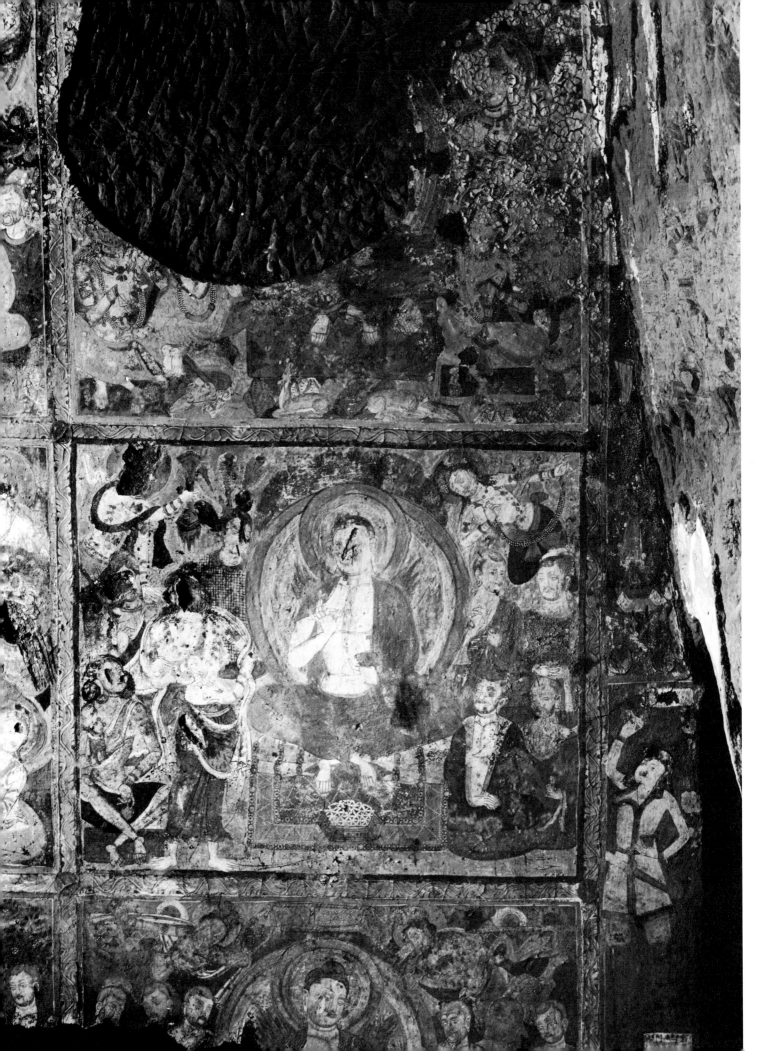

CATALOGUE

THE CATALOGUE ENTRIES WERE WRITTEN BY

Herbert Härtel and Marianne Yaldiz

WITH THE FOLLOWING EXCEPTIONS

Nos. 1–5, by Martin Lerner;
Nos. 123, 125–128, 131, 137, 139–141, 148,
149, 151, by Willibald Veit; and
No. 152, by Raoul Birnbaum.

Measurements are given in centimeters;
height precedes width.

The Influence of Gandhara

AFTER THE DEATH of the famed Macedonian general Alexander the Great, around 323 B.C., his vast empire, assembled through conquest, began to disintegrate. A legacy, however, was left in the ancient region of Gandhara, today within the borders of Pakistan and Afghanistan, of strong links to the classical world.

Strategically situated along the crossroads to northern India, the Mediterranean, ancient Bactria, and far-off China via Central Asia, Gandhara was of tremendous military and commercial significance. Throughout its early history it attracted many different peoples—among them Seleucids, Scythians, Bactrians, Sogdians, Indians, Romans, and Sasanians—who all in varying degrees left their cultural imprint on the region. It was under the Kushans, however, a people originally of Scythian origin, that Gandhara achieved its greatest glory.

The most important of the Kushan rulers, Kanishka, who probably acceded to the throne sometime between A.D. 78 and 144, was one of Buddhism's greatest patrons. The classical legacy of Alexander and contacts with the Mediterranean world under the Kushans led to the development in Gandharan Buddhist art of a style markedly dependent upon Hellenistic and Roman prototypes. Other influences contributed to this style, but the classical flavor of Gandharan sculpture is strong and unmistakable. The iconography, on the other hand, is almost completely Buddhist, resulting in a marriage that made Gandharan art unique.

This is particularly significant in that Gandhara served as one of the major stylistic and iconographic sources for the development of Buddhist art as it extended to other countries. The caravan routes across Central Asia to China were traveled not only by Buddhist monks carrying religious texts, but also by merchants and pilgrims returning home with portable images they had acquired in the fabled lands of the West. The few Gandharan portable sculptures excavated in Central Asia can only hint at what must have been an extraordinary traffic in icons to the East. Woven through the complex fabric of the art of Central Asia are many threads of Gandharan origin.

M. L.

1 Maitreya Preaching to an Audience

Pakistan, Gandhara, ca. 3rd century
Said to have been found at Charsadda (Pakistan)
Schist, 24.5 × 61.8 cm.
MIK I 87

Maitreya, the messianic bodhisattva who waits to become the Buddha of the next great world-age, is seated on a raised throne, his legs crossed at the ankles and his feet resting on a stool. In his lowered left hand he holds the sacred water vessel and in his hair is a device that may represent a stupa; both are attributes associated with Maitreya in Gandharan art.

The preaching Maitreya is flanked by ten devotees, five on each side; included among the larger figures are perhaps the donors of the image. Relieving the strict frontality of the composition, a monk glances

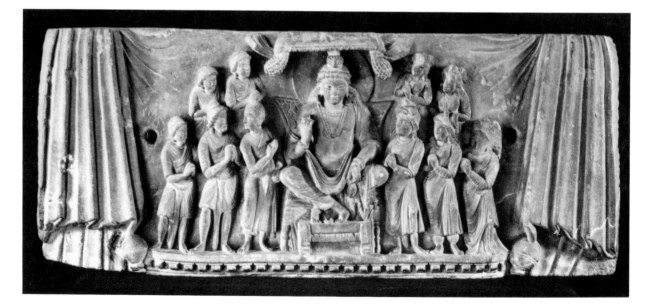

over his shoulder at the figure next to him. The composition is framed at either end by two large panels of cloth whose arrangement indicates that the figure originally supported by this pedestal was seated.

Maitreya's right hand is raised, palm turned inward. This unusual gesture appears often on Gandharan Maitreyas and is preserved in later Kashmiri and Swat Valley representations of this deity. T. A. G. Rao (1914, p. 16) identifies the gesture as *vismayahasta*, signifying astonishment and wonder, but different meanings have been advanced by other authorities.

It is interesting to note that a preaching bodhisattva seated with legs crossed at the ankles became a standard theme in the repertory of Buddhist art of both Central Asia (see No. 27) and China, and motifs such as the flared throne-back appear in the wall paintings of Central Asia and at Tun-huang in western China.

REFERENCES
Foucher 1905–23, II, fig. 348 (ill. cast in the Lahore Museum). Le Coq 1922–26, I, pl. 13c. Ingholt 1957, pl. 285 (ill. cast in the Lahore Museum). Uhlig 1979, p. 91, fig. 23.

M. L.

2 The Seven Steps of Prince Siddhartha

Pakistan, Gandhara, ca. 3rd–4th century
Schist, 34.0 × 21.5 cm.
MIK I 94

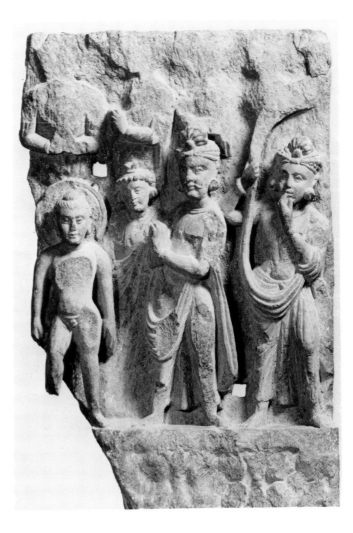

According to tradition, immediately after the miraculous birth of Prince Siddhartha in the Lumbini garden near Kapilavastu, the divine baby, later to become the Buddha Shakyamuni, received his "First Bath." This ritual bath of consecration and purification can be depicted as two streams of water falling from the heavens or from the great cosmic serpents. In Gandharan sculpture, the Brahmanical gods Indra and Brahma are often shown pouring the holy water over the child. This episode is followed by the "Seven Steps": the baby is said to have taken seven steps in the direction of each of the cardinal points, proclaiming that he had been born to become the Buddha—the enlightened one—and that this birth was his final one, since he had achieved the necessary merit in previous existences to escape the cycle of reincarnation, as is the goal of all Buddhists.

The two scenes are sometimes combined, and it is not always easy to determine which is being specified. The Seven Steps can at times be identified by the raised right arm of the baby symbolizing his proclamation, while in the First Bath he is normally shown standing on a stool, his arms hanging at his sides. However, in the absence of water being showered over the child, even the arms-pendent position is usually identified as the Seven Steps. The Berlin fragment shows the naked infant standing on the ground where he took the seven steps, his arms at his sides; the spiritual energy emanating from him is indicated by a halo.

The birth of Siddhartha was attended by Indra and Brahma as well as a group of lesser divinities. Here the attendant figures clasp their hands in the traditional gesture of adoration; the figure to the right of the infant in the foreground probably represents Indra. Another god, standing to the right of Indra, fingers raised to his lips in wonder and waving his scarflike garment, is often present at the birth scene.

REFERENCE
Uhlig 1979, p. 80, fig. 11.

M. L.

3 Standing Newborn Prince Siddhartha

Chinese(?), 6th century or later
Acquired at Khocho
Ivory, H. 6.8 cm.
MIK III 4747

This remarkable sculpture, which to my knowledge has never been properly identified or put into historical perspective, illuminates in many ways the crosscurrents of iconography and style that influenced Central Asian art. The iconography derives from Gandharan sculpture, the style is Chinese, the ivory was discovered in Central Asia, but where it was made is unclear.

The association of this figure with the First Bath or Seven Steps in the narrative of Siddhartha's career is less important than the recognition of its significance as a cult image. Where the elevation of the newborn Siddhartha to cult status first took place is not known, but it did not occur either in Gandhara or in India. Fifth-century reliefs from Sarnath with scenes from the life of the Buddha emphasize the iconic nature of the infant by placing him on a lotus pedestal and making him proportionately larger than in Gandharan art. I am not aware, however, of any icons in the round from this period.

Credit for the subject's evolution to cult status belongs either to Central Asia or to China, with the weight of available evidence in favor of the latter. A Chinese gilded-bronze sculpture in The Cleveland Museum of Art, probably dating to around A.D. 500, is apparently the earliest candidate for a cult image of the newborn Siddhartha known (Lee 1955, figs. 1 and 2). At Cave 6 of the Yün Kang Caves in Shansi province, dating to the end of the fifth century, the divine child as icon is already clearly represented (ibid., figs. 4 and 5).

A remarkable object, extraordinary in the emphasis of its subject matter, shows the continuation or survival of the cult of the newborn child in Central Asia in the eighth or ninth century. Sir Aurel Stein recovered from the shrines of the Ming-oi site at Karashahr, not too far from Khocho, a section of a portable wooden shrine devoted to the newborn Siddhartha (Stein 1921, IV, pl. CXXVII). In the two main compartments are very unorthodox representations of the over-life-size child with a nimbus, making the traditional, but iconographically premature, gestures of the Buddha, his right hand raised in the fear-allaying gesture (*abhayamudra*) and his left lowered in the boon-granting gesture (*varadamudra*). In one panel an attendant holds an umbrella over the man-child; in the other, he is adored by three figures. So conspicuous a departure from traditional iconography can only be explained by the existence of a cult devoted to the newborn child. In both these representations, as well as in the Berlin sculpture, the child wears a loincloth, probably reflecting the effect in Central Asia of the traditional Chinese abhorrence of the display of nudity. In Indian prototypes the baby is almost never clothed.

One cannot with any degree of confidence insist on either a Chinese or a Central Asian origin for the Berlin ivory, since both possibilities exist. But the elongated figure is close to Chinese figural styles of the late Northern Wei and Eastern Wei dynasties and could be as early as the sixth century. The schematic, symmetrical folds of the loincloth and their sculpturesque handling are also more Chinese in flavor than those of the portable shrine from Karashahr, being close to fifth- and sixth-century Chinese Buddhist bronze sculpture.

M. L.

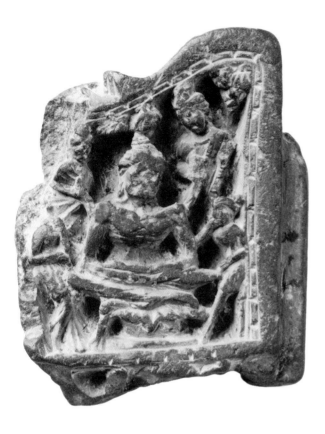

4 The Fasting Siddhartha

Pakistan, Gandhara, 5th–6th century
Said to have been found at Khotan
Stone, 4.3 × 3.5 cm.
MIK III 4849

After Prince Siddhartha renounced his royal heritage and his luxurious existence in the palace at Kapilavastu, he wandered for six years in search of personal salvation and enlightenment. He tried all the traditional approaches, including the ascetic practice of severe physical austerities. Eventually he forsook these methods as being too extreme, having realized that moderation in all things would bring him closer to his goal.

Here, the emaciated Siddhartha is shown seated in a yogic posture surrounded by disciples and Vajrapani, the thunderbolt bearer, who throughout Gandharan Buddhist iconography assumes the position of the Buddha's personal bodyguard even though never specifically contributing to his personal safety.

This fragment is part of a miniature portable shrine in the form of a diptych which would have included additional scenes from the life of the Buddha. Originating in the Gandharan region, such objects played a major role in the dissemination of Buddhist iconography and Gandharan styles, being transported by the faithful to lands far distant from those where the Buddha lived out his life.

Fig. A Fragment of a portable diptych. Gandhara, 5th–6th century. Stone, H. 8.8 cm. Collection Samuel Eilenberg (photo: Otto E. Nelson)

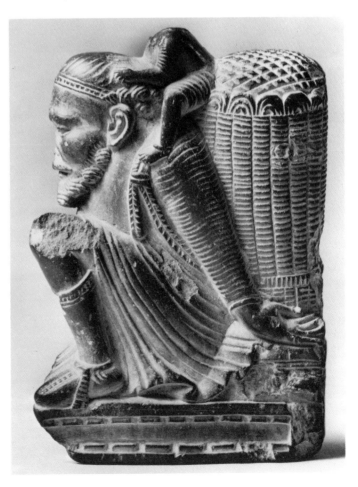

The reverse of this sculpture shows what might at first appear to be part of a large leg. The existence of similar fragments and of a complete ivory diptych would then suggest a reconstruction of this side (Barrett 1967, pls. II and III), in which the leg is that of a noble figure riding an elephant, which supports a relic casket on its head. This scene refers to the transportation of the Buddha's relics after he was cremated and the remains divided.

A more careful examination, however, and comparison with a previously unpublished portable diptych in the collection of Professor Samuel Eilenberg, indicate that this identification cannot be correct. The Eilenberg diptych has on its outer side a seated or kneeling figure with a smaller figure riding on his shoulders (Fig. A). The main figure clearly has a basket of some sort strapped to his back and one arm reaching around the lower part of the basket to help support it. By analogy, what the reverse of the Berlin fragment shows is not a leg but the remains of an arm and a basket strapped to the back of a now headless figure. The subject depicted is rather problematic but may also be connected with the distribution of the Buddha's relics.

In writing about these portable shrines Douglas Barrett (1967, p. 12) rejects Stein's own description—"bearing on the back a basket, the straps passing over the shoulder"—of a fragment he had acquired in Khotan town. In fact, the Stein fragment does indeed show a figure bearing a basket on his back and thus is related to the Berlin and Eilenberg pieces (Stein 1907, II, pl. XLVIII, Kh.003.g). Barrett dates these Gandharan portable shrines to the late seventh and eighth centuries (Barrett 1967, p. 13). On the basis of style, however, I believe a fifth- to sixth-century date to be closer to the mark.

Two other fragments of Gandharan portable shrines were acquired by Stein at Khotan: one was also part of a diptych, and the other was from a four-part shrine (Stein 1907, II, pl. XLVIII, Kh.005, B.D.001.a).

M. L.

5 Head of an Unidentified Male

Pakistan, Gandhara, ca. 4th century
Said to have been found at Khotan
Stone, 2.5 × 3.0 cm.
MIK III 5229

Many small Gandharan secular stone sculptures owing strong stylistic allegiances to the classical world have been recovered from the Gandhara–Kashmir areas. They occur most commonly in the form of toilet trays, cosmetic boxes, lids from various vessels, and objects of undetermined usage. That at least some of these transmitted classical motifs further east, into Central

Asia, is apparent from this rare fragment, said to have been found at Khotan on the southern Silk Route, which could well serve as the paradigm for this whole category of object.

Still preserved on the fragment is the head of a male in profile. This rather authoritarian figure wears a diadem, and above his head a small hand—probably belonging to a winged deity such as Eros or Nike—holds a wreath or ring of some sort.

The subject matter derives from Greco-Roman prototypes. Whether a Bactrian intermediary existed is not clear, but within a Gandharan context there is no reason not to accept the inspiration as coming directly from the classical world, particularly from Rome.

The hole at one corner unfortunately does not help to explain the original function of this enigmatic object.

M. L.

6 Three-Handled Vase

Said to have been found at Borazan near Khotan,
5th–6th century
Pottery, H. 45.0 cm.
MIK III 7665

This clay vase, discovered by von Le Coq and said to come from near Khotan on the southern Silk Route, is evidence for the penetration of classical models as far as Central Asia.

Fashioned on the wheel from a very dense, reddish brown clay, the vessel is a wide-girthed, three-handled vase, the upper half of which, below the broad rim, is richly decorated with ornaments borrowed from classical antiquity. On each of the handles is a small female head in the antique style (one has broken off). Eleven rosettes are impressed in the rim, and there is a frieze around the shoulder. The bulbous part of the

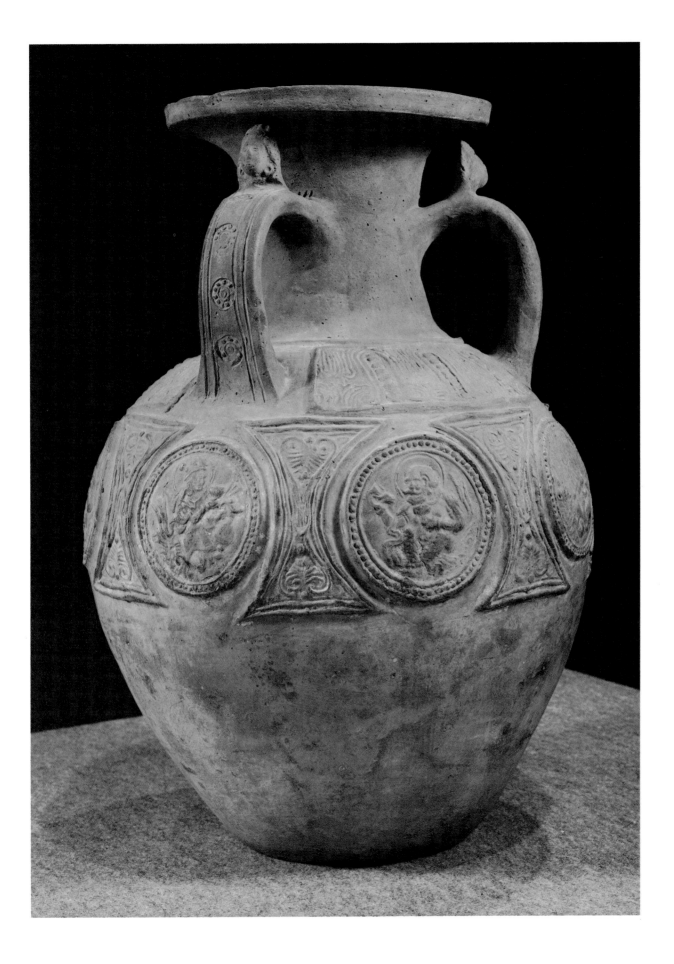

body bears the most important decoration, namely seven circular medallions in relief, about 10 centimeters in diameter, which clearly betray their classical origins. Each medallion is bordered by two concentric circles, separated by a beaded ring. Three different designs appear in the medallions: four have a female figure attired like an Indian goddess, standing and facing right, with a pitcher and hemispherical goblet; in two there is a seated man facing left, portly, bearded, and shaggy-haired, though bald on top, with a nimbus, rhyton, and goblet; the third motif, a lion's head, occurs only once. All the ornaments were mold-made or stamped with dies and applied to the vase before it was fired.

REFERENCES
Le Coq 1922–26, I, pl. 45, p. 29. Härtel & Auboyer 1971, fig. 235, p. 265. Indische Kunst 1971, no. 456, pl. 54; 1976, no. 456, p. 214. Rowland 1974, p. 138, fig. 63.

7 Votive Stupa

Khocho
Red sandstone, H. 66.0 cm.
MIK III 6838

This votive stupa was found among the debris of the "Khan's Palace" (Ruin E). It consists of an octagonal base, a cylindrical central portion, and a crown with eight niches surmounted by a lotus. These niches contain Buddha figures, most of them mutilated, in the attitude of meditation; as far as we can make out, one of them has a garment around his shoulders leaving his chest bare, while the other seven are fully clothed. The pointed arches of the niches ascend to form the dividing lines between the lotus leaves. The stupa is topped by an octagonal cap with stepped ornamentation on its faces.

The central segment is engraved all round with thirty-five columns containing the twelve *Nidanas* ("Links in the Chain of Existence") in Chinese. Bodhisattva figures are incised into the eight faces of the base.

Alexander Soper has compared this votive stupa with others found in the cave temples of the Northern Wei style in Kansu, which are dated between 420 and 430, and suggested that it also originated in the middle of the fifth century A.D. (Soper 1958).

REFERENCE
Le Coq 1922–26, pl. 60 (Chinese text reproduced in text to pl. 60).

8 Votive Stupa

Probably Khocho
Stone, H. 27.7 cm.
MIK III 610

Though considerably smaller and possibly less attractive at first glance owing to damage and blackening by fire, this stupa is more completely preserved than No. 7, as far as the upper part and the text are concerned. Like the other it consists of an octagonal base, though without incised figures, a cylindrical midsection, and a crown of eight niches surmounted by a lotus. Seven of the figures seated in the niches have survived in various states of preservation. The only image of a bodhisattva here is that of Maitreya: he sits with his legs crossed on a draped lotus pedestal. Above the waist he is naked, with a shawl hanging over his upper arms; his hands are laid one in the other. Below the waist he is clad in a pleated garment. Maitreya's ornaments consist of large round earrings, a necklace with a gem in the center, and bangles on the arms. His hair is arranged in tresses, and a high, three-point crown on a circular base rests on his head.

The figure next to him is a Buddha sitting on a lotus pedestal. He wears a robe that leaves the right half of the chest free, and a shawl that completely covers both shoulders and arms; even the hands are hidden by one end of the garment. After this is a Buddha seated in the attitude of meditation, who differs from the preceding one in his clothing: he, too, has a shawl around his shoulders, but it leaves the right forearm and the hands exposed. The next Buddha wears a pleated garment leaving only the hands visible, followed by a figure identical with the Buddha seated in the niche beside Maitreya. The next niche has been broken off. Then comes a Buddha whose shoulders are covered but whose right forearm and hands are exposed; and the last one is again fully clothed, with his hands uncovered. Thus, each type of Buddha occurs twice, along with a no-longer-recognizable figure and the bodhisattva Maitreya.

As this votive stupa closely resembles No. 7 in its conception and style, it dates in all likelihood from the same period.

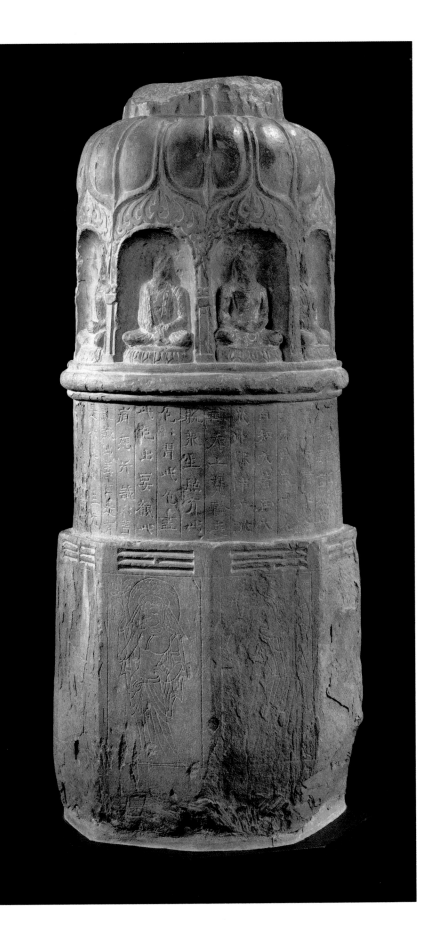

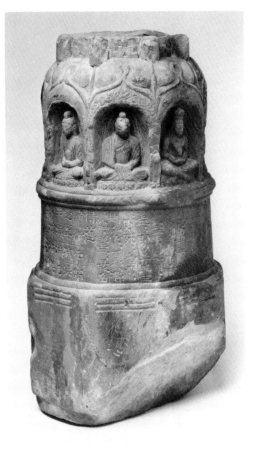

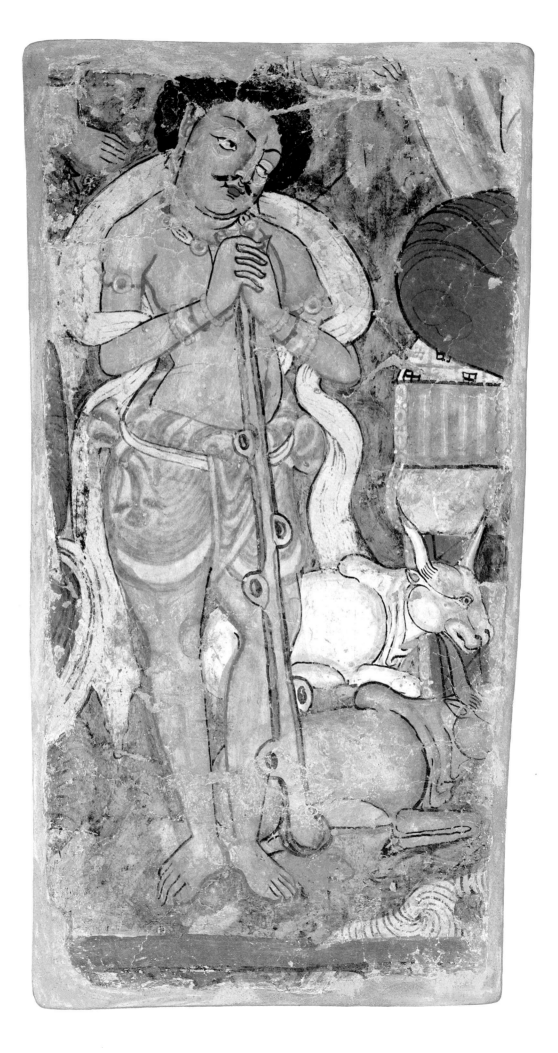

9 The Cowherd Nanda

Kizil, Cave of the Statues, ca. 500
Wall painting, 60.0 × 33.0 cm.
MIK III 8838

This and No. 10 belong to a series of wall paintings of the preaching Buddha that were found in one of the oldest caves at Kizil, the Cave of the Statues, named from the quantity of clay figures discovered there.

Buddhist literature contains numerous references to sermons that the Buddha is said to have preached during his wanderings. Many of these are quoted at length, in order to pass on to the faithful the moral tenets they enjoin. Pictures being more effective than words, it is not surprising that Buddhist artists should have taken up the theme and depicted it in so many variations. Scenes of preaching are particularly common in the cave monasteries of Central Asia, where one type of composition dominates: the Buddha seated in the center, his hand raised in the gesture of teaching, with only the attributes, figures, or animals that surround him varying with the particular sermon represented. This fragment once belonged to such a scene.

Part of the Buddha's mandorla, right arm, and knee are visible in the upper right corner. At the lower right we see a brook, a swirl of green with a red blossom floating on it. Two cattle, one dark in color and the other white, lie on the ground behind the central figure. This is the cowherd Nanda, who, resting on his gnarled stick, watches over his animals as he listens devoutly to the words of the Buddha. So deep is his concentration that he is oblivious of the poor frog he is crushing beneath his stick. The frog, so the legend goes, would have escaped if it had not meant disturbing Nanda's attention; the frog will be rewarded by being reborn as a god, while Nanda will enter the Buddhist order (Dutt 1947, pp. 48ff).

REFERENCES
Le Coq & Waldschmidt 1928–33, VI, pl. 3c and p. 66. Bussagli 1963, p. 72 (ill.). Indische Kunst 1971, 1976, no. 418. Indische Kunst 1980, no. 7.

10 Seated Vajrapani

Kizil, Cave of the Statues, ca. 500
Wall painting, 57.0 × 40.0 cm.
MIK III 8839

Vajrapani, shown here gracefully seated on a wicker stool, is often described merely as the guardian spirit of the Buddha; actually he was one of the most fascinating and ambiguous, as well as one of the most often and variously represented, personalities among the Buddha's following. In his left hand he holds the vajra, the thunderbolt, which here resembles a scepter rather than a weapon. With his right he fans the Buddha, of whose figure only parts have been preserved. Like No. 9, this fragment was originally part of a scene of the Buddha preaching.

Vajrapani is elaborately draped in chains and strings of beads or metal disks. He wears a brown skirt with ruffled green borders, and suspended from his headdress long green scarves whose ends almost touch the ground. His divinity is indicated by a halo. On his head is a diadem decorated with beads and disks, with a white band hanging from either side; rising from it are plumes of feathers at the sides and in the center a large ornamented disk. Similar diadems appear in Sasanian art—for example, on a stone relief of the third century A.D. from Sar Meshed that depicts King Bahram II as a lion slayer (Ghirshman 1962, figs. 215, 216). Roman Ghirshman has pointed out that a royal crown decorated with eagle feathers was originally the symbol of the Avestian god of victory, Verethragna. Verethragna had the same function as Indra, the Vedic god of war, who was included in the Buddhist pantheon.

Visible at the right edge of this fragment is the bare knee of the Buddha, who was seated on a carpeted throne. Below it are two sharp-beaked falconlike birds, one perched on the ground, the other diving from above.

Vajrapani's almond-shaped eyes, his narrow mustache, and his cross-shaped navel are characteristics that are very commonly found in contemporary Indian art.

REFERENCES
Le Coq & Waldschmidt 1928–33, VI, pl. 3b, p. 66. Indische Kunst 1971, 1976, no. 416. Indische Kunst 1980, no. 45.

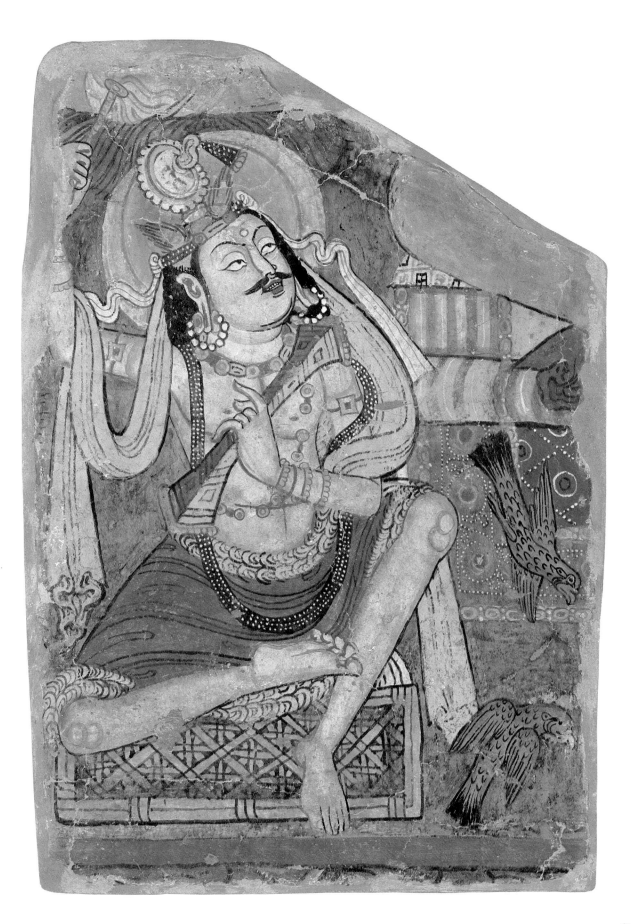

11 Head of a Bodhisattva

Kizil, Cave of the Statues, 6th century
Clay, painted, H. 38.0 cm.
MIK III 7920

Most of the sculptures from the cave temples of the Kucha oasis, though they originated at the same time as the wall paintings, no doubt continued to be produced in the same style for a much longer period. This is because they were not individually created but made from molds. A great number of stucco molds have survived, some of which bear Sanskrit names on the reverse, probably those of the craftsmen who made them or whose property they were.

Since chalk and stone are rare in the loess regions of Eastern Turkestan, the artisans had no choice but to use clay as raw material for the manufacture of religious images. To the clay they added chopped straw, plant fibers, or animal hair for greater durability. Small figures were built up on a wooden cross as armature, larger ones on a core of stone. Head and limbs were molded separately out of the kneaded and compressed clay mix, then attached to the torso. The artist completed the fine modeling of the figure with a thin layer of liquid clay, applied a ground coat of stucco, and painted it. The sculptures on exhibit show what attractive effects could be obtained by this method. Buddhas and bodhisattvas were the beings most commonly represented, followed by devatas, those numerous, nameless Buddhist deities.

It is well to remember when contemplating this fine head of a bodhisattva that life-sized figures seldom appeared alone, but were part of a larger tableau consisting of several sculptures and sometimes paintings as well.

The bodhisattva has regular features, and his forehead and face are framed by curls represented as stylized S-curves. The almond eyes, flaring nostrils, and finely drawn mustache are found, with only slight variation, in other figures from the Kucha region. An individual touch is given by the crown, an imaginative combination of wreath and lotus blossom, with a tassel of hair hanging from its center.

REFERENCES
Le Coq 1922–26, I, pl. 20a. Rowland 1974, pp. 168, 170, 173 (ill.).

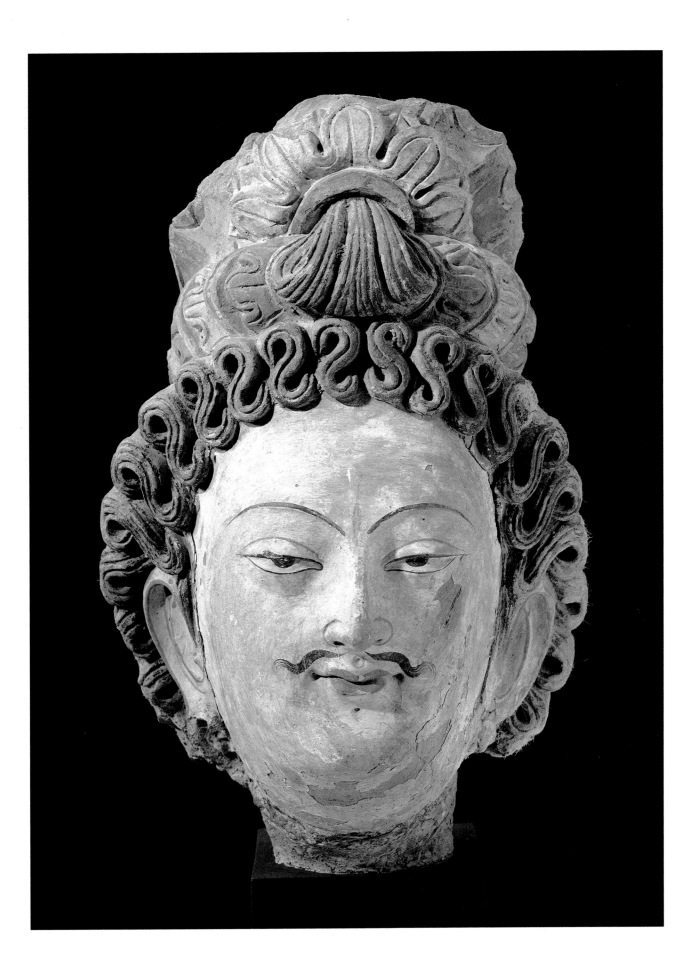

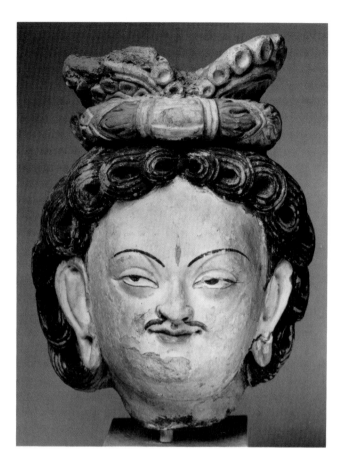 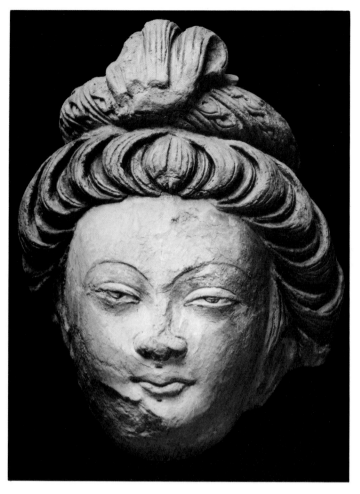

12 Head of a Bodhisattva

Kizil, Cave of the Statues, 6th century
Clay, painted, H. 27.0 cm.
MIK III 7882

The coloring of this head is very similar to that of No. 11, but its expression is quite different. The broader face with its short, hand-modeled nose, the leftward glance of the eyes, and the eyebrows whose painted line diverges from that of the sculpture, all give it a peculiarly individual touch. The individuality of the face is heightened still more by the treatment of crown and hair. The crown consists of a red-and-green wreath with two slanting ornamental disks on top.

The range of colors used in both this head and No. 11 is commonly found in the early phase of the first Indo-Iranian style. Their stylistic correspondence to the wall paintings of the period allows us to date them at about the same time as the paintings found in the Cave of the Statues (for example, Nos. 9 and 10).

REFERENCE
Le Coq 1922–26, I, pl. 20c.

13 Head of a Devata

Kizil, Cave of the Statues, 6th century
Clay, painted, H. 38.0 cm.
MIK III 7918

This head once belonged to a larger than life-sized figure and was completely painted. The lack of a mustache gives the face a peculiarly gentle expression, and it is not hard to identify it as that of a devata, one of the nameless Buddhist deities. Beneath a crown composed of a wreath and overhanging tress, the hair is loosely swept up in symmetrically arranged, crescent-shaped locks. The color scheme is the same as that of the other sculptures and paintings found in the Cave of the Statues.

REFERENCE
Le Coq 1922–26, I, pl. 21c.

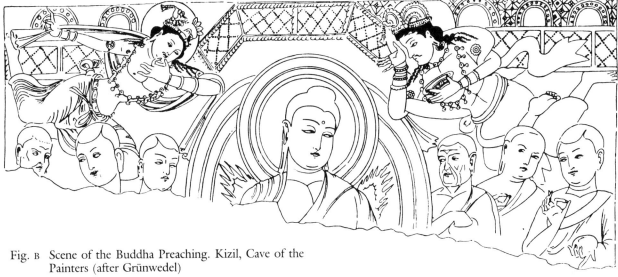

Fig. B Scene of the Buddha Preaching. Kizil, Cave of the
Painters (after Grünwedel)

14

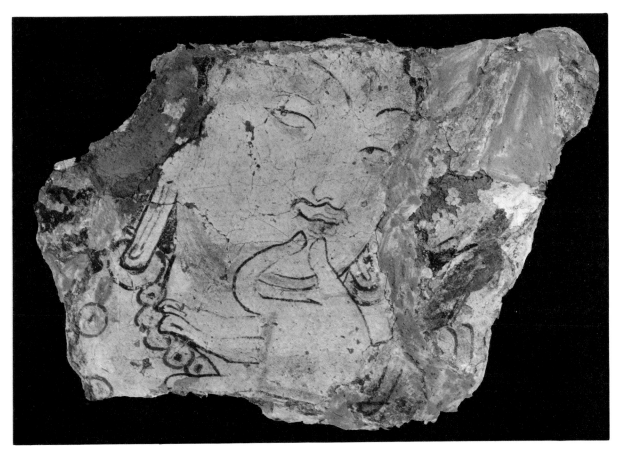

preceding page

14 Head of a Devaputra

Kizil, Cave of the Painters, ca. 500
Wall painting, 10.0 × 17.0 cm.
MIK III 8690a

The Cave of the Painters is, if not the earliest, one of the earliest cave temples of its type, and certainly the most beautifully decorated. It consists of a wide vestibule connected with the cella by a flight of wooden steps. At the time of its discovery the ceiling of the cella had largely collapsed, but the remains of an imitation lantern roof were still recognizable.[1] Architecturally, this cave is of the third type: in other words the icon stood on a pedestal against the rear wall of the cella and a barrel-vaulted ambulatory led around it.

Though the cult image itself was not preserved, a painting of the Visit of Indra was still visible on the niche walls. According to legend, the Buddha once retired to a cave in order to meditate. Indra, wishing to ask him some questions, approached him with a crowd of other gods. To announce his coming Indra sent ahead the gandharva Panchasikha, who played a soothing melody on his harp.

Each of the side walls of the cave bore nine scenes of the preaching Buddha. To one of them (Fig. B) belonged this beautiful head of a devaputra, hovering in the air, the thumb and forefinger of his left hand placed thoughtfully and gracefully to his lips.

The Cave of the Painters was so called on account of the many depictions of painters found on its walls (Fig. C). One of them was even signed: above the male head at the foot of Figure C is a cartouche with the name of the artist (or donor): *citrakara tutukasya*, "[portrait] of the painter Tutuka." As Waldschmidt comments:

These words are written, beyond doubt, in the ductus of the archaic style of Turkestanian Brahmi, which Lüders dates to the fifth to sixth centuries. To be even more precise, it would seem to me more likely that these inscriptions, compared with ones of a similar type, were executed before rather than after A.D. 500. If we agree to say "shortly before or around A.D. 500," this gives us a precise date for the Cave of the Painters, and also a definite starting point for the first style. I do not believe that the other paintings (in the same style) can vary more than fifty years from the execution of the Cave of the Painters. (Le Coq & Waldschmidt 1928–33, VII, p. 28)

1. In free standing buildings this type of construction was made by placing four triangular stone slabs across the corners of a square. The process was repeated in diminishing tiers until the opening at the top was small enough to be closed with a single slab. This method of construction has been imitated in the caves.

REFERENCE
Grünwedel 1912, p. 154, fig. 354.

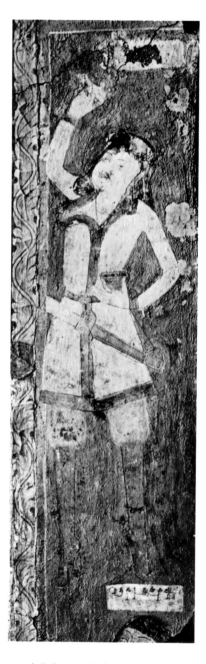

Fig. C A Painter. Kizil, Cave of the Painters

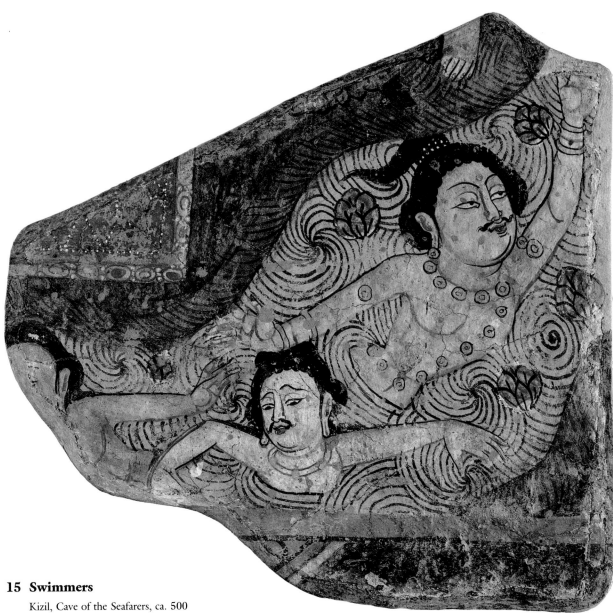

15 Swimmers

Kizil, Cave of the Seafarers, ca. 500
Wall painting, 37.8 × 39.5 cm.
MIK III 8398

The Cave of the Seafarers belongs to the simplest type of building that occurs in Central Asia, consisting of a long, narrow, rectangular room with a barrel-vaulted ceiling. The major paintings on the side walls, in the first Indo-Iranian style, illustrate two seafaring legends, the Shronakotikarna and the Maitrakanyaka Avadana, which relate the consequences of good and bad deeds performed in an earlier life (see Figs. Q and R in the appendix, which gives a synopsis of these legends).

This fragment, found among the debris, had been part of the vault. The scene, which has not yet been identified, could be from the Maitrakanyaka Avadana or from some other seafaring tale. It shows three men swimming among water lilies; the middle one seems barely able to keep his head above water, while the man on the right swims with powerful strokes. His expression and gestures reveal great determination.

Larger than the others, he is surely the main figure in the scene; the chain hanging from his left shoulder is reminiscent of the brahmanic cord that bodhisattvas traditionally wear. A comparison of his face with the faces of the Cowherd (No. 9) and of Vajrapani (No. 10) shows the close stylistic similarity between the paintings of this cave and those of the Cave of the Statues.

It is difficult to say to whom the foot at the top of this fragment once belonged. The edge of a carpeted throne at the left, however, is reminiscent of that of the merchant Mitra in the second scene of the Maitrakanyaka Avadana (see appendix and Fig. R).

REFERENCES
Grünwedel 1912, p. 147. Grünwedel 1920, figs. 30 and 31, pp. II 29–II 53. Le Coq 1922–26, IV, pl. 9a. Bussagli 1963, p. 73 (ill.). Indische Kunst 1971, 1976, no. 410.

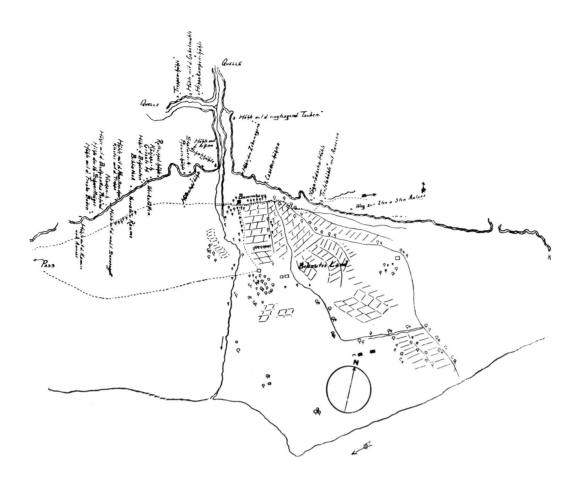

Fig. D Sketch map of the main site at Kizil (after Grünwedel)

Fig. E Plan of the Cave of the Devils with Annexes, Kizil

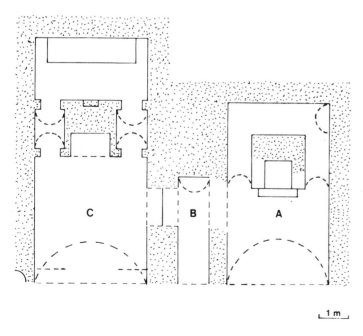

16 Icon Niche with Figures of Monks

Kizil, Cave of the Devils C, ca. 600
Wall painting, 153.0 × 147.5 cm.
MIK III 9042

The group of temples that Grünwedel called "Teufels-höhle mit Annexen," or Cave of the Devils with Annexes (Grünwedel 1912, pp. 132ff), after its representations of demons from Mara's army, lies in the eastern part of the main site at Kizil (Fig. D), between the Narrow Ravine and the pass that leads to the Second Site. It comprises three interconnected caves, A, B, and C, in parallel alignment (Fig. E). Their vestibules have been destroyed. Caves A and C are similar in type; they represent the column or stupa temple, which has a barrel-vaulted cella, an icon niche attached to a stupa on the wall, and an ambulatory. Cave B, by contrast, is a long, narrow, barrel-vaulted room similar to the Cave of the Seafarers. Much smaller than the neighboring caves, it serves primarily to connect A and C.

The wall painting here came from Cave C on the far left, more precisely from the transverse passage that connects the two corridors. This passage was relatively wide and had a flat ceiling. A small niche was let into its short wall; on both sides of it were murals which together with the icon once made up a single composition. Only the painting to the left of the niche has survived. It shows five monks, arranged on three

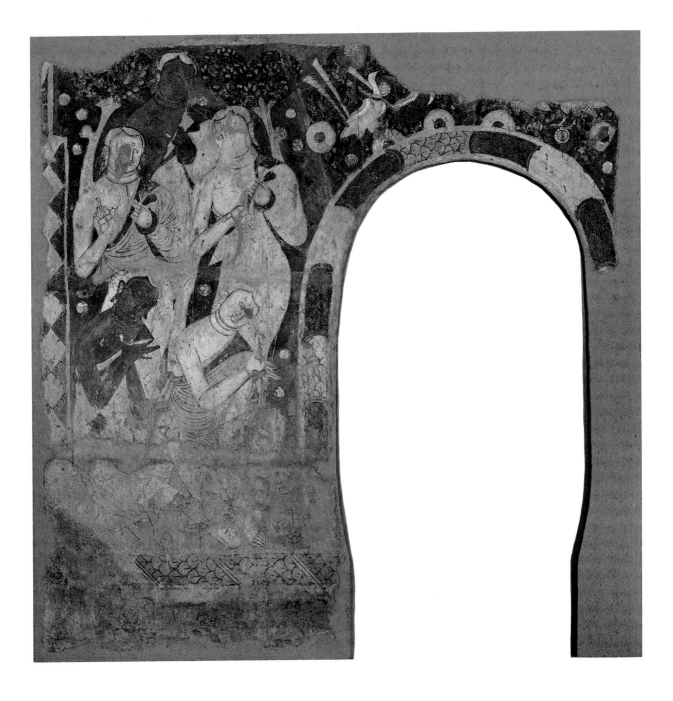

planes. The two in front are kneeling, their hands clasped in devotion. The monk on the left is dark-skinned; the outlines of his body are drawn in light brownish red, his palms in a bright pink. His green upper garment, its top corner folded over, is lined in brown. Parts of his lower garment can just be discerned. He and the other monks have their right shoulders bare. The fair-skinned monk beside him is dressed in a robe of dull blue; the palms of his hands, like those of the other figures, are pink, emphasizing the plastic effect. In the background a fifth, dark-skinned

monk peers over the heads of the others. The gestures of the standing monks suggest a lively interchange of ideas.

Trees in the background indicate that the episode takes place in a wood. The scene is enlivened by pheasantlike birds. Stylized plants surround the niche and recur along the lower edge of the painting. The left-hand border, only part of which has been preserved, is decorated by a row of green lozenges.

Grünwedel gives the following description of the niche in situ (Fig. F):

Fig. F Kizil, Cave of the Devils C, diagram of icon niche (after Grünwedel)

The short wall was disposed thus: beneath three peg-holes, which may have served to support a balcony or large "clay" statues, a round-topped niche had been carved into the lower wall.... What sort of statue the niche contained can no longer be determined. It was flanked by ten religious figures, in standing and kneeling postures. These figures are somewhat higher than the niche itself. Above it one can make out superb phoenixes. Many heads of these once beautiful figures of monks I found cut out: 1. a nude Jaina-digambara, whose head has been removed; whoever defaced this section overlooked the remarkable fact that the figure wears a *lingavalaya* (of exactly the same type that is still worn in India); 2. a monk wearing a patchwork robe; 3, 4, 5. Buddhist monks; the middle one is dark-skinned; all of these figures are standing; 6, 7. two kneeling monks, of whom 6 has a very dark skin; 8, 9, 10. three standing monks, the middle one again dark-skinned.

Waldschmidt comments:

From Grünwedel's description we know that, with the exception of one hermit, the scene depicted only monks. That means the hermit must be the main character in the story. Grünwedel assumed that this group was part of the Parinirvana scene depicted on the opposite back wall of the passageway. I too think that the scene may stand in close relation to the Parinirvana episode. It most likely represents the meeting of Mahakashyapa with Ajivika, who, under a tree on the way from Pava to Kushinagara, informs him of the death of the Buddha. One would expect to find a statue of Mahakashyapa in the niche.

REFERENCES
Grünwedel 1912, p. 142. Le Coq & Waldschmidt 1928–33, VII, pl. 15 and p. 47.

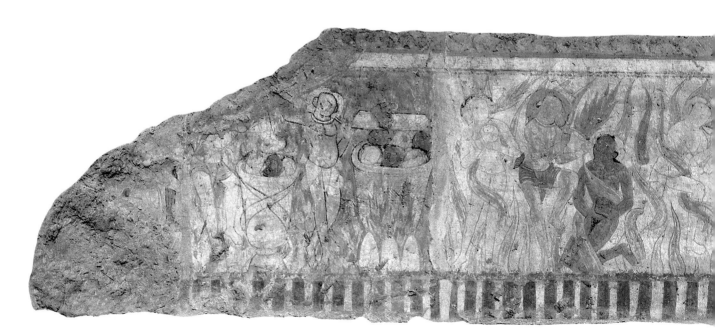

17 Scenes of Hell

Kizil, Cave of the Devils A, ca. 600
Wall painting, 50.0 × 260.0 cm.
MIK III 8432

On the right wall of the Cave of the Devils A (see Fig. E), this frieze was found below two rows of scenes of the Buddha preaching.

According to Buddhist tradition there are six places of life: the worlds of the gods, of the asuras, or demons, of human beings, of spirits, of animals, and finally, of the damned. "If someone, monks, is burdened with three things, then he will go, as he deserves, to hell."[1] With these words the Buddha commences his description of the numerous hells and of the tortures that there await sinners.[2]

In the first hell, Samjiva, the damned are suspended head downward by the infernal watchmen of King Yama, who proceed to hack them to pieces with axes. Some unfortunates even grow claws of iron and inflict havoc on one another in their struggle.

Whoever is able to escape from this hell falls into the next one, called Kukkula. Here the torment consists of incessant beatings, and the sinners are hounded from one end to the other until finally they pass on to Kunapa. Here they are flayed alive by black monsters, then devoured by ravenous eagles, crows, and vultures. When nothing is left of them but bones, the flesh grows back and the torture begins anew. Seeking

rescue the sinners come to the fourth hell, Vaitarani. To cool their wounds they leap into pools of water, only to discover that it is acid that eats away their limbs. In the Kalasutra hell demons dismember them with plumb line and ax, as one might fell a tree. Nor do the sinners find relief in the next hell, Samghata, for there the mountains move and shift, crushing the damned between the walls of ravines. Tortures by fire follow in Raurava, and in the Tapana hell the unfortunates are forced to eat molten iron, and are then boiled and thrown to the dogs. In Avici, the last of the main hells, the sinners are transformed into pillars of fire in expiation for their misdeeds.

Six such scenes have survived in this wall painting, that on the far left only partially. The second scene from the left shows a fiend about to crush his victims in a huge mortar, while another brings a new load of sufferers, or their heads, to a blue caldron which already is overflowing. Fires burn under both vessels, indicating that this is probably a depiction of the Raurava hell.

In the center of the next scene, a flaming inferno, kneels a dusky, naked man. He has been tightly bound, and a grayish brown demon seems to be forcing him to drink from a blue vessel. Two naked white figures flank this scene; the left one carries a monk's begging bowl with flames licking out of its mouth, the other

1. *Anguttara Nikaya III*, 141 (Seidenstücker 1923, p. 39).
2. *The Mahavastu* (Jones 1949–56, I, pp. 6ff).

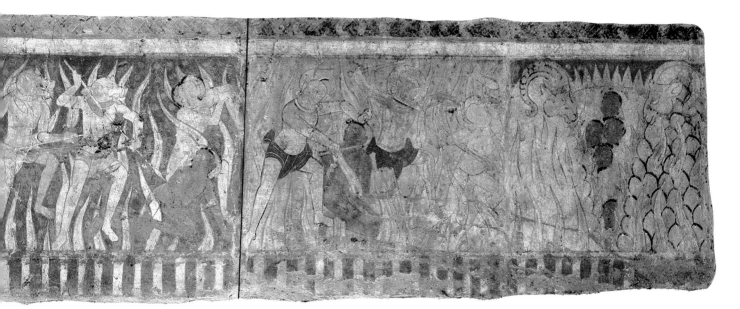

a flat dish out of which flames also flare. Is this the Tapana hell?

The next scene, on a red ground, shows a white, boar-headed demon attacking a prostrate sinner with his lance. A similar blue figure approaches them from the left, and a fair-skinned man seems to be trying to escape.

Two demons are engaged in torturing their two victims in the following scene. The first, his ruffled hair flaming horribly, is about to behead the dark-skinned, chained sinner, while the other demon has grabbed his victim by the hair and is about to punish him. Possibly this is an illustration of the Kalasutra hell.

The last scene certainly illustrates the Samghata hell. Against the red background two mountains, a green one and a blue, are visible, both engulfed in flame. The ravine between them is filled with sinners who will be crushed when the mountains collide. According to von Le Coq, the rams' heads on top of the mountain peaks symbolize the frequent repetition of this event.

REFERENCE
Le Coq 1922–26, IV, pl. 9d, pp. 16f.

18 A Brahman

Kumtura, Second Domed Cave, ca. 500
Wall painting, 69.0 × 56.5 cm.
MIK III 9054

The cave temples of Kumtura lie in a broad valley about twelve and a half miles southeast of the Kizil caves, on the lower reaches of the Muzart River. They have been carved out of the cliffs of a mountain chain that stretches from north to south along the eastern bank of the Muzart. As at Kizil, deep ravines cut into these mountains from the east; on their slopes many cave temples have been found.

Two of the temples in the second ravine had domed ceilings; their paintings belong to the early Indian-influenced phase. It is of great interest that three other temples in Kumtura, a little further north and part of the main group, contained paintings of the much later T'ang period.

This fragment comes from the ceiling of the Second Domed Cave, which in its architecture resembles the Peacock Cave. It shows a bearded brahman with gray hair and darkish skin. He wears the typical dress of an ascetic, a skirt and a narrow sash over his shoulder. Less typical are the ornaments on his ear, chest, and upper arms. In his right hand he holds the attribute of the ascetics, a slim-necked flask, while he gesticulates with his raised left hand. He appears to be conversing with a Buddha, of whose figure only parts of the left arm and knee are preserved; the Buddha was clad in a brown robe and surrounded by a mandorla. Between the head of the brahman and the mandorla another, smaller Buddha hovers, and behind the brahman a devata is visible. The rosarylike string of beads on the devata's right hand appears to have been added later.

Since the scene is so fragmentary, it is difficult to say what legend it represents. Like many of the wall paintings of other early caves (e.g., the Cave of the Painters), this is framed by an acanthus border.

REFERENCES
Le Coq & Waldschmidt 1928–33, VII, pl. 5 and pp. 35f. Gaulier et al. 1976, fig. 120 and p. 53.

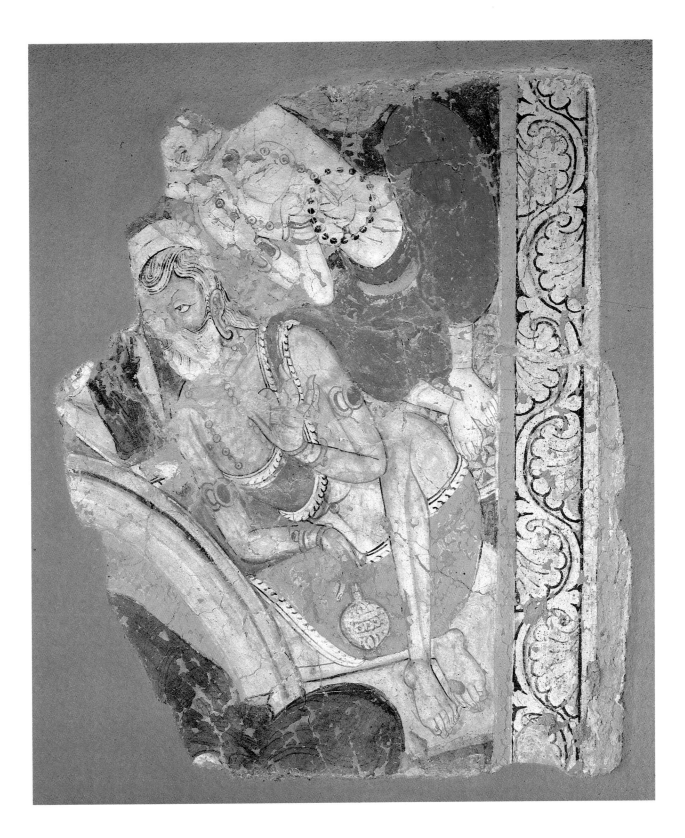

19 Decorative Frieze

Kizil, Largest Cave, 6th–7th century
Wall painting, 52.0 × 110.0 cm.
MIK III 8419

Although larger caves exist in Kizil, they had yet to be discovered when the temple known as the Largest Cave was named (Grünwedel 1912, pp. 77ff). Each of its side walls carried a bench on which clay sculptures of Buddhas, bodhisattvas, or devatas had originally stood. The fronts of these benches were decorated with friezes of bead-edged medallions, of which this fragment is an example.

In these medallions ducks face each other in pairs, holding in their beaks strings of beads with pendent green or black gems. Ribbons tied around their necks flutter in the wind. Their breast and stomach plumage is variously patterned, in scales, checks, or vertical or horizontal stripes. The large medallions are connected by similar, smaller ones, with crescents in the center, and the spaces between them carry starlike flowers, each with three blossoms. Though the colors of this painting have faded, the design is still very clear.

Bead-edged medallions depicting animals or fabulous beings derive originally from Sasanian textiles, but are also found frequently in other materials such as clay.

REFERENCES
Le Coq 1922–26, IV, pl. 15o and p. 25. Rowland 1974, pp. 160 (ill.), 164.

20 Head of Mahakashyapa

Kizil, Cave above the Largest Cave, 7th century
Wall painting, 46.5 × 71.0 cm.
MIK III 8373a

High above the Largest Cave and difficult to reach is a small temple of the usual type, consisting of a cella with an icon platform and an ambulatory at the back wall. The paintings in this cave have been destroyed, all except for two small fragments, of which this is one. It represents Mahakashyapa, one of the Buddha's best-known pupils.

His head is inclined before a flowered background; his hair is cut short and shaved back from his temples in two wings. The eyes, eyebrows, and nose are strongly accented. Mahakashyapa's face is framed by a light blue beard of the same color as his hair. His earlobes have been distended by the weighty earrings he once wore; his neck, chin, and mouth are heavily lined. A fragment of his green patchwork robe is preserved on his shoulder.

This wall painting belongs to a depiction of a Mahaparinirvana scene, as we may conclude from similar, better-preserved paintings. It is from the *Mahaparinirvanasutra*, a Sanskrit text found in Central Asia, and its parallels in Pali, Tibetan, and Chinese, that we learn

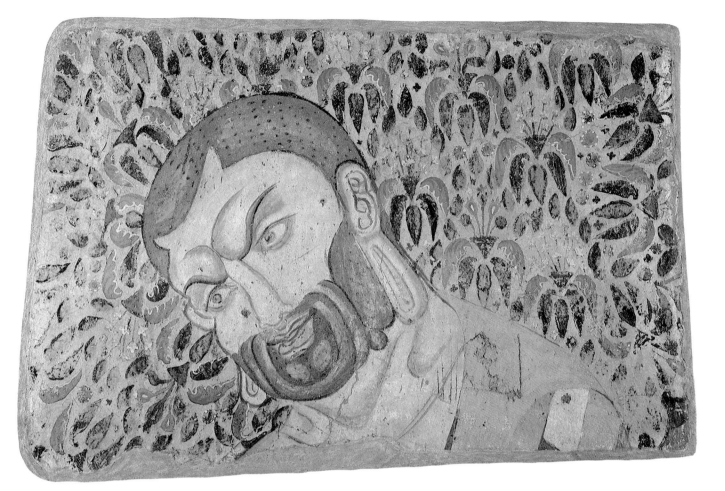

of the events that took place shortly before and after the death of the Buddha (Waldschmidt 1948, Bareau 1970).

All these texts give almost the same description regarding the preparation of the final resting place of the Buddha. He asked his favorite disciple, Ananda, to make a place ready between two *shala* trees in a forest near Kushinagara. The Buddha wished to lie on his right side, his head pointing north. The *shala* trees bloomed out of season, strewing his body with flowers while celestial music sounded. The texts mention several other events of less importance in this connection, such as the last instructions of the Buddha concerning his doctrine and his community, and two final conversions. Then, after having pointed out the transience of the *samskaras* and having admonished his monks to improve themselves continually, the Buddha attained nirvana.

At that time Mahakashyapa was not with the Buddha but on his way from Pava to Kushinagara with a great congregation of monks. He stopped to speak to a brahman who had come from Kushinagara bringing a *mandaraka*-flower from the celebration held in honor of the Buddha. From this man he learned that the Parinirvana had taken place seven days before. Mahakashyapa went immediately to the cremation ground, where, finding the body of the Buddha lying in an oil-filled vessel, he lifted it out, washed and anointed it, and wrapped it in fresh cloths. Then he placed the body on the pyre and set it aflame.

Depictions of Mahakashyapa are very often found in connection with the Parinirvana of the Buddha. To judge from its expression of deep grief, the present image was no exception, although it is now impossible to determine whether Mahakashyapa was shown kneeling at the head of the Buddha or at his feet during the cremation.

REFERENCES
Le Coq 1922–26, III, pl. 2, p. 28. Bussagli 1963, pp. 71, 75 (ill.).

21 Scene from the Vishvantara Jataka

Kizil, Cave of the Musicians, 600–650
Wall painting, 30.0 × 27.0 cm.
MIK III 8392

The once very beautiful Cave of the Musicians in the third architectural style, consisting of a barrel-vaulted cella, an icon pedestal on the rear wall, and an ambulatory, was richly decorated with paintings. Even the underside of the door lintel carried a painting, and the ceiling was covered entirely with stylized, lozenge-shaped mountain landscapes, showing scenes from Jatakas and of bodhisattvas immolating themselves.

This painting illustrates what is probably the most famous, and throughout the Buddhist world the best-loved, story of one of the former existences of the Buddha, the Vishvantara Jataka (see Lienhard 1980). With its 800 stanzas it can be considered a true epic. Different versions of it in many languages, countless paintings and sculptures, and the accounts of Chinese pilgrims, all go to prove its popularity.

The story is as follows: Prince Vishvantara once pledged never to deny anything to anyone in the world, no matter what might be demanded of him: "My heart and eyes, my flesh and blood, my entire body—should someone desire them of me, I will give them to him." When without considering the welfare of his people he was led by generosity to give away a rain-bringing state elephant, he was banished from the kingdom. Shorn of all his possessions except a wagon drawn by four horses, Prince Vishvantara went into sylvan solitude, accompanied by his faithful wife

Madri and their two children. Soon they met four brahman beggars who asked for the horses, and four others who wanted the wagon. After giving them all they desired, Vishvantara and Madri walked on, carrying their children. Soon they arrived at a hermitage in the woods, where they decided to stay.

One day, when Madri was out gathering berries in the woods, the god Shakra appeared to Vishvantara in the guise of an evil, covetous brahman, and demanded Vishvantara's children as his house slaves. Our wall painting shows the two children clinging desperately to their father in an attempt to avoid this sad fate. The scene, the giving up of Vishvantara's children, many descriptions of which exist, is the true climax of the tale—a full 344 stanzas are devoted to it. Finally, the wicked brahman asked for Madri too, and when Vishvantara consented even to this, the god Shakra revealed himself and everything turned out for the best after all. Having passed his trials the prince returned home accompanied by his relatives, and was reunited at the palace with his wife and children. In his next existence Vishvantara would achieve Buddhahood.

REFERENCES
Grünwedel 1912, p. 68 (23), fig. 129. Le Coq & Waldschmidt 1928–33, VI, p. 21, fig. 41.

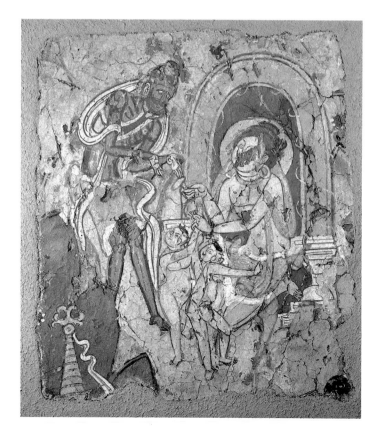

22 The Self-Immolation of a Bodhisattva

Kizil, Cave of the Musicians, 600–650
Wall painting, 30.0 × 25.5 cm.
MIK III 8390

The scene represented here has not yet been identified. It shows a male deity standing under a tree who is about to cut his throat with a long sword. In front of him, to his right, kneels a woman with a child in her arms. The baby seems to be very ill. Is the swaddling in which its tiny body is completely wrapped meant to symbolize the nearness of death? The male figure, we may assume, represents the bodhisattva who sacrifices himself to save the child.

Blood offerings of this kind are depicted in many of the Kizil paintings. In the Prayer-Wheel Cave, for instance, we find an illustration of the Rupavati Avadana, a legend in which the Bodhisattva, in the guise of a noblewoman by the name of Rupavati, cuts off

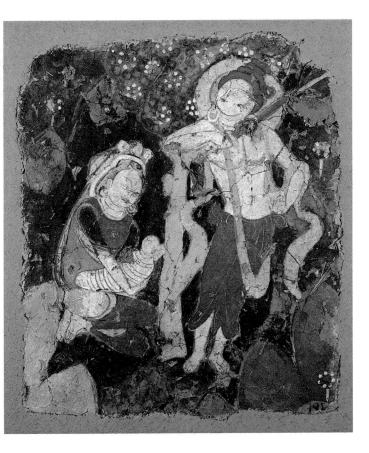

23 The Buddha on a Dragon-Boat

Kizil, Cave of the Musicians, 600–650
Wall painting, 34.0 × 30.7 cm.
MIK III 8707

The Buddha is seated on a dragon-boat, his head shaded by a canopy which seems not to be connected to the boat. His large circular mandorla and his halo dominate the scene. As the mountain peaks projecting into the picture from below suggest, the boat must be quite close to shore. If this interpretation is correct, the small figure at the left is probably a ferryman.

The subject of this painting might well be one of the last miracles the Buddha performed before his earthly death. The story goes that he wished to journey from Rajagriha to Vaishali, and had to cross the Ganges near Pataliputra. Since the river was high, however, no ferryman was willing to take him to the other bank. So the Buddha called upon his supernatural powers and floated through the air across the water.

REFERENCES
Grünwedel 1912, pp. 69f (50). Uhlig 1979, fig. 62, p. 131.

her breasts to feed a starving woman who was about to eat her own child.[1] The same story occurs in the Cave of the Musicians.[2] In both paintings, as in the present one, the baby is fully swaddled. But as Waldschmidt proves, this particular scene is an illustration neither of the Rupavati legend nor of the Sujata Avadana.[3]

1. Grünwedel 1912, p. 116, fig. 254. The subject was identified by Waldschmidt (Le Coq & Waldschmidt 1928–33, VI, fig. 36).
2. Grünwedel 1912, p. 66, fig. 125.
3. Le Coq & Waldschmidt 1928–33, VI, p. 46. Rather than swaddling clothes, it seems more likely to me that the baby is wrapped in a kind of winding-sheet, which indicates that it is near death.

REFERENCES
Grünwedel 1912, p. 69, fig. 141 and p. 70. Le Coq 1922–26, V, pl. 10a (55). Le Coq & Waldschmidt 1928–33, VI, p. 46, fig. 126. Bussagli 1963, p. 48 (ill.). Rowland 1974, pp. 166f, 170, 171 (ill.).

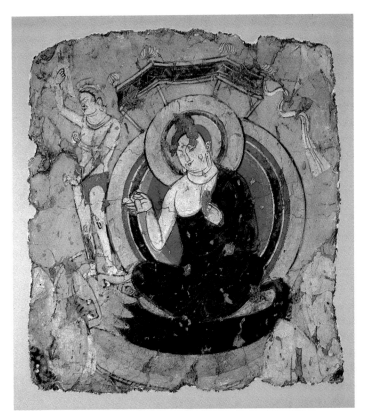

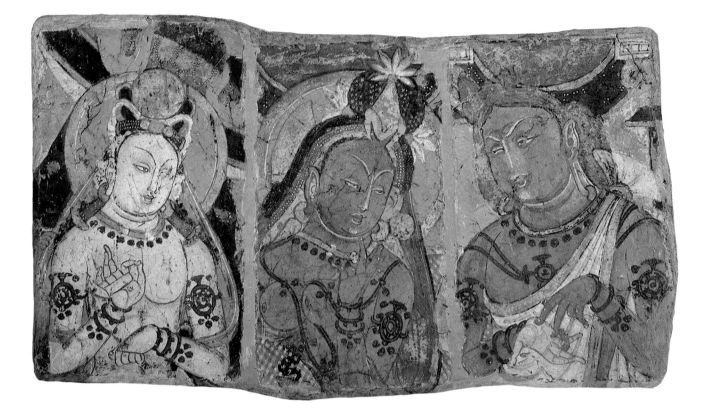

24 Three Half-Figures: King Ajatashatru; His Wife and His Minister Varshakara (?)

Kizil, Maya Cave (Site III), 600–650
Wall painting, 41.0 × 72.0 cm.
MIK III 8864

25 Head of Varshakara

Kizil, Maya Cave (Site III), 600–650
Wall painting, 20.0 × 30.0 cm.
MIK III 8880

From Site II, which is very difficult to reach, a narrow path leads over steep hills and intervening stretches of sand to a small valley about one mile further into the mountains. As Grünwedel describes it:

The site consists of eight different-sized caves of which only two or three are remarkable for their paintings. One of the caves certainly qualifies as superb, since here parts of a vestibule are preserved, which has fallen into ruin everywhere else, and its paintings show interesting variants in style. The caves of this site have been numbered [1–8].... Beyond Cave 8... the valley grows narrower until finally it becomes impassable. Here, at the most protected spot, relatively high open terraces have been cut on either hand into the mountain face, with one step leading up to them. These terraces apparently served as temporary lodgings for pilgrims coming to visit the hermits who lived in this remote spot, that is,

shelters where they could tether their horses, and prepare oblations and offerings of food and other things for the temples and for the ascetics living in the caves. (Grünwedel 1912, p. 169)

The Maya Cave (Fig. G), from which these paintings originate, corresponds with Grünwedel's Cave 5; as he noted, its nearly square vestibule has been partially preserved. From the vestibule a step about fifteen inches high leads into the slightly irregularly shaped cella.

These wall paintings were parts of larger compositions connected with the legend of King Ajatashatru, a legend which is depicted in five of the Kizil caves: Ajatashatru Cave, Cave Group near the Chimney Caves, Maya Cave (Site II), Maya Cave (Site III), and Nagaraja Cave. According to the story, as the Buddha entered Parinirvana the honorable Mahakashyapa was stopping in a bamboo grove near Rajagriha. The shaking of the earth announced to him that the Buddha

had died. Fearing for the life of King Ajatashatru, who was devoted to the Buddha, Mahakashyapa pondered on how to break the news to him as gently as possible. He decided to ask Varshakara, the royal minister, to paint on a cloth a picture of the four main events in the life of the Buddha, and to procure seven jugs of fresh ghee and one of sandalwood powder.

"Now when the king comes to the gate of the park, you must ask him whether he desires to see the painting; and when he approaches it you shall explain the pictures to him, beginning with the first. And when he hears that the Buddha has died, he will fall to the ground; whereupon you must lift him up, and put him into one of the jugs of fresh ghee, and when the butter begins to melt, you must put him in the jug of sandalwood powder, and he will recover." (Grünwedel 1920, p. II 104)

The events recounted here are all illustrated in the Maya Cave, Site II (Fig. H). Even the earthquake is shown by the collapsing of Mount Meru. In the Maya

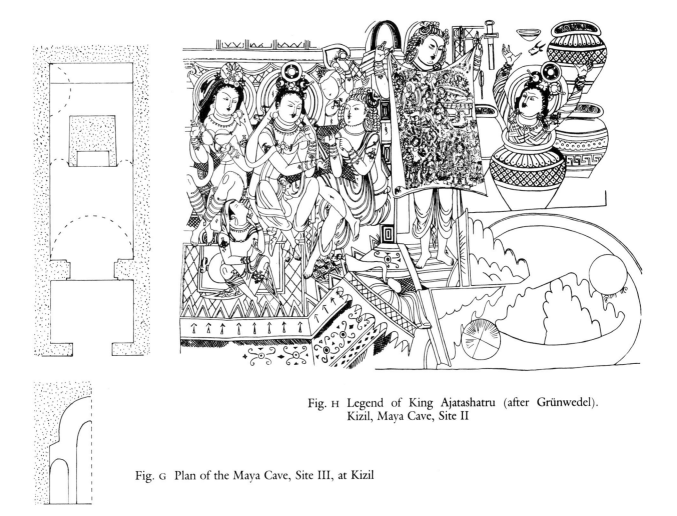

Fig. H Legend of King Ajatashatru (after Grünwedel). Kizil, Maya Cave, Site II

Fig. G Plan of the Maya Cave, Site III, at Kizil

1 m

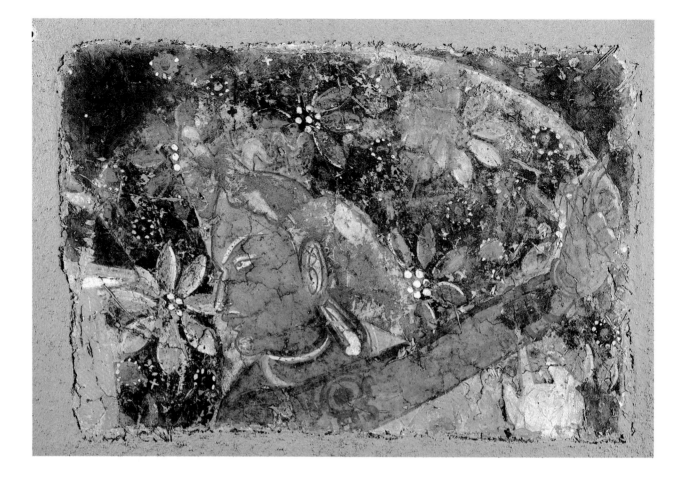

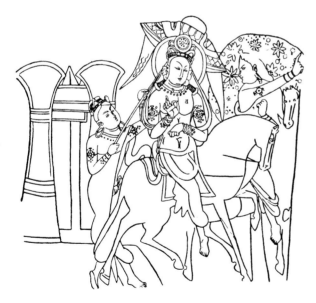

Fig. I King Ajatashatru Rides Out of the City with Var-
shakara (after Grünwedel). Kizil, Maya Cave, Site
III

Cave, Site III, the king was depicted leaving the city
on horseback with his minister, the brahman Var-
shakara (Fig. I), a painting to which the half-figure on
the left of No. 24—King Ajatashatru—and the head
and pointing arm of Varshakara in No. 25 certainly
belong. Behind the king in the original composition
there was a man carrying an umbrella; the brown hand
of a servant can be seen at the far left of No. 24, at
the height of the king's shoulder.

The dark-skinned woman in the central panel of
No. 24 has youthful features and, like the king, a halo;
she wears a scarf that is brought together over the
forehead in a triangle and crowned by a blossom.
Waldschmidt has identified her as probably repre-
senting the king's wife, and the brahman on the right,
who has neither nimbus nor crown, as in all likelihood
another depiction of Varshakara.

REFERENCES
Grünwedel 1912, pp. 171ff. Le Coq & Waldschmidt 1928–33, VI,
pl. 16 and p. 82 [No. 24]; VII, p. 52. Indische Kunst 1971, 1976,
no. 448 [No. 24].

26 Miraculous Crossing of the Ganges

Kizil, Maya Cave (Site III), 600–650
Wall painting, 48.5 × 97.5 cm.
MIK III 8863

This small fragment is part of a large, only partially preserved composition that once decorated a passageway in the Maya Cave. In the center of the composition the Buddha is shown on the bank of a river, his left hand on his chest, his right hand outstretched and holding a dish. At the left five princely clad devotees are standing or kneeling, some of them presenting offerings. The most important of these figures, who is the only one covered by an umbrella, is shown here.

The following interpretation of the scene has been suggested by Waldschmidt:

In my view the subject can be none other than the miraculous crossing of the Ganges by the Buddha, as it is narrated in the Vinaya of the Mulasarvastivadin (Kyoto Tripitaka, 18.8)....The presence of the brahman Varshakara relates this painting to the Ajatashatru episode depicted on the opposite wall; in both legends Varshakara plays an important part.

The story of the crossing of the Ganges goes like this: King Ajatashatru's minister Varshakara has invited the Buddha and his community to a meal, at the close of which Varshakara offers the Buddha a costly bowl, making a solemn pledge. The Buddha replies with a few verses; then he proceeds on his journey to the Ganges, which he desires to cross. Curious as to which gate the Sublime will leave the city by, and at what point he will cross the river, Varshakara accompanies him, planning to erect a gate-tower and start a ferry service. The Buddha leaves the city by the western gate, then turns north toward the Ganges. There he notices that many people are crossing the river with the aid of gourds—a method that does not appeal to the Buddha. Summoning his transcendental powers he transports himself and all his community to the far shore. This miracle inspires a monk to compose three glorifying stanzas. Varshakara, for his part, carries out his plan and builds a gate-tower, calling it the "Gautama Gate" and the Buddha's crossing point the "Gautama Ford."

Note the interesting depiction of a city gate in the left background.

REFERENCE
Le Coq & Waldschmidt 1928–33, VI, pl. 13 and pp. 78f.

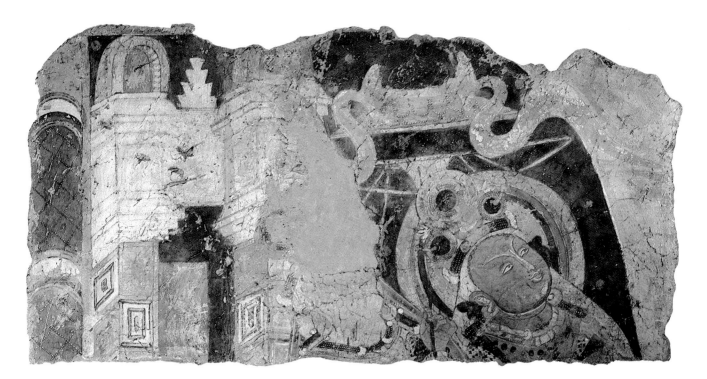

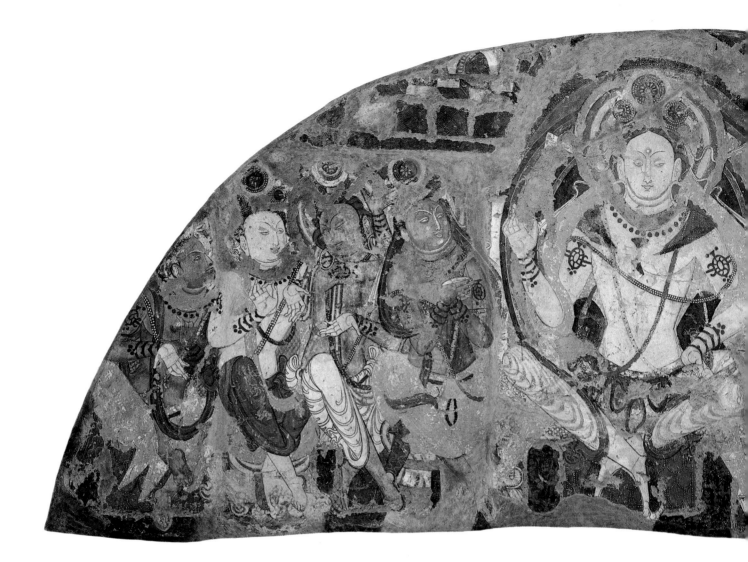

27 The Bodhisattva Maitreya with Attendants

Kizil, Maya Cave (Site III), 600–650
Wall painting, 104.0 × 261.0 cm.
MIK III 8836

The Buddhists, whose main philosophical principle was the instability of the world, cannot have expected their own doctrine to be an exception from the rule. Soon after the death of the Buddha signs of decay began to appear at the First Council, held at Rajagriha under the leadership of Mahakashyapa. By the time the Second Council convened at Vaishali, about 110 years after the death of the Buddha, these tendencies had grown even more serious. At the Third Council, held at Pataliputra, a schism occurred. This, however, arose less out of theological disputes than out of problems in determining the social status of the arhats:

The arhat had moved into the limelight, the position had become attractive to a power-seeking man.... Thus we may assume that by the second century following the death of the Buddha an "arhat hierarchy" had become an established fact. If one inquires into the reasons for this development, the most important seems to be the establishment of mon-

asteries, probably quite widespread by this time, and the need for dignitaries to run them.

During the second century after the death of the Buddha the spread of Buddhism entered a critical phase. The quantity of monasteries adversely affected the quality of the monks. The discrepancy between life and doctrine grew too great; hence the latter had to be adapted to the former. A more liberal wing, desiring almost unrestricted growth, began to gain ground against a more conservative opposition. Open disputes followed, in the course of which the conservatives proved themselves incapable of defending their views, despite their being theoretically more in line with the teaching of the Buddha. Against them stood not only the masses of the faithful but the habit of easy living they had fallen into. Realizing their defeat the conservatives began to disparage their opponents. (Schneider 1980, p. 139)

They even went so far as to interpret their own incapacity as a sign of their followers' decay of faith. Matters were further complicated by another change.

90

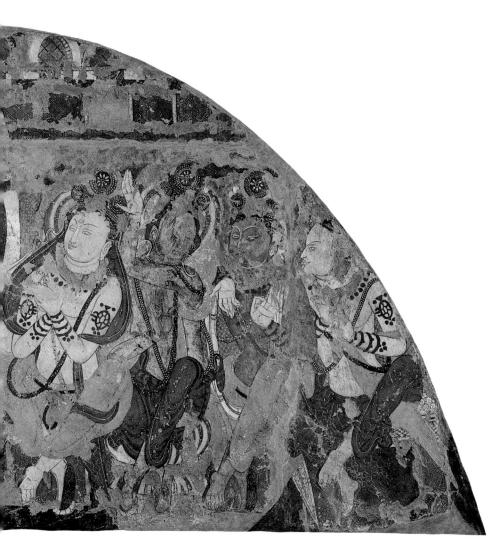

For a short time after the death of the Buddha many monks had attempted to achieve nirvana, only to realize that this was an impossible goal during their lifetime. Probably at about this time there arose the tradition of the Future Buddha, Maitreya (*Digha Nikaya*, sutra 26, Foucaux 1884, ch. V), who began to play a more and more important role for the Sarvastivadin and the followers of Mahayana Buddhism. Now, according to Buddhist cosmology the earth goes through periodic cycles in which human lifetimes vary between ten years and hundreds of thousands of years. At the time of the Buddha Shakyamuni men's average life expectancy was 100 years. After his Parinirvana decadence set in, but at its nadir a new upswing began, bringing with it an increase in longevity that would peak at about 80,000 years. Then Maitreya would descend from the Tushita heaven and appear on earth, where superabundance of food prevailed and mankind now lived in peace.

It is the Future Buddha, the bodhisattva Maitreya, who is portrayed in this lunette above the door of the cella, where it was meant to bring the promise of consolation to the monks on leaving the cave. Maitreya is seated on a throne, in his left hand a flask, his right hand raised in a gesture of teaching. His unclothed upper body is richly ornamented, and like the figures flanking him he wears a tripartite crown.

The painting shows all the characteristics of the second Indo-Iranian style at the peak of its development. Eschewing naturalism the artist reveled in colors, particularly in a deep ultramarine blue heightened by gold leaf, traces of which, despite defacement, can still be seen on Maitreya's throat and halo.

REFERENCES
Grünwedel 1912, p. 174. Le Coq & Waldschmidt 1928–33, VI, pl. 17, pp. 82f. Indische Kunst 1971, 1976, no. 502.

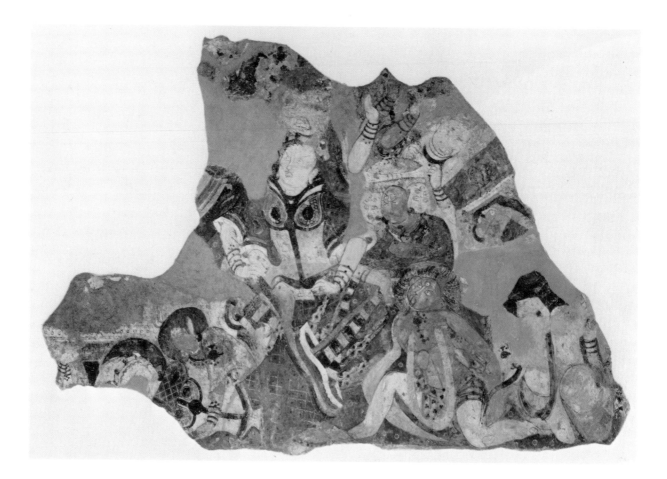

Fig. J Kizil, Stairs Cave. Partial view of the icon niche; in the lunette, the Attack of Mara

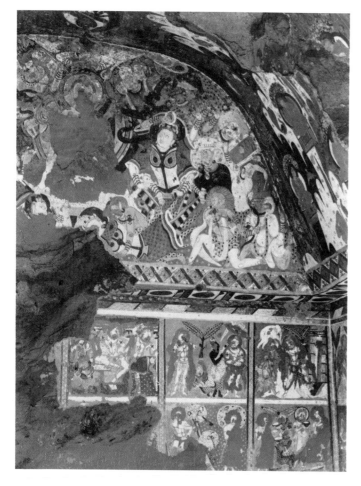

28 The Attack of Mara

Kizil, Stairs Cave, 600–650
Wall painting, 136.0 × 203.0 cm.
MIK III 9154a

The Stairs Cave, so named for the steps leading up the rock face to a narrow landing, is one of the most interesting caves at Kizil, since here the complete life of the Buddha was depicted on the side walls and the back wall of the cella. This painting, a fragment from the lunette of the icon niche (Fig. J), is a detail of a scene that has enjoyed great popularity in Buddhist art from Gandhara to China—the temptation of the ascetic Gautama by Mara.

As the legend runs, Mara, the Evil One, fears for his dominion if the Bodhisattva should succeed in achieving enlightenment. So he marches off with his army of demons to the Nairanjana River, where the Bodhisattva is meditating under the Tree of Enlightenment. With various weapons they attack the Bodhisattva, who remains unperturbed, continuing his meditation. Mara is forced to admit defeat. Some texts say that Mara, after failing to disturb the Bodhisattva, tries to convince him that he cannot consider himself savior of the world since he has performed no good deeds. Yet recalling the good deeds of an earlier life, the ascetic Gautama touches the soil with his right

hand (*bhumisparshamudra*) and evokes the earth as a witness. The ground opens, and the earth goddess appears and attests to the truth of his words. Mara is thus finally vanquished.

The entire painting, with the meditating Bodhisattva seated in the center, showed all these three scenes. Mara himself was depicted three times. At the left, he had drawn his sword and was assaulting Gautama with his demonic soldiers. At the right, in this surviving fragment, the originally six-armed Mara is seated to the right of the Bodhisattva (no longer preserved), debating his good deeds. Mara's body is protected by an elaborate scale-armor, worn over a robe of gray-and-blue checked cloth with short, wide, bell-shaped sleeves. "Mara's armor," according to von Le Coq, "is surely a leather cuirass onto which small plates have been riveted and which is closed at the front by thongs." Among Mara's soldiers a curious demon with three heads and pointed ears is to be noted.

The third scene, of which only part remains, shows Mara the Tempter lying prostrate on the ground in front of the throne of the Bodhisattva. Another demon with pointed ears is attempting to help him up, apparently in vain. Mara is defeated.

REFERENCES
Grünwedel 1912, pp. 117–19. Grünwedel 1920, p. II 16, fig. 22. Le Coq & Waldschmidt 1928–33, VII, pl. 7, pp. 38f.

29 Divine Musician

Kizil, Prayer-Wheel Cave, 600–650
Wall painting, 22.7 × 18.0 cm.
MIK III 9233

The musical traditions at Kucha are mentioned in early Chinese records: Chang Ch'ien, whom Emperor Wu-ti sent to the West in 138 B.C., is said to have brought back musical instruments and melodies from Kucha to the capital, Ch'ang-an (Liu Mau-tsai 1969).

Only the name of these melodies has come down to us: it is Mo-ho-tou-le. *Mo-ho* is clearly the Chinese transcription of *maha* (great). As far as *tou-le* is concerned, the last word still remains to be spoken; it is perhaps a variant of Tou-k'u-le, or Tochara. The name of this melody suggests an Indian origin. Possibly this originally Indian melody was first known at Kucha, where, as we know, Tocharian was spoken in later days. It was the center of Indian-influenced music in Central Asia, which later spread to China. At that early date Kucha must already have been under Indian cultural influence. In China, a son-in-law of Emperor Wu-ti (140–87 B.C.) wrote twenty-eight new tunes based on the Mo-ho-tou-le melody, which were played as military music. (Liu Mau-tsai 1969, p. 100)

Musical tradition in Kucha continued unbroken throughout the centuries to follow. And when the Western Countries again fell under Chinese rule in 382, the General Protector, Lü Kuang, brought groups of performers—actors, musicians, and dancers—back to China as booty. From then on this foreign music began to gain popularity with the Chinese. Among the instruments used were the five-stringed lute, the harp, the mouth-organ, drums, cymbals, gongs, and the four-stringed Kucha lute. In China one of the teachers of this lute was a brahman, to judge by his surname a Sogdian. Another renowned lute player, Sujiva, who went to China in the year 568, bore the family name of Po, of the royal house of Kucha. He taught the seven keys of Kucha music, which are often traced back to an Indian origin.

Thus it appears that together with Buddhism, Indian music was brought to Kucha, an inference that is strengthened by the many musical subjects depicted in the wall paintings.

This fragment shows the head of a dark-skinned divinity playing a flute, and in front of him the remains of a lute player. Originally they formed part of a scene of the Buddha preaching.

REFERENCE
Grünwedel 1912, p. 113, Schema VI, h, i.

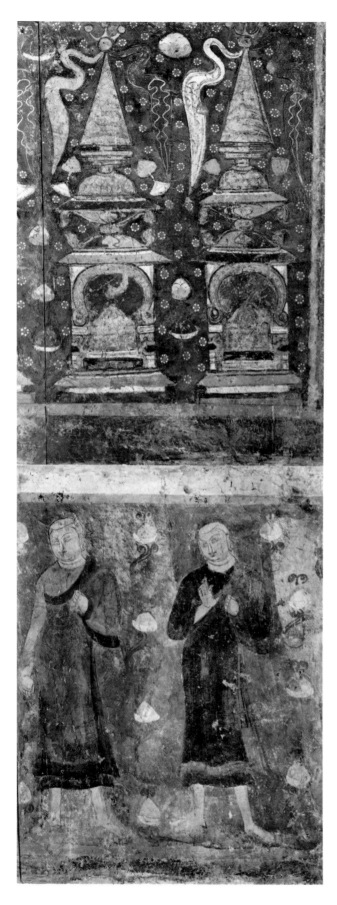

30 Monks and Stupas

Kizil, Cave of the Frescoed Floor, 600–650
Wall painting, 78.0 × 58.0, 81.5 × 54.0 cm.
MIK III 8859, III 8860

The Cave of the Frescoed Floor at Kizil consisted of a vestibule, now destroyed, and a nearly square barrel-vaulted cella. An icon niche, with an ambulatory behind it, was inserted into the back wall. The cave was named from a painting on the clay-coated floor in front of the icon niche, which continued onto the floor of the ambulatory. The ambulatory walls also bore paintings, of which these are fragments. Two rows of paintings, clearly separated from each other by white bands of calligraphy, are discernible. Above a frieze of standing monks, whose names were originally inscribed in Brahmi in the strip over their heads, a row of stupas is to be seen, each of which contained either a seated Buddha or, as here, a reliquary casket.

REFERENCES
Grünwedel 1912, pp. 48ff. Le Coq & Waldschmidt 1928–33, VI, pl. 9.

31 The Buddha Preaching

Kizil, Foot-Washing Cave, 600–650
Wall painting, 103.5 × 103.0 cm.
MIK III 8649a

This cave of the usual structural type consists of an almost square cella, with an icon niche and an ambulatory in the back wall. Each side wall was decorated with eight sermons of the Buddha, square in format, whose color scheme was dominated to a great degree by shades of blue. Though the wall to the right of the entrance has been almost completely destroyed, that to the left was quite well preserved. Our wall painting was found at the end of the bottom row, and it is the only one, according to Grünwedel (1920), that contains a double scene in addition to the Buddha figure.

The Buddha is shown turned to his right, seated on a raised, carpeted throne. In front of this stands a small table on which flowers have been spread as offerings. The several legs of the table have the shape of snakes, their flat heads serving as supports. Seated directly before the Buddha, to his right, is a noble couple, both provided with halos; another richly adorned fig-

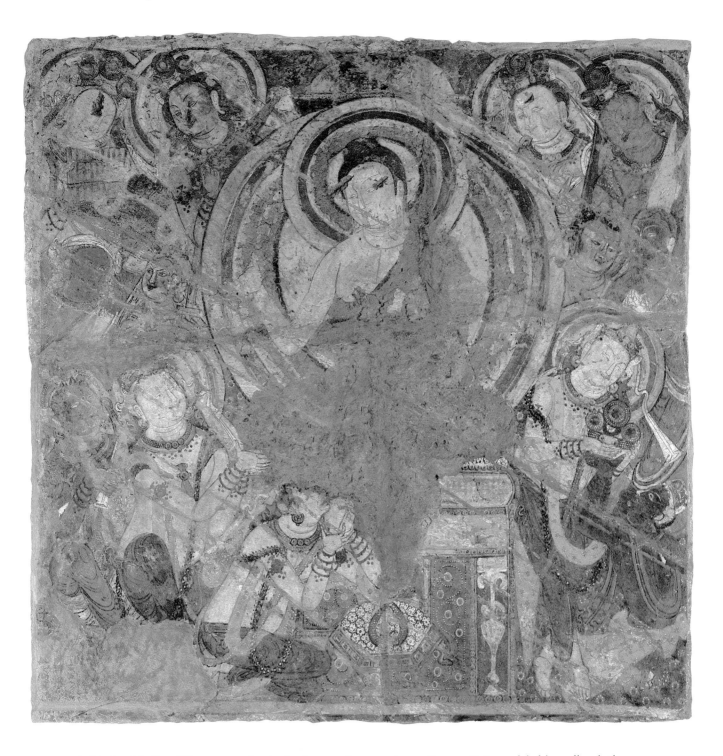

ure is kissing his feet. The persons in the background appear to be the nobleman's servants, carrying umbrella and sword. Above them a dark-skinned god playing a Kucha lute and a second playing a panpipe are to be seen. To the Buddha's left the same nobleman is handing his crown to a kneeling servant. Above them two monks appear, whom Grünwedel supposes to be Ananda and Mahakashyapa, and above these the three-eyed Indra and some other deity.

According to Grünwedel this wall painting represents the Buddha preaching to his father Suddhodana and other members of his family (the scene to the Buddha's right). The second episode shows Suddhodana's attempt to pass on his crown and thus his royal dignity.

REFERENCES
Grünwedel 1912, p. 159. Grünwedel 1920, p. II 87, pls. XXX and XXXI.

32 Scenes of the Buddha Preaching

Kizil, Middle Gorge, Small Cave, 7th century
Wall painting, 67.0 × 53.0 cm.
MIK III 8846

This fragment portrays two different sermons, not as yet identified. In the foreground of the left-hand scene kneels a dark-skinned Vajrapani in full armor, looking up at the preaching Buddha (now lost). A green, white, and black nimbus surrounds his head, which is adorned with an unusual three-point crown. Next to him, in a graceful pose, a woman is seated on a low chair, her hands in the *anjali* mudra. She wears a white blouse with blue spots and a green undergarment. The third fully preserved participant in this scene is a young monk standing behind the two characters already mentioned. His brown robe with a bluish border leaves his right shoulder free. The position of his hands suggests that he is disputing with the Buddha.

The main characters of the right-hand scene face the missing figure of the Buddha in graceful poses. They too are moving their hands in gestures of argument. The main group in the foreground consists of a man, laden with jewelry and wearing only a short dhoti which reaches to his thighs, and, to his right, a woman with the upper part of her body bent back like a dancer; she is dressed in a green jacket with fancy braiding and wide brown oversleeves, under which green borders can be discerned. Over the narrow, blue-speckled skirt reaching down to her ankles she wears an unusually short piece of white cloth with a brown border.

REFERENCES
Le Coq & Waldschmidt 1928–33, VI, pl. 10. Tokyo 1978, no. 1125, p. 301.

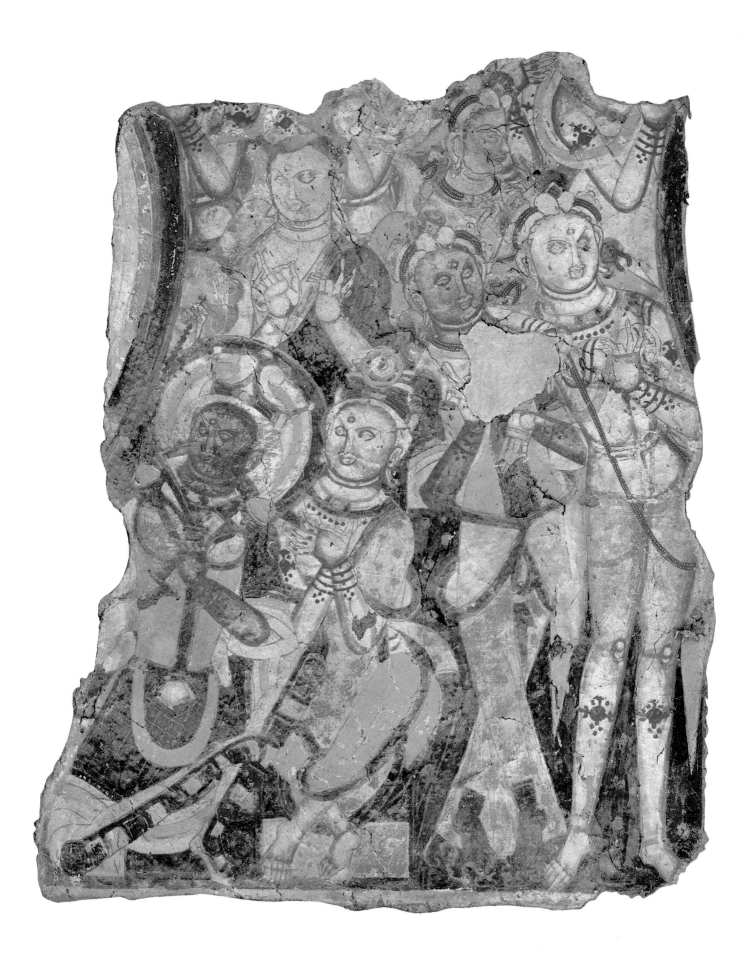

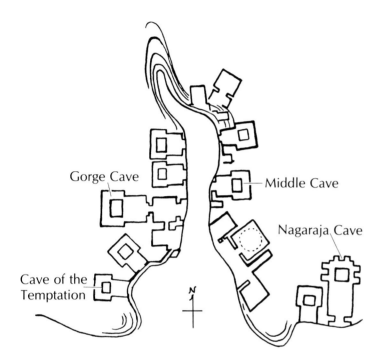

Fig. K Sketch map of the Second or Small Gorge at Kizil (after Bartus; Le Coq & Waldschmidt)

33 The Attack of Mara

Kizil, Cave of the Temptation, 7th century
Wall painting, 139.0 × 164.5 cm.
MIK III 8878

The cave temples of the Second or Small Gorge in Kizil, which narrows as it leads northward into the mountains, are hewn into the cliff face high up on both sides (Fig. K). Six caves were discovered on the west side, seven on the east. Six of the latter are on more or less the same level, while the seventh is on the second story as it were, further up the cliff wall. The cave nearest the mouth of the gorge on the west side is the Cave of the Temptation. Waldschmidt writes:

This cave provided abundant finds. We secured for our collection not only the paintings on the side walls but also small pieces of the wall behind the devotional image..., fragments of pictures from the vaulted ceiling and from the ambulatory.... The piece which is most important for the classification of the cave, and which gave it its name, is a representation of Mara's attack on the Buddha (Bartus's "Temptation").

Waldschmidt describes this representation as a replica of the one found in the Stairs Cave (see No. 28 and Fig. J).

The Buddha is seated with his legs drawn up; his right hand touches the earth, a gesture with which he calls on the earth goddess as witness. Mara and his demonic horde of wild and weird beings seem to be in mid-assault; some, however, have already been defeated and are lying vanquished on the ground.

In this mural Waldschmidt sees a special development of the second Indo-Iranian style, which in his view manifests itself in the striking, often greatly exaggerated, shading of the body.

REFERENCE
Le Coq & Waldschmidt 1928–33, VII, p. 19.

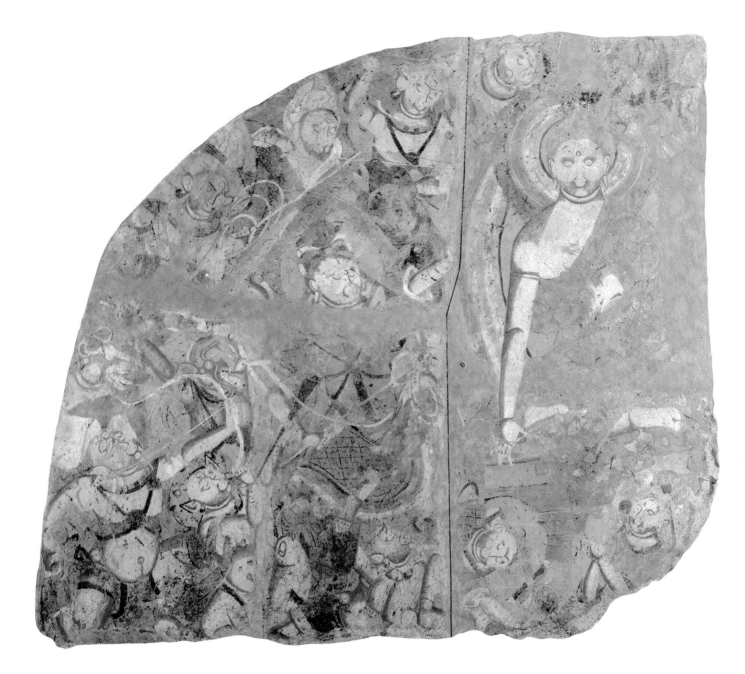

34 Jataka Scenes

Kizil, Gorge Cave, 7th century
Wall painting, 168.8 × 221.7 cm.
MIK III 8449a

This large mural is part of the painted ceiling of the Gorge Cave and gives an idea of the size such pictures could assume. It is generally taken as an example, along with No. 33, of a special development of the second Indo-Iranian style.

A stylized mountain landscape forms the setting for a number of Jataka scenes, which illustrate the essence of key moments in Buddhist legends telling of the Bodhisattva's boundless compassion and its moral repercussions. Each of the main figures, human or animal, suffering or sharing in another's sufferings, is to be identified with the Bodhisattva, that is, the Buddha in one of his previous existences. Here we shall mention only the most important and most easily identifiable scenes of the painting.

In the center is a scene from the previous incarnation of the Bodhisattva as Shyama. Legend has it that as a young ascetic Shyama lived a life of sacrifice in order to care for his old, blind parents, who dwelt in seclusion in the mountains. One day, while fetching water, he was accidentally shot by a king out hunting. Through speaking with the dying Shyama the king attained to increased wisdom and took it upon himself to look after the bereaved parents. The scene shows Shyama kneeling by a semicircular pool; he is filling a jug in his right hand with water for his parents. The royal huntsman charges toward him on a white horse, his bow at the ready. The legend is very popular in the Buddhist world and is also to be seen in the art of Gandhara and at Sanchi.

The next scene to the right is an illustration of the Sarvandadaraja Jataka. A king leaves his vast realm to an envious rival and goes off to live the life of a hermit. While he is meditating under a tree, he is approached by a beggar in the guise of a brahman; he allows himself to be delivered up to the rival king so that the beggar can collect the bounty on his head. The tall figure standing left of the tree is the king, his hands bound, while the dark-skinned brahman on the right is about to lead him off.

The scene below and between these two depicts the Shankhapala Jataka. The devout snake king Shankhapala submits without resistance to ill-treatment. The dusky king is standing in front of a tree, while a man to the left is about to strike him.

The next scene to the right is unfortunately difficult to decipher. It illustrates the popular legend of the Simhakapi Avadana, which tells of the lion who gave his own blood to save the life of a baby monkey that had been snatched by an eagle. On the right kneels the father monkey, imploring the lion's aid, while above them the eagle is about to make off with the infant.

All the scenes of this great painted ceiling are composed on similar lines, against a background of mountain landscapes. The same secondary features—such as the birds sitting in the mountains, the monkeys climbing trees, and the motif of the semicircular pool—occur again and again, and are often conceived as purely decorative elements.

Along the top is a strip containing an Avadana illustration, to be precise the Sumagadha Avadana. Sumagadha, the daughter of Anathapindika, is given in marriage by her father to the son of a friend. Her parents-in-law are devotees of the Digambara Jaina cult. Deeply ashamed to have to look upon these naked ascetics, Sumagadha is anxious to convert her parents-in-law and therefore wishes to invite the Buddha to visit them. Having obtained her parents-in-law's permission, she performs a flower sacrifice on the roof garden of the house. Pouring water from a jug, she prays the Buddha to visit her with his retinue. The Buddha does indeed hasten thither with his disciples, who are possessed of magical powers, and, as they approach, Sumagadha gives her parents-in-law the fol-

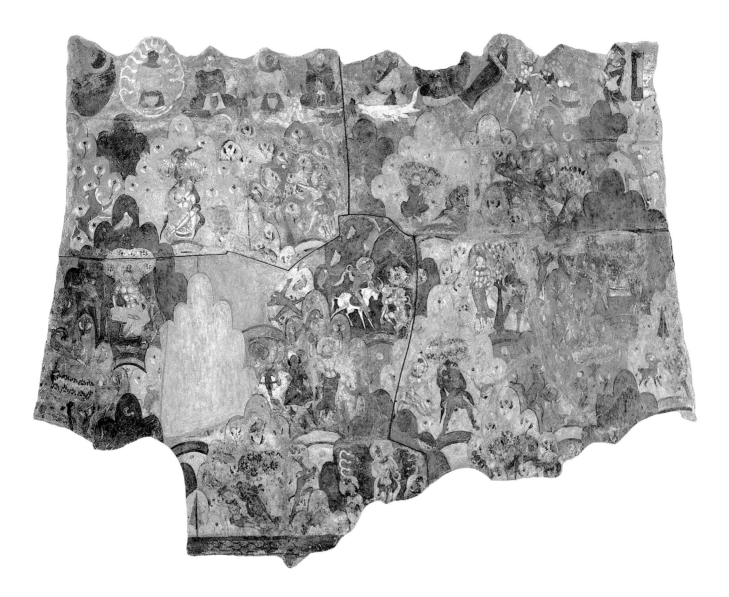

lowing description of the host in full flight: "He who sits in the chariot yonder and unleashes lightning and rain is Kaundinya; he who has his throne on the flowery mountain is Kashyapa the Great; he who rides yonder on the lion-drawn chariot is Sariputra; astride the elephant is Maudgalyayana; seated on the golden lotus is Aniruddha; in the chariot drawn by Garuda sits Purna, son of Maitrayani; the rider on the cloud is Ashvajit; he who leans against the palm tree is Upali; he who reclines on the palace of lapis lazuli is Katyayana; he who rides in the chariot drawn by bulls is Koshthila; in the chariot drawn by a swan sits Pilindavatsa; he who walks in the grove of trees is Shronakotivimsha; yonder is Rahula, in the form of a Chakra-vartin." Then the Buddha himself appears in the midst of his retinue.

On the extreme right is a woman standing with hands together in an attitude of entreaty—doubtless Sumagadha; two servants carrying jugs are running up to her. To the left appears a hovering figure, and next to it a seated one. Then follow: a pupil of the Buddha on a swan, Pilindavatsa; Purna on Garuda(?); Mahamaudgalyayana on his elephant; a seated pupil, not identifiable; and Ajnatakaundinya in his snake chariot. The figure on the extreme left cannot be identified.

REFERENCES
Grünwedel 1920, p. II 57, figs. 42, 44. Le Coq 1922–26, IV, pl. 10, pp. 17f. Le Coq & Waldschmidt 1928–33, VI, pp. 9ff.

35 Scenes of the Buddha Preaching

Kizil, Gorge Cave, 7th century
Wall painting, 143.0 × 145.0 cm.
MIK III 8725a

The remains of four square pictures of the Buddha preaching are contained in these paintings from the left-hand wall of the cella, which form a series complete in itself. They are composed on the same lines, with the Buddha seated in the center and addressing a group of believers, sometimes to his right, sometimes to his left. His static form is enlivened only by the varying position of the hands with broad webbing between the fingers. The Buddha is bigger than all the other figures, who surround him on both sides and sometimes encroach over the edges of the picture and the nimbus.

In the upper register, the left half of the first scene on the left has been almost totally destroyed. Originally the Buddha appeared in a nimbus and mandorla, preaching to his left. Above his nimbus on the left stood Brahma in a patchwork garment; the god Indra on the right has been preserved. Three rows of persons were originally portrayed in the left half. Directly at the Buddha's feet knelt an old ascetic in a patchwork garment, doubtless Mahakashyapa; behind him sat Vajrapani wielding in the left hand a stylized fly whisk, with the vajra poised on his right knee; the third person was a young brahman. In the second row, adjacent to the mandorla, there was a young man with his hands together in an attitude of adoration, thought by Grünwedel to be the monk Subhuti. Behind and above him three brahmans could be seen, the one on the top left holding in his right hand a bowl from which he strewed flowers. In the midst of these four stood a dark-skinned lute player.

In the right, remaining half of this scene we can distinguish the following groups of figures. The first row from the bottom shows a king and queen looking up to the Buddha in adoration. Squatting at the queen's feet a maid supports a tray of flowers. Behind the king stands a figure holding the royal parasol rather low so as not to conceal the other attendants behind him, who carry the rest of the regalia: first, a woman holding the crown and a man standing behind the king, bearing the sword; then a flutist and two devaputras. Thus, the king is being invested with his insignia in the presence of the Buddha.

The story can be identified, as Grünwedel first pointed out, by reference to the dusky man who kneels at the Buddha's feet clasping a liquor bottle (*dhurta*). It is the story of Dhurta the cobbler, who on the instructions of the Bodhisattva is carried in a drunken stupor into the king's palace, where he is waited on as king when he awakes. The cobbler is astonished at the change in his fortunes; he is then plied anew with wine, only to wake up again in his own hovel.

The way this scene is put together is very interesting, as the cobbler and the king are, of course, one and the same person. The contrast between these two types in a man's life constitutes the theme of the sermon.

In the upper right-hand scene the Buddha is preaching to his right. Before him kneels a brown-skinned man, apparently making an entreaty, and turning his head toward a royal couple who are seated immediately next to the Buddha. Grünwedel interprets the scene thus:

A striped ruff is discernible behind the shoulder of the kneeling figure, which I would explain in the following way. We always find similar paper ruffs attached to the skull-masks of the Tibetan lamas. . . . I am fairly certain that the kneeling man so designated is meant to be an offender under sentence of death. The two figures behind the king and queen perhaps relate to the crime the man has committed: an old woman with a stick is talking to a maid who holds a parasol (the artist has drawn this very small) over the royal couple.

In the lower register on the left the Buddha faces to his right; Indra and Brahma are again to be seen above his nimbus, Sariputra and Maudgalyayana on either side of his mandorla. The crescent moon in the tree is meant to suggest night. Two demon princes with their retinue sit on each side of the Buddha. In front of him are three bowls on a small trolley. There should in fact be four, namely those that the guardians of the four quarters of the universe, the lokapalas Dhritarashtra, Vaishravana, Virupaksha, and Virudhaka, offered him when the two merchants Trapusa and Bhallika brought him gifts.

In the last scene on the right, of which only the left half has come down to us, the seated Buddha was shown in the company of two naked women (the one on his right has been preserved)—obviously temple prostitutes with their companions. A dead woman lay at his feet. By analogy Grünwedel postulated that the woman who originally sat on the Buddha's left was the same person as the dead woman. "She is meant to be the beautiful Shrimati, Jivaka's sister, with whom one of the monks fell in love, and who died suddenly. According to the legend, the Buddha preached a sermon to King Bimbisara over her corpse to the effect that human beauty is as nothing."

REFERENCE
Grünwedel 1920, p. II 63, pl. XXIV/V, figs. 2–4.

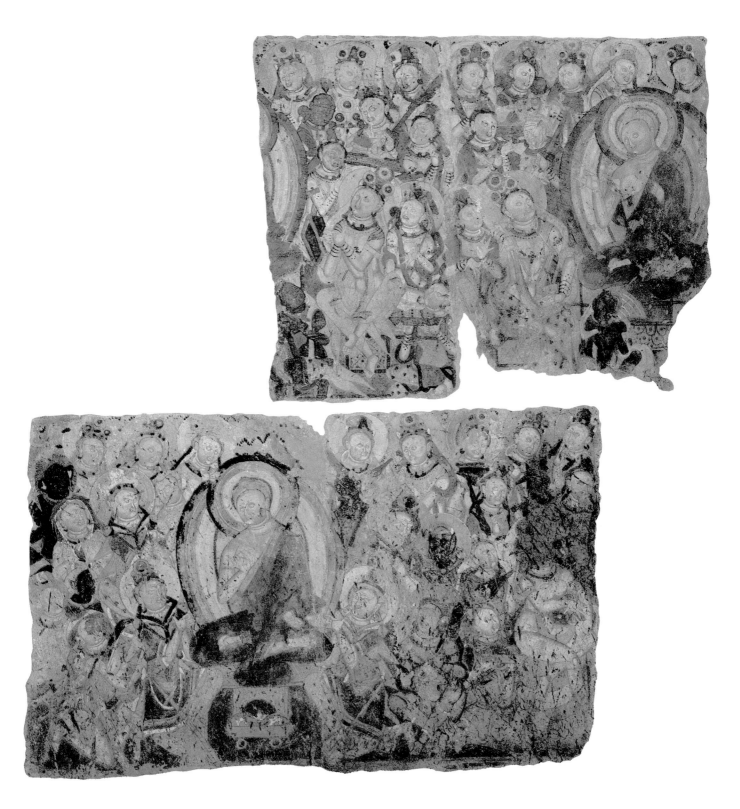

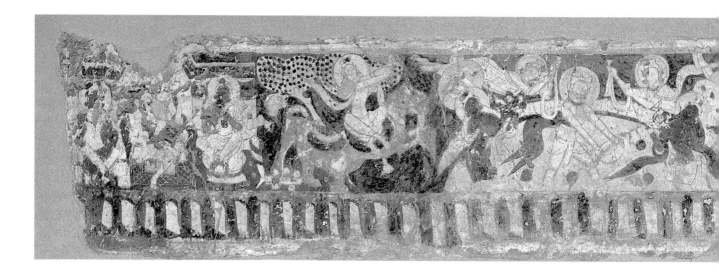

36 Jataka Scenes

Kizil, Second Gorge, Middle Cave, 7th century
Wall painting, 244.0 × 38.0 cm.
MIK III 8851

We can make out four Buddhist legends on this pedestal frieze. The first picture on the left extends from the broken edge to where the pool begins. It is an illustration of the Mahaprabhasa Avadana, which we shall meet again in No. 37 from Kirish. According to the legend, King Mahaprabhasa once went for a ride on a domesticated elephant. The elephant was in rut, and on seeing a wild elephant cow charged after her in leaps and bounds. The mahout was unable to bring the elephant under control and advised the king to grab the branches of a tree to save himself from the careering animal. Safely back at the palace, the king summoned the mahout, whom he accused of having given him an unschooled mount. But the mahout proved the elephant's obedience by ordering the animal to swallow red-hot iron balls.

The picture shows the king in front of the palace, sitting on a throne draped with carpets; on his right we see the queen, on his left a brahman. To the right of this group kneels a man gesticulating wildly, with a brazier of red-hot balls at his feet. In the adjacent scene the king, mounted on the rutting elephant, is grabbing the branches of a tree with both arms.

The next picture relates the legend of the ascetic Mahatyagavan, who once upon a time visited three cities guarded by snakes on the other side of the ocean; in each he won for himself a *chintamani*, a wish-granting jewel. The snake gods, or nagas, were envious and wanted to rob him of the magic gems, whereupon he threatened to dry up the ocean, their element, with his

supernatural powers. The snakes in their terror then offered him precious gifts.

In the picture we see Mahatyagavan standing in the oval ocean, on the point of bailing out the water with a shallow vessel. On each side a dark-skinned naga appears from below the waves, offering him precious stones in a bowl. Two deities hover over the scene and help the Bodhisattva to bail.

The third scene depicts the Kshantivadin Jataka. In the legend the king's wives are strolling in the park while he sleeps, when they meet an ascetic and listen to his preaching. When the king learns of this he metes out a barbaric punishment, chopping off the ascetic's hands and feet.

On the left we see the Bodhisattva as the ascetic in a rustic hut, his arms extended to the right; the dusky king is about to chop them off. The ascetic's right foot already lies on the footstool. A pupil of the ascetic's approaches, floating through the air.

The fourth and last of the legends depicted in the frieze is that of the ape king Mahakapi, who rescues his people from a hunting king by making a bridge over the river with his own body. Conical mountains frame the almost symmetrical picture on each side. Mahakapi has made himself into the bridge. On his back three little apes are hurrying to safety on the other side. To the left lurks the kneeling king with his arrow drawn.

REFERENCE
Le Coq & Waldschmidt 1928–33, VI, pp. 9ff.

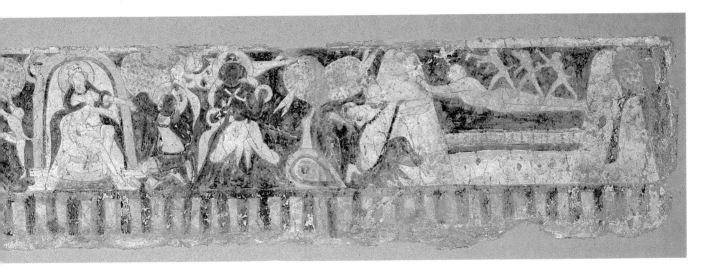

37 Mahaprabhasa Avadana

Kirish, Knights' Cave, 7th century
Wall painting, 130.0 × 180.0 cm.
MIK III 8917

The village of Kirish lies about twenty-five miles east-northeast of Kucha. Temple complexes with many fine wall paintings and sculptures have been excavated in the area.

The Knights' Cave in Kirish housed two series of pictures in strip form on its lateral walls. This fragment represents only a small part of them. Unfortunately,

the murals were found in very bad condition, heavily coated with soot, so that an interpretation of the subject matter and a comparison of styles are very difficult. Yet it takes no more than a glance to appreciate the graphic finesse of this painting. There are no obvious criteria by which it can be assigned to one or other of the Indo-Iranian styles. Waldschmidt takes the view

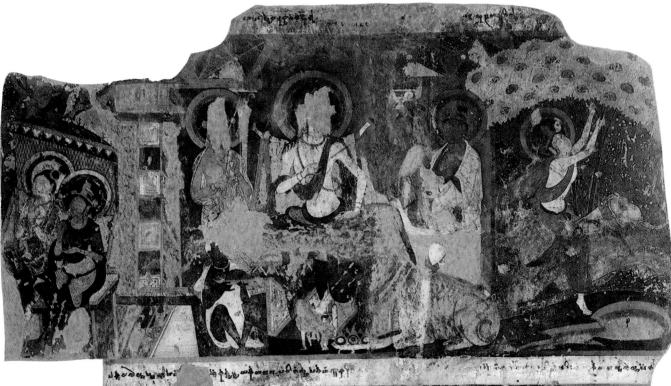

that the pictures exemplify a hybrid style of earlier and later elements. He also draws attention to peculiarities such as the curved back of the king's throne, the ends of which are here—an exceptional occurrence—visible above the drapery that hangs over it, or the king's small rectangular footstool, which is shown in oblique perspective.

The main section consists of two scenes illustrating the Mahaprabhasa Avadana, which has been described under No. 36. On the right is the charging elephant with the king on its back; he is clearly to be seen grabbing at the branches of the tree overhead. To the left of this is the king seated in front of his palace, attended by two courtiers and a servant who is presenting a bowl. The elephant, missing from this scene in No. 36, is here shown lying at the king's feet. In front of the throne is the bowl with the three red-hot iron balls. Behind the elephant can be seen the top half of a man gesticulating wildly with his right hand.

A caption in Tocharian occupies the top border of this illustration. According to Dr. K. Schmidt it reads: "...recited to him in [great] detail the...Jataka: Because of an elephant he [*scil.* King Mahaprabhasa] renounced the world [and] attained prophecy."

Because of their poor state of preservation it is for the time being impossible to explain the scene to the left of the Mahaprabhasa legend and the heads below the lower band of script.

REFERENCE
Le Coq & Waldschmidt 1928–33, VI, pl. C, p. 25.

38 Death Mask (?)

Kizil, Cave of the Red Dome, ca. 600
Stucco, H. 16.0 cm.
MIK III 7930

One of the most important sites in Kizil is the Cave of the Red Dome, which consisted of an almost square cella surmounted by a bright red dome. The paintings in the cave were of extraordinary interest, though many were in a poor state of preservation when they were found. Not far away, hewn high up in the mountainside, a small, flat-ceilinged chamber was discovered, which must have served as a library. It contained quantities of manuscripts written on palm leaf, birch bark, or paper in many different scripts and languages—one of the few libraries of Central Asia to present us with texts in such great numbers and of such superb quality.

This head from the Cave of the Red Dome is remarkable in being shaped not out of clay, the usual material, but out of stucco, a material that is hardly known on the northern Silk Route. Moreover, it may not be the head of one of the standard figures in the Buddhist pantheon, but the actual death mask of a man who lived in Kizil around A.D. 600.

The face has an extremely naturalistic expression, and in comparison with the mold-made heads of the clay figures it reveals not a trace of artificiality or mannerism. The hairstyle is also freer and less conventional than that of comparable devata heads.

39 Standing Buddha

Kizil, Cave above the Cave of the Coffered Ceiling, 7th century
Painting on wood, 48.0 × 10.0 cm.
MIK III 7591

As well as wall, paper, and fabric paintings, pictures of the Buddha on wood, as here, were also found in the Kizil caves; they were principally votive offerings made by pious pilgrims.

The Buddha stands on a stylized lotus pedestal with an extended pistil. A large mandorla and a nimbus surround the head and body. The mandorla is made up of colored stripes, light grayish brown, reddish brown, and green. The nimbus is a reddish brown circle edged with a band of light grayish brown. The Buddha wears a reddish brown garment with drapery folds indicated by double lines, which leaves the right shoulder free, and a green undergarment. He faces a little to his right, with his legs apart and his right hip slightly jutting forward. His right hand is raised in the teaching gesture and his left holds an alms bowl in front of the chest. Note that webbing can be seen between the fingers of the right hand, whereas those of the left appear normal.

The inscription along the top of the panel is written in the Tocharian language and reads, according to W. Siegling: "This Buddha was painted by the hand of Sanketava."

REFERENCES
Le Coq 1922–26, V, pl. 7a, p. 10. Indische Kunst 1971, 1976, no. 470. Bhattacharya 1977, no. 17, pp. 52f.

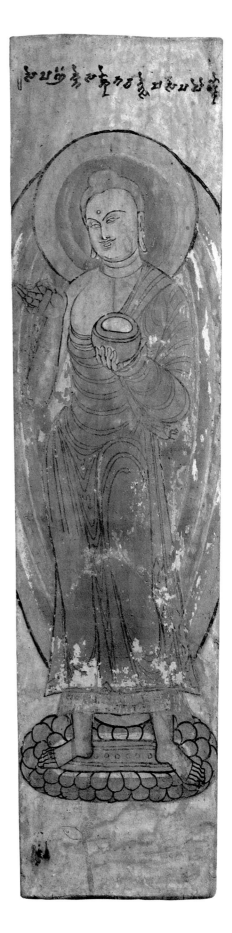

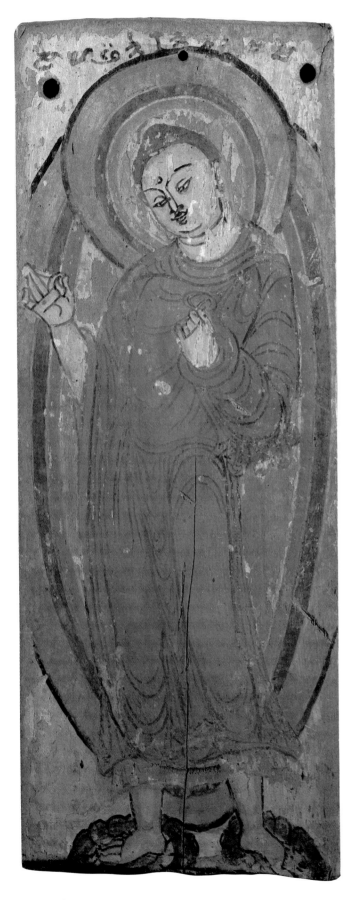

40 Standing Buddha

Kizil, Last Area, Last Cave, 7th century
Painting on wood, 30.2 × 11.8 cm.
MIK III 7390

Despite the somewhat coarser technique, this Buddha was painted in the same period as No. 39. Pure chance cannot account for the common elements such as the double-line drawing of the garment folds and the draping of the material around the hips. The upper part of the body and the head are more dynamic than in the preceding panel, from which this Buddha differs notably in three iconographic details: the right shoulder is covered by the outer garment; the left hand holds, instead of the alms bowl, one end of the garment; and the figure stands on two separate lotus blossoms.

The inscription along the top is again in Tocharian, written in the Brahmi script of Northern Turkestan. W. Siegling's reading of the text is: "This Buddha [was painted] by the hand of Ratna..." (the name of the painter is partially lost).

REFERENCES
Le Coq 1922–26, V, pl. 7b, p. 11. Bhattacharya 1977, no. 12, pp. 50f. Uhlig 1979, p. 131, fig. 64.

41 Devata

Kizil, Last Area, Last Cave, 7th century
Clay, H. 35.0 cm.
MIK III 8200

This unusual statue of a devata, one of the nameless divine beings, is clothed in a transparent garment that shows only in broad folds around the neck. The crown, in the form of a wreath with reddish brown and green stripes, rests on the attractively styled, blue-tinted hair, which falls in ringlets over both shoulders. Similarly curly hair can be seen in many clay figures from Shorchuk, the site to the east of Kucha halfway toward Turfan. The figure is primed white with a matt finish; the eyebrows, mustache, and edges of the eyelids are delineated by black lines, the sides of the nose, the eyelids, ears, and lines of the forehead by fine reddish lines.

REFERENCE
Le Coq 1922–26, I, pl. 33a, p. 27.

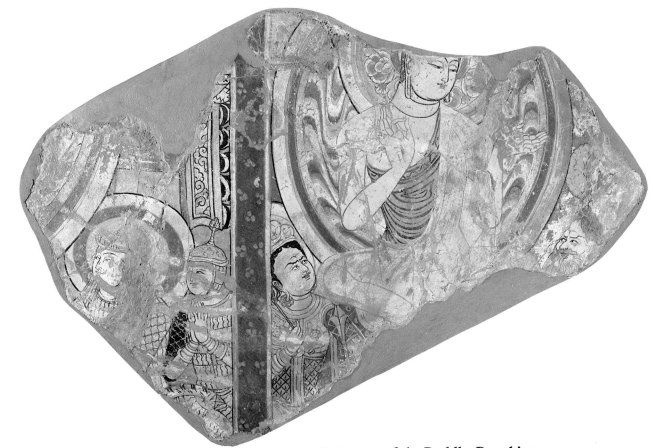

42 Scenes of the Buddha Preaching

Tumshuk, Eastern Area, 7th century
Wall painting, 51.0 × 75.0 cm.
MIK III 8716

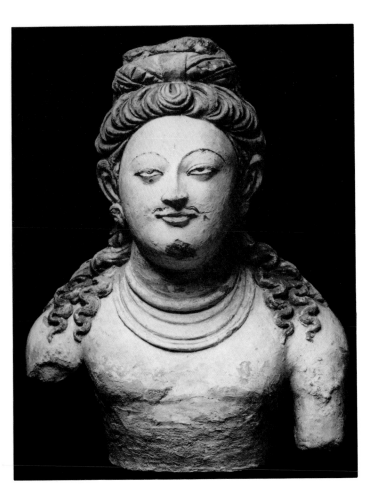

The main ruins at Tumshuk are situated above the hamlet of that name on a ridge whose northern end divides into three spurs. The flat tops of these spurs and parts of the side of the massif between them are covered with the ruins of places of worship. Surprisingly enough, although the stone here is a brittle schist with abundant traces of clay, no works of art in this material have been found at the site.

While the French expeditions led by Paul Pelliot investigated the ruins of monasteries and temples north of the Aksu–Maralbashi road, the fourth German expedition under von Le Coq studied the complexes on the three cliffs to the south.

The area on the middle spur is the smallest and least interesting. On the eastern spur, however, remains of wall paintings were discovered, the only examples to have survived from these two great complexes. Von Le Coq considered the paintings to be quite different from those in the Kucha region and earlier in date.

This fragment of wall painting shows two scenes of the Buddha preaching. On the left the remains of a Buddha mandorla are visible. In front of it, to all appearances, stands a knight whose helmet is an unusual sort of *Spangelhelm*. The nimbus round his head

109

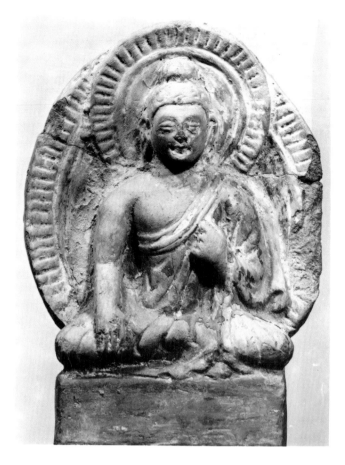

sets him off from another, younger man to the right, with lamellar armor and a conventional helmet.

A broad border separates this scene from a second, better-preserved one showing a seated Buddha with both hands raised in the teaching position. Webbing can be seen between his fingers. His body is surrounded by a circular mandorla, composed of concentric rings of different colors and filled in with a wavy pattern. The same ornamentation is known to us from later wall paintings under Chinese influence, for example, a large lunette in the Nirvana Cave in Kumtura (see No. 64, Fig. L). The design of the floral motifs around the Buddha's head also suggests a later date for this painting, as does the separation of the scenes by an ornamental border. There is a similar example in the Third Cave from the Front in Kizil, which Waldschmidt dated after A.D. 650.

The Buddha inclines his head to the right toward a brahman, whose expressive face with its blue beard has been preserved. To the left of the Buddha we see Vajrapani in armor, in his hands the traditional vajra and a fly whisk. Curiously enough, he is characterized as a demon by fangs in the corners of his mouth.

REFERENCES

Le Coq 1925b, pp. 67–72. Le Coq 1922–26, V, pl. F1, pp. 31ff. Bussagli 1963, p. 70 (ill.). Indische Kunst 1971, 1976, no. 379.

43 Seated Buddha

Tumshuk, Great Temple, Eastern Area, 7th century
Clay, H. 15.8 cm.
MIK III 7658

Many of the objects found in Tumshuk were of clay. Usually mixed with chopped straw or animal hair, this was the material out of which divine images of all kinds were commonly made.

This small painted relief was probably a votive offering. It represents a Buddha seated with his legs drawn up beneath him on a high, unornamented pedestal. His head and body are surrounded by a nimbus and mandorla with rayed borders. The robe bares his right shoulder. His right hand seems to hang down in the gesture of calling the earth to witness (*bhumisparshamudra*), while his left grasps the robe at chest level.

Although the relief is very roughly modeled, the East Asian style exerts a definite influence, especially in the face.

44 Seated Buddha

Tumshuk, Temple with the Frescoes, 7th century
Clay, gilt, H. 12.5 cm.
MIK III 7657

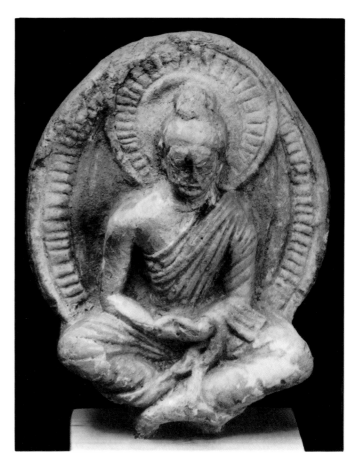

Although this Buddha, like the previous relief (No. 43), was made from a mold, it reveals a different formal and iconographic conception. The Buddha is portrayed in an unmistakable attitude of meditation, with the hands clasped in the gesture of meditation at the level of the parted thighs. The legs are not drawn up to the torso as is customary but hang down somewhat, so that the crossed feet would have touched the pedestal on which the figure was originally placed.

The aesthetic effect of the relief, which was originally richly painted and overlaid with gold, is slightly impaired by the damage it has suffered. Even so, clothing, limbs, and decoration reveal a much finer workmanship than that of No. 43.

45 Turbaned Head

Tumshuk, Demons' Temple, 7th century
Clay, H. 17.9 cm.
MIK III 7629

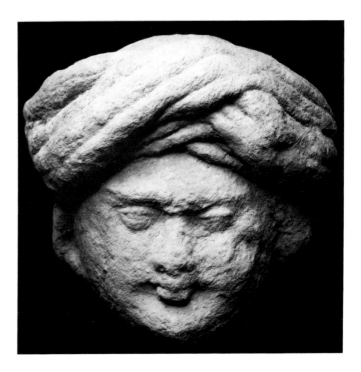

This damaged head, wrapped in a turban apparently wound out of thick cloth, originally belonged to an almost life-size secular figure. The paint has crumbled off, revealing the raw material: clay mixed with fine animal hairs.

REFERENCE
Le Coq 1922–26, I, pl. 18b, p. 21.

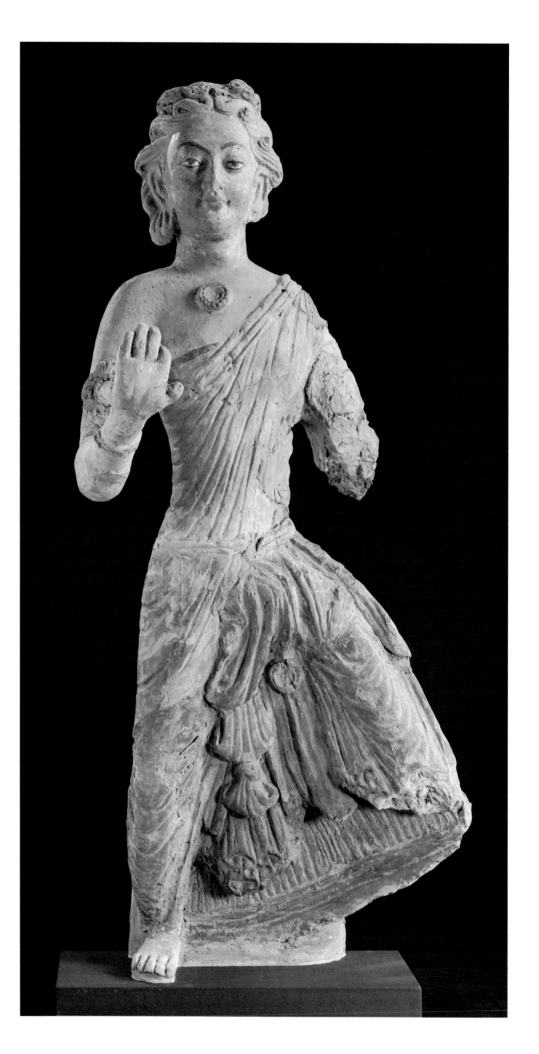

46 Standing Devata

Tumshuk, Eastern Area, 7th century
Clay, H. 72.7 cm.
MIK III 8948

In contrast to the clay figures from the Kucha region, most of those found in Tumshuk are of a soft, sensual elegance, reminiscent of the paintings and sculptures from Fondukistan in Afghanistan.

This slender, graceful devata wears a green shawllike garment, which leaves the right shoulder and arm bare. The garment covering the lower part of the body, held in place by a belt below the waist, seems to consist of several lengths of material, some of them knotted in the middle, others hanging free. The figure stands on her right leg, the left leg raised in a dancer's pose. It is hard to say whether the raised right hand has any particular significance. Unlike the bodhisattva figures, where the ornamentation is often taken to extremes, this devata is adorned with only a few rosettes and armbands. Her graceful look is enhanced by the mild expression on her face.

REFERENCES
Le Coq 1928, pl. 32, p. 147. Le Coq & Waldschmidt 1928–33, VI, pl. 1, p. 65.

Sculptures in Wood

ALREADY IN prehistoric times wood appears to have been the most important material in men's daily lives. Since it decays quickly, however, very few wooden remains have come down to us. What we do know is that wood was used first for essential needs, to build houses and temples and to make tools and vehicles, and only later for artistic purposes.

Central Asia must have been rich in commercial timber during the middle of the first millennium A.D. In the temples of Niya and Lou-lan, Sir Aurel Stein, the great explorer of the sites of the southern Silk Route, found wooden boards with Kharoshthi inscriptions dated between A.D. 263 and 330. These early wooden relics would never have survived if the temples of Central Asia had not been buried under desert sands for centuries.

A quite remarkable number of wood sculptures have come down to us from the Kucha region, as well as from Tumshuk further west. In terms of quantity they cannot be compared to the masses of clay figures that have survived, but their quality is often superb.

Most of these wood sculptures are representations of the Buddha, though the artists also carved bodhisattvas, devatas, monks, and secular subjects such as groups of musicians and various animals. Often they were part of a larger grouping, illustrating legends familiar to us from wall paintings and clay reliefs.

The style of these pieces varies considerably. In wood sculpture more than in any other branch of art, the local artists left their personal stamp.

47 Seated Buddha

Tumshuk, 5th century
Wood, H. 16.0 cm.
MIK III 8034

Among the treasures of the Central Asian collection in Berlin is one of the most beautiful ancient wood figures ever found, a sculpture of the Buddha seated in the attitude of meditation (*dhyanasana*). His head is slightly inclined forward; the hair and the topknot are smooth. The contours of his body are clearly discernible beneath a tight-fitting, apparently transparent overgarment, the only garment to be seen. This type of smooth, unwrinkled robe is reminiscent of some of the masterly sculptures of the Indian Gupta dynasty found at Sarnath. The webbings that are one of the thirty-two marks (*mahapurushalakshanas*) of a world-ruling king (*chakravartin*) or a future Buddha are here only visible between the thumb and forefinger of the right hand, yet we must picture them between all the Buddha's fingers. Missing are the halo and mandorla, and the throne on which the figure was originally seated has been lost.

As traces of polychrome suggest, the sculpture was once entirely painted. Statues of this type and size seem to have been votive offerings from pious Buddhists.

REFERENCES
Le Coq 1922–26, I, pl. 42c, p. 28. Waldschmidt 1925, pl. 60, pp. 104f. Härtel & Auboyer 1971, pl. 236. Indische Kunst 1971, 1976, no. 463. Rowland 1974, pp. 144, 145 (ill.), 149. Bhattacharya 1977, no. 19, p. 54.

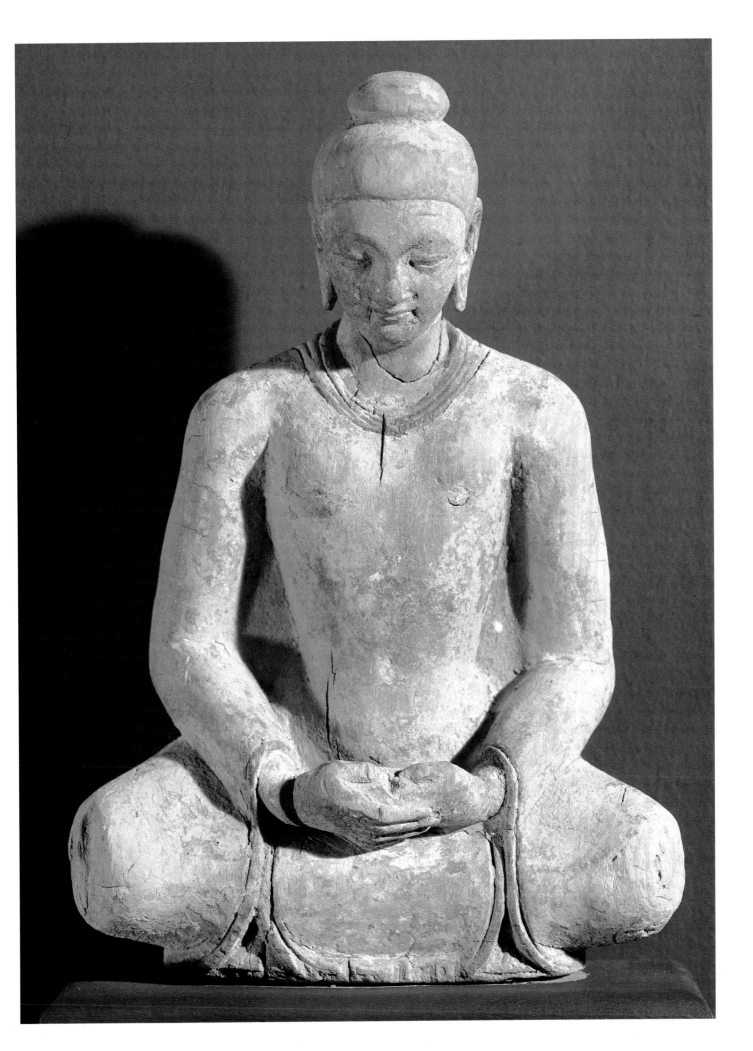

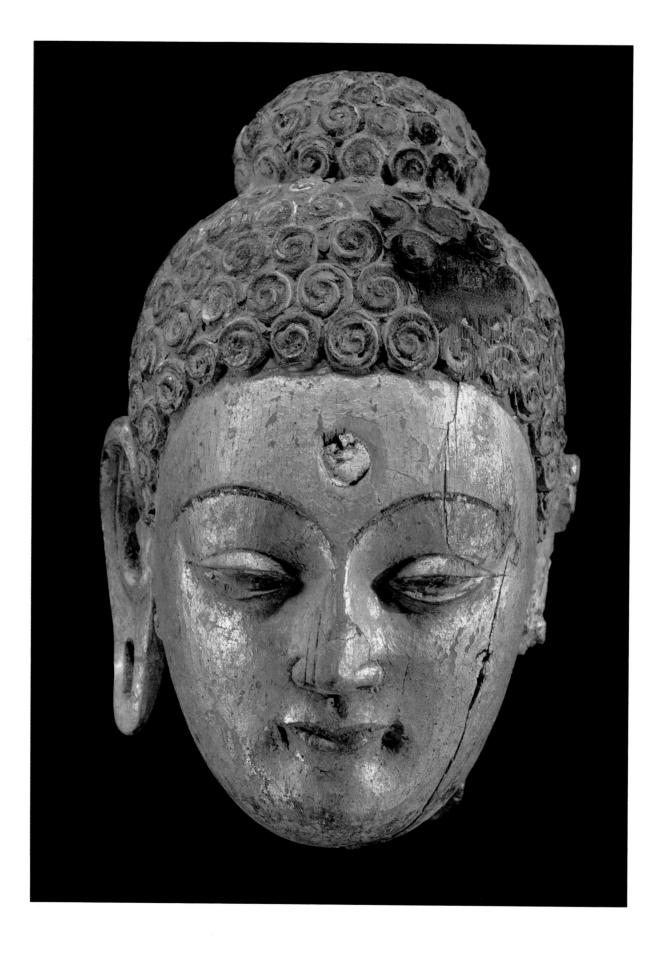

48 Head of a Buddha

Tumshuk, 5th–6th century
Wood, gilded, H. 11.0 cm.
MIK III 7656

This gilded head of a Buddha is another example of wood sculpture from Tumshuk. The coiffure of close-clinging spiral locks that continue up into the topknot is one traditionally worn by Buddhist ascetics. This topknot, the distended earlobes, and the round *urna* in the forehead, which probably once contained a precious gem, are three of the textually prescribed *mahapurushalakshanas*. In addition to the gold leaf, traces of red and blue paint have survived.

Stylistically, the sculptures in this exhibition show influences similar to those of the wall paintings. The more westerly sites on the northern Silk Route, Tumshuk included, were obviously affected by the Indian and Iranian cultures. In shape and expression this head reflects classical Indian art of the fifth to sixth century. Though several of its details, for example, the full lips, are found in the figures of the same period from Mathura and Sarnath, they have been translated here by local artists into an individual style.

REFERENCES
Le Coq 1922–26, I, pl. 42a, p. 28. Indische Kunst 1971, 1976, no. 465. Rowland 1974, pp. 144, 146 (ill.), 149f. Bhattacharya 1977, no. 42, p. 68. Indische Kunst 1980, no. 48.

49 Standing Buddha

Tumshuk, 5th–6th century
Wood, H. 22.0 cm.
MIK III 8031

This sculpture of a Buddha standing on a lotus pedestal is quite different from the previous two. His topknot is unusually high; the curls of his hair are indicated by lozenge-shaped incisions. A garment with heavy folds hangs loosely over his sloping shoulders, covering his body completely without, however, concealing its contours.

The lower arms and the hands of the figure, now missing, were made separately and attached to the elbows with dowels. The position of the elbows suggests that the hands were once held in the *abhaya* or *vitarka* mudra.

REFERENCES
Indische Kunst 1971, 1976, no. 460. Bhattacharya 1977, no. 2, pp. 45f.

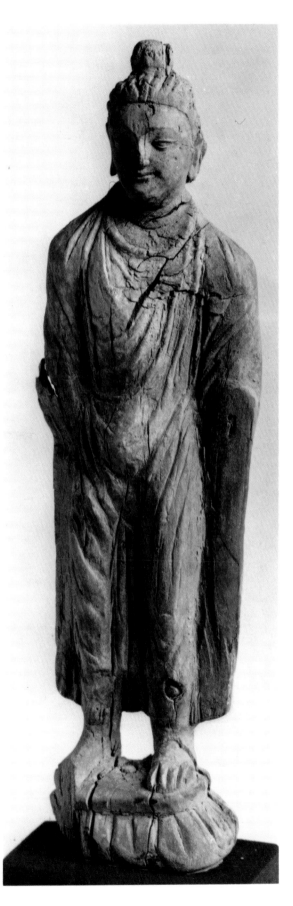

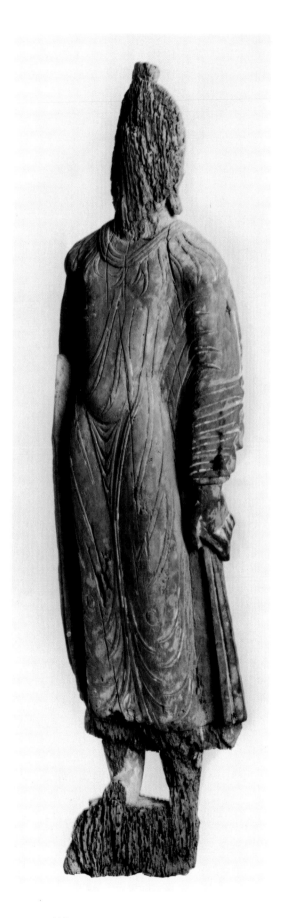

50 Standing Buddha

Tumshuk, 5th–6th century
Wood, H. 30.8 cm.
MIK III 8035

This figure is striking for the extremely fine carving of the drapery, which has been rendered with great skill. The robe is folded over at the neck to form the typical broad border, while the undergarment is visible below its hem. Unfortunately, the head, the lower legs, and the lotus pedestal of this lovely piece have been severely damaged.

REFERENCE
Bhattacharya 1977, no. 3, p. 46.

51 Seated Buddha

Kizil, Peacock Cave, 6th century
Wood, H. 16.3 cm.
MIK III 8151

This sculpture and Nos. 52–54 were found in the Peacock Cave at Kizil. At the time of its discovery this magnificent cave, one of the most ancient at that site, was completely filled with sand and rubble. It comprised a vestibule, slightly wider than it was deep, and a domed cella with three steps of unequal height leading up to it. As Grünwedel describes the discovery:

To the right and left of the door leading into the cella, strange antiquities were found...a high table on four legs with delicate ornamentation, and next to it a narrow small bench. Here a number of wooden idols were found. Also, on the opposite side, there were beautiful wooden Buddha figures, a small, greatly decayed stupa made of wood, etc. (Grünwedel 1912, p. 87)

The Buddha is seated, deep in meditation, on a throne decorated with a lozenge pattern. His head and body are surrounded by a halo and mandorla, and are, like his robe and hands, carved quite roughly. On the mandorla traces of tiny Buddha figures in the attitude of meditation are visible.

REFERENCE
Bhattacharya 1977, no. 29, p. 59.

52 Seated Buddha

Kizil, Peacock Cave, 6th century
Wood, H. 12.1 cm.
MIK III 8135

This small figure is represented with legs pendent (*pralambapadasana*), his right hand once raised in the gesture of protection or teaching (*abhaya-* or *vitarka-mudra*). The robe leaves his right shoulder bare, and the lower hem of his undergarment, which is tied at the waist, is just visible. This figure, which originally

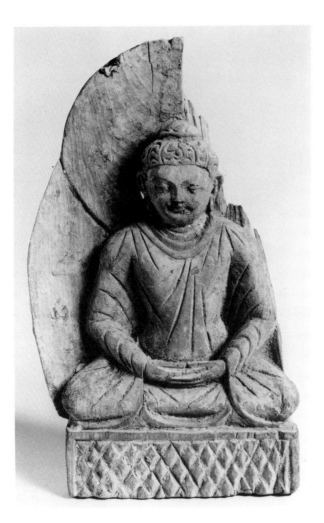

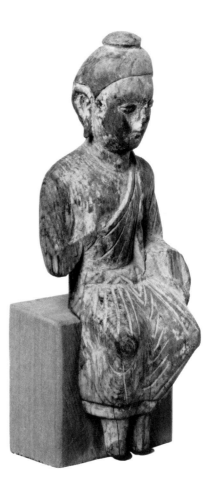

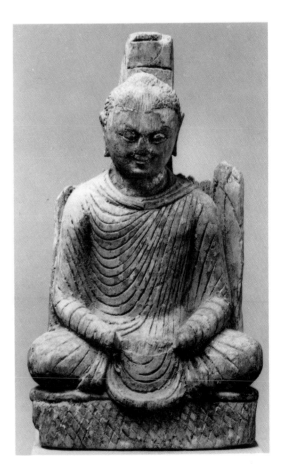

was painted and gilded, seems to be based stylistically on Indian models.

REFERENCES
Le Coq 1922–26, I, pl. 43e, pp. 28f. Bhattacharya 1977, no. 26, pp. 57f.

53 Seated Buddha

Kizil, Peacock Cave, 6th–7th century
Wood, H. 18.3 cm.
MIK III 7414

The Buddha is seated on a throne decorated with a lozenge pattern. He is dressed in a robe with multiple folds which covers both shoulders. The hands, now missing, once rested together in the gesture of meditation. The features of his comparatively broad face and the treatment of his hair, with its slightly incised strands and the suggestion of a topknot, may originate in similar Buddha statues of the Gandhara region.

REFERENCES
Härtel & Auboyer 1971, pl. 249a, pp. 99, 269. Bhattacharya 1977, no. 23, p. 56.

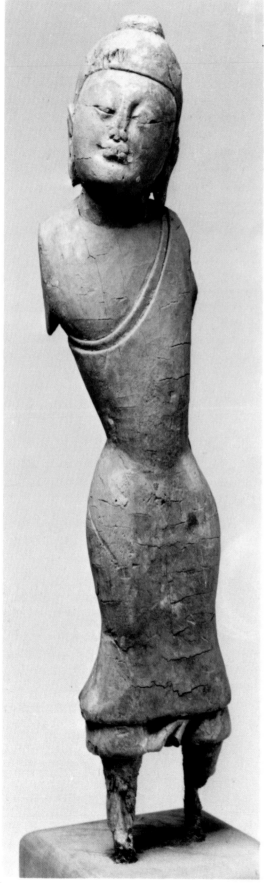

54 Standing Buddha

Kizil, Peacock Cave, 7th century
Wood, H. 22.7 cm.
MIK III 8137

This Buddha, standing in the double-flexed position (*dvibhanga*), wears a robe baring his right shoulder; narrow borders of an undergarment are visible at the top and below the hem of the robe. Although the treatment of the hair is common to both Indian and Chinese stylistic phases, the rounded face with its heavy eyelids and full lips shows the influence of East Asia, suggesting that the sculptor was Chinese.

REFERENCES
Le Coq 1922–26, I, pl. 43c, p. 29. Bhattacharya 1977, no. 5, p. 47.

55 Arm of a Buddha Vairocana

Kizil, Largest Cave, 6th–7th century
Wood, gilt, 6.5 × 2.1 cm.
MIK III 8133

Representations of the cosmic Buddha Vairocana were very popular in the art of Central Asia, especially along the southern Silk Route in the kingdom of Khotan,

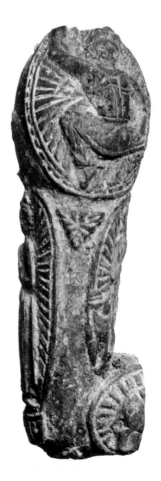

but also in Kucha and Karashahr. The iconography of this type of Buddha is based on a Mahayana text, the *Avatamsakasutra*. Devoted among other things to the cult of Vairocana, it was first translated from Sanskrit into Chinese in 421 by the Indian monk Buddhabhadra.

Vajras, triangles, and circles are specifically mentioned in the text as forms in which the Buddha sometimes exists. The octagonal and circular forms on either side of the chest ... represent the two kinds of jewels. ... And the curious segments of chain which end abruptly on the collarbone ... are apparently the half-necklaces (*ardhahara*), which in Sanskrit refer to short necklaces with half the full number of jewels. Perhaps this is a misunderstanding of the text, perhaps a deliberate way of underlining the abstract supernatural nature of the whole image.

Mount Sumeru is mentioned frequently in the text as an epitome of the universe, at the centre of which it stands. The hour-glass form wound with snakes ... seems to represent the world mountain in highly abbreviated form, in the same way that the seat of the Buddha with such an outline is described in the Far East as a Meru-throne. The sun and moon on either shoulder are thus explained in origin as the two luminous bodies which circle the world mountain, although these are present on all examples of the cosmic Buddha even when there is no Meru symbol in the centre. (Williams 1973, pp. 120f)

This small fragment represents the right arm of the Buddha Vairocana from shoulder to elbow. It is subdivided into medallions containing various figures. At the top is the god Surya with his right arm raised and

his left resting on his thigh. He is easily identified by the way he sits, typical in the art of Central Asia, with one arm raised as if wielding a whip, by his clothing, and by his position on Vairocana's right shoulder.

The medallions on the outside and inside of the arm each show a worshiper standing in *anjalimudra*, surrounded, like Surya, by a mandorla. To the right of the worshiper on the inside arm is an animal watching him.

REFERENCES
Le Coq 1925a, fig. 73, p. 60. Le Coq & Waldschmidt 1928–33, VI, p. 71. Bhattacharya 1977, no. 45, pp. 68f.

56 Two Lions

Achik-ilek near Kirish, 7th century(?)
Wood, 23.9 × 18.2, 23.9 × 17.7 cm.
MIK III 7667a,b

Found near the village of Kirish, these two realistically carved lions, which at first sight are almost identical, were most probably part of a throne. With wide-open mouth, revealing fearsome fangs and a throat in naturalistic color, they were meant to ward off unwelcome visitors.

REFERENCE
Bhattacharya 1977, nos. 182, 183, p. 98.

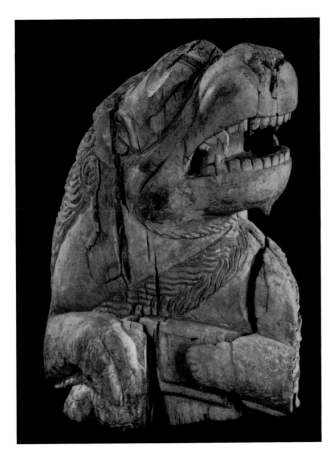

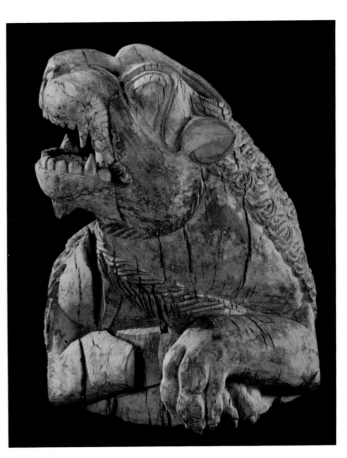

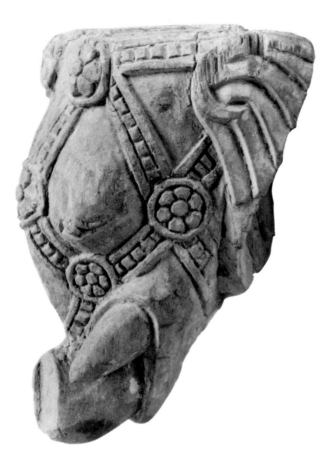

58 Scene of the Buddha Preaching

Kumtura, Cave at the Bend, 8th century
Wall painting, 47.0 × 42.0 cm.
MIK III 9024

The Buddha is shown with a nimbus and flaming mandorla, seated crosslegged on a lotus pedestal. He is debating with a monk who squats to his right, offering what is probably a flower (the object is difficult to identify). The stubble on the monk's chin, dabbed on with a brush, is an original touch, making him more lifelike. The following considerations may help to explain the unconventional style of the painting.

There are caves in Kumtura with paintings in the Indo-Iranian style (see No. 18), and others where the pictures betray a definite East Asian touch. This fact gives us an idea of the historical influences operating along the northern Silk Route. It is remarkable that the two different styles are found in caves of the same area, without any tendency to merge. We do, however, possess a few fragments of paintings from Kumtura that cannot be positively ascribed to one style or the other: this is one of them. Indo-Iranian elements are mingled with Buddhist Chinese features; drawing and coloring techniques cannot be compared with the works of the main schools. The facial characterization of the Buddha, the flaming mandorla, and probably the speckled pattern on the robe are of distinctly Oriental inspiration, whereas the border, the lotus, and the portrayal of the monk reflect a different style. It is interesting to compare this painting with the six Kumtura murals that follow and to note the disparity that exists between them.

REFERENCES
Bussagli 1963, pp. 88 (ill.), 90. Uhlig 1979, p. 131, fig. 65.

59 A Gandharva

Kumtura, Kinnari Cave, 8th–9th century
Wall painting, 41.0 × 68.0 cm.
MIK III 8913a

Minor Buddhist deities often to be seen in the paintings of Central Asia are the gandharvas, kinnaras, and vidyadharas. They usually occur singly or in pairs in flight beside the nimbus of a major god, in whose honor they bear garlands or strew flowers. Their female counterparts, who are usually to be seen dancing or making music, are the apsaras, whose main function is to entertain the gods.

The small, cloud-borne figure in this fragment of wall painting is a gandharva. With a bowl full of blossoms in his hands he flies toward the Buddha, whose

57 Elephant's Head

Kizil, Cave 10, 6th–7th century
Wood, 10.0 × 10.0 cm.
MIK III 8139

The trunk and right tusk have been broken off this head of an Indian elephant, adorned with trappings of beaded bands and six-petal rosettes. Remnants of paint, blue-black on the head and white on the ears and tusks, show that it was originally colored. Its flat top indicates clearly that the head was originally an architectural element.

REFERENCE
Bhattacharya 1977, no. 179, p. 97.

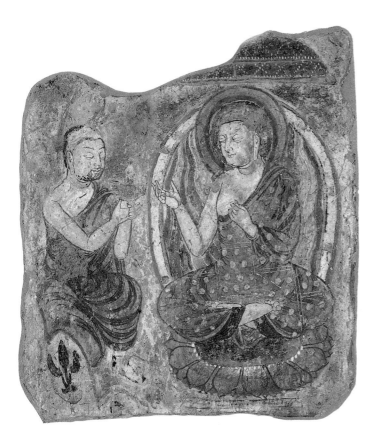

seated figure would have appeared below the large parasol. Motion is suggested by the fluttering ends of the scarf and the long robe billowing out behind him. (For a painting on silk with a similar subject, see No. 124.)

The Berlin paintings in the Buddhist Chinese style come mostly from the Turfan oasis, though some caves with paintings of this type have been discovered in other complexes further to the west, primarily in Kumtura. Interestingly enough, none has been found in Kizil.

This is the first of a group of murals (Nos. 59–64) from the four Kumtura caves that were painted entirely in the Buddhist Chinese style. That this is a distinct style is evident in every respect. Whereas the Indo-Iranian school, especially in its later stages, tended to produce stereotyped works with recurring motifs, here we have a freer, more casual brush technique which gives greater scope to individual forms of expression. The gamut of colors, too, ranging from soft pastel shades via deep red and radiant yellow to dark green, is unknown in the Indo-Iranian styles.

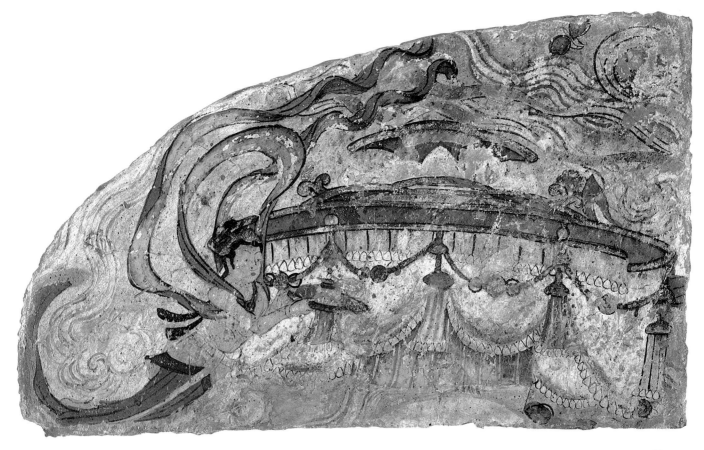

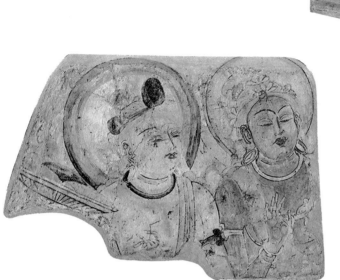

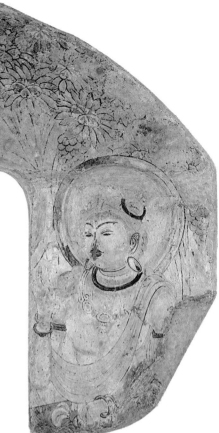

60 Three Gods of the Tushita Heaven

Kumtura, Apsaras Cave, 8th century
Wall painting, 56.5 × 84.0, 63.5 × 111.0 cm.
MIK III 9021

These fragments, painted in the Buddhist Chinese style, are from a large lunette above the entrance to the cella of the Apsaras Cave. In the caves with paintings in the Indo-Iranian style this position is usually occupied by an image of the Future Buddha, the bodhisattva Maitreya in the Tushita heaven. Presumably here, too, the same theme was illustrated.

The center of the picture was originally occupied by the bodhisattva Maitreya on his throne, with three deities on either side. The two fragments are from the outermost segments left and right of the lunette. The painting delights the eye with the extraordinary softness of its pastel coloring, which avoids stark contrasts; the figures of the gods, especially the brown-skinned one, are drawn with remarkable delicacy.

REFERENCES
Le Coq & Waldschmidt 1928–33, VII, pl. 26a, pp. 61f, pl. 27, pp. 62f. Bussagli 1963, pp. 89 (ill.), 90. Indische Kunst 1971, 1976, no. 534.

61 Buddhas and Attendants

Kumtura, Nirvana Cave, 8th–9th century
Wall paintings, 71.0 × 108.0 cm.
MIK III 8826

This cave in the Buddhist Chinese style was adorned with unusual paintings, the vaulted ceiling being occupied by series of Buddhas accompanied by devatas. Auspicious clouds and floral ornamentation fill the spaces between. The Buddha figures, which look almost identical, are meant to represent the Thousand Buddhas of our epoch. The series were continued on the vaults of the passages.

REFERENCE
Le Coq & Waldschmidt 1928–33, VI, pl. 28c, p. 89.

62 Dignitary Seized by Soldiers

Kumtura, 8th–9th century
Wall painting, 23.0 × 29.0 cm.
MIK III 8915

This fragment of painting was not found in situ but among the debris of a temple. We can only hazard a guess, therefore, as to what its companion pictures—which would have helped us to interpret the scene—might have been.

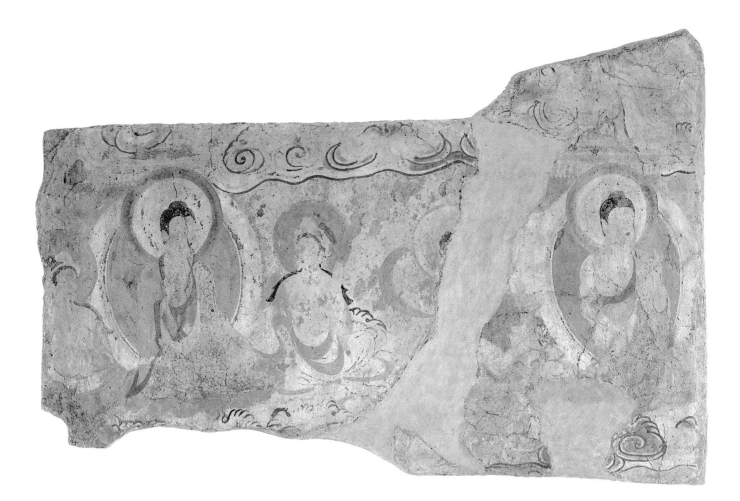

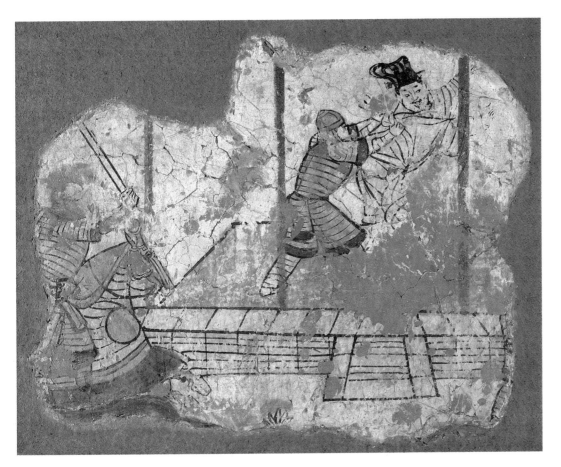

From the early history of India we know that the Buddha lived as an itinerant preacher in Magadha, not only tolerated but actually protected by his patrons, the powerful King Bimbisara (ca. 550–490 B.C.) and his violent son Ajatashatru. It is said that in his youth Ajatashatru was a follower of the Buddha's scheming cousin, Devadatta. Devadatta, who according to legend caused a schism in the Buddhist order and several times tried to kill the Buddha, is supposed to have incited Prince Ajatashatru to depose his father, hoping thus to put an end to the activities of his cousin and rival.

It is a historical fact that King Bimbisara was taken captive by his son Ajatashatru; there is a legendary account of this event in the *Amitayurdhyanasutra*, a Mahayana text which was translated into Chinese between A.D. 265 and 316 and which contains sections dating from various periods. This scene may be an illustration of the legend, which ends with the murder of the king. The story goes that after his father's violent end Ajatashatru turned away from the power-crazed Devadatta and adopted a friendlier attitude toward the Buddha.

63 Worshiping Bodhisattva

Kumtura, Temple 12, 8th–9th century
Wall painting, 63.0 × 31.5 cm.
MIK III 8377

This fragment is one of the finest examples of richly colored mural painting in the entire Central Asian collection. It is from the wall to the right of the door in Temple 12 in Kumtura. Next to a meander strip that forms the right-hand border of the picture is the figure of a worshiping bodhisattva. There is a large nimbus round his head, and his hair is tied with a band below the topknot. The upper part of his body is draped with fluttering scarves. A garment made up of two different-colored parts hangs down from the hips, around which a white cloth is tied. The partially preserved figure on the left, wearing rich ornaments and a crown, holds an Indian manuscript. In the lower right-hand corner is a head in profile with an oblique nimbus. Below and to the left, the remains of a head and nimbus are visible.

REFERENCES
Le Coq 1922–26, III, pl. 11, p. 39. Bussagli 1963, pp. 90, 91 (ill.). Indische Kunst 1971, 1976, no. 531.

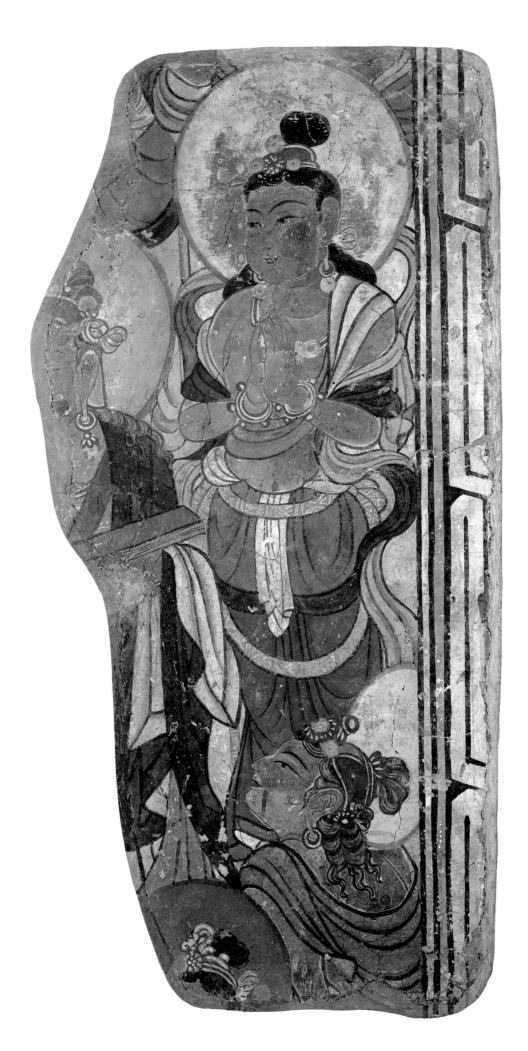

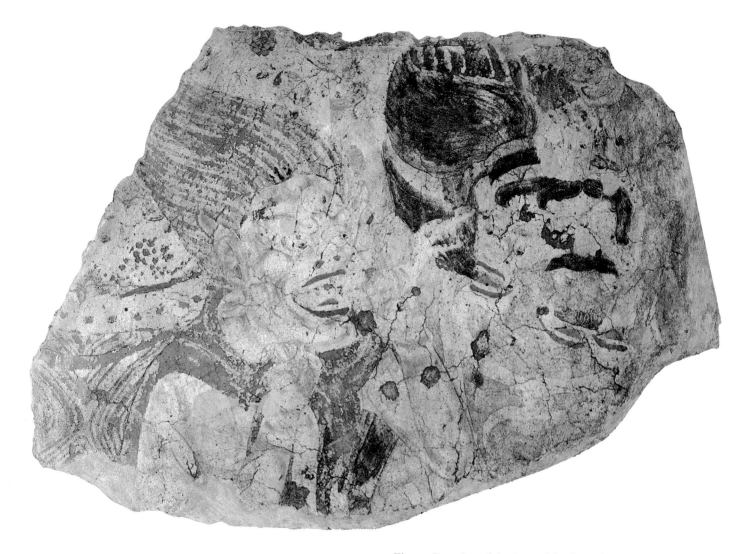

Fig. L Remains of the icon niche from the Nirvana Cave,
Kumtura; the Attack of Mara, and the Bodhisattva's
nimbus and mandorla

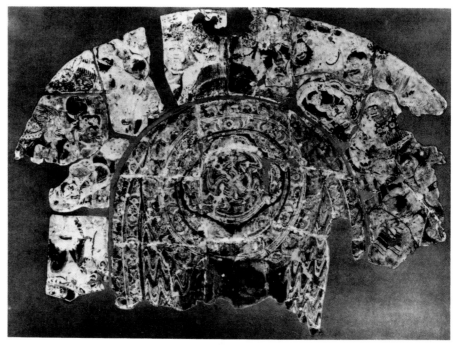

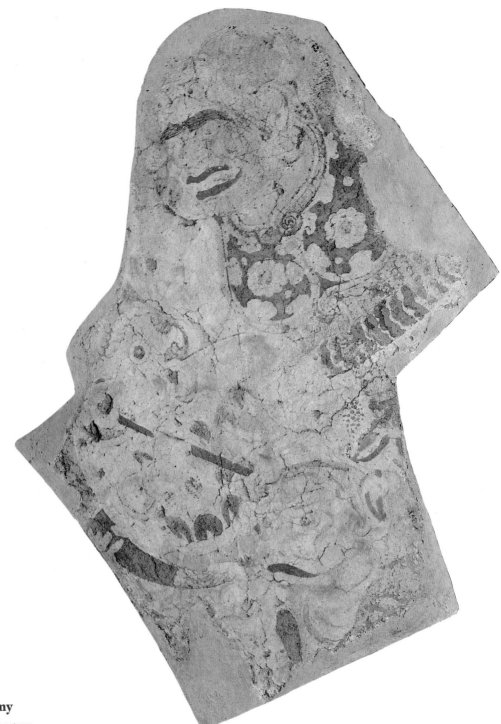

64 Demons from Mara's Army

Kumtura, Nirvana Cave, 8th–9th century
Wall painting, 85.0 × 56.0 cm.
MIK III 8834

In the cella of the Nirvana Cave, the lunette of the wall behind the cult image illustrated Mara's attack on the Bodhisattva as he sought enlightenment; this picture contains unusual artistic elements. The image, a clay statue, had disappeared, but the nimbus and mandorla that filled the niche were rescued. Both were filled in with wave patterns and bordered by a ring of floral motifs (Fig. L). Encircling the niche was Mara with his horde storming to the attack. These two fragments are from the left and right of the scene.

The demon with the hair standing on end is blowing on a snake as on a flute. On his back he carries a drum. To the right of him a black-haired monster with two faces seems to be about to throw a firebrand at the Bodhisattva. Of the demons on the right we can make out only a ferocious-looking, two-faced figure in armor.

REFERENCES
Grünwedel 1912, pp. 28f, figs. 57, 59. Le Coq & Waldschmidt 1928–33, VI, pl. 23, pp. 86f.

facing page

65 Half-Figure of a Devata

Shorchuk, Nakshatra Cave, 7th–8th century
Clay, H. 52.0 cm.
MIK III 8197

Shorchuk is a small village halfway between Kucha and Turfan, with the towns of Kurla to the west and Karashahr to the east. At the foot of the mountains stood a whole row of temples in the open, but these seem to have been destroyed by fire. As they yielded nothing but a few badly damaged fragments of clay figures, attention was directed to the nearby cave temples, where extremely interesting manuscripts and wall paintings were discovered, together with numerous painted clay statues of great beauty.

As at many other sites in Central Asia, the interiors of the cave temples in Shorchuk were religious settings composed of painting and sculpture, all grouped around the central cult image. A few examples of clay statues, taken mainly from the niches, will help us to appreciate the style of these decorations. The devata half-figures, which differ only in their details, were undoubtedly made from molds. They appear stereotyped with their symmetrical faces, the almost identical chaplets worn on top of the head, the hair which is tied together behind and falls in wavy locks around the shoulders, and the ornamental chains resting on the naked chest. Yet the artists always managed to introduce new and imaginative variations.

REFERENCE
Le Coq 1922–26, I, pl. 32b, pp. 26f.

following pages

66 Half-Figure of a Devata

Shorchuk, Nakshatra Cave, 7th–8th century
Clay, H. 52.0 cm.
MIK III 8201

The green shawl hangs down from the back of the devata's head in roughly executed folds around the hand-modeled body, which is bare-chested, primed with a flesh color, and painted. The face is made from a mold. The hairline, the edges of the eyelids, and the furrow in the chin are drawn in red; the mouth is also painted red. The chaplet, hairstyle, and ornaments are very similar to those of No. 65. Both sculptures were evidently designed as niche figures.

REFERENCE
Le Coq 1922–26, I, pl. 33b, p. 27.

67 Female Half-Figure

Shorchuk, Nakshatra Cave, 7th–8th century
Clay, H. 50.8 cm.
MIK III 8198

In contrast to the two preceding sexless devata figures, this sculpture—although the face, hairstyle, and chaplet resemble theirs—is clearly female. The lady wears large blossom-shaped earrings, a simple necklace, and a bluish gray bodice which leaves the breasts bare. The skirt is green and is set off at the front and sides by an off-white garment tied in a bow under the breasts. A red, short-sleeved jacket and a yellowish-brown mantle complete the costume.

Here, more noticeably than in the devata figures, we see the typical Shorchuk "balloon" face, full and round with plump cheeks and occasionally a double chin. The upper and lower lids are sharply carved, set off against the rounded cheek by a pronounced groove.

REFERENCE
Le Coq 1922–26, pl. 32a, p. 26.

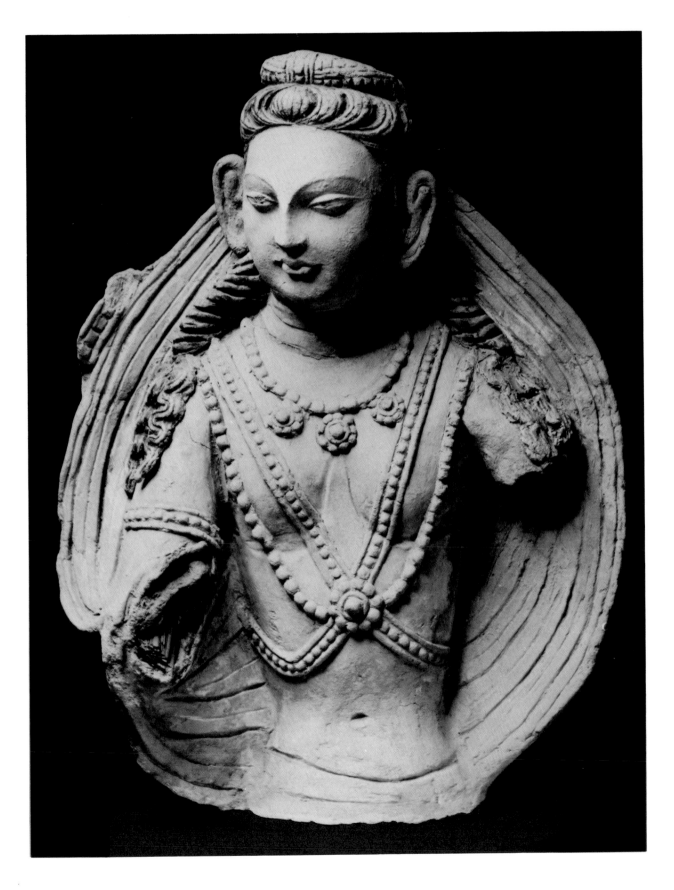

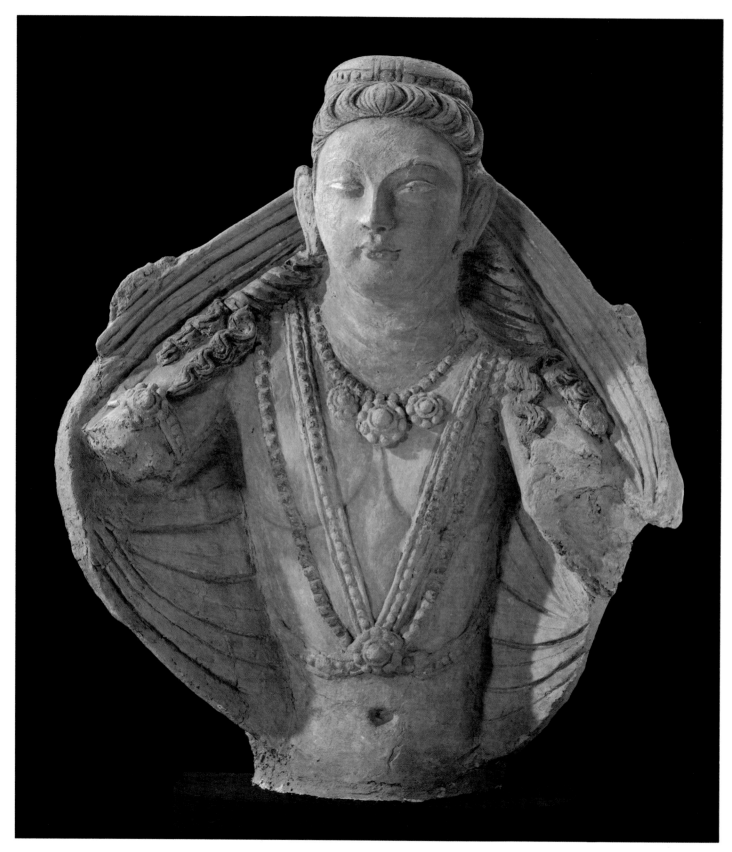

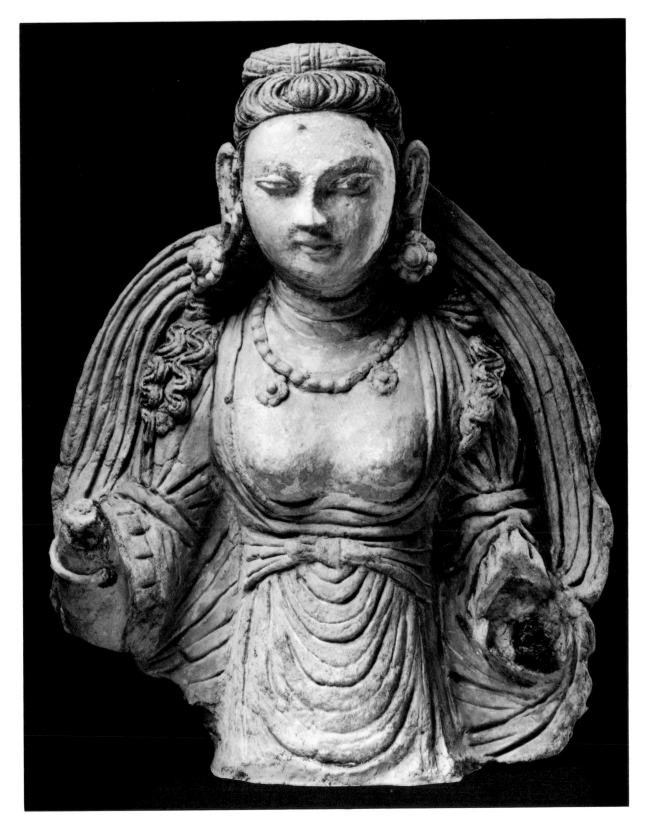

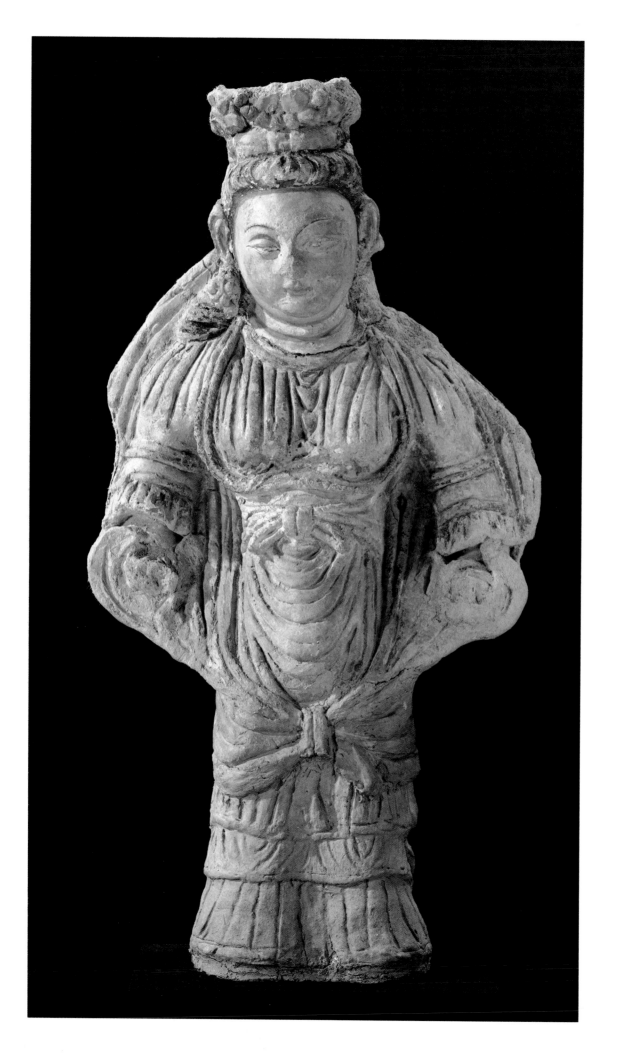

68 Female Figure

Shorchuk, Nakshatra Cave, 8th century
Clay, H. 38.3 cm.
MIK III 7896b

The figure's feminine charms are veiled by a mass of clothing. The typical Shorchuk face is again to be seen, here with a particularly delicate mouth. The hair is styled conventionally but crowned with an ornamental or floral diadem with beaded leaf patterns. A dark gray blouse covers the breasts, a green skirt the lower part of the body and the legs. The red jacket seems to be fastened below the breasts; the rest of the apparel, including the shawl(?) tied above the double hem, serves decorative rather than practical purposes. It is difficult to say how closely contemporary fashion is reflected in these clothes.

69 Female Half-Figure

Shorchuk, Kirin Cave, 7th–8th century
Clay, H. 45.1 cm.
MIK III 8202

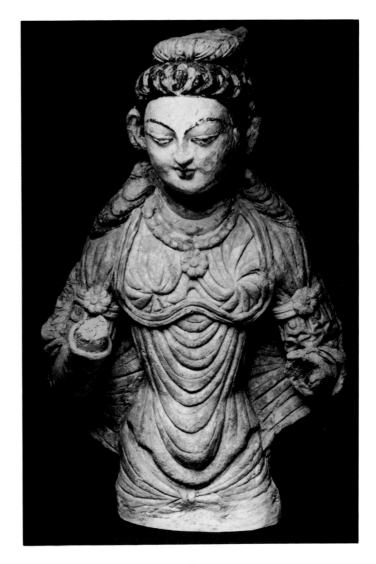

The face and arms of this figure are colored white, her eyebrows and the edges of the eyelids black. Her hair is interwoven with green leaves and falls upon her shoulders in thick curly tresses. The white chaplet, the top of which is damaged, shows traces of red paint.

The woman's costume is rather curious. She wears a yellowish red mantle, damaged at the sides, and a green bodice of unusual spiral design. Around the rest of her body is wound a length of grayish white material, gathered in folds, which is complemented by a skirt fastened with a bow.

The missing right hand was originally raised, in a gesture of welcome to the visitor, with a flower made up of seven rosettes in the palm.

REFERENCE
Le Coq 1922–26, I, pl. 31a, p. 26.

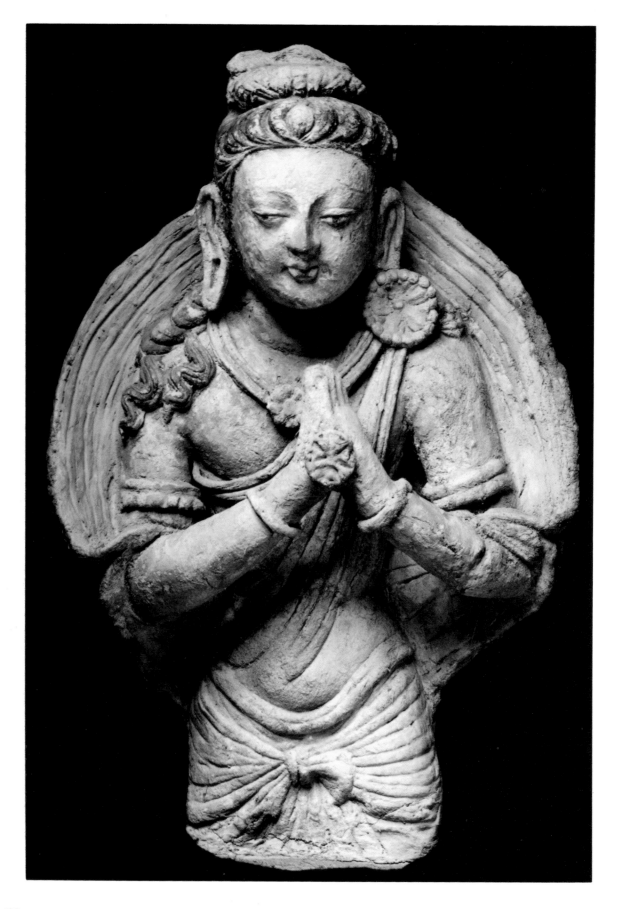

70 Half-Figure of a Devata

Shorchuk, Kirin Cave, 7th–8th century
Clay, H. 46.0 cm.
MIK III 8203

This half-figure of a devata, with hands gracefully joined in *anjalimudra*, differs in detail from comparable sculptures. The right ear was apparently always without ornament; instead, the hair on that side falls decoratively upon the upper arm. The ornamentation of the upper arms is also different, and the shawl, which is spread like a mandorla, is rather awkwardly draped over the bent elbows. With a flower clasped between the hands, the devata radiates peace and tranquillity.

71 Head of a Devata

Shorchuk, Temple in the South of the City, 7th century
Clay, H. 11.5 cm.
MIK III 7862

This small head of a devata is very similar to those of the half-figures previously described. The mold-made face is regularly proportioned, and the entire head is heavily painted. Heads of this type, of no great iconographic significance, have been found in many different sizes.

72 Head of a Demon

Shorchuk, Temple in the South of the City, 7th century
Clay, H. 12.3 cm.
MIK III 7860

Here the face is marked by very expressive features: below the high forehead the eyes peer out from beneath menacingly raised eyebrows. This is in effect a simple variation on the basic Shorchuk head, dynamically emphasizing the few lines of the face. The demonic expression sought after is intensified by the shorter, flatter nose and the vertical furrows of the brow above it.

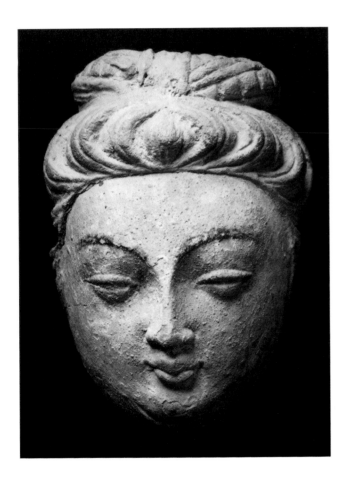

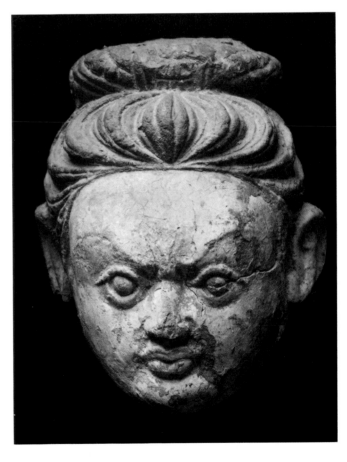

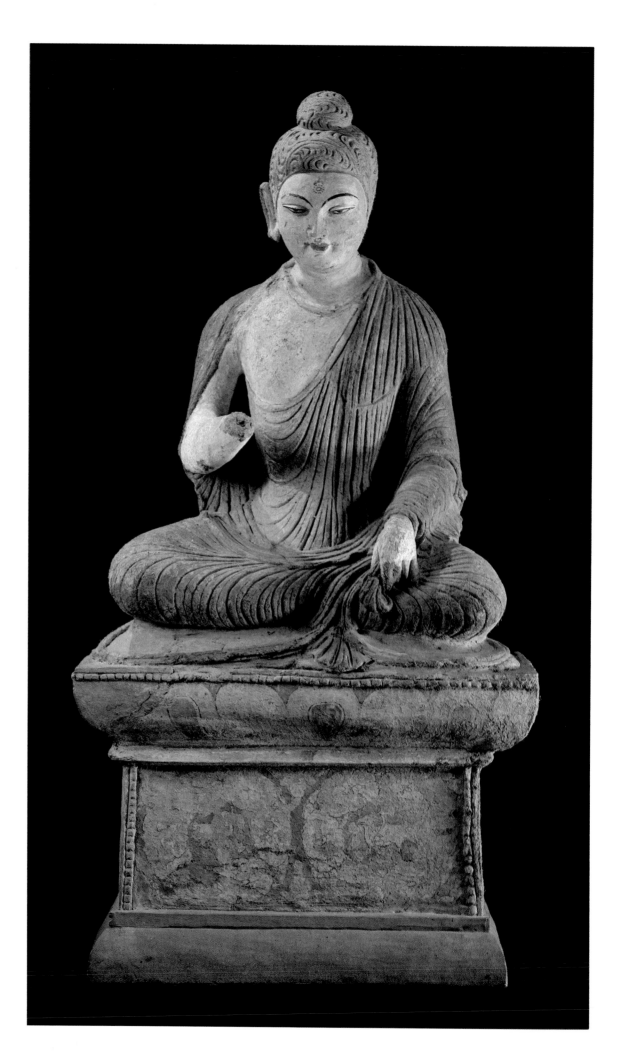

73 Seated Buddha

Shorchuk, Kirin Cave, 7th–8th century
Clay, H. 102.0 cm.
MIK III 7841

The Buddha sits on a high, finely painted pedestal, conceived at the top as a lotus throne with rounded contours. This is supported by a rectangular block adorned with a pair of floral medallions, in the center of which two winged stags stand facing each other. The motif is probably derived from the Sasanian school.

The Buddha appears to be clothed in three garments: a transparent undergarment, a yellowish brown robe, and a reddish shawl. This would conform to the threefold dress prescribed for monks (*antarvasa, uttarasanga,* and *sanghati*), but the high-necked undergarment is here draped more in accordance with artistic dictates than the monastic rule would allow.

The legs, crossed in the lotus posture, are fully covered; the left hand holds one end of the shawl, while the right was presumably raised in the fear-allaying gesture (*abhayamudra*). The hair is styled in waves, the hairline marked in red. The *urna*, one of the canonical signs of a great being (world ruler or Buddha), takes the form of a stylized jewel on the forehead. The figure's left ear has unfortunately been broken off.

The winged stags in the medallions on the pedestal might be taken as gazelles, signifying that the Buddha is here shown preaching his first sermon, that of the Deer Park in Benares. But such an interpretation would require that the Wheel of the Law be also in evidence, and this really cannot be construed from the medallions.

REFERENCES
Le Coq 1922–26, I, pl. 40, p. 28. Indische Kunst 1971, pl. 56 and no. 457. Rowland 1974, pp. 176f, 182, 185 (ill.).

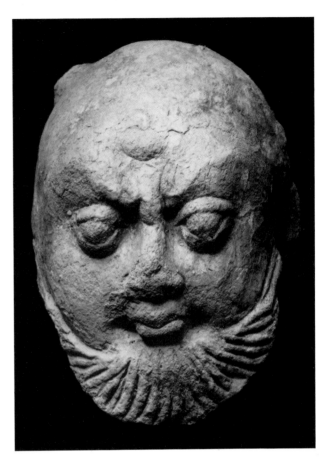

74 Head of a Brahman

Shorchuk, Temple of the Priests' Initiation, 7th–8th century
Clay, H. 16.2 cm.
MIK III 7871

The brahmans, as representatives of the group of non-believers in the Buddha's teachings, seem often to have been exposed to ridicule by Buddhist artists. Such, at any rate, is the impression conveyed by the brahman images of Central Asia, an impression confirmed by this head. Very individualistic in his physiognomy, the brahman expresses anger in his wide, staring eyes and the pronounced wrinkles of his forehead. The eyes protrude from their sockets as in the depictions of demonic figures; the mouth appears small and compressed. The beard, modeled in strands, fans out to the ears. The coiffure is a curious one; the hair may originally have lain close to the head and perhaps been tied up on the brahman's right-hand side.

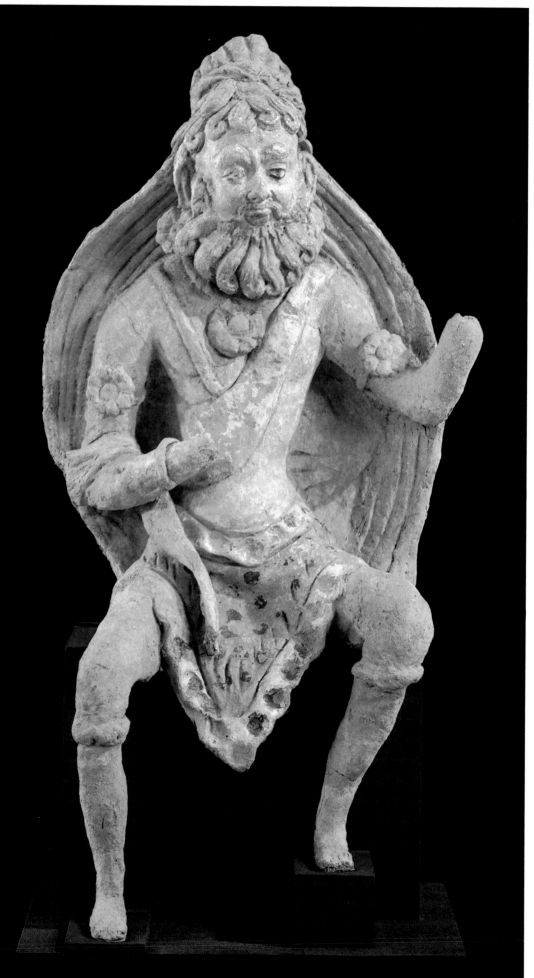

75

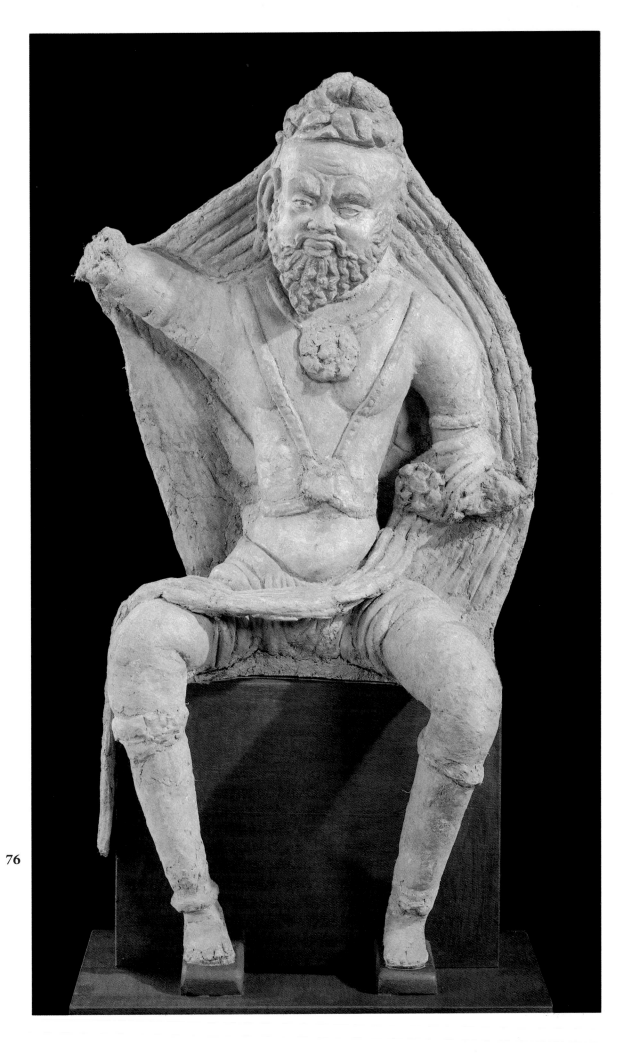

preceding pages

75 Seated Brahman

Shorchuk, Kirin Cave, 7th–8th century
Clay, H. 16.5 cm.
MIK III 8199b

This seated brahman, in his panther skin, knee-length stockings, and shawl in the form of a mandorla, cuts an almost comical figure. His hair is tied up in the ascetic style, but on his forehead and in his beard bushy ringlets hang down like snakes. He gives the impression of participating in a lively discussion.

REFERENCE
Le Coq 1922–26, V, pl. 4b, pp. 8f.

76 Seated Brahman

Shorchuk, Kirin Cave, 7th–8th century
Clay, H. 42.4 cm.
MIK III 8199a

The brahman is encompassed by a mandorlalike shawl and wears a loincloth and knee-length stockings. The ear ornaments have been broken off; he has a necklace with a round floral pendant, and on his chest two decorative chains, crossing at the navel under a rosette. Like No. 75, he appears to be taking part in a disputation (his missing right hand was originally raised). The craggy, lined face with its prominent eyes and bushy beard gives the figure its special character, that of the typical, grumpy brahman as the Buddhists visualized him.

REFERENCE
Le Coq 1922–26, V, pl. 4a, p. 8.

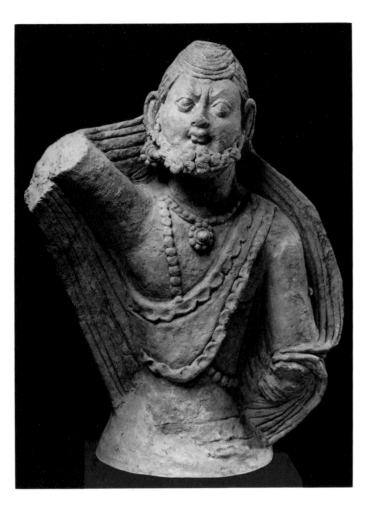

78 Head of a Devata

Shorchuk, Nakshatra Cave, late 8th century
Clay, H. 16.5 cm.
MIK III 7865

This noteworthy head can be taken as an example of the transition from West to East, from the Indo-Iranian style to the Buddhist Chinese. In the face, though it is still of the "balloon" type, and in the small mouth there is little to remind us of Western physiognomy. The coiffure also seems to announce new developments: the hair is still set in waves around the forehead, but is arranged in the center in a mushroom shape instead of an oval. The eyelids are no longer traced horizontally: they turn distinctly downward.

77 Half-Figure of a Brahman

Shorchuk, 7th–8th century
Clay, H. 51.9 cm.
MIK III 8721

Modest in execution and conventional in dress and ornaments, the figure wears his hair in the typical ascetic style, originally tied on top, which distinguishes him as a brahman.

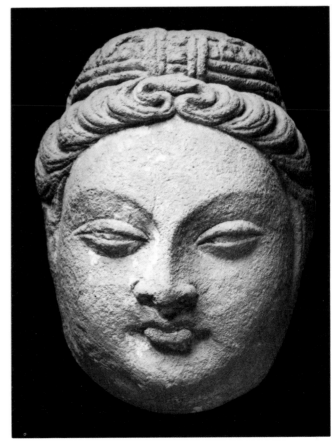

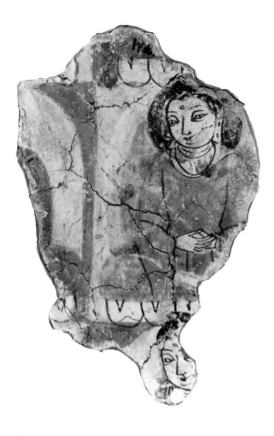

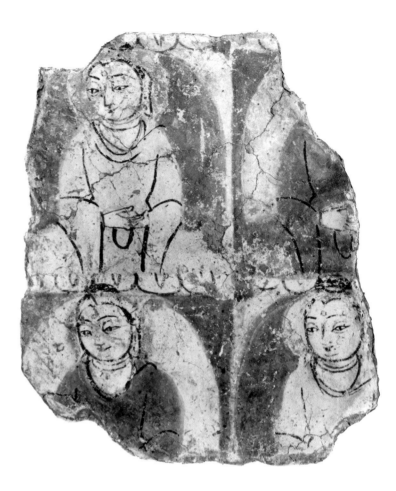

79 Seated Buddhas

Dandan-oilik, 8th century
Wall paintings, 20.0 × 15.0, 22.0 × 19.0, 14.0 × 14.0 cm.
MIK III 9273c,f,h

Dandan-oilik, about seventy-five miles northeast of the city of Khotan, was one of the most important temple cities on the southern Silk Route. In the ruins of the Buddhist monasteries, crumbling away and buried in the desert sand, manuscripts and coins from the seventh and eighth centuries were found, and also sculptures and paintings on wood and clay. Many of the paintings were significant both for their subject matter and for their iconographic relevance. But there were also stereotype series of innumerable, almost identical Buddhas, such as the ones depicted in these fragments. Each Buddha sits in a niche on a lotus in *dhyanamudra*, the attitude of meditation. The head and fully clothed body are encircled by a nimbus and mandorla. The color range used here embraces shades of red and brown, with black for the hair, eyebrows, eyes, and garment folds.

REFERENCES
Bussagli 1963, p. 62 (ill. MIK III 9273c). Uhlig 1979, p. 66, fig. 66 (MIK III 9273f).

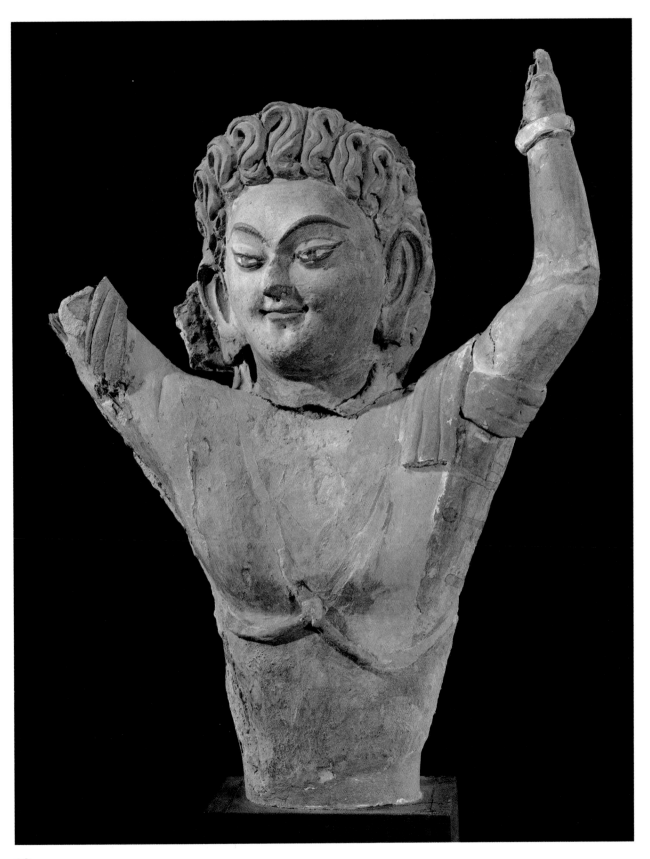

80

80 Half-Figure of a Male Deity

Yarkhoto, 8th–9th century
Clay, H. 49.5 cm.
MIK III 7621

If the religious art of Turfan is mainly exemplified by paintings, it also led to a huge number of sculptures in various materials, chiefly clay. As in the Kucha region, here too the clay was kneaded with chopped straw and animal hair; figures were sometimes mold-made, sometimes modeled by hand.

This half-figure of a male deity is painted blue and is of rather unusual design. The arms are raised, apparently as an expression of surprise; the right arm has been broken off at the elbow, and the fingers are missing from the left hand. The scarf wound round the upper arms originally came down to the chest, which is decorated with crossed bands. The only articles of jewelry are the remains of a snug-fitting chain round the neck and a bracelet on the wrist. The god has a friendly smile on his face, enhanced by his round cheeks. His red hair is dressed high in front in a stylized S-pattern; behind the ears it reaches down to the neck.

With his blue body and red hair the figure is often taken to represent a demon; but he has neither fangs, almost a sine qua non for a demon, nor pointed ears. Missing, too, are the prominent eyes that are frequently a characteristic of demons.

REFERENCES
Le Coq 1922–26, I, pl. 34b, p. 27. Indische Kunst 1971, no. 384, pl. 53; 1976, no. 384, fig. p. 213. Indische Kunst 1980, no. 47.

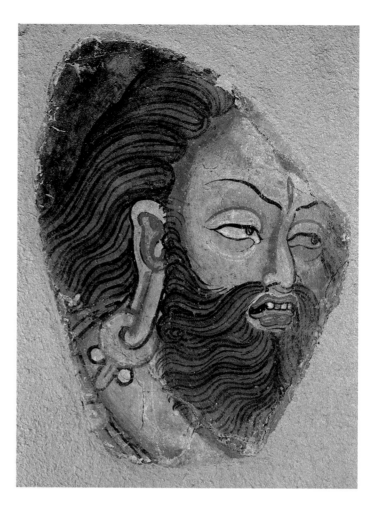

81 Head of a Brahman

Bezeklik, Temple 9, 7th–8th century
Wall painting, 20.0 × 15.5 cm.
MIK III 6756

Among the most important excavation sites in the Turfan region are the temples of Bezeklik (in Eastern Turkish, "place where there are paintings and ornaments"), situated to the south of the village of Murtuk. They are reached by following the gorge of Sengim northward as far as the point where the Murtuk brook flows into the Sengim River. The high cliffs on the right bank have to be climbed in order to find a narrow, winding path that leads along the cliff top to the great monastic complexes of Bezeklik. They cannot be seen from the path until the visitor is on top of them, for the monks endeavored, here as everywhere else, to build their temples and settlements as far away as possible from the profane world. The path opens out and

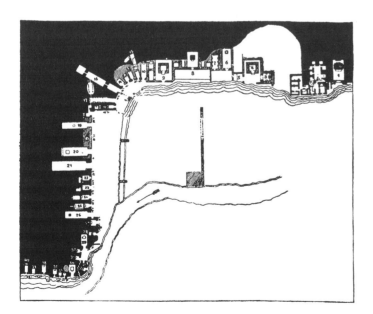

Fig. M Sketch map of the temples at Bezeklik (after Grünwedel)

ends in a wide flat area; here there is a terrace cut into the bank where it forms a horseshoe bend, about ten yards above the bed of the stream (Fig. M).

Altogether several hundred temples have been preserved. The majority were built in the open and were originally joined together by means of wooden porches; there are also cave temples hewn in the rock. A whole row of temples was completely buried in the sand or covered by loess dust; as was to be expected, they yielded many well-preserved relics of early cultures. Other temples, used as temporary accommodation by the goatherds who tended their animals there in the summer, were damaged and black with soot from their campfires.

This head of a brahman was found in the rubble of Temple 9, the source of many of the most important and interesting murals—the very large Pranidhi scenes. The brahman seems agitated, as if taking part in a discussion. His long strands of hair, apparently wind-blown, the thick beard, and the slightly opened mouth in which a few teeth are visible, all strengthen the impression of a heated argument.

This fragment, unlike most of the other paintings found at the site, shows the influence of the Indian school.

REFERENCE
Le Coq 1913, pl. 39d.

82 Demon with a Lamp

Bezeklik, Temple 9, 9th century
Wall painting, 64.2 × 25.7 cm.
MIK III 6875

From the porch of Temple 9 two stuccoed steps led to the cella. The door reveals were once adorned with paintings, but so many had crumbled off at the left-hand pillar that only the remains of a life-size female deity, probably the goddess Hariti, could still be made out. The right-hand pillar bore the outline of a male figure in armor, no doubt meant to represent the god Kubera. To his right knelt this demon as lamp bearer, holding aloft in both hands a tray with a small vessel that contains two burning wicks. The demon's round, pudgy face has been given a grotesque expression with the help of prominent, wide-open eyes, unnatural eyebrows, and fangs. His hair is styled like a cap, reminiscent of the Buddha coiffure, but here we find a decorative ribbon with feathers in front. He is ornately dressed over a plain undergarment.

REFERENCES
Le Coq 1913, p. 15. Bussagli 1963, pp. 102 (ill.), 104. Härtel & Auboyer 1971, fig. 246, p. 268. Indische Kunst 1971, 1976, no. 254.

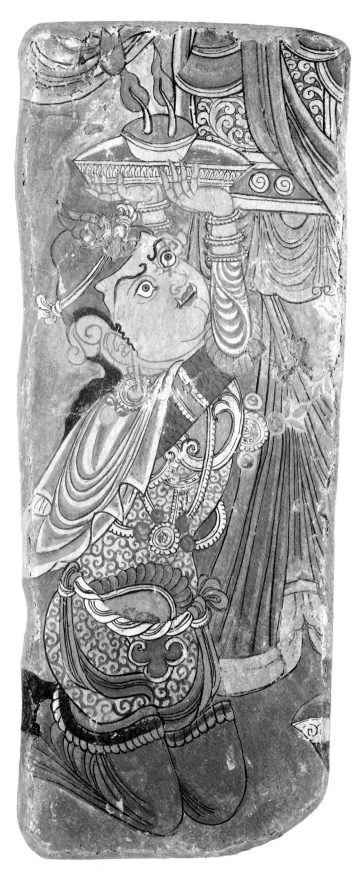

147

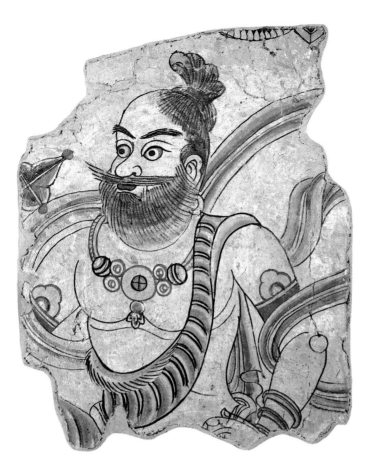

83 A Brahman

Bezeklik, Temple 9, 9th century
Wall painting, 65.0 × 52.0 cm.
MIK III 6891

The annex of Temple 9 is entered from the porch through a doorway over six feet high. Two brahmans and sixteen female demons riding various animals were painted on its walls. One of the brahmans—or at least a fragment of him—was brought back to Berlin.

Notwithstanding its lack of subtlety, this is an amusing and lively portrayal. The hair is tied up in the ascetic style; the exaggerated mustache and beard heighten the grotesque effect. The eyes are like those of demonic figures. A band of tiger skin crosses the upper part of the brahman's body, while ends of a scarf flutter behind him. Above his right shoulder we see the point of a vajra, which was probably held in his right hand; the symbol in this case does not identify its bearer as Vajrapani.

REFERENCES
Le Coq 1913, pp. 16, 17. Indische Kunst 1971, 1976, no. 526.

84 Dragon in a Lake

Bezeklik, Temple 19, 9th century
Wall painting, 66.0 × 56.0 cm.
MIK III 8383

The hall of worship designated Temple 19 in Bezeklik is a cave temple hewn in the rock, which has a barrel vault with an arched window over the entrance door. The pedestal of the cult image is situated further forward than usual, so that the space behind it is almost as large as the cella in front.

This mural is part of a larger scene on the right-hand wall of the pedestal, of which we have no description or visible evidence in its entirety. Stylized mountains, their valleys wooded with various kinds of trees, encircle a lake from which is emerging a two-horned dragon with slender wings. In view are the monster's forequarters, its claws, and its head and neck with a white mane. Anger is visible in the eyes, and its jaws are wide open. In a valley in the foreground the head and neck of a gazelle can be seen.

The legend to which this painting refers cannot be positively identified.

REFERENCES
Le Coq 1922–26, III, pl. 22, pp. 49f. Bussagli 1963, pp. 104, 109 (ill.). Indische Kunst 1971, 1976, no. 537.

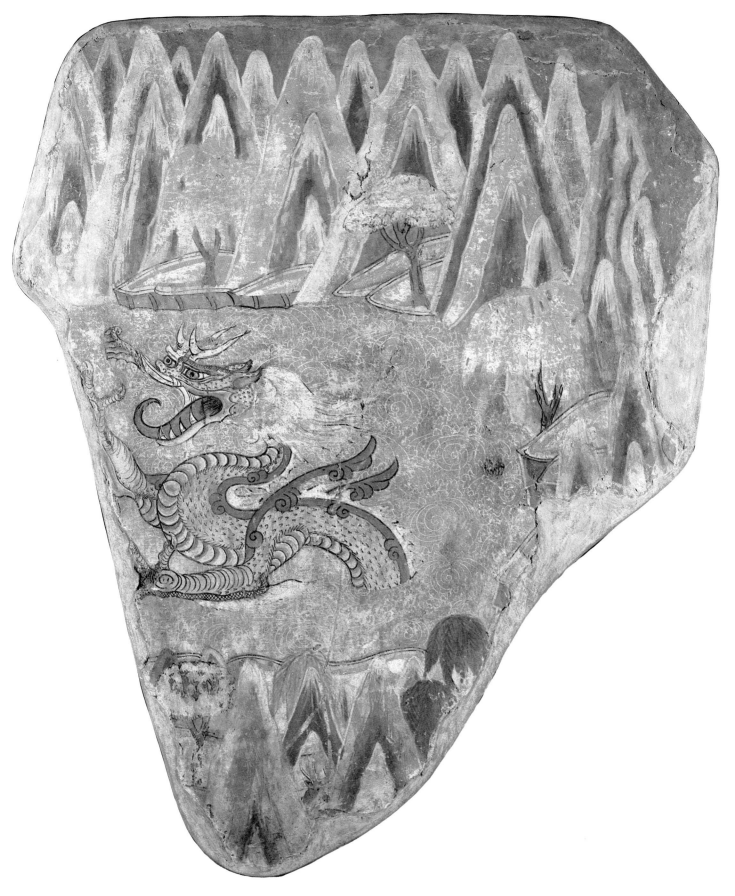

149

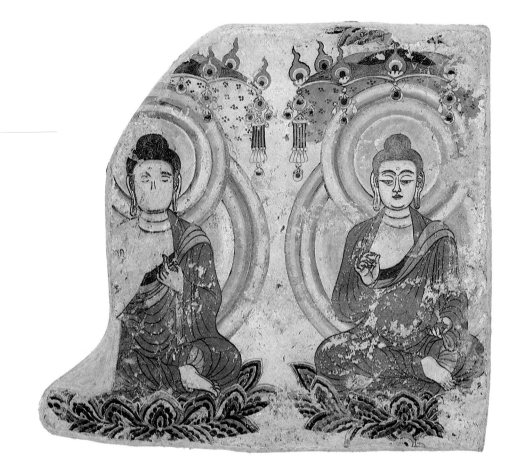

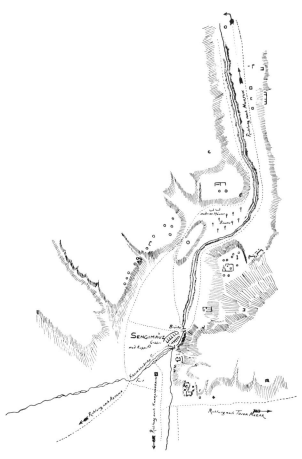

Fig. N Sketch map of the temples at Sengim (after Grünwedel)

85 Seated Buddhas

Bezeklik, Temple 19, 9th century
Wall painting, 67.0 × 72.0 cm.
MIK III 8382

This fragment of a row of almost identical Buddhas is from the corners of the pedestal of Temple 19. Two Buddhas, alike apart from the position of their hands, are sitting with legs crossed on large stylized lotus blossoms under canopies hung with bells and studded with precious stones. The figure on the left has his left hand (and probably also his right hand, now badly damaged) raised in the gesture of teaching; the second Buddha has his right hand raised in the teaching gesture, while his left holds one end of his garment. The nimbuses and the mandorlas round the bodies lend warmth to the picture by their harmonious gradations of color. The East Asian character of this painting, in the Buddhist Chinese Style, is very evident.

REFERENCES
Le Coq 1922–26, III, pl. 21, p. 49. Härtel & Auboyer 1971, fig. 250, p. 269. Indische Kunst 1971, 1976, no. 539. Rowland 1974, pp. 179f, 186, 187 (ill.).

86 Deity Offering Flowers

Sengim, 9th century
Wall painting, 19.0 × 15.0 cm.
MIK III 6761

About three miles north of Khocho, where the Ka-
rakhoja River issues from a narrow gorge (called in
Turkish *agiz*, or the mouth), lie the temple complexes
of Sengim (Fig. N).

It is a dark, mysterious gorge with steep hills, raising their
threatening heights along the western bank of the stream,
and with frequent torrents of stones and avalanches of mud,
during the melting of the mountain snow, crashing down
upon its narrow paths. In spite of the forbidding character
of the landscape, the left or western side of the ravine is
studded with a line of temples, whilst the heights on the
right are occupied by many Indian relic memorials (*stupas*),
some of which rise on the very edge of the stream. (Le Coq
1926; trans. 1928, p. 83)

This small deity was found in the ruins of the terrace
of Southern Temple 10. The two-dimensional face
appears to be without expression. The hair is tied at
the back of the head in an artistic bow; a jaunty little
hat decorated with flowers is perched on the front of
the head. A scarf flutters around the robe, which is
crossed over in front. In the deity's hands is a bowl
of flowers.

REFERENCE
Le Coq 1913, pl. 39h.

following pages

87 Head of a Demon

Sengim, Small Stupa, 8th–9th century
Clay, H. 30.3 cm.
MIK III 8560

Scenes with demons are common in the art of Central
Asia, especially in connection with the attack of Mara,
the Buddhist Tempter, and his horde against the Bo-
dhisattva. Yet what we see here is apparently not so
much a fearsome spirit as a comic mask, like the ones
still found in the Himalayan lands today.

A broad cap in the form of a helmet comes down
low over the head. The protruding eyeballs below the
brows, whose delineation is anything but menacing,
the broad nose, and the large, expressive mouth give
the face a humorous air. The mask effect is heightened
by the generous application of paint.

REFERENCE
Le Coq 1913, pl. 55c.

88 Blue Demon

Sengim, 8th–9th century
Clay, H. 21.7 cm.
MIK III 8541

This very expressive demon's face gains its fearsome
aspect from the protruding eyeballs, peering to the
side from under bushy, twirled eyebrows, the large,
vertical, third eye on the forehead, and the fangs in
the open mouth.

REFERENCE
Le Coq 1913, pl. 55o.

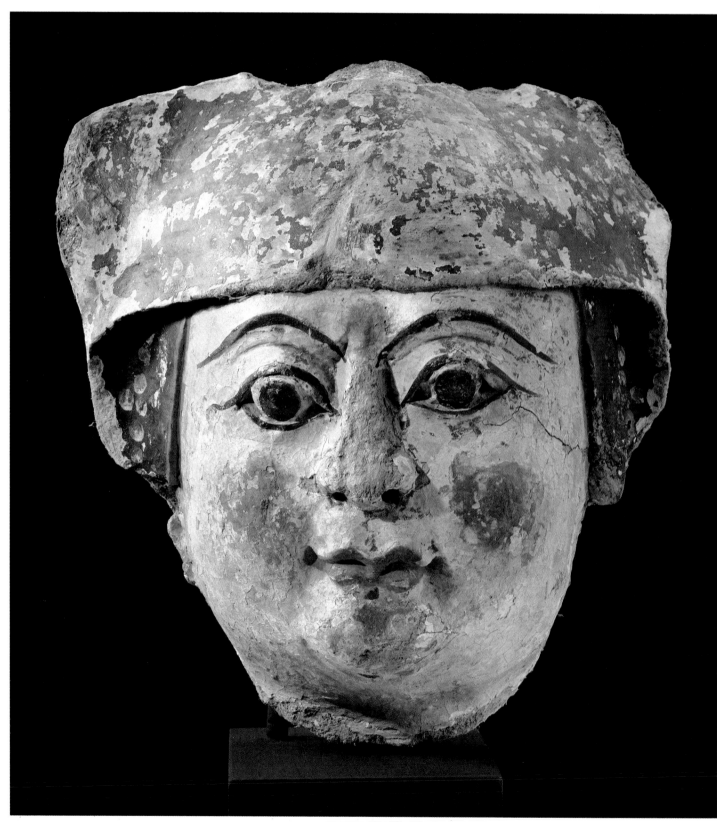

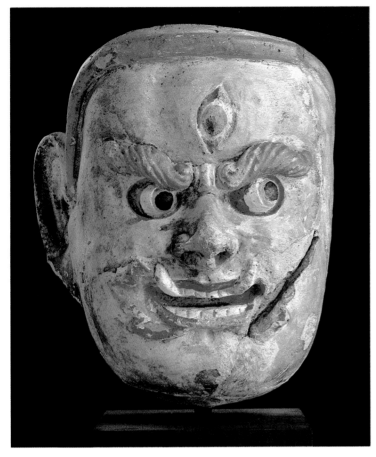

89 Half-Figure of a Deity

Chikkan Kul, 9th century
Clay, H. 34.5 cm.
MIK III 8538

Near Murtuk, between the village of Bezeklik and the uppermost part of the Sengim gorge, to the west of the mountain ridge, is another settlement, by the name of Chikkan Kul. It consists of a number of caves in a gorge near a large lake. Buddhist ruins have been found on the shores of the lake and on an island lying in shallow water. Discovered in the caves, besides a few badly damaged wall paintings, were some very fine heads from clay statues.

This rather paunchy half-figure has Chinese features. The eyes are narrow, the eyebrows and nose straight; the mouth, originally painted a bright red, is small. Traces of a green mustache and a vertical green furrow in the chin are to be seen. There are also traces of green paint on the only remaining arm, which hangs at the figure's right side. The hair, bound by a decorative fillet, is arranged in stylized waves on the forehead and temples. The only ornament worn by the deity was a string of beads, two of which have survived at the neckline on the right.

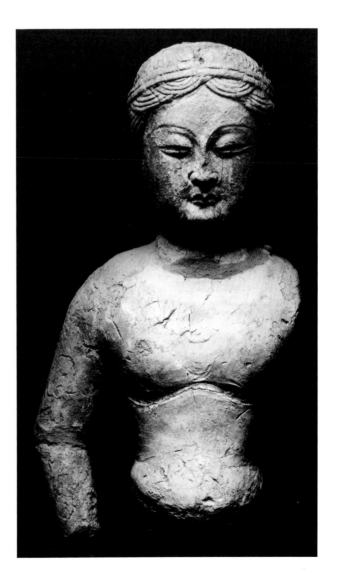

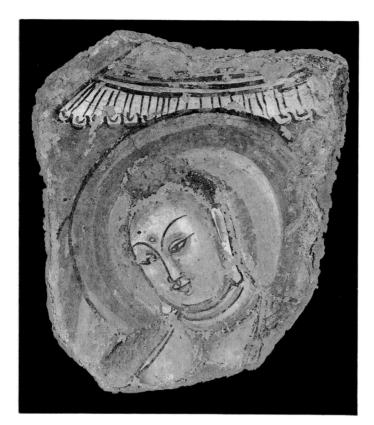

90 Buddha Under a Canopy

Khocho, 7th century
Wall painting, 23.5 × 21.0 cm.
MIK III 8731

Although its geographical position made the Turfan region more susceptible to cultural trends from the East than from the West, there is evidence here too of the activity of Indo-Iranian artists. True, there are no examples in Khocho of the earliest wall paintings, but this fragment can definitely be classified as in the second Indo-Iranian style.

This beautiful head of a Buddha, inclined slightly toward the left, is surrounded by an oval nimbus and surmounted by a canopy of rather unusual design. Despite the pronounced relief effect created by broad patches of shading, the physiognomy is more reminiscent of that of the Buddha on the dragon-boat from the Cave of the Musicians in Kizil (No. 23) than of Chinese antecedents.

REFERENCES
Bussagli 1963, pp. 96, 97 (ill.), 101. Uhlig 1979, fig. 61, p. 131.

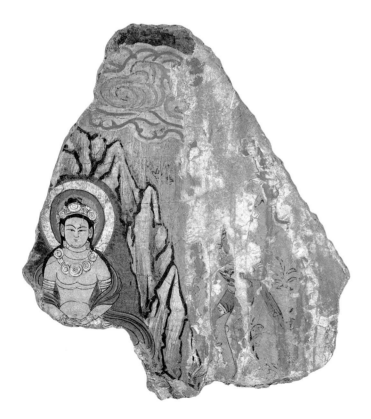

91 A Bodhisattva in a Mountain Cave

Khocho, 8th century
Wall painting, 25.0 × 22.0 cm.
MIK III 4466

Where precisely this miniaturelike painting was found is not known. The scene is in the mountains, with thick clouds overhead. The small form of a bodhisattva sits meditating in a cave. A large nimbus surrounds his head, on which he wears a diadem mounted with small disks. A similar necklace rests on the chest; the upper arms and wrists are adorned with bangles. A scarf is realistically draped around his shoulders, its ends flowing over his upper arms down to the ground. A brahman approaches the cave from the right.

92 The Great Departure

Khocho, Ruin β, 8th century
Wall painting, 47.0 × 26.5 cm.
MIK III 4426

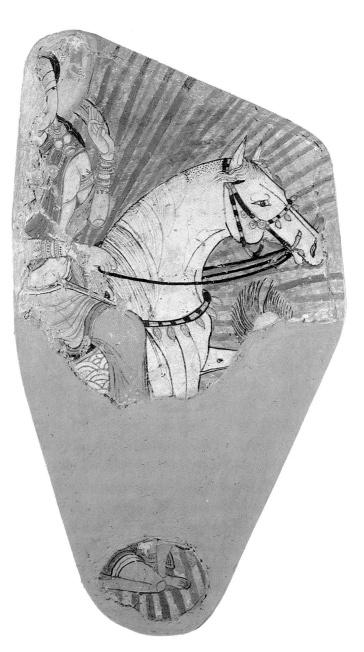

This fragment was found in the rubble of the northern passage of Ruin β in Khocho. Its original location was at first a mystery, until Grünwedel found the answer on a visit to Sengim. There he discovered a painted dome, with a central rosette at the apex depicting just such a scene (Fig. o). The radial stripes in this fragment prove that it must have come from a corresponding location. The reduced dimensions suggest that it belonged to the dome of the porch of Ruin β.

Behind the scene depicted here is the legend of Prince Siddhartha. Although his father sought to interest him in worldly pleasures and keep him oblivious of suffering, it came to pass that while riding out on four occasions he met an old man, a sick man, a dead man, and a monk. These experiences convinced him of the transitory nature of all forms of life and led him to renounce the world. At the age of twenty-nine he left his father's palace, and his wife and son, secretly in the middle of the night.

Fig. o Reconstruction drawing of the dome of Temple 6, Sengim, showing the Great Departure (after Grünwedel)

Here the Bodhisattva Siddhartha, partly visible on the left, rides his favorite horse Kanthaka "away from home to homelessness." He was assisted in his clandestine flight, the legend tells us, by gods and demigods. To avoid any noise demigods held the horse's hooves. In the mural the forehead and bristling hair of one such being can be seen below the horse's head. At the bottom there is a fragment of the figure of another demigod.

REFERENCES
Grünwedel 1906, pp. 94f. Le Coq & Waldschmidt 1928–33, VII, pl. 32a, pp. 66f. Bussagli 1963, p. 26 (ill.). Indische Kunst 1971, no. 536; 1976, no. 536, fig. p. 224. Rowland 1974, pp. 180, 188, (ill.).

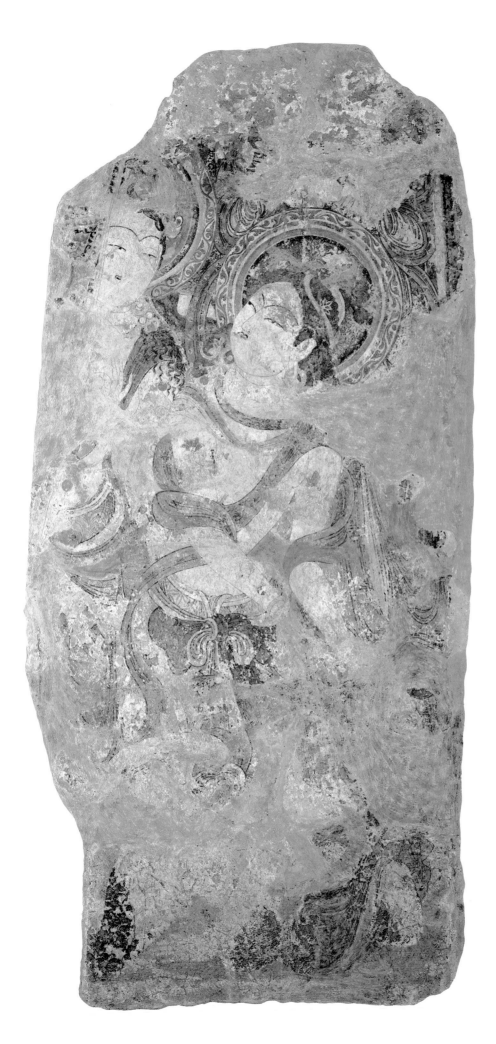

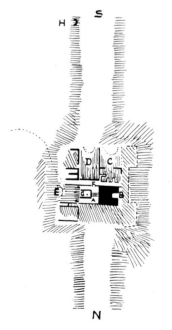

Fig. ᴘ Plan of Temple α, Khocho
(after Grünwedel)

93 Part of a Pranidhi Scene

Khocho, Temple α, 9th century
Wall painting, 179.0 × 86.0 cm.
MIK III 4458b

In the southwest of Khocho, in the high wall of what could be called the inner encirclement, lies a ruin which Grünwedel designated Temple α (Fig. P). The complex consisted of several rooms, the finest murals being located in room A with cella G. The interior walls of the room and the exterior walls of the passage were once covered with paintings; some walls have caved in, on others the murals have been damaged beyond recognition. But enough has survived to show that these must have been Pranidhi scenes. Pranidhi refers to certain genres of Bodhisattva legend in which in a previous incarnation the Bodhisattva—later to become the Buddha Shakyamuni—encounters the Buddha of the corresponding epoch, venerates him, and expresses the wish (*pranidhana*) to become a Buddha himself.

This fragment is part of such a scene. The paintings, conventionally composed, show a large Buddha standing in the center, surrounded by smaller bodhisattvas standing or kneeling. Of the two deities depicted, the one on the left seems to be explaining something to the one on the right, who listens with interest. His left hand is lifted in a gesture of animated discussion. The heads of both figures are surrounded by nimbuses with scroll-patterned borders. Their hair, in part tied up on top of the head, in part falling down in curls onto the shoulders, is threaded with chains and decked with flowers. Both figures are laden with sumptuous jewelry. The figure on the left has a scarf draped around his naked chest; the one on the right also wears a scarf over his shoulders fastened with a brooch. The lower part of both bodies is wrapped in garments which are tied in bows.

REFERENCE
Grünwedel 1906, pl. VII, p. 65.

94 Vajrapani

Khocho, Temple α, 9th century
Wall painting, 80.0 × 49.5 cm.
MIK III 4459a,b

This fragment of a painting was recovered from the rubble in the side passage to the north of the cella. It is also part of a Pranidhi scene. As it lay at the inner corner of the external wall, we may assume that the various series of pictures that extended along the walls ended at each corner with a figure like this.

Depicted is a Vajrapani with an angry look on his face; he has long, blue, wavy hair and beard; the eyes and mouth are open wide. His left hand, which once held the vajra, has been destroyed, but parts of his armor are still visible. On the right can be seen the remains of a decorative border, which separated this picture from the one next to it.

Like all the paintings from this temple, the fragment reveals the hand of a master.

REFERENCES
Grünwedel 1906, pl. V, fig. 3, p. 64. Le Coq & Waldschmidt 1928–33, VI, pl. 29, pp. 89f.

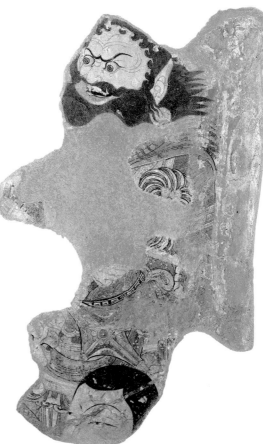

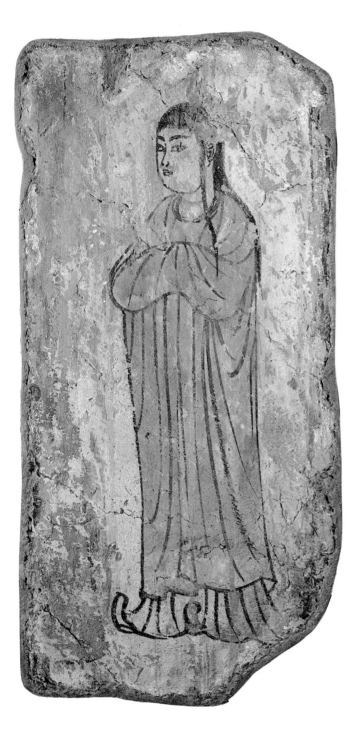

95 Contemplative Figure

Khocho, Nestorian Temple, 9th century
Wall painting, 43.5 × 21.0 cm.
MIK III 6912

Beyond the actual city limits of Khocho, northeast of
the city wall and the river, between Temple T and the
great stupa group, lie the ruins of a three-room temple
which was rebuilt several times. When first discovered,
it was thought to be devoid of any works of art; only
when some of the more recent walls had been demol-
ished did the remains of wall paintings come to light.
They were of a kind unknown in Buddhist and Man-
ichaean art (see Nos. 112–119), justifying the as-
sumption that Christianity was here the inspiration;
for, as we know, the Nestorian heresy was the third
religion to be disseminated through Central Asia. Tak-
ing its name from Nestorius, patriarch of Constanti-
nople, who was deposed by the Council of Ephesus
in 431, Nestorianism was recognized as a sect in the
Persian empire around 485, and as early as the seventh
century brought Christianity to China.

The wall painting shows a youthful figure in long,
flowing robes. The reddish brown overgarment has
wide, baggy sleeves that conceal the hands, which are
held together on the chest. The whitish undergarment
reaches to the feet, leaving only the turned-up toes of
the shoes visible. The black hair hangs down in plaits
over the back and shoulders.

REFERENCES
Le Coq 1913, pl. 7b. Bussagli 1963, pp. 111, 113 (ill.). Härtel
& Auboyer 1971, Fig. XLVI, p. 269. Indische Kunst 1971, no. 541,
pl. 60; 1976, no. 541, fig. p. 220.

96 Head of a Devata

Khocho, 7th century
Clay, H. 28.1 cm.
MIK III 4480

The Turfan region was not exclusively the province of
Chinese artists, as is shown not only by one or two
wall paintings, such as No. 90, but also by a few sculp-
tures. This head of a devata with its regular features
is evidence of Indo-Iranian artists at work in Khocho.

The deity's face is in low relief. Below the elegant
brows the half-open eyes, revealing the irises, have a
dreamy look. The high forehead has a shallow incision
between the eyebrows. On each side of the center
parting, the hair is dressed in an elaborate design
similar to the motifs of a floral border, while the rest
of the hair is swept up in tresses that disappear under
a lozenge-patterned chaplet.

REFERENCE
Grünwedel 1906, pl. 1, fig. 2.

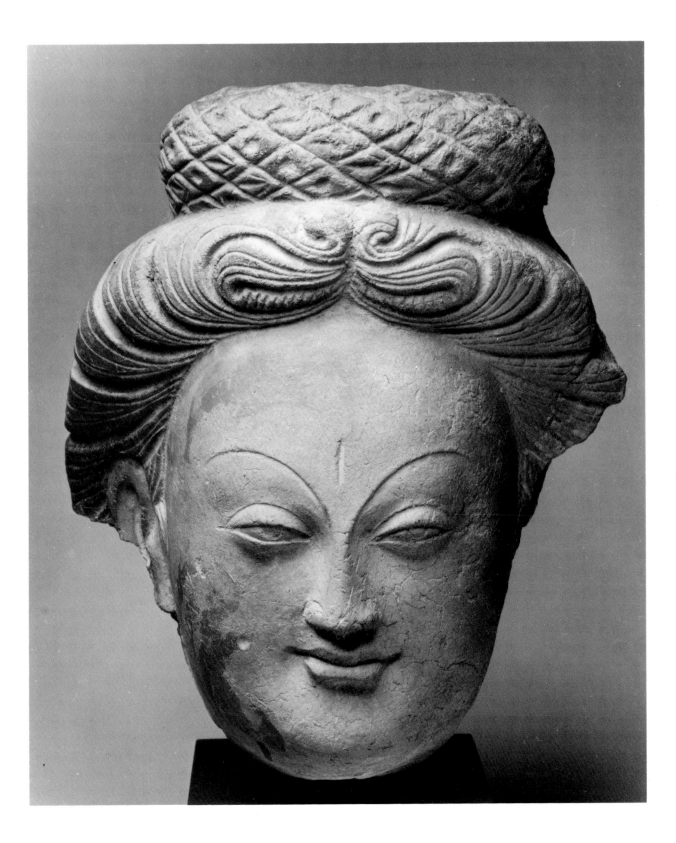

159

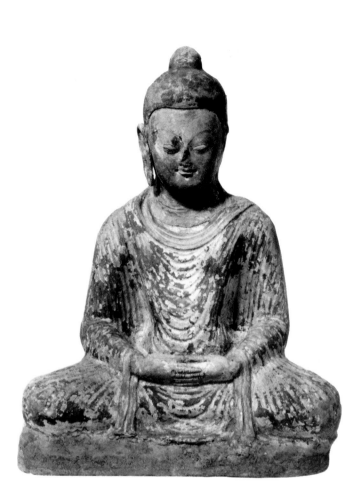

97 Seated Buddha

Khocho, Pillar Temple W, 8th century
Clay, H. 43.3 cm.
MIK III 4516

A type of architecture often found in the Turfan region especially is the so-called pillar or stupa temple in tower form. It is built up of several square plinth-type tiers one on top of the other, and was probably originally topped by a stupa dome. Varying numbers of niches for Buddha images were let into these tiers.

This clay figure of a Buddha comes from one such niche. The Buddha sits in the attitude of meditation on a flat pedestal. His head is bowed in contemplation, the eyes are closed. The broad face with its high, arched brows, the heavy eyelids, and the small but expressive mouth help to classify the figure in the Buddhist Chinese style. His blue hair is modeled as a flat surface without any details, and is tied up in a comparatively small bun. His overgarment, covering both shoulders, is gold with green edges at the neck and wrists. The curves of the Buddha's body can be seen despite the folds of his clothing.

REFERENCES
Grünwedel 1906, pl. 4, fig 1, pp. 46f. Uhlig 1979, fig. 63, p. 131.

98 Male Head

Khocho, Temple α, 8th–9th century
Clay, H. 25.5 cm.
MIK III 4528

This is one of many heads of statues found in passage E of Temple α in Khocho (see Fig. P). The man's physiognomy is characterized by unusually large, prominent eyes with black irises, strikingly arched eyebrows, a strong nose, and a small mouth. The wavy mustache is almost comical; the grotesque effect is heightened by the blue beard, composed of individual tufts of hair and parted down the middle, which acts as a frame for the chin and the cheeks. The hair, which retains traces of red and blue paint, is combed tightly toward the back of the head; the strands are indicated by notches of varying depth. The head is crowned by a great bird (of which only the body remains), seated on a beaded circlet; the bird's feathers are suggested by incisions in the shape of scales. Headdresses of this sort were by virtue of their components characteristic of warriors; thus we sometimes find Vajrapani, a frequent subject in the Western-influenced Kucha region, wearing feathers in his headdress (No. 10). In Chinese art of the T'ang period, however, bird hats or helmets are also found, especially among military officials.

REFERENCE
Grünwedel 1906, pl. 13, fig. 2, p. 63.

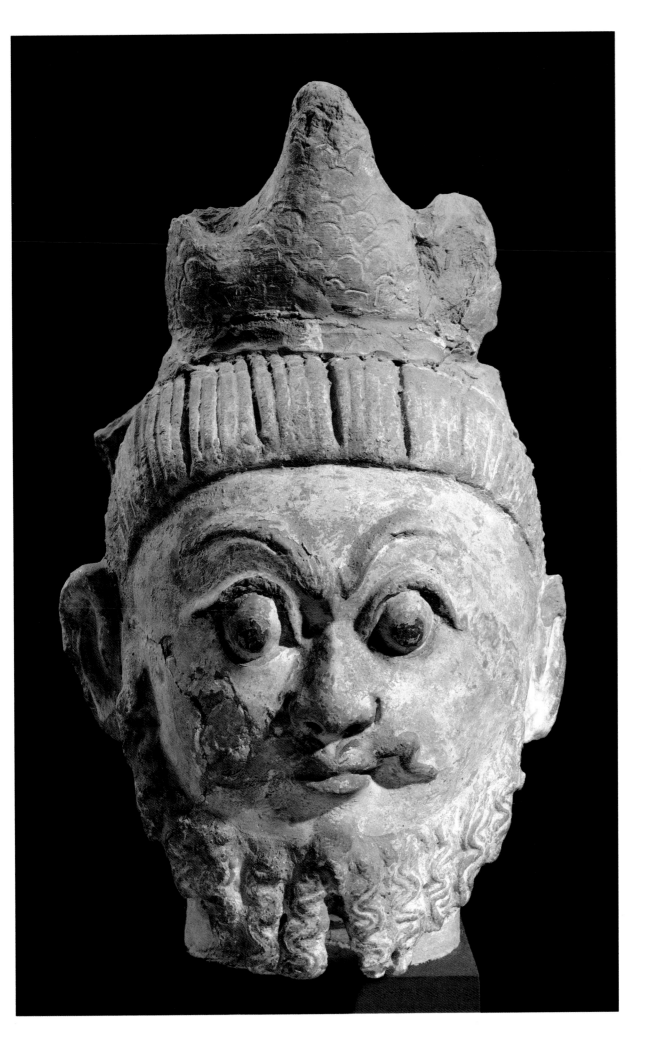

99 Head of a Demon

Khocho, Temple α, 8th–9th century
Clay, H. 21.4 cm.
MIK III 4527

This head, with its pink-primed face, has many features that identify it as that of a demon. The eyes have a green iris and protrude from underneath thick, brownish, high-arched brows. The nose, comparatively short, is flared at the sides; below it is a wavy brown-and-black mustache. The open mouth, with its curling lower lip, reveals four ordinary teeth and two fangs in the corners of the upper jaw. The curious beard is composed of two thick, separate locks of hair. Above the two V-shaped furrows in the forehead is a shock of red hair, combed back in strands.

REFERENCE
Grünwedel 1906, pl. 13, fig. 1, p. 63.

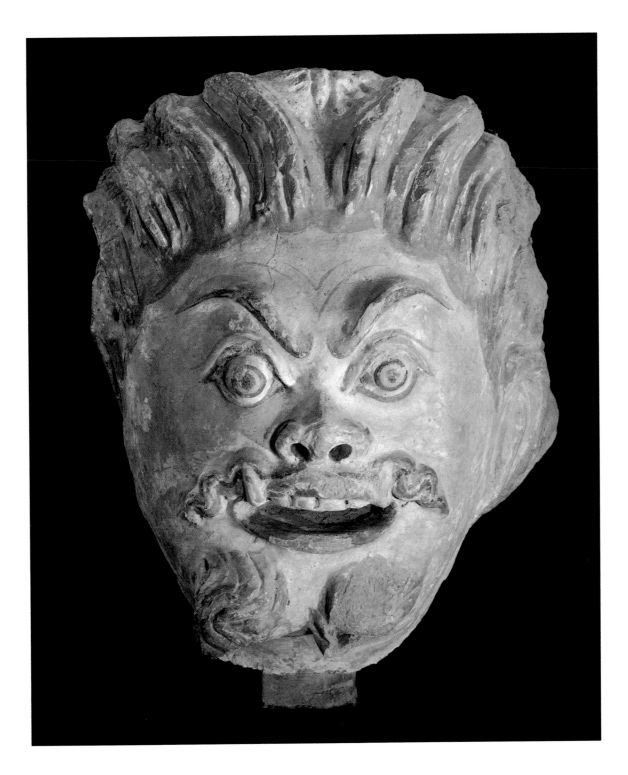

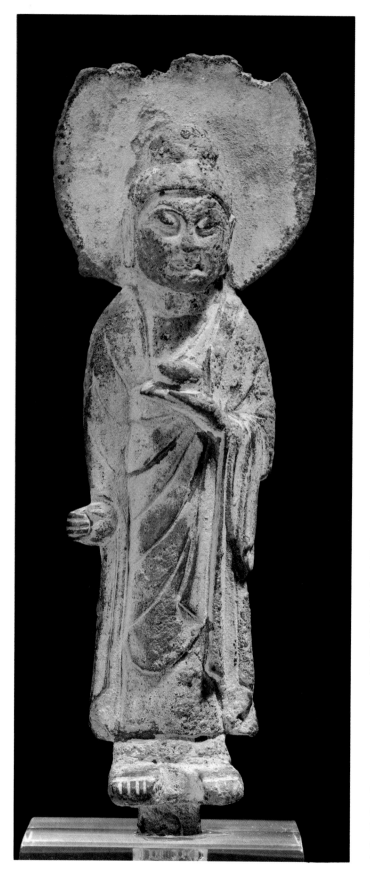

100 The Healing Buddha Bhaishajyaguru

Khocho, 6th–7th century
Bronze, H. 9.5 cm.
MIK III 6125

Representations of the Healing Buddha were very popular, especially where the culture of East Asia was predominant. The head with its Chinese features is encircled by a large nimbus; the hair is tied up in a broad knot. The Buddha is wearing an undergarment, a robe, and a covering shawl. His right hand is turned outward at hip level, his left hand holds a medicine bowl in front of his chest.

There is a tenon under the feet by which the figure can be attached to a base. The back is not modeled. The bronze has a green patina.

The folds of the robe and the slightly forward position of the head suggest that this statuette was modeled on prototypes created during the Chinese Sui dynasty (589–618).

REFERENCES
Le Coq 1913, pl. 58i. Indische Kunst 1971, 1976, no. 478.

101 The Bodhisattva Avalokiteshvara

Probably Khocho, 7th–8th century
Bronze, H. 8.8 cm.
MIK III 539

During the T'ang period the popularity of the bodhisattva Avalokiteshvara increased enormously and no other Buddhist deity was the subject of so many works of art. This small, entirely gilded statuette is very similar in style to No. 102. Avalokiteshvara stands in a graceful pose on a stepped lotus pedestal, the lotus in his right hand, the flask in his left. Ribbons fall from his multipointed crown almost to the ankles, meeting the robe before they turn out to end in a point.

102 The Bodhisattva Avalokiteshvara

Khocho, 7th–8th century
Bronze, H. 7.5 cm.
MIK III 6124

This small bronze is one of a series of very similar statuettes (cf. Munsterberg 1967, pl. 37, p. 61), and though the position of the hands is reversed is clearly akin to No. 101. Avalokiteshvara is standing on a lotus which is fashioned into a tenon below. In his right

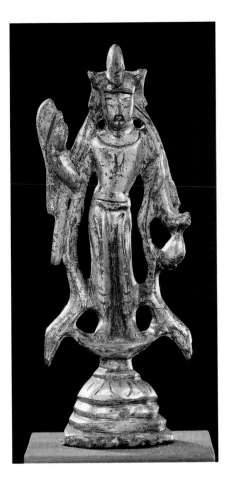

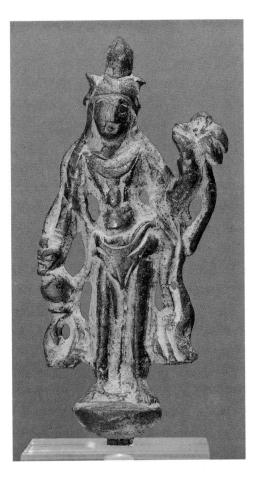

hand hanging by his side he holds the flask which is his hallmark, in his raised left hand the lotus. Ribbons fall from his crown.

REFERENCES
Le Coq 1913, pl. 58m. Indische Kunst 1971, 1976, no. 479.

103 Seated Buddha with Worshipers

Khocho, 7th–8th century
Bronze, D. 6.2 cm.
MIK III 7197

This repoussé gilt-bronze medallion depicts a seated Buddha with a worshiper at each side. His robe covers both shoulders, and his head and body are surrounded by a nimbus and mandorla. He is sitting on a lotus pedestal with hands clasped in his lap. The medallion has a beaded border with holes through which it can be attached to a support.

REFERENCE
Indische Kunst 1971, 1976, no. 471.

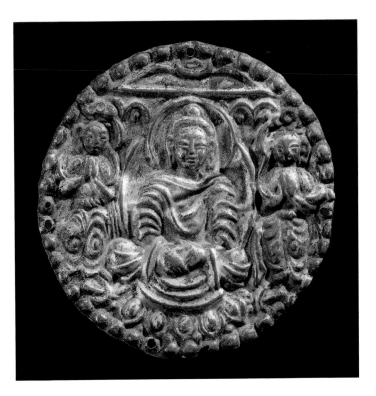

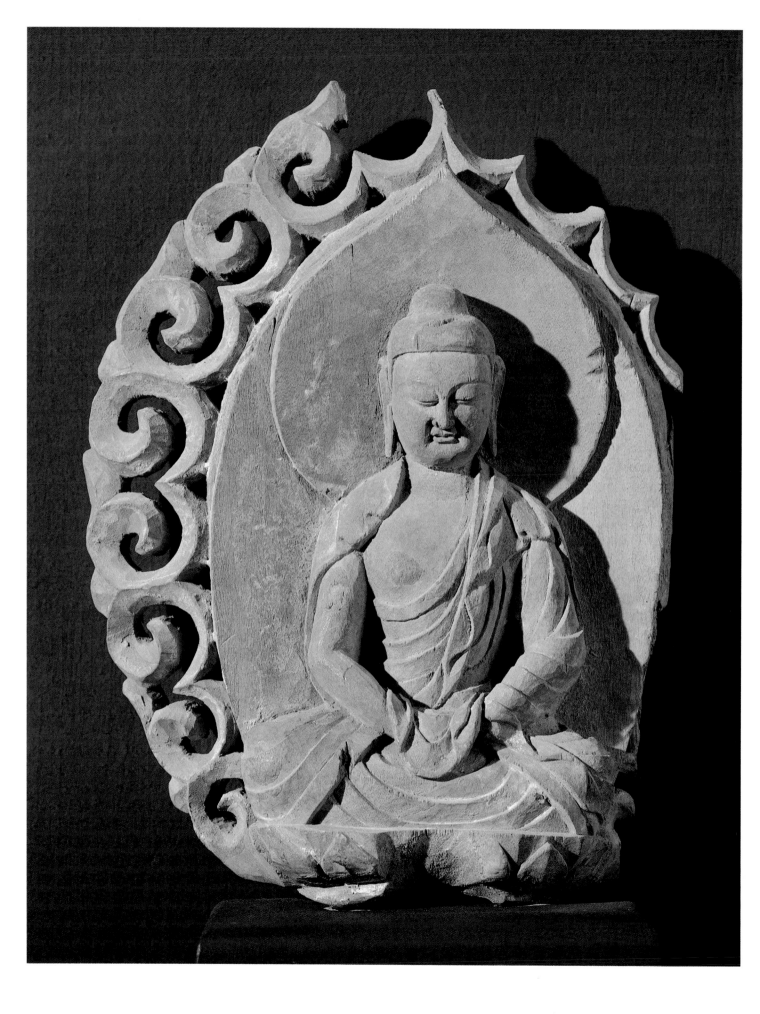

104 Seated Buddha

Khocho, 9th century
Wood, H. 15.0 cm.
MIK III 4722

The Buddha sits on a lotus pedestal before a mandorla and a nimbus in the form of a pointed leaf. His right shoulder is partly covered by a section of the shawl. The broad, fleshy face has East Asian features. The Buddha is in an attitude of meditation; his hands rest on his lap beneath the shawl. Around the mandorla is a border of addorsed spirals, carved from the full thickness of the wood. A sharp contrast in style is noticeable between this seated Buddha and No. 53.

It is possible that the figure comes from the crown of an Avalokiteshvara and is to be identified as the Buddha Amitabha.

REFERENCES
Härtel & Auboyer 1971, pl. 249b, p. 269. Bhattacharya 1977, pl. 32, pp. 60f.

105 Seated Arhat

Khocho, 9th century
Wood, H. 11.2 cm.
MIK III 6110

The function of this carving is easily deduced from the metal fittings on the right: it is part of a portable triptych. The bald arhat is seated on a lotus pedestal. He wears a robe that covers both shoulders. His head is encircled by a nimbus terminating in a point like a leaf. The face is round, the narrow eyes with their heavy lids are open. The arhat's right hand rests on his lap, his left holds a spherical object in front of his chest. His right leg rests on the seat, while the left foot hangs down and is supported by a small lotus.

Traces of white paint show that the figure was originally colored. The back of the niche has been left in its natural state.

REFERENCES
Le Coq 1913, pl. 57c. Bhattacharya 1977, no. 79, pp. 78f.

106 Reliquary

Toyok, Manuscript Room, 8th–9th century
Wood, H. 13.4 cm.
MIK III 6115

Southeast of Khocho, carved in the bare sides of a range of mountains, lie the extensive complexes of Toyok. One of its many caves, the site of this find, was filled with hundreds of manuscript fragments, hence the name Manuscript Room. Apparently someone once tried to destroy these manuscripts by fire, fortunately without success.

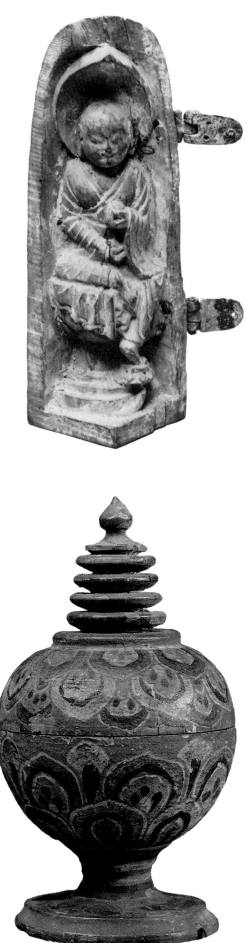

This small, lathe-turned, wooden reliquary is in two parts: the lower half is in the form of a bowl standing on a large round foot, while the upper half acts as the lid, terminating in the form of a stupa. The reliquary is primed white, painted, and lacquered. Its decoration consists of lotus leaves arranged in rows, pointing down on the lid and up on the bowl.

REFERENCES
Le Coq 1913, pl. 61d. Le Coq 1922–26, I, pl. 61d, p. 61. Indische Kunst 1971, 1976, no. 476. Bhattacharya 1977, no. 400, p. 125.

107 Group of Donors

Kizil, Cave of the Sixteen Sword-Bearers, 600–650
Wall painting, 150.5 x 208.0 cm.
MIK III 8426a,b,c

No other relics of the culture of Central Asia tell us so much about the various origins of its inhabitants in the second half of the first millennium A.D. as the portraits of donors in the murals. Here are four representatives of the race under which Kucha's art flourished. They are Tocharian knights, of undeniably Indo-European origin. With their short, reddish brown hair parted in the center, their light-colored eyes, and what looks like Iranian apparel, they form a marked contrast to the Uighurian princes of No. 108. Over their tight-fitting, Parthian-style trousers they wear splendid lapelled coats in the fashion of Sasanian nobles, differing only in color and ornamentation. Each of the four has a dagger and a sword with an unusually long hilt hanging from his belt, which is made of metal disks. Their faces are badly damaged.

Portrayals of donors were usually to be found in the caves on the walls of the side passages to the left and right of the niche for the cult image. The Cave of the Sixteen Sword-Bearers takes its name from the four donors depicted on each wall of the left- and right-hand passages.

REFERENCE
Grünwedel 1912, pp. 50, 56.

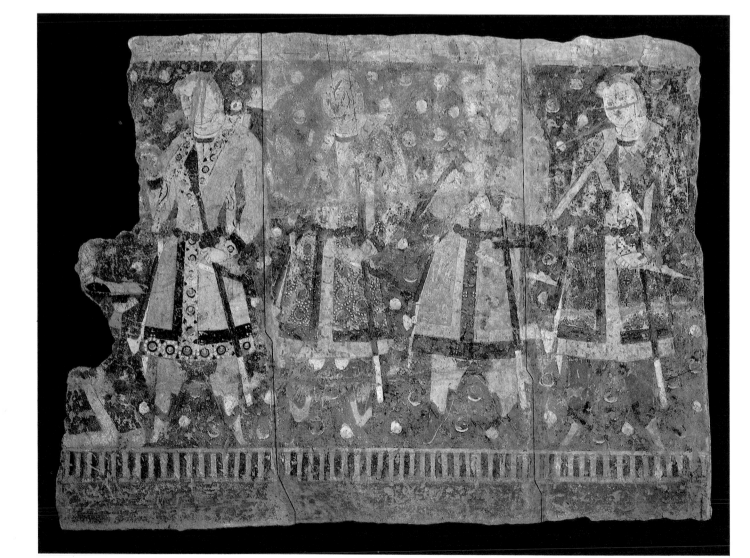

108 Uighurian Princes

Bezeklik, Temple 9, 9th century
Wall painting, 62.4 x 59.5 cm.
MIK III 6876a

The two narrow faces of the east wall of Temple 9 at Bezeklik bore pictures of princes on each side. In this well-preserved painting are portraits of three princes of East Asian aspect, who seem to be striding forward on a carpet. All three are dressed alike, in differently patterned, long red robes with a round neckline. It is difficult to make out how these are fastened; perhaps they are sewn together in the middle. Over the right leg, the side facing the spectator, the robes fall open to reveal high, dark boots. The princes hold their hands, hidden by fairly wide sleeves, above the belt, which was evidently made of plaited leather studded with metal disks. Some of its thongs hang down without any apparent function, while to other thongs or cords are attached a dagger, flint-pouch, awl, knotted kerchief, and other objects; these were perhaps meant not so much for everyday use as to denote the rank of their bearer.

The darker-skinned prince on the right precedes the other two by a couple of paces and appears to be of higher rank. All three wear high tiaras, which are fastened by ribbons under the chin. In contrast to the common people the aristocrats wore their center-parted hair in long tresses, hanging down the back and cut square at the ends. The flower that each holds seems to have been added at a later date. Anne-Marie von Gabain believes that this flower must have had a special significance: she quotes a Uighurian text translated from the Chinese, which in its many prayers for the dead expressly mentions "those who hold the flowers."

In our branch of Buddhism we venture the hypothesis that the lotus bud in the hands of worshipers denotes the hope of rebirth as an *Aupapaduka*, i.e., in Amitabha's paradise, while a different kind of flower symbolizes some other desirable reincarnation. This would explain why the Buddha does not carry a flower, as he has already attained perfection, and why his immediate followers are not distinguished by the flower symbol either—the presence of the Enlightened One assures his pupils of the best possible prospects of nirvana.... As the long-stemmed flower without hands to hold it occurs quite often in pictures, we cannot speak of an oversight on the part of the painter; such a contravention of the laws of statics must have had its significance. We believe we have found a clue in a picture from Tun-huang dating from 971: the accompanying text identifies the members of a group of worshipers as the deceased parents and several family members. The father bears a stemless flower on his hands, the mother too, though her hands are covered. The other persons, whom we may suppose to be still alive, as their death is not mentioned, have no flower. Hence our postulation that the bereaved showed their reverence for a dead relative by commissioning a portrait of him with the flower, to show that they wished him a joyous rebirth. Living persons, however, were painted without a flower. But when after the completion of a picture the person died, this symbolic flower was then added, painted in across the breast. (Gabain 1973b, text vol., pp. 165f)

There is a cartouche at the head of each prince. Only that of the foremost bears a complete inscription, in which von Le Coq has identified the name of a well-known Uighurian family. His reading is: "The Tutuq Bugra [from the house of] Sali." This family is reported to have flourished in Khocho for a long time.

REFERENCES
Le Coq 1913, pl. 30a and text. Indische Kunst 1971, 1976, no. 561. Indische Kunst 1978, p. 98.

109 Uighurian Princesses

Bezeklik, Temple 9, 9th century
Wall painting, 66.0 x 57.0 cm.
MIK III 6876b

Two Uighurian princesses with East Asian features walk solemnly toward the left over a wave-patterned carpet with borders on each side. They are wearing wide, sand-colored robes without a pronounced waistline. The V-shaped neckline is edged by a collar embroidered with red spiral lines. The fastening in the middle and the seams on the upper sleeves and the knee-line of the garments are marked with red-and-white braid, which may—as von Gabain believes—indicate the width of the material, here 35 centimeters (Gabain 1973b, p. 124). The red crosshatched material of the undergarment can be seen at the neck and wrists. The elaborate coiffure, which marks its owners as members of a privileged class, shows two wings of hair at each side fastened with ornamental pins; a magnificent crown is worn on top. From the hair at the back, a rust-red sash hangs nearly to the floor and is tied in a decorative bow at hip level. Like the princes of No. 108, each woman has been given a flower. According to von Le Coq, the inscription on the cartouche preserved next to the right-hand figure reads: "This is the picture of Her Highness Princess Joy."

REFERENCES
Le Coq 1913, pl. 30b and text. Bussagli 1963, pp. 101, 107 (ill., left figure). Indische Kunst 1971, 1976, no. 560.

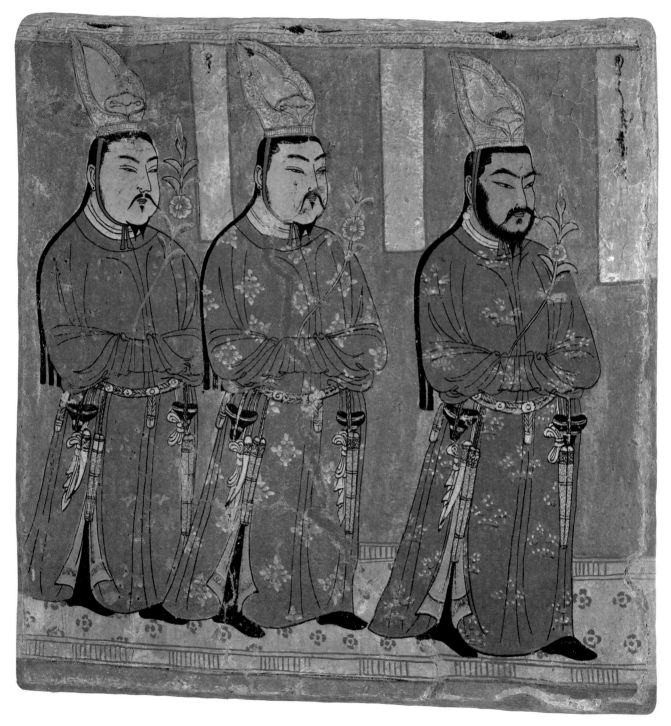

108

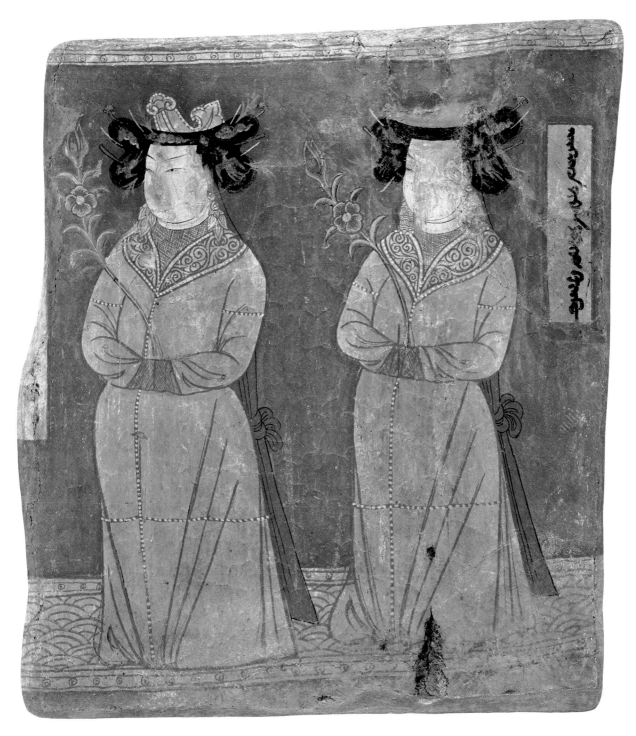

109

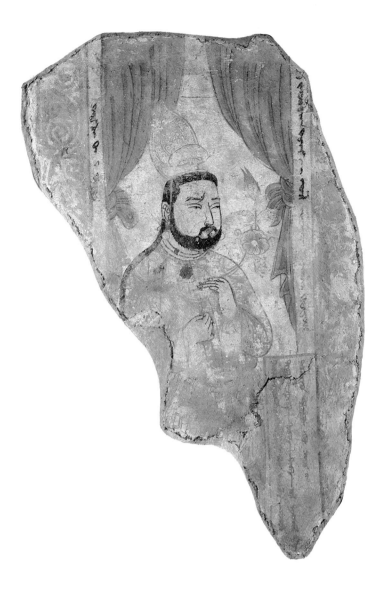

rather than covering them completely. Prince Alp Arslan ("brave lion"), whose name and title can be read on the cartouche located below the elbow, holds the stem of a flower in his hands, unlike the figures of Nos. 108 and 109; if von Gabain's hypothesis is correct, all those represented with flowers were deceased at the time.

REFERENCES
Le Coq 1922–26, III, pl. 18, pp. 46f. Bussagli 1963, pp. 101, 106 (ill.). Indische Kunst 1971, 1976, no. 555. Rowland 1974, pp. 189f, 195 (ill.).

111 Group of Donors (?)

Shorchuk, Kirin Cave, 8th–9th century
Wall painting, 48.5 x 37.8 cm.
MIK III 8378

The two walls to the right and left of Cave 7 in Shorchuk, also known as Kirin Cave, were decorated with series of what seem to be portraits of donors, of which this is probably an example. It is composed of two couples. The lined face and bent back of the first man on the left clearly reflect old age. On his head he wears an unusual, tall, black hat with a broad brim slightly turned up at the sides, which is fastened under the chin with an orange band. His long, floor-length robe is pale yellow with reddish yellow trimming on the chest. The face has obviously been painted over: the furrows in the brow, the contours of the nose, and the eyes appear twice.

Next to him on his left stands a taller woman in a short-sleeved yellow jacket; at the neckline we see the edge of an orange undergarment that covers the forearms. Her reddish white dress reaches to the floor in abundant folds and seems to be fastened in the middle. The expressionless face is white as chalk; her high coiffure is held in place by a ribbon and ornamental combs.

The next figure is again that of an old man, dressed in the same way as the first one. But on his head he wears a hat like a crown with a red kerchief hanging down behind.

The female figure on the right is identical with the other woman in every respect but her green dress.

The unconventional headgear worn by the men gives this group an unusual look.

REFERENCES
Grünwedel 1912, p. 204. Le Coq 1922–26, III, pl. 13a, pp. 40f.

110 Uighurian Prince

Bezeklik, Temple 19, 9th century
Wall painting, 57.0 x 37.5 cm.
MIK III 8381

This picture of a prince was part of the painting on the pedestal of the cult image, which had, according to Grünwedel (1912, p. 271), the sermon of Benares depicted on its front side.

The prince stands before a door or window opening, between red curtains which have been tied back on either side. He wears a long, belted robe; his head is crowned with a high tiara fastened under the chin with a red band. Unlike the princes of No. 108 he has a thick beard. Von Gabain's research indicates that young men generally went clean-shaven; only on attaining full manhood did they wear a thin mustache, slightly drooping at the sides of the mouth (Gabain 1973b, p. 117). A beard, though less common, could also be worn, as this portrait shows, framing the cheeks

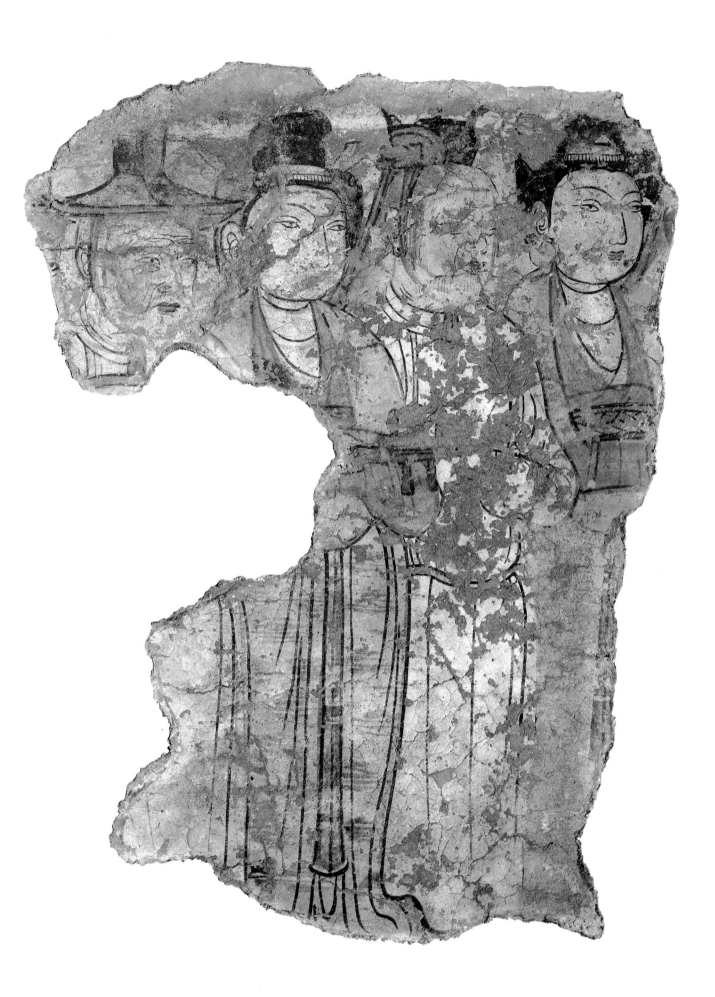

Manichaeism

UNDOUBTEDLY the most important finds in many respects made by the four German expeditions to Turfan were the manuscripts, both with and without illustrations. The many thousands of manuscripts recovered from the area, on various materials—such as palm leaf, birch bark, leather, and paper—and in many different scripts and languages, have given us significant information on religious, political, and philological aspects of eastern Central Asia. Our knowledge of Manichaeism, for example, was considerably amplified by these finds. Most of the Turfan miniatures, richly painted in gold and opaque colors, are from Manichaean books written in Middle Persian; the artists were probably Sogdians.

Mani, the founder of the religion to which he gave his name, was born in southern Babylonia in the year 527 of the Babylonian Seleucid era, that is, A.D. 216/217. On the maternal and probably also on the paternal side he was related to the Parthian dynasty of the Arsacids, which was overthrown in 226 by the Sasanian Ardashir I. Mani's father, Patek, had emigrated from Ecbatana in Media to Babylonia, settling in Ctesiphon. After hearing a voice one day that commanded him to abstain from meat, wine, and sexual intercourse, he joined a sect whose way of life corresponded to these injunctions. This was the background of Mani's early years. At the age of twelve he, too, is reported to have had his first revelation: an angel commanded him to dissociate himself from his father's religious community, although it was not until later that Mani first began to preach in public. He traveled to India and there founded his first community. We know just as little about the reasons that prompted him to leave his homeland as we do about the circumstances surrounding his return to Ctesiphon. This took place after Ardashir's death, and he first preached in public on the coronation day of Shapur I. Mani is reported to have been granted an audience with the king and even permission to proselytize the land. Under the reign of Shapur's successor, Hormizd I, Mani was able to pursue his missionary work, but when this monarch was succeeded after only one year by Bahram I, things took a turn for the worse. The Persian priests feared for their power at court and incited the king into bringing charges against Mani. He was sentenced to death and, we are told, met his end by crucifixion in Belapat in Susiana in 276; his head was displayed on a pole at the city gate. His followers were put to death, wherever they could be found; hence they fled toward the east, crossed the Oxus, and eventually reached Chinese territory. Here, in the seventh and eighth centuries, they founded small Manichaean communities. From China they set out about the middle of the eighth century to convert the Uighurians, apparently not without the express encouragement of the Chinese government, who saw in Mani's teachings a spiritual means of taming that wild Turkish race. Manichaeism also spread rapidly toward the west: in Syria it retained most of its original character, while in other parts it began to converge more and more with Christianity.

What Mani taught was a syncretism embracing many components, in the form of a philosophy of nature; it was based on Iranian dualism mingled with elements from the Buddhist and Christian creeds. For Mani saw it as his calling to give final perfection to the teachings of his "predecessors" Buddha, Zoroaster, and Jesus: he was the latest of the prophets, the Paraclete promised by Christ.

The basic premise of Manichaean doctrine is the dualism between good and evil, which expresses itself in nature as light and darkness. Manichaeism teaches deliverance from evil through recognition of this dualism and through following a rule of life derived from its recognition. The world as macrocosm and man as microcosm represent a mingling of the two principles. It is man's special duty to separate the two and render the evil principle harmless. Thus, one must avoid all that is detrimental to the light and seek to free it from the darkness with which it is mingled. If a man does this to perfection, that is, if he lives according to the ascetic principles of Manichaeism, the separation of the two principles will take place immediately after his death.

As Manichaeism was a religion of strict asceticism, forbidding its followers among other prohibitions all use of meat, wine, and sexual intercourse, it is obvious that not all could become full members. And indeed, Mani had laid down a double standard for his disciples, one of the strictest abstinence for those who wished to renounce the world totally, and the other less stringent for the lay believer. The former, known as the elect, lived in absolute seclusion from the world, and wore white ritual gowns as a distinctive dress. The latter, with less spiritual ambition or achievement, were called the auditors.

The original writings of the Manichaeans have been discovered in two widely separated areas, Egypt and the Turfan oasis. Three Iranian dialects—Persian, Parthian, and Sogdian—are represented in the Turfan texts, as well as Uighurian and Chinese.

112 Manichaean Hymnbook

Khocho, Temple α, 8th–9th century
Manuscript on paper, 9.0 x 7.5 cm.
MIK III 53

This little book of hymns contains Sogdian and Persian texts. Although only 6.6 centimeters separate the top from the bottom line, each page manages to accommodate eighteen lines of calligraphic Manichaean characters. The book is sewn in European fashion and contains forty-eight pages, with gaps between them. At the top of each page, above the body of the text enclosed between two vertical scarlet lines, figure one or more words of the title, which consists—as was customary—of a whole sentence and is divided up over several pages in sequence. These running titles are here always written in somewhat larger letters and in colored inks, usually red and blue, occasionally brown and yellow. Presumably each sentence that constituted one such title was written in the same ink; thus, if we find a page with the title in red followed by a page with the title in some other color, we may assume either that this is the beginning of a new text or that one or more pages are missing.

Hymnbooks like this must have existed in large numbers, to judge by the loose pages that are constantly being found. Yet a complete book, like this specimen, is a rarity.

REFERENCES
Le Coq 1922–26, II, pl. 4d, pp. 39f (for F. W. K. Müller's transcription and reading of the texts, see p. 40). Henning 1936, no. 10.

113 Book Cover

Khocho, Temple K, 8th–9th century
Leather, 8.5 x 10.0 cm.
MIK III 6268

This is one of the oldest leather bindings ever found; in all probability it is from a Manichaean book. The front (on the left) is a rectangular surface decorated with floral motifs punched out over a layer of gold leaf and bordered by a row of punched holes.

The middle of the back cover (right) has been lost, but appears to have been decorated with a circular pattern, perforated in similar fashion to the front; the part still intact is patterned with rectangles and diagonals.

REFERENCE
Le Coq 1922–26, II, pl. 4e (shows the binding in a more complete state), p. 40.

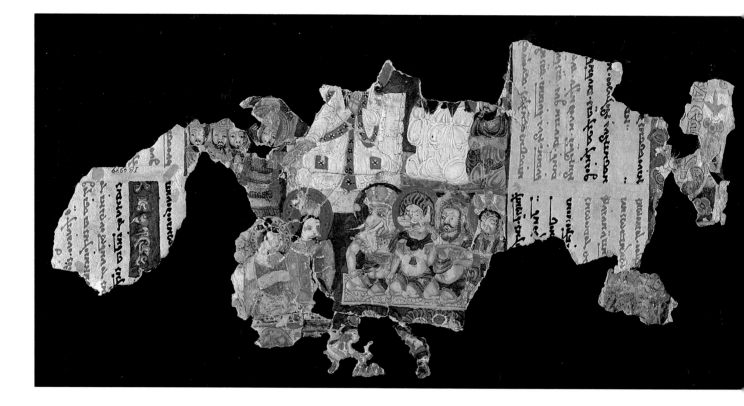

114 Leaf from a Manichaean Book

Khocho, Temple α, 8th–9th century
Manuscript painting, 12.4 x 25.5 cm.
MIK III 4979

This is the largest fragment of a Manichaean miniature in the Berlin collection and is painted on both sides.

On one side a church ceremony is depicted. In the background we see the body of the principal character (his head has been destroyed), a high-ranking Manichaean priest in full vestments. A red embroidered stole is wound round his neck, shoulders, and arms, and hangs down in front. He is sitting on a carpet with a pattern of red lozenges on a white background, and his back is supported by six white bolsters with yellow dots, over which there falls a white sash. The priest's left hand is raised, while in his right hand he grasps that of a man in full armor who kneels to his right. The kneeling man is a prince or king, perhaps even the Uighurian king in person; behind him stand three of his attendants. To the priest's left kneel two of the Manichaean elect in white robes and a layman, probably an auditor.

The eye is immediately attracted by the curious-looking group in the foreground. Here we seem to have portrayals of Hindu deities: the one with the elephant's head is undoubtedly Ganesha, the boar's head possibly represents Vishnu as Varaha, the third could be Brahma, and the one on the extreme right Shiva (see Banerjee 1970 and Klimkeit 1980). Facing them on the left are two Iranian-Manichaean gods. Below these can be seen part of a red disk, possibly a nimbus. Below the Hindu deities the page has been badly torn; fragments of flowers and ducks can still be made out.

The miniature on the other side depicts a religious celebration, the famous feast of Bema. Commemorating the martyrdom of Mani, it was celebrated every year, probably in the spring, for St. Augustine (who was himself at one time a Manichaean) tells us that Mani died in March 276. A podium was erected for

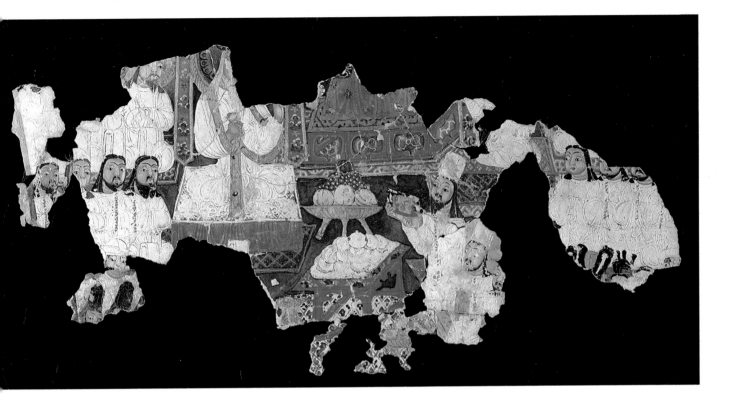

the liturgical rites, with five steps leading up to it; it was draped with sumptuous tapestries. The celebration fell into two parts: first, on the eve the faithful fasted in preparation and kept a vigil during the night in remembrance of Mani's death; then came the feast day itself.

In the center of the miniature is a red dais standing on a blue carpet with a white pattern; there is no trace of the five steps. Directly in front of the dais stands a three-legged golden bowl containing fruit: watermelons, grapes, and honeydew melons. Further forward, on a patterned white carpet, stands a red table with a floral pattern on top, bearing loaves of wheat bread in the shape of the sun (disk) and moon (crescent).

The priest kneeling in the background to the left of the table looks very like the one on the other side of the leaf. His stole, however, is of gold brocade. On his right kneel four rows of different ranks of the elect: those in the second row from the top have their names written on their white robes. The persons in the bottom row are rather unusual and may represent the auditors in their festal attire: they are smaller than the others in size and wear high, conical, black hats; part of the leaf, now missing, showed them in white robes with gold belts.

Two figures dressed in white kneel before the table on the right; behind are several more rows of the elect, some of them again with their names on their garments.

REFERENCES

Le Coq 1922–26, II, pls. 8ᵃ,a and 8ᵇ,a, pp. 49ff (for transcriptions of the texts see pp. 53 and 55f). Bussagli 1963, p. 3 (ill. detail).

115 Leaf from a Manichaean Book

Khocho, Temple K, 8th–9th century
Manuscript painting, 17.2 x 11.2 cm.
MIK III 6368

On one side of the leaf, the illumination is in two parts separated by a narrow band of script in the middle. On each side there are two rows, one above the other, of Manichaean priests in white robes and tall white hats. They all have smooth black hair that covers the ears and reaches down to the shoulders; their beards, however, vary in style. Each priest kneels at a low desk draped with colored material; each has a sheet of white paper in front of him; some are holding pens.

In the background two flowering trees grow up on either side; in one of them sits a golden bird. Two large bunches of red grapes hang down as far as the band of script.

The entire miniature is painted on a blue ground.

On the other side of the leaf is a different layout.

Here the writing is divided into two blocks one above the other, red above and black below; a narrow strip delineated by two red lines separates the columns.

At the left, framed by two splendid decorative climbing plants, the title of the book—*The Four Princely Gods*—is inscribed in faded, dull green ink. A five-petaled flower is seen at the top of the left-hand creeper, and above it the form of a seated man. The border at the top was originally occupied by musicians, of whom only the vina player has survived. To the left of him a man kneels in an attitude of worship.

REFERENCES
Le Coq 1922–26, II, pls. 8ª,b and 8ᵇ,b, pp. 56ff. Härtel & Auboyer 1971, pl. 252, p. 269.

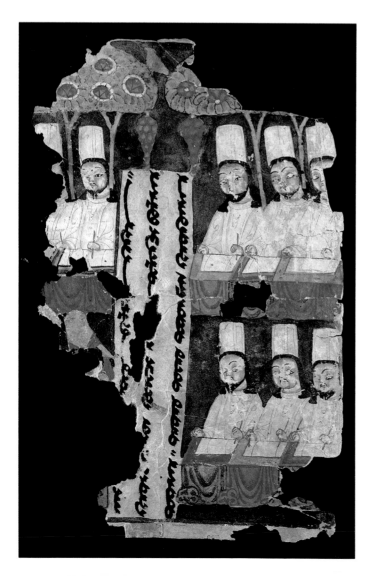

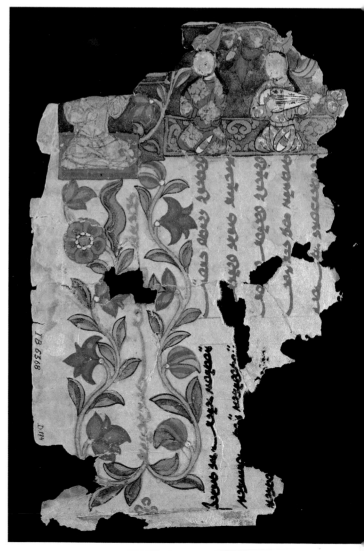

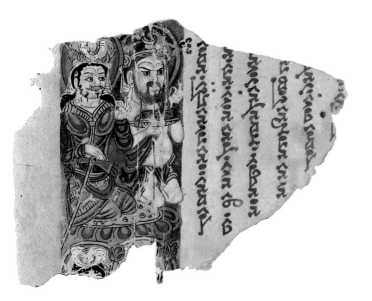

116 Leaf from a Manichaean Book

Khocho, Temple α, 8th–9th century
Manuscript painting, 8.2 x 11.0 cm.
MIK III 4959

One side of this fragment shows, to the left of six lines of red script, two figures of demonic aspect, kneeling side by side on a red-and-yellow lotus pedestal. The figure on the left is no doubt supposed to be wearing a magnificent suit of armor, though this has been falsely interpreted as a pleated garment made of soft materials sewn together. As a weapon he has been given a long-handled battle-ax. His head is encircled by a red nimbus; his face is flesh-colored and detailed by means of white shadows and thin red lines. The large eyes seem to be bulging out under the flat brows, and the nose is strikingly curved. Two fangs in the big, open mouth identify this figure as a demon. His mustache, beard, and sideburns are intricately curled. A long white cloth covers his head, on top of which rests a magnificent crown decorated with feathers, perhaps meant as a bird. His left hand is raised in the gesture of teaching.

The considerably more corpulent figure to the right is naked except for a loincloth and a sash worn diagonally across his chest. His large head is surrounded by a green nimbus; his hair is done in the ascetic style with a parting down the middle, and he wears a gold headband with the sun and crescent moon. There is a menacing look in the wide-open eyes that gives the face its demonic character. In his right hand the man holds a gold dish with a green fish in it; his left hand is raised in the gesture of teaching.

Below this pair can be seen the halos of two other persons, each holding a staff with a three-petaled flower at the tip.

The other side of the leaf was also, it appears, illuminated with a series of miniatures running from top to bottom. Three figures are still intact. On the right, in a rather awkward posture, stands a man clad only in a white loincloth. His arms hang down in resignation; his entire body is the expression of uncertainty and fear. He has an unusual hairstyle with a couple of black curls on the forehead and what appears to be a strip of hair shaven over the temples from ear to ear. To the left of this timorous figure there is a bound green sheaf, under which two horizontal parallel footprints are to be seen.

The next figure differs from the first in that his hands are tied behind his back and he wears a bull's head attached to a white band round his neck.

Facing this captive on the left stands a man in a red robe, wagging the very long index finger of his left hand in an imperious and admonitory manner. Beside him to the left can be seen traces of a fourth person.

REFERENCE
Le Coq 1922–26, II, pls. 8ᵃ,d and 8ᵇ,d, pp. 60f.

179

117 Fragments from a Manichaean Book

Khocho, 8th–9th century
Manuscript painting, 3.3 x 2.1, 2.6 x 5.0, 4.2 x 2.7 cm.
MIK III 4962

All three fragments originate, if not from the same leaf, then at least from the same book. Its format must have been rather sizable, because the Manichaean script on the other side is very large.

The first fragment, left, shows the head of a woman(?) with black spit curls, wearing a white hat. The man in the right fragment has a black mustache and beard and long hair down the back of his neck; his white hat has the form of a calyx. Below is a third fragment which shows the remains of floral decoration on both sides.

REFERENCE
Le Coq 1922–26, II, pl. 7d, p. 49.

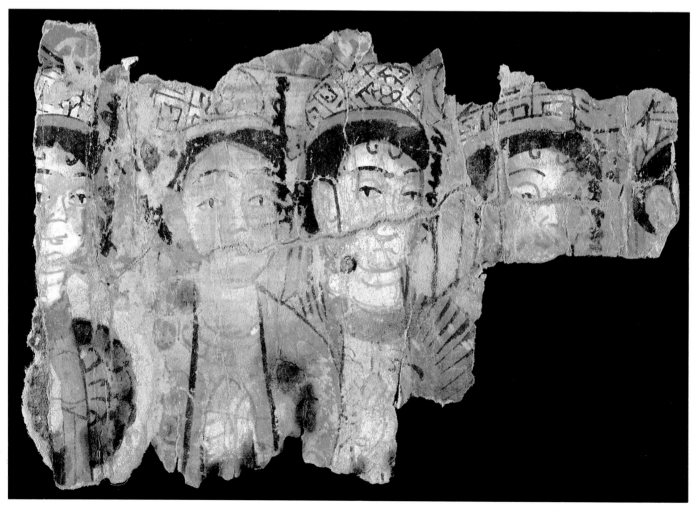

118 Fragment of a Manuscript

Khocho, 8th–9th century
Painting on paper, 6.2 x 8.9 cm.
MIK III 4937

The miniature portrays four noblewomen, of whom only the heads and parts of the upper torsos with remains of clothing have been preserved. Their names are written beside their heads.

Their black hair is parted in the middle, with a spit curl on either side. Their physiognomy is, if anything, Western. The crowns they wear are decorated with geometrical patterns and with a rosette in the center over the forehead. The women are dressed, as far as can be seen, in long, collarless robes with elaborate woven or embroidered decoration. The hands are joined before the breast in a manner familiar from Buddhist representations; the Manichaeans seem as a rule to have kept their hands covered.

REFERENCE
Le Coq 1922–26, II, pl. 6c, p. 44.

119 Three Manichaean Women

Khocho, 8th–9th century
Wall painting, 27.0 x 22.0 cm.
MIK III 6916

This fragment of mural with the portraits of three Manichaean women is painted on a blue ground, as was the practice in manuscript illustration; only parts of the heads, which are turned to the right, and upper torsos have survived.

The three women resemble each other closely. Their black hair is parted in the middle and falls over the back and shoulders, with a tress curling down in front of the ear (a style that can also be seen in the miniatures). The headgear consists of a roll of white cloth, apparently tied in a bow behind the ears and then hanging free down the back. Rising above it in front in the fashion of a diadem is a disk within a frame, which here again is perhaps meant to symbolize the sun and moon (see No. 116). The only ornaments are earrings. What can be seen of the costumes shows that they were high-necked and were colored respectively red and blue, blue and red, and green.

The fragmentary nature of the painting makes it impossible to establish whether the subjects are laywomen or—despite the absence of halos—Manichaean deities.

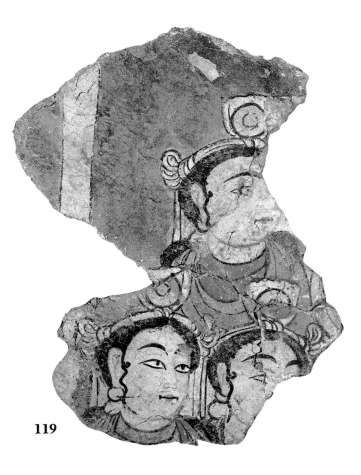

119

120 Buddha and Worshipers

Khocho, 9th century
Painting on paper, 15.5 x 16.0 cm.
MIK III 10

This exquisitely decorated miniature, which is part of a leaf from a book, reflects the influence on Buddhist artists of Manichaean works of art, whose principles they adopted for their own purposes.

Painted on a blue background, the miniature shows on the extreme right a Buddha with a halo and mandorla walking toward the left, shaded by a baldachin. Covering both his shoulders is a red robe, its hems edged with gold; below it a length of blue and another length of gray-and-green gathered material can be seen at his left side. Before the Buddha in an attitude of worship kneels a figure clad in a gold-edged dhoti, with a long scarf—red on the one side and gray and green on the other—curling around his shoulders and arms. His long hair is parted in the middle and hangs down over his shoulders onto his back. His head, surrounded by a nimbus, is crowned with a large diadem in the form of a flower in the center; from each side of the diadem, which was once embellished with gold leaf, a broad, knotted ribbon hangs down.

In the foreground there appears to be another scene, which has not yet been identified. The protagonists

181

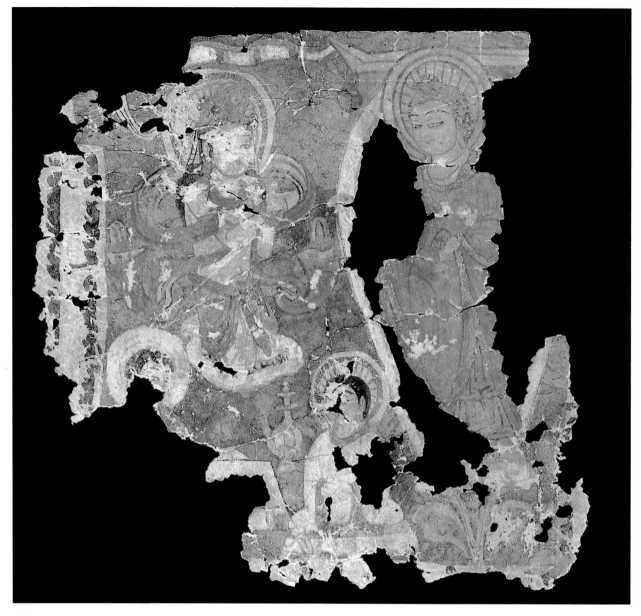

120

are two men—obviously monks—sitting opposite each other. The man on the right wears a gold-edged robe covering his entire body. His black hair is cut short and a halo encircles his head. A tree is visible behind him on the right. In front of him stands a table covered with a white cloth, which has been almost totally lost except for parts of the right half; beside it on the floor to the right stands a ewer with a spout and lid, of a kind known in Japan since the eighth century.[1] On the other side of the table, somewhat further back, are the white nimbus and part of the head of another monk, also with short hair. The left

edge of the miniature is formed by a cartouche with Uighurian text; though illegible, this is—like the text on the other side of the leaf[2]—in Middle Persian and written in Sogdian script.

1. We are indebted to Professor von Gabain for this information.
2. Dr. Werner Sundermann has kindly transcribed this text and provided the following reading: "[The devati] deva Buddha [spake thus] to the great [assembly(?)]: 'Know then that through(?) this [] this (?)-eyed, blind [] attitude of these people [] because of this five-hundred existences without intermission [] are born in hell. . . . will be saved from hell. Then" (the text breaks off at this point).

Temple Banners

AS EARLY AS 647/648, the second emperor of the T'ang dynasty, T'ai-tsung (reigned 616–649), finally brought Eastern Turkestan under Chinese hegemony. From this date on, the artistic influence of China is very marked, particularly in the Turfan region. Here, as in Tun-huang, a large number of temple banners made of silk or ramie (a stem fiber widely used for textiles in the Far East) were discovered, painted with figures of the Buddhist pantheon. Many of these figures are not named, rendering an accurate iconographic interpretation of them difficult. Cartouches left uninscribed (as in No. 126, for example) indicate that temple banners of the kind were produced on a large scale in monastery workshops; when a believer purchased one as an offering, the appropriate dedication would be added. It was believed that by offering one of these temple banners the donor or his relatives would gain admittance to paradise more easily, or would be blessed with long life, numerous children, or prosperity; the gift could also represent a plea or a thank offering for a successful business trip.

W. V.

121 Double Image of the Buddha

Khocho, 8th century
Painting on ramie, 52.0 x 19.0 cm.
MIK III 6301

The curious painting on this temple banner shows two Buddha figures with separate bodies that merge into one in the region of the legs. They share a common mandorla and nimbus. The Buddha on the left raises his right arm and holds an alms bowl in his left hand before his chest. His head appears to be more inclined than that of his double; he looks down at the now hardly discernible Uighurian woman kneeling in adoration at his feet. The clothes are in light colors with brownish red stripes to indicate the folds. Above the feet can be seen the blue edge of the undergarment, possibly shared by both figures.

The unusual subject of this picture—the Buddha as a double image—crops up again and again in many different parts of Central Asia. It is inspired by a legend which is reported by the famous Chinese pilgrim Hsüan-tsang, who traveled through Central Asia and India in the seventh century. Two poor pilgrims, he tells us, each gave an artist a coin to paint them separate pictures of the Buddha. But when they came to pick these up on the appointed day, they suffered a great

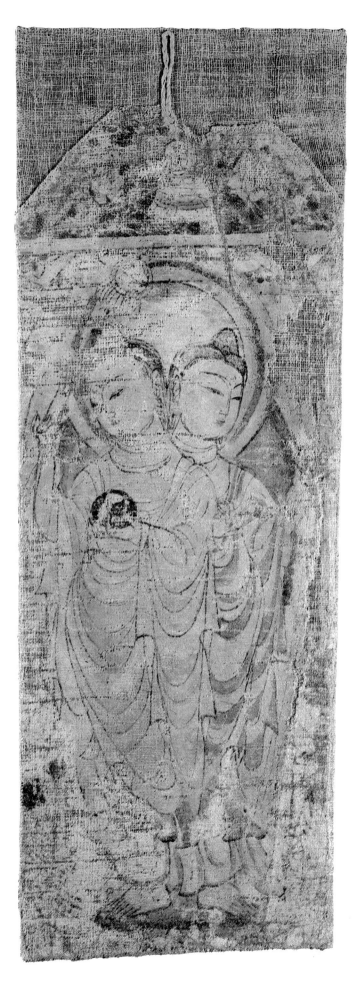

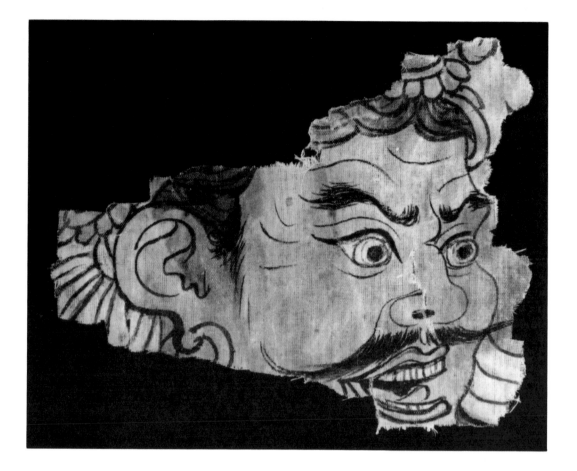

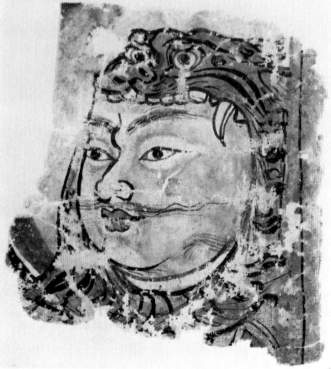

disappointment: their money had been sufficient for only one painting. Thereupon the Buddha in his boundless compassion performed a miracle: he doubled his image to honor the piety of the two pilgrims.

REFERENCES
Le Coq 1913, pl. 40a. Indische Kunst 1971, 1976, no. 499.

122 Head of a Lokapala (?)

Toyok, Manuscript Room, 8th century
Painting on silk, 6.3 x 8.4 cm.
MIK III 6350

This small fragment of a painting on silk was found, like the reliquary (No. 106), in the cave at Toyok known as the Manuscript Room. It shows a male head with an angry look—possibly a lokapala, one of the guardians of the four quarters of the universe. His eyes bulge, his mouth is open in a snarl to reveal the teeth. The ends of his thick mustache reach nearly to the ears. The face is drawn with reddish lines, the bejeweled hair is brown. Part of his headdress can be seen behind the ear and above the hair.

REFERENCES
Le Coq 1913, pl. 46b. Indische Kunst 1971, 1976, no. 517.

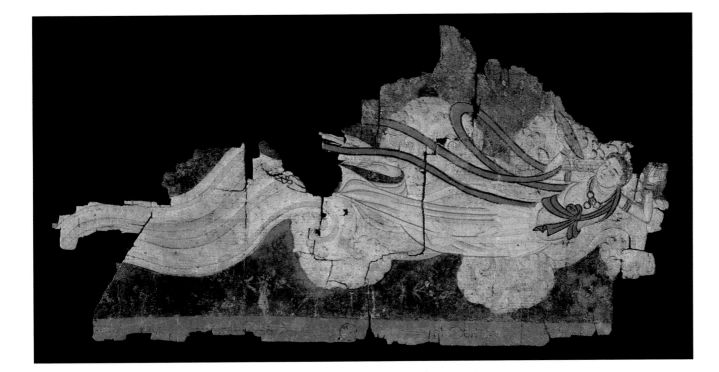

123 Head of Gandharva

Khocho, 8th–9th century
Painting on cotton, 6.6 × 6.6 cm.
MIK III 4799

This fragment, which is only a couple of inches high, shows the head of Gandharva, one of the eight guardian deities in the service of the Buddha Shakyamuni.

Gandharva's head is covered with the skin of a lion's head; he appears to be looking out through the open jaws of the beast. In contrast to the terrifying snarl of the lion with its rolling eyes and bared teeth, the deity's soft, full face has an almost benevolent aspect; it is only the pronounced furrow between the eyebrows that lends him a slightly skeptical, perhaps even vexed expression. The brushwork, with its decisive strokes, is full of vitality; only the eyebrows and beard are painted with thin, stringy lines. The plasticity of the face is enhanced by washes of color; this technique for achieving a three-dimensional effect was brought to China along with Buddhist painting, but it was not pursued and soon disappeared from religious and secular painting.

W. V.

124 A Gandharva Strewing Flowers

Khocho, 8th century
Painting on silk, 17.5 x 35.3 cm.
MIK III 4534b

This broad fragment of a silk painting depicts a gandharva floating aloft; four banks of clouds against a blue background make it plain that the scene takes place in midair. The celestial flower-strewer, his robe and scarf streaming behind him in the wind, carries in his right hand a bowl, out of which he has just plucked a handful of flowers with his left. The long billowing train of blue, pink, and green material, which extends practically from one side of the fragment to the other, appears to belong to a thin silken cloth fastened to his hair.

REFERENCE
Indische Kunst 1971, 1976, no. 519.

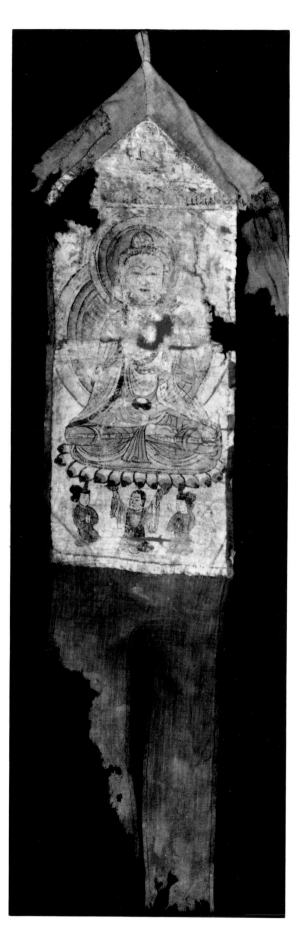

125 The Healing Buddha Baishajyaguru

Khocho, 8th–9th century
Painting on ramie, 90.5 x 27.5 cm.
MIK III 4803

On both sides of this slightly damaged temple banner the Healing Buddha is portrayed seated on a lotus pedestal. In his left hand he holds a bowl, while his right hand is raised, probably in the gesture of teaching. Head and body are surrounded by a nimbus and mandorla.

On one side of the banner the Buddha's pedestal is supported by a kneeling monk on upstretched hands. On either side of the monk kneels a donor, a Uighurian woman with hands joined in front of the breast. Next to the woman on the right a small, almost naked child with raised right hand can just be made out.

On the other side of the painting the Buddha's pedestal is borne by a Uighurian nobleman in a green robe and a black, helmet-type headgear, seated with his legs crossed. His hands, raised above his head, are concealed by the long, hanging sleeves of his robe. On the left is a kneeling monk, on the right two girls standing in long red robes, their hands joined before them.

A temple banner with a similar configuration found in Tun-huang bears a cartouche with the inscription in Chinese: "Homage to the Buddha Baishajyaguru" (see Matsumoto Eiichi 1937, pl. 38).

In the triangular space at the top of the banner sits a small meditating Buddha, separated from the main picture by an ornamental band.

The cult of the Healing Buddha, to which this banner belongs, seems to have arisen in Central Asia. None of the Chinese pilgrims to India mentions the cult in his records. The Baishajyaguru sutra was already known in China in the fourth century A.D., which is also the date of its earliest pictorial representations. According to a sixth-century commentary, the sutra deals among other things with ways of prolonging one's life, an aspect which is very important in Chinese thinking.

REFERENCE
Uhlig 1979, p. 124, fig. 60.

W. V.

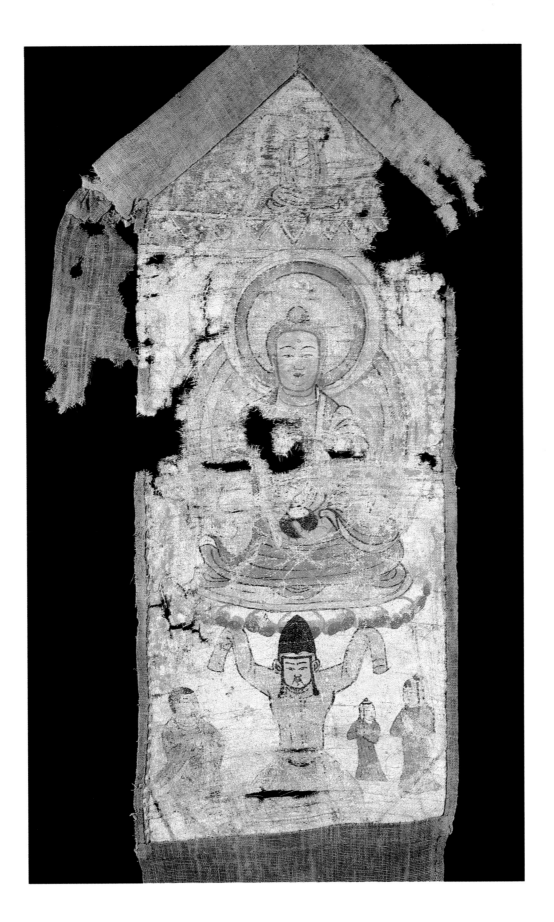

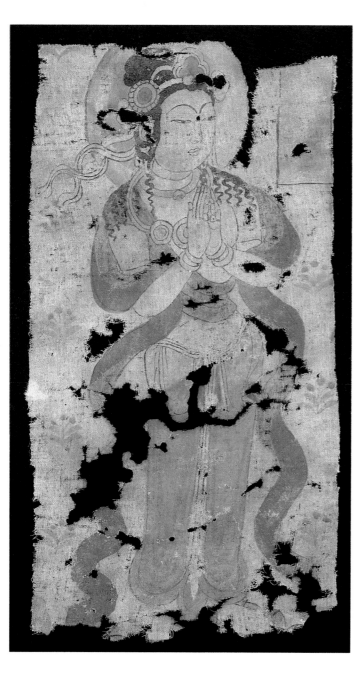

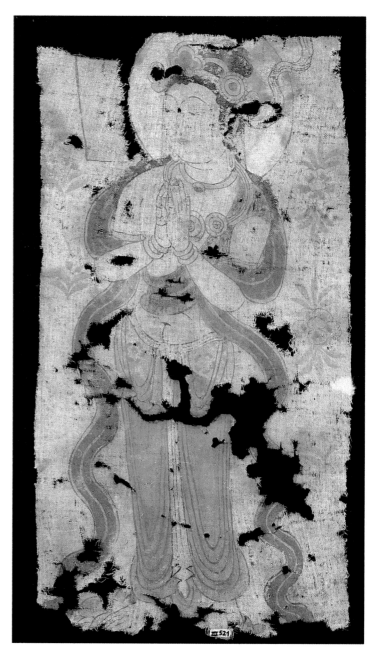

126 Bodhisattvas

Turfan region, 8th–9th century
Painting on ramie, 51.5 x 22.5 cm.
MIK III 521

The bodhisattvas on either side of this banner each stand on a lotus pedestal, hands joined in front of the chest. Behind the head is a nimbus; no name has been inscribed in the cartouche beside it. The figures differ only in details, such as hair ribbons, length of hair (falling to the shoulders or down the back), and, in part, the color and patterns of the clothing. To prevent the image showing through on the other side of the fabric, the figures were painted with the aid of stencils so that their outlines would practically correspond. The use of stencils in monastery workshops was unavoidable because of the great demand for paintings and the strict iconographic requirements.

The background is decorated with floral motifs; the colors red, vermilion, blue, and green are by now very faded.

This simple and unpretentious stencil painting reveals Chinese influence both in the slightly modulated brushwork of the ink lines and in the full-bodied physique of the bodhisattvas, reflecting T'ang aesthetic ideals.

REFERENCES
Le Coq 1913, pl. 41c. Nara 1978, p. 253.

W. V.

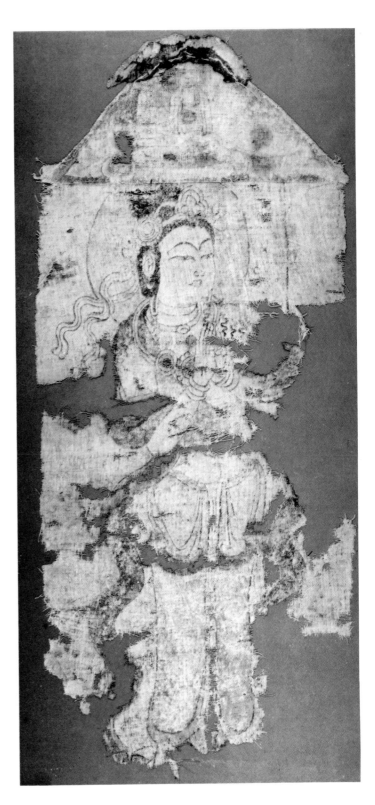

127 Bodhisattva

Yarkhoto, 8th–9th century
Painting on ramie, 55.0 × 25.5 cm.
MIK III 6304

This temple banner could almost have been painted with the same stencil as No. 126. Again there is no inscription in the cartouche, making precise iconographic identification impossible. Portrayed in three-quarter profile, the bodhisattva looks to the right with hands joined before the chest. Despite the banner's poor state of preservation, its original form is still clear. Visible in the triangular section sewn to the top is the faint image of a Buddha seated in meditation, his head and torso backed by a nimbus and mandorla; the left and right corners are filled in with a foliate design.

W. V.

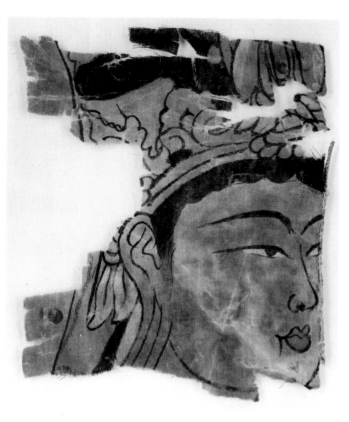

128 Head of the Bodhisattva Avalokiteshvara

Toyok, 8th–9th century
Painting on silk, 8.5 x 7.5 cm.
MIK III 6534

This head of a bodhisattva can be identified as that of Avalokiteshvara by the fragmentary miniature Buddha in the headdress. An aid to dating is a comparison with murals in the tombs of the Crown Princes Changhuai and I-te and of Princess Yung-t'ai. These tombs near the capital city Ch'ang-an were constructed in the years 706–711. On account of the great distance between them the style of the capital would have reached Turfan some time later, but it would also have lasted there a good deal longer than at its source. Here we have a round face with full lips, whose upper line is prolonged in an angle to suggest the plump cheeks; pronounced, gently curved upper eyelids and semicircular pupils; and thin lines marking the lower lids: the style is reminiscent of the full-bodied type of female depicted in the first half of the eighth century. This influence cannot have appeared in the Buddhist painting of Turfan before the middle of the eighth century, which dates the small bodhisattva head in the second half of the eighth century or the first half of the ninth.

W. V.

129 Angry Arhat

Foothills near Turfan, 8th–9th century
Painting on silk, 29.0 x 47.5 cm.
MIK III 7241

To understand the essence of Buddhism, one must have a clear picture of the sort of person it aimed to produce and the kind of perfection its adepts were supposed to strive after. The ideal man is known as an arhat (from the Sanskrit root *arh*, "to deserve, be worthy"), or one who is worthy. Free from sensual desires and the longing for existence, he has severed his worldly connections. In the early days of Buddhism all Buddhist ascetics were given this title; later only the wise ones were thus designated.

Among Buddhist works of art many idealized portraits of arhats have been preserved. An arhat is usually depicted as a venerable old man with a bald head and an austere expression. In this fragment of a silk painting his look is more one of irritability or anger. He has turned to face his left; his right arm is raised with the hand clenched in a fist, while he thrusts out his left hand and arm in a defensive gesture. His head is thrown back, with a furious glint in the eyes, and the mouth is open in a scream. He seems to be trying with all his might to ward off evil, hostile spirits. Brownish-skinned, he has a muscular physique; his head is shaven but the hair appears to be growing again. Under the shaggy brows the whites of the eyes are slightly tinged with red. A simple nimbus shows this monk to be a holy man. The picture, with its gray-green background enlivened with dabs of color, betrays the hand of a master of free expression.

REFERENCES
Le Coq & Waldschmidt 1928–33, VII, pl. 33, pp. 67f. Indische Kunst 1971, no. 498, pl. 57; 1976, no. 498, fig. p. 217.

130 Flutist

Yarkhoto, 8th–9th century
Painting on wood, 9.0 x 16.0 cm.
MIK III 7403

This fragment of a wooden vessel (an urn?) with yellowish white priming shows the remains of a painting of a divine musician. Still intact are the head and part of the chest and arms. Around the shoulders the figure wears a billowing green-and-brown scarf. The hair is partly caught up at the back with a ribbon to which an ornament is attached in front; a reddish brown nimbus is visible behind the head. The skin of the face

and body is delicately colored. The hands are lifted to hold a flute to the red, puckered lips.

In spite of its fragmentary nature, this is a very fine example of painting on wood.

REFERENCES
Indische Kunst 1971, 1976, no. 469. Bhattacharya 1977, no. 88, pp. 81f.

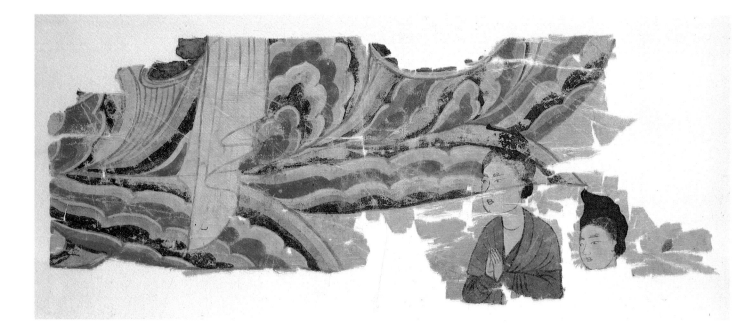

131 Two Female Donors

Toyok, 8th–9th century
Painting on silk, 9.5 x 25.0 cm.
MIK III 6341

This modest fragment of a large silk painting gives an idea of the sumptuousness and artistic quality of the original work. On the right are the half-figure and the head of two Chinese noblewomen of the T'ang dynasty, portrayed in three-quarter profile. They probably formed part of a group of donors represented below a Buddha or bodhisattva to the left. The two women have their hair up and their cheeks and eyelids powdered a fashionable pink. The woman on the left, wearing a red shawl over a violet dress, has her hands joined in front of her breast. Both women originally stood or knelt before and to the right of a multicolored lotus pedestal. Parts of its leaves have survived, painted in the traditional range of colors, blue, red, green, and violet, and the lower end of a white shawl hangs down over it.

REFERENCE
Le Coq 1913, pl. 46e.

W. V.

132 Hand Holding a Flower

Toyok, 8th–9th century
Painting on silk, 9.2 x 4.3 cm.
MIK III 6348

This small fragment of a painting on silk shows a hand holding a white-and-pink flower delicately between thumb and forefinger, against a green background.

REFERENCE
Indische Kunst 1971, 1976, no. 522.

133 Dancing Demon

Khocho, 8th–9th century
Ink on paper, 17.5 x 9.0 cm.
MIK III 4951

This ink drawing with its very curious subject is part of the illumination of a Uighurian manuscript. A partly skeletal demon or entity from hell performs a wild dance beside a bowl. He wears a loincloth round his hips. The head is broad at the top and comes to a point at the chin; on his right temple is a crescent-shaped mane of hair. The artist has managed with fairly coarse strokes to sketch a very lively figure; in the frenzy of the dance the elevated bush of hair seems almost to shake to and fro, and the arms and legs to jerk up and down.

This is the only ink drawing of such outstanding quality that has come down to us from this early period of history of Central Asia. On the back can be seen a few lines of Uighurian script, which may have been added later.[1]

The fragment appears to come from a rolled manuscript. Scrolls of this kind were formed by pasting large pages of a book together at the edges; the front page was attached to a stick around which the whole manuscript was rolled up and tied with a ribbon. The drawing was executed either with a brush as used in China or, if this was not obtainable, a reed pen, which was more common in the western border regions.

1. The text, incomplete at the beginning, consists of six lines. According to Dr. Peter Zieme, they read as follows:

(1) Khocho . . .
(2) [?]
(3) This is a brilliant dancer,
(4) this is a brilliant dancer—
(5) I, Mongoltay, have written [it]; it is true,
(6) I, Mongoltay, have written [it]; [it is true].

If the drawing was done at the same time as this was written, the manuscript would have to be dated a good deal later, namely in the Mongol period.

REFERENCES
Bussagli 1963, pp. 104, 108 (ill.). Härtel & Auboyer 1971, pl. 254, p. 270. Indische Kunst 1971, no. 515, pl. 58; 1976, no. 515, fig. p. 218. Indische Kunst 1980, no. 50.

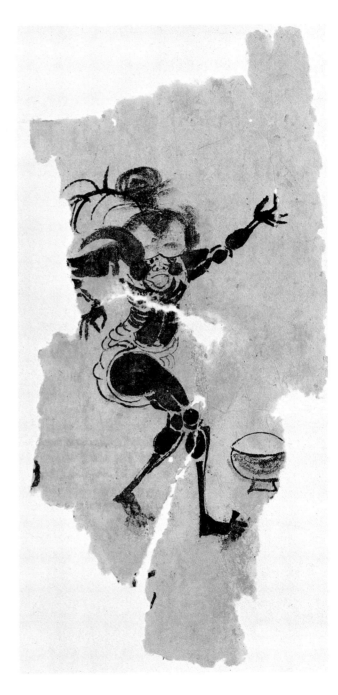

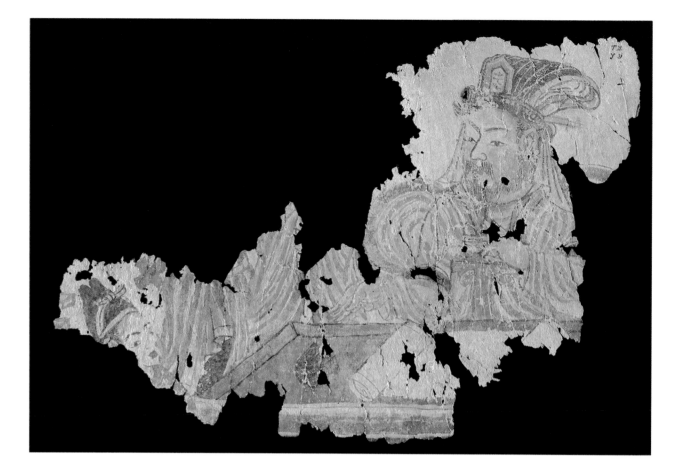

134 One of the Ten Kings of the Underworld

Yarkhoto, 8th–9th century
Painting on paper, 18.0 x 26.8 cm.
MIK III 6327

Apart from the richly painted miniatures found in the Turfan oasis, which as we have seen are mostly from Manichaean manuscripts, the site yielded two other kinds of book illustration: wood blocks, which deal with Buddhist themes and accompany texts in either Chinese or Uighurian; and black-and-white or lightly colored drawings relating to various texts, such as the one which is the subject of this illustration and No. 135.

As von Gabain (1973a) has established, the text here concerns the cult of Kshitigarbha, the bodhisattva who rescues repentant souls from hell, which was widespread in Central Asia. Dated not earlier than the eighth century A.D., the text is entitled *The Ten Kings Institute the Seven*. It tells how after death each person must appear before the tribunal of the ten underworld kings in succession, every seventh day before each of the first seven kings, before the next two kings after one hundred days and one year respectively, reaching the tenth king finally after three years.

As in an earthly court, the offenses of the deceased—the evil he has done and the good he has failed to do—are read out to him from a charge-sheet, that is, a scroll. He is berated by each of the Ten Kings, menaced by their myrmidons, locked in the pillory, and even tortured.... In view of this highly unenviable position, it is necessary—as the text enjoins again and again—for pious relatives to earn merit (*punya*) for him by copying sacred texts and ... commissioning "pictures" or "sculptures." If succor is given to a dead person in this way, even the last of the Ten Kings will be inclined to show mercy. Kshitigarbha appears to him ... and rescues him from this prison; indeed, he even escorts the deceased to Amitabha in his Western Paradise. (Gabain 1973a, pp. 48f)

Kshitigarbha in this text appears as the great savior, and seems to have had a special connection with the cult of the dead. Illustrated copies of the Central Asian text, made in Tun-huang in the tenth century, are evidence for the assertion that a whole series of drawings in Berlin's Turfan collection belongs to a work of this kind.

In the painting shown here we see a bearded man, one of the Ten Kings, sitting at a table. A label in the middle of his cap, from which a veil is suspended, bears the inscription "king" in Chinese. His wide-sleeved overgarment is Chinese; the undergarment is belted with a sash. The charge-sheet in the form of a scroll lies on the table in front of him. At the bottom left is the head of a small figure—one of the youths who, the text tells us, bring a pair of scales to weigh the good and bad deeds of the deceased against each other.

REFERENCES
Indische Kunst 1971, 1976, no. 520. Gabain 1973a, p. 53, fig. 57, pp. 54, 58.

135 Lady in Waiting to One of the Ten Kings

Toyok, 8th–9th century
Painting on paper, 12.6 x 2.8 cm.
MIK III 47

The retinue of each of the Ten Kings includes, we are told, ladies in waiting of noble rank, of whom this is one. She faces left, presumably looking toward her underworld master. Her hair is piled up in an elaborate coiffure tied with a reddish ribbon. She wears a red undergarment, a yellow-and-brown dress with a panel in blue silk, and a wide, reddish sash. Round her neck is a simple chain. The costume of the ladies in waiting, like that of the Ten Kings, is not Uighurian, nor is it purely Chinese in style.

REFERENCES
Indische Kunst 1971, 1976, no. 521. Gabain 1973a, p. 54, fig. 61, p. 55.

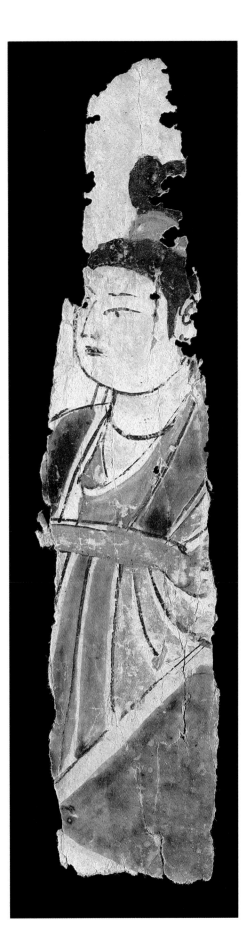

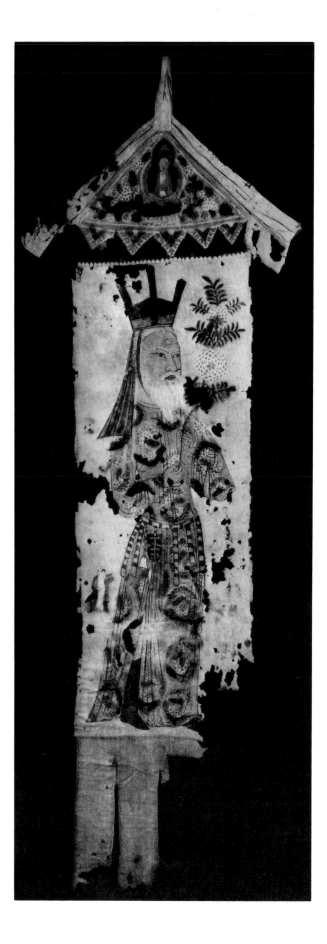

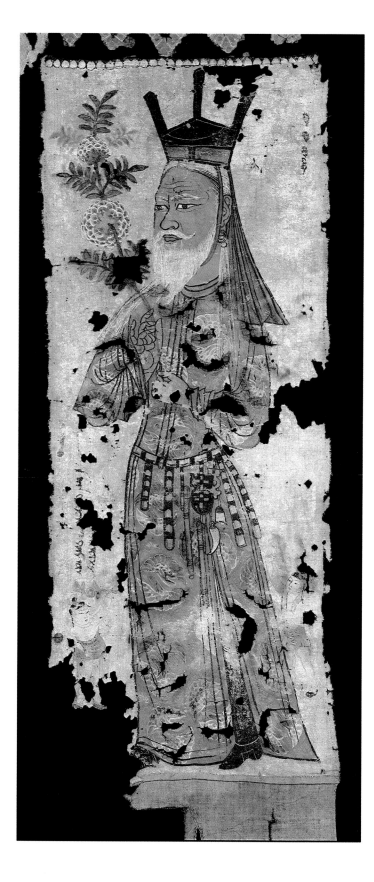

136 Uighurian Prince

Khocho, 9th century
Painting on ramie, 142.0 x 52.0 cm.
MIK III 4524

As seen already in several examples, portrayals of princes and their families are an extremely interesting feature of the art of Central Asia. In the form of wall paintings they were placed in locations that would catch the eye, on the entrance ways or passages in the cave temples or on the pedestals of statues. Where the hangings with portraits were displayed cannot be accurately deduced from where they were found.

The finest painting on cloth in the Berlin collection is this large banner, possibly a votive offering, with the portrayal of a Uighurian prince on both sides. Like all votive banners it consists of three parts: the long, narrow, rectangular banner itself, the triangular segment at the top, which here depicts a seated Buddha, and rectangular strips of material at the bottom with a wooden stick to weigh it down. The subject has an aristocratic bearing and is getting on in years. Unlike men of lesser standing, he wears his long white hair parted in the middle and falling in individual tresses squared off at the ends. On his head is a three-pronged cap, held by a strap under the chin; a shoulder-length veil hangs down behind. As well as an attractively curled mustache he has a beard covering his chin and framing his cheeks.

The prince's fine robe, patterned with a large floral design, is modeled on the typical dress of the country. It is a long-sleeved, round-necked garment reaching to the feet. There is a belt fastened in front, with rectangular decorative pieces containing a slit from which to hang straps with objects of daily use, such as sheaths for chopsticks and reed pen, flint-pouch, awl, and amulets. A slit in the side of the garment reveals a black knee-length boot. In his hands the prince holds a stem with several blossoms, perhaps intended to win him a joyous reincarnation.

The Uighurian inscriptions are very difficult to decipher. On the side with the prince facing left a line of writing can be seen at the level of his hat on the right. At bottom left we can read: "For the soul of my father (or: our father) [Tangri?] m Xan Totoq." The other side, with the prince looking to the right, bears a similar inscription. "This(?) (is) for the [soul of my father] [//] tym (or: Tangrim?) X[an] T[otoq]." This reading, for which we are indebted to Dr. Peter Zieme, would if correct confirm von Gabain's hypothesis that flowers held in the hands or laid across the arms indicate that the bearers have died.

REFERENCES
Le Coq 1922–26, III, pl. 17, pp. 45f. Bussagli 1963, pp. 101, 105 (ill.). Härtel & Auboyer 1971, pl. 45, p. 268. Indische Kunst 1971, 1976, no. 566. Indische Kunst 1980, no. 52.

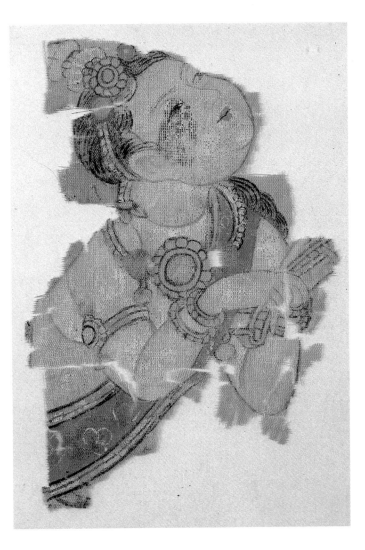

137 Devata

Khocho, 9th century
Painting on ramie, 10.0 x 7.0 cm.
MIK III 4998

Holding the handle of a censer in both hands, the diminutive figure faces right, his head thrown back. In the original composition he had probably made an offering to a Buddha or bodhisattva. All that is left of the painting is this small fragment, showing the pious devata's head and chest. His long blue hair hangs down his back behind his left shoulder. Head, chest, and arms are richly decked with gold ornaments studded with jewels. A scroll-patterned sash, edged with gold, is worn over his left shoulder and across the chest.

W. V.

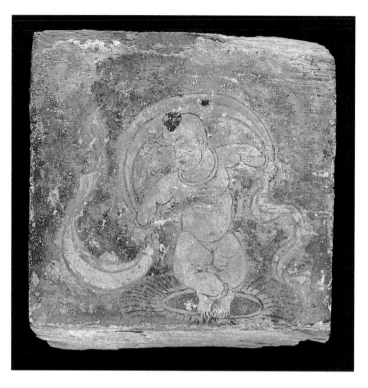

138 Child Dancing

Khocho, 9th century
Painting on wood, 6.0 x 6.0 cm.
MIK III 4763

This fragment comes from a fairly large wooden panel primed blue and white. A small chubby boy, wearing only a loincloth, is pirouetting on tiptoe, his feet crossed. In his hands he holds a long scarf colored red at the top and green at the bottom; this billows up behind his head, while both ends are whirled around at the sides in the movement of the dance. The child's squat figure, the tuft of black hair on the almost bald head, and the hoop with charms around his neck are to be found again in the children of No. 147; he differs from them, however, in the bangles worn on his wrists and ankles and in his lack of shoes.

REFERENCE
Bhattacharya 1977, no. 89, p. 82.

139 Vaishravana

Khocho, 9th century
Painting on ramie, 41.0 x 27.5 cm.
MIK III 5015

Vaishravana is one of the four lokapalas, or guardians of the universe. Specifically, he is the guardian of the north and is depicted with a stupa or pagoda in one hand and a lance in the other. In China, since the middle of the T'ang dynasty (618–906), he has been revered as the god of wealth and as a guardian at the entrances to Buddhist temples.

On both sides of this fragment of a temple banner Vaishravana can be clearly identified by his attributes, a pagoda, here octagonal, and a lance, here entwined with ribbons. Both figures were outlined with the aid of stencils, painted, and outlined again in ink; the hand and face of one are done over in red. The two Vaishravanas, haloed and wearing armor and helmets, differ

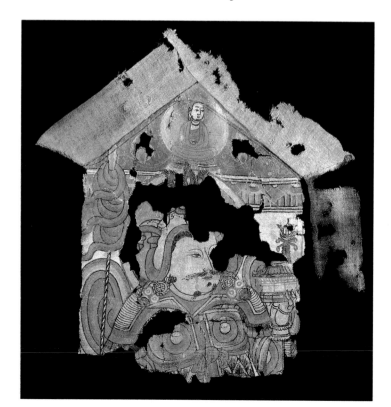

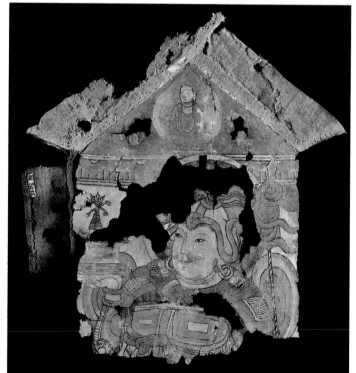

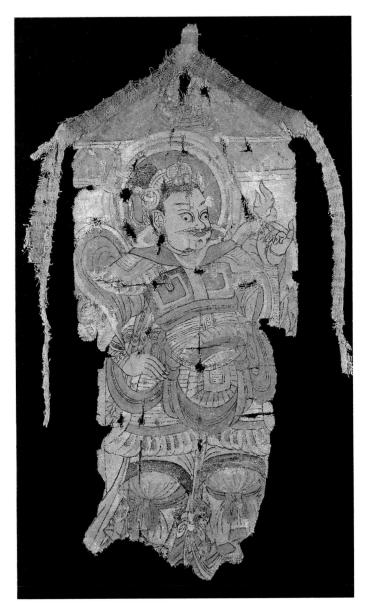

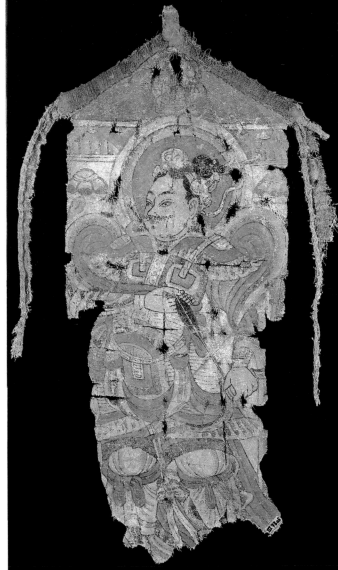

only in the position of the hands and in the design of the earrings and breastplates. Beards enhance their martial appearance. Behind both shoulders their scarves billow in oval forms.

The triangular top of the banner is marked off from the main portion by a decorative band. This is conceived as a draped dais on which a meditating Buddha, with a red nimbus and a green mandorla, is seated on a lotus pedestal before a violet background. The Buddha is flanked on each side by a tendril with a lotus bud.

W. V.

140 Two Lokapalas

Toyok, 9th century
Painting on ramie, 47.0 x 28.0 cm.
MIK III 7305

This small temple banner shows a different lokapala on each side. Looking to the left is the guardian of the east, Dhritarashtra, identifiable by his attributes: in his left hand he holds a bow and with his right he is laying an arrow to its string. The other guardian cannot be identified. Notwithstanding the flaming pearl, which Vaishravana, guardian of the north, can be shown holding in his left hand instead of the stupa or pagoda (cf. No. 139), it is unlikely that this is a portrayal of the most high-ranking of the four lokapalas. Vaishravana was greatly revered, particularly in Central Asia, and he would hardly have been depicted without his complete attributes, the lance being missing here.

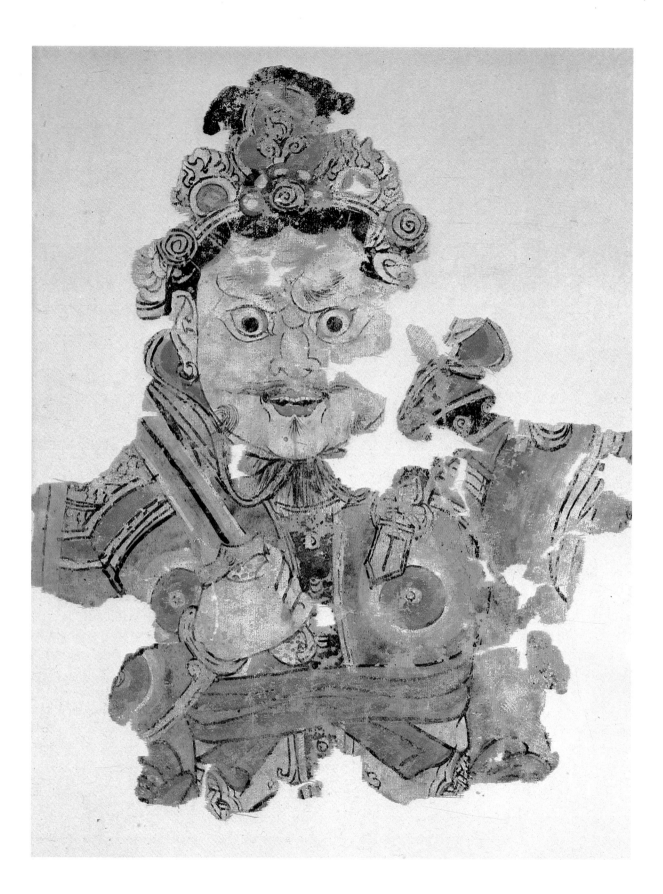

Both lokapalas presumably stood on cowering demons. They are dressed as generals in full, flexible armor. Shawls flutter around them, billowing up behind their shoulders and lending additional emphasis to the impression of martial strength. The head of each is surrounded by a nimbus; the bands holding the headgear in place flutter in the wind. Under their armor, which was probably composed of segments of lacquered leather, both lokapalas wear long robes which cover the legs to just above the knee. Below the knee their loose-fitting trousers are tied with ribbons.

The section at the top of the banner shows a small Buddha in the attitude of meditation on what was originally a violet background, decorated with scrollwork. This triangular field is marked off from the main picture by a decorative band transected by the nimbus.

The impact of this unpretentious stencil painting is enhanced by its use of strong color.

REFERENCE
Nara 1978, p. 253.

W. V.

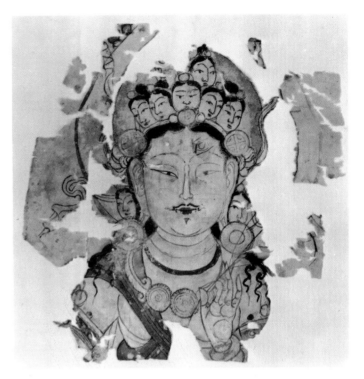

141 A Lokapala (Virudhaka?)

Murtuk, 9th century
Painting on ramie, 14.5 x 12.5 cm.
MIK III 163

This full-face depiction of a lokapala probably represents Virudhaka, the guardian of the south, an identification based on the sword he holds in his right hand and possibly the predominant blue coloring of his armor.

With a grim expression on his face, knitted brows, eyes bulging, and mouth open, the lokapala wards off evil. His bushy eyebrows and beard contribute to his martial appearance. The face and hands are white; the addition of a delicate pink enhances their plasticity. The hair is tied up and held in place by a headdress studded with gold and jewels. The two blue breastplates are fastened by a gold buckle to the richly gold-plated shoulder armor and held in place on the body by a broad strip of cloth.

The painting combines the artistic traditions of Central Asia and China, dominated by the Chinese linear style of calligraphy.

W. V.

142 Eleven-Headed Avalokiteshvara

Yarkhoto, 9th century
Painting on silk, 17.0 x 15.7 cm.
MIK III 8001

In Mahayana Buddhism a new concept developed early on, namely that one had a right to expect universal salvation. To make it possible for every individual to achieve this, various doctrines evolved, one of them being the idea of the bodhisattva. Thus, Avalokiteshvara appears as the typical bodhisattva, who delays his own Buddhahood until all beings have been delivered. His prime task is to bring the doctrine of salvation to all beings.

Many texts speak of him, for example, the *Sukhavativyuha*, the *Lokeshvarashataka*, the *Sadhanamala*; he is also mentioned in chapter 24 of the *Saddharmapundarikasutra*. Another great Mahayana sutra, the *Avalokiteshvaragunakarandavyuha*, is entirely devoted to him. This text was translated into Chinese as early as A.D. 270.

The cult surrounding the bodhisattva Avalokiteshvara ("the Lord who looks down from above," that is, who looks on all beings full of compassion)[1] was also

1. For the various theories as to his name, see Mallmann 1948, pp. 59–67.

201

known to the Chinese pilgrim Fa-hsien. He himself beseeched the bodhisattva to rescue him when he was caught in a sudden storm on the voyage from Ceylon to China.

Avalokiteshvara is portrayed in various guises. This silk painting shows him with eleven heads: there is one head beside each ear; above the hairband six more heads are clearly visible, with two others only partially preserved; one head, presumably that of the Buddha Amitabha, formed the peak of the pyramid.

REFERENCES
Le Coq 1913, pl. 45c. Indische Kunst 1971, 1976, no. 523. Rowland 1974, pp. 191, 196, 197 (ill.).

143 Head of a Bodhisattva (?)

Turfan region, 9th century
Painting on cloth, 13.0 x 10.3 cm.
MIK III 609

This painting on one side of a bast-type fabric shows a richly decked male head, with a curling mustache and a tuft of beard. The face is colored lilac. The ears are adorned with very large disks reminiscent of lotus blossoms. Note the vertical third eye on the forehead.

REFERENCE
Indische Kunst 1971, 1976, no. 518.

144 Standing Buddha

Toyok, Manuscript Room, 8th–9th century
Embroidery on silk, 14.5 x 6.0 cm.
MIK III 6178

This standing Buddha has been executed in *Zopfstick-technik* (interlacing backstitching?), silk on silk. Remains of material on one side prove that it formed part of a larger textile, perhaps a temple banner. The Buddha is standing on a lotus, his head encircled by a nimbus. His outer garment is bordered in blue at the top and bottom hems and at the sides. His right hand is raised, while his left holds one end of the garment. Red, black, and blue stitches create the contours.

Otto von Falke, who is quoted by von Le Coq, explains the embroidery technique thus: "Nothing is to be seen...of the very delicate ground material, as the embroidery totally covers the front and back of the fabric. *Flechtstich* is used to follow the lines of the design and thus enhance its clarity of form by clarity of texture."

REFERENCE
Le Coq 1913, pl. 52c and text.

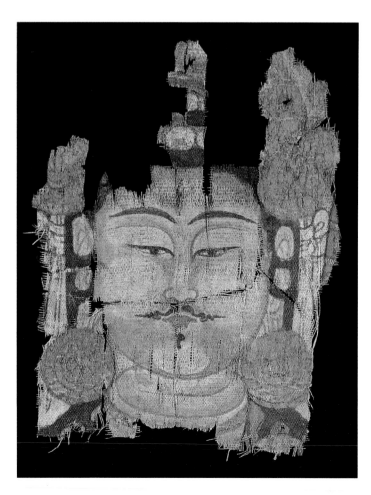

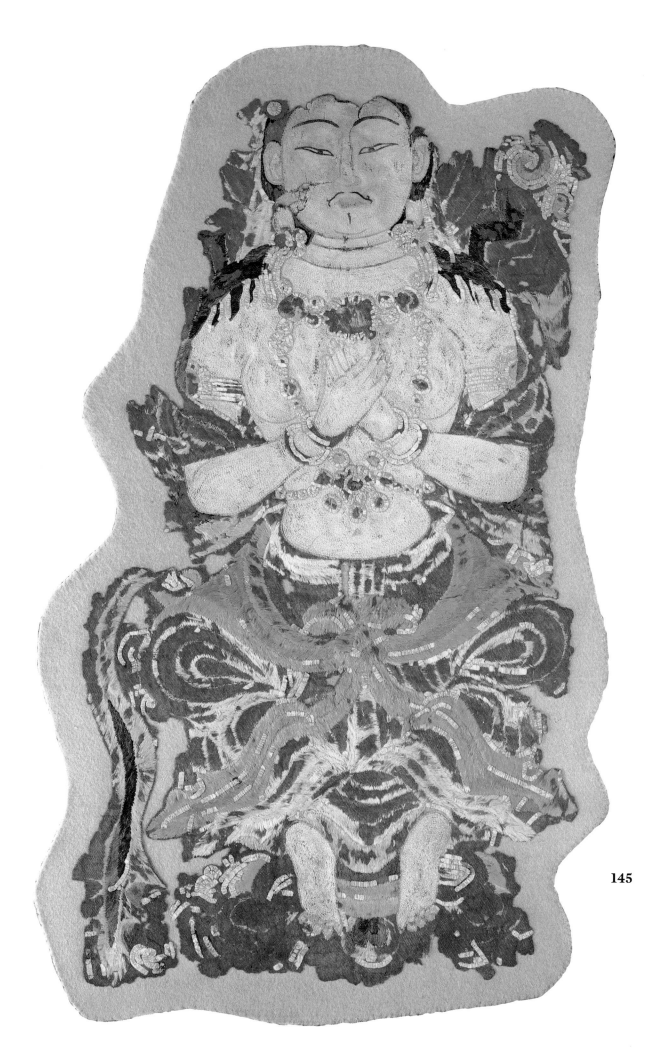

145

preceding page

145 Bodhisattva

Khocho, 9th–10th century
Embroidery, 40.0 x 23.0 cm.
MIK III 4796

This fine fragment of embroidery shows a bodhisattva, with a mustache and a tuft of beard on his chin, seated on a lotus throne, his knees parted and his legs crossed. The hands are crossed in front of the chest. The features are East Asian. On the shoulders lie neatly arranged tresses of long hair. The upper part of the body is naked and hung with sumptuous chains.

The fragment is of special interest in that it shows, as Waldschmidt points out, how different embroidery techniques were used to create the various effects.

The type of stitch often changes according to the desired effect. The bodhisattva's body is entirely worked in chain stitch. The thread is flesh-colored for the actual skin; eyes, brows, and beard are black, the mouth and the contours of the body dull red.

The throne, hair, and various articles of clothing are embroidered all over with closely packed satin stitch, which often overlaps. This also seems to be the case with the background.

Silk is used for both types of stitch, for the chain stitch in the form of a fine, slightly twisted thread, and for the satin stitch an open, multifilament floss.

A third technique to be observed in this fragment is the appliquéing of strips of gilt paper. The outlines of the hair, garments, and throne and all of the jewelry are formed from strips of paper just over two millimeters thick, held in place by transverse stitches.

This fragment is not the only one of its type in the Berlin collection, but as a picture it is probably the most complete that the museum possesses.

REFERENCES
Le Coq & Waldschmidt 1928–33, VII, pl. 34, p. 68. Bussagli 1963, pp. 48, 50 (ill.). Indische Kunst 1971, 1976, no. 500.

146 Princess and Child

Khocho, 9th–10th century
Embroidery, 17.5 x 14.0 cm.
MIK III 4920b

This very fine, skillfully executed embroidery is a product of the same techniques as those used in No. 145. The subject is a Uighurian princess with her daughter. The aristocratic-featured woman grasps the stem of a flower in both hands. She wears her hair high and bedecked with ornaments. Her robe is fastened down the middle and topped with a collar—a style of costume recalling that of the princesses portrayed in the wall painting of No. 109. A remarkable fact is that mother and daughter appear to be on cushions of a lotus-blossom design, such as are normally reserved for the Buddha.

REFERENCES
Härtel & Auboyer 1971, fig. 47, p. 270. Indische Kunst 1971, 1976, no. 516.

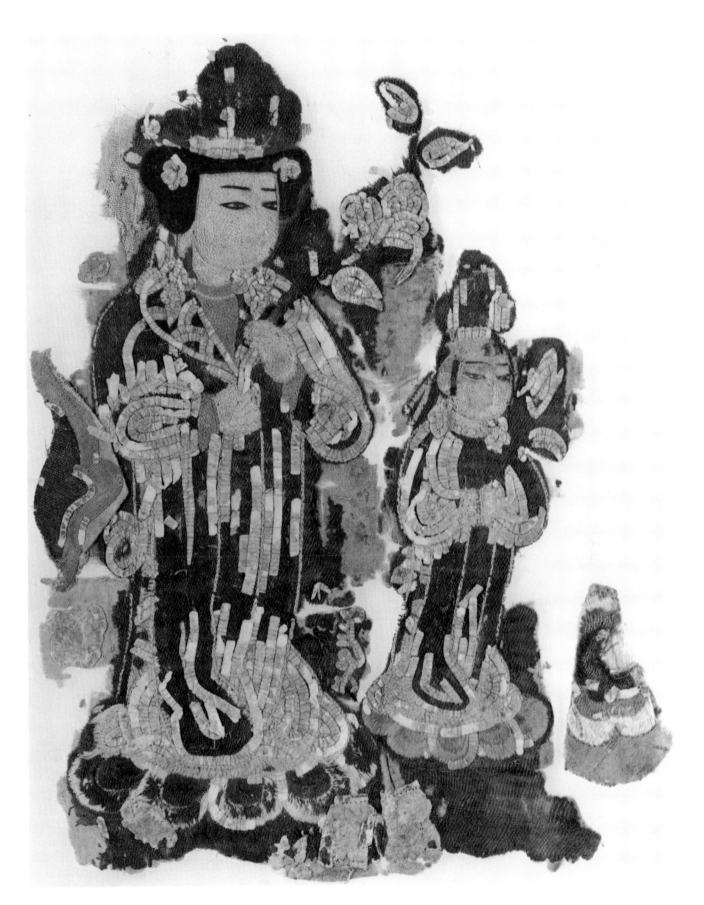

147 The Goddess Hariti

Yarkhoto, 9th century
Painting on ramie, 37.0 x 51.0 cm.
MIK III 6302

This painting represents the goddess Hariti, the tutelary goddess of children. Enthroned on a richly ornamented seat, she faces left and nurses a baby cradled in her right arm. On her head she wears a carmine-red kerchief lined in white, with a decoratively embroidered border, which is secured by means of two lateral ribbons at ear level tied in a bow at the back. A yellow-and-red nimbus surrounds Hariti's head. Her only jewels are earrings and a string of beads lying snugly around the neck. The collar and edges of her orange-red robe, which reaches down to her feet and is fastened in the middle, are decorated with an embroidered border identical to that on the kerchief. The robe is patterned with yellow lozenges divided into four by two black lines at right angles to each other. Her right foot, the only one remaining, is shod in a neat, dark slipper like a ballet shoe and rests on the base of the throne.

Hariti is the central figure in a group of eight small children at play. Reminiscent of chubby Chinese cherubs, their bodies are naked apart from a loincloth passing between the legs and tied in a bow at the back. They are occupied in various activities: some are playing ball, one is plucking a stringed instrument, one is carrying a bowl of melon slices, and another has a pitcher on his head.

REFERENCES
Foucher 1910, pp. 255–275. Le Coq 1913, pl. 40b.

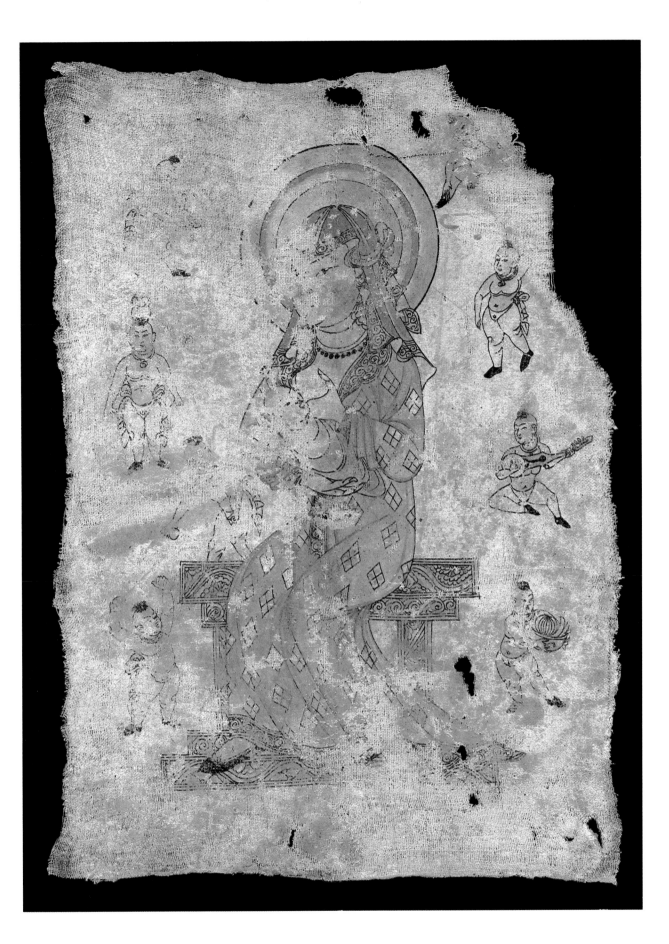

148 Scene of the Buddha Preaching

Khocho, 9th century
Painting on silk, 21.5 x 16.8 cm.
MIK III 6361

Of a large group of figures only a badly damaged fragment on the right-hand side of the picture has survived. It shows the Buddha, wearing a brown robe, before a blue, flame-patterned mandorla. A pair of golden flames shoots up behind his shoulders. His right hand is depicted in front of the chest in an explanatory gesture. Before him, hands joined in adoration, is a brahman with a long red beard and red hair tied up in a knot at the back. His brown robe leaves the upper arm exposed, and he wears a gold bracelet and necklace.

This picture was undoubtedly painted by a Chinese artist. The evidence lies not merely in its convincing contrast between the almost plump, Chinese Buddha and the old foreigner, the ascetic, red-haired brahman, but even more in its style, which is based on the linear calligraphic tradition. Each element of the picture is uniform in color, with no variations of shading to create a plastic effect.

The age difference between the two figures is brought out through calligraphic brushwork: the brahman is characterized by distinct brushstrokes—for example, the four lines on the neck and the lean hands—while the youthfulness of the well-nourished Buddha is highlighted by the use of soft, smooth lines.

REFERENCE
Le Coq 1913, pl. 45b.

W. V.

149 Bodhisattva

Khocho, 9th century
Painting on silk, 15.0 x 9.5 cm.
MIK III 4794

What we see in this fragment may be a *pradakshina*
bodhisattva who, in circumambulating an effigy of the
Buddha, carries a thin, red, lighted candle. Parts of the
painting are very faded, particularly the hair and nim-
bus. As a result, there is a delicacy of coloring that
lends the image a special charm.

The bodhisattva is portrayed in three-quarter profile,
facing left; his earlobe has stretched considerably under
the weight of his earring. The elegant, decorative head-
dress displays a diadem and two lotus blossoms. An
elaborate chain is worn around his neck.

W. V.

150 Bodhisattva

Khocho, 9th–10th century
Painting on silk, 34.5 x 27.5 cm.
MIK III 6166

This fragment shows the head and shoulders of a bo-
dhisattva. The face is of a yellowish hue, picked out
with reddish lines. Its East Asian features are evident,
although the picture seems to have been based on an
Indian model and adapted to the East Asian style. The
urna on the forehead is drawn as a large circle. The
bodhisattva wears a magnificent, richly decorated,
gold crown and an elaborate, colorful costume. Long
tresses of hair are neatly arranged on the shoulders,
behind which part of the mandorla that surrounded
the figure can be seen; there is a complementary nim-
bus around his head.

REFERENCES
Le Coq 1913, pl. 43b. Bussagli 1963, p. 33. Härtel & Auboyer
1971, fig. 253, pp. 269f. Indische Kunst 1971, 1976, no. 497.

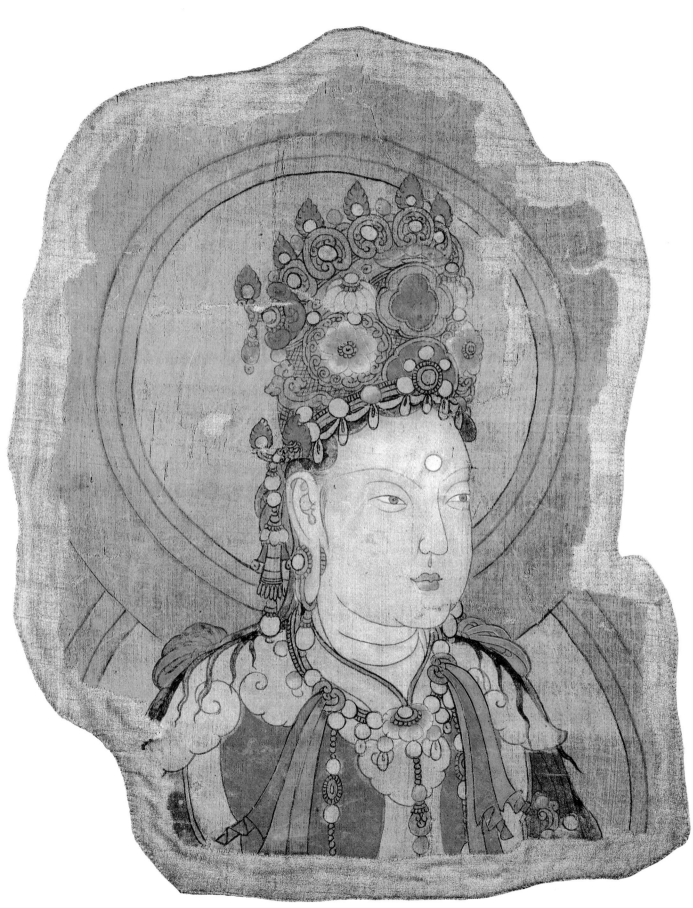

211

151 The Bodhisattva Avalokiteshvara

Murtuk, 9th–10th century
Painting on ramie, 95.0 x 59.0 cm.
MIK III 8559

This devotional picture, framed by a sequence of red circles on a white ground, is still an effective work despite its fragmentary state of preservation. In a severe hieratic pose the bodhisattva Avalokiteshvara sits in meditation on a lotus blossom, the stem of which grows out of a pool. On either side of the stem stands the figure of a worshiper wearing white robes.

Avalokiteshvara (in Chinese, Kuan-yin) is portrayed in his male form; his right hand is raised in the gesture of disputation or teaching (*vitarkamudra*), his left hand is held in front of the torso. On the palm is a flask (*kalasha*), one of the attributes of the bodhisattva, containing divine nectar or, as the Chinese called it, "sweet dew" (Buddhism fitted in well with the Chinese way of thinking; dew is in China the drink of the Taoist immortals). The bodhisattva, sumptuously arrayed and adorned, has a representation of the Buddha Amitabha, his spiritual father, in his crown. The crown is embellished with jeweled pendants on either side. Avalokiteshvara's head and body are surrounded by a nimbus and a mandorla whose beaded edges show that the Sasanian style of textile decoration had not been forgotten.

To either side of the bodhisattva Avalokiteshvara, on a dark blue background strewn with wish-granting jewels (*chintamani*), are three bodhisattvas of varying size, who may represent his different embodiments. At left center, clad in a white robe with a white cloth draped over a tall headdress, sits one of Avalokiteshvara's Chinese embodiments, the so-called Pai-yi (white-robed) Kuan-yin or the Sung-tzu (child-bestowing) Kuan-yin. This figure holds his right hand aloft, pointing with the index finger to a child borne on the palm of the left hand. The other five bodhisattvas display no special attributes.

Above the nimbus behind Avalokiteshvara's head is a red cloud formation from which ten branches ascend, supporting lotus pedestals; on each sits a Buddha in the attitude of meditation, dressed alternately in a brown or red robe. With the inclusion of the Buddha on the extreme right, now lost, this is probably the group of ten Buddhas who in the Amitabha cult are assigned to the ten directions.

In the lower part of the painting three men and three women kneel on each side of a cartouche containing a Uighurian votive inscription. Of the male donors only parts of the heads and bodies have been preserved. The women, on the left, are wearing Uighurian robes with wide borders. Their hairstyles and make-up are Chinese, as can clearly be seen from the woman in the middle.

The inscription is for the most part illegible. According to Dr. Peter Zieme, we can, however, deduce the name of the donor, a mention of the donation of the picture as a "good deed" (the passage itself is undecipherable), and the wish that the persons named in the text be absolved from reincarnation in undesirable forms of existence and attain Buddhahood. The inscription also contains the term *triratna*, or "three treasures," which in popular Buddhism often signifies a grouping of three deities. In this case it refers probably to a painting of the Buddha Amitabha with the bodhisattva Avalokiteshvara on the left and the bodhisattva Mahasthamaprapta or Manjushri on the right. Thus we may assume that this votive picture constituted the left-hand section of a triptych.

REFERENCE
Uhlig 1979, p. 124, fig. 59.

W. V.

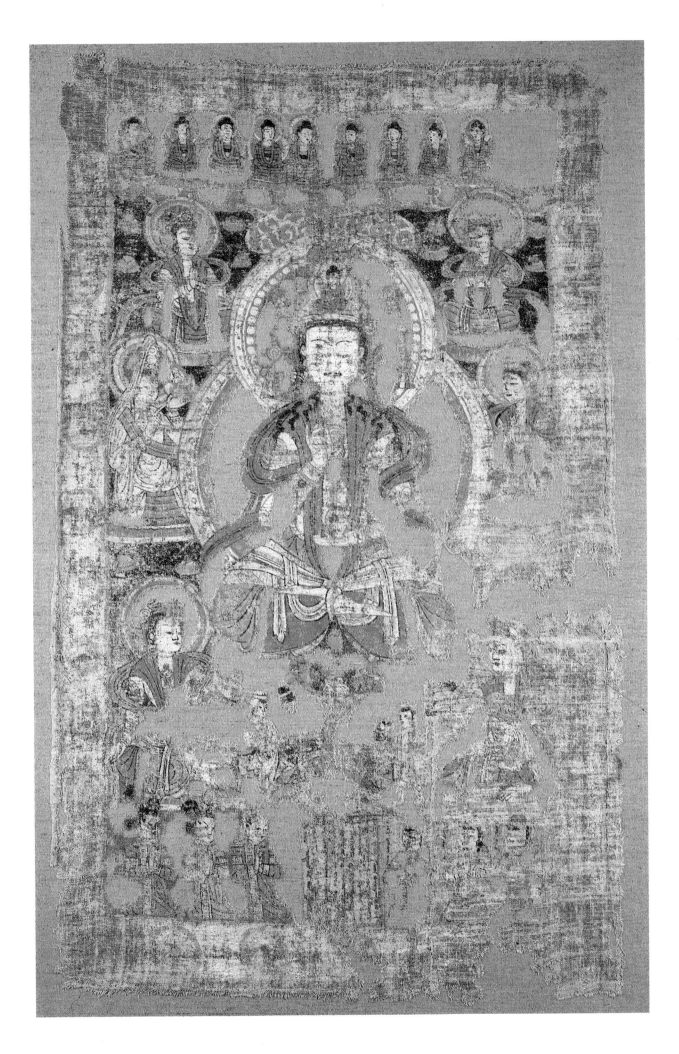

152 Fragments of a Handscroll

Probably Turfan region, 10th century
Painting on paper, H. (max.) 0.20, L. (total) 324.5 cm.
MIK III 520

This long handscroll, of line drawings on paper with some soft colors applied in certain sections, was painted by a highly skilled draftsman possessing a sure and confident hand. It is a significant work, containing numerous elements that indicate the dynamic nature of cultural interchange along the ancient Central Asian trade routes. These diverse elements include such typically Chinese features as a dragon and a rectangular porcelain pillow; an amphora with a classical shape and motifs; Hindu deities depicted in accordance with Indian iconographic traditions; and costume elements typical of diverse oasis regions such as Kizil, Khotan, and Tumshuk. Previously unpublished and unidentified, the work presents many fascinating questions of iconography and meaning, provenance, and date.

Physically, the scroll consists of two long continuous sections, with eight additional shorter segments detached. It has suffered serious damage along the entire width of the scroll, so that in many cases the feet, faces, and even hands (including what they hold) of the various figures have been lost. The extensive damage makes it difficult, if not impossible, to reconstruct the original order of the fragments by relying solely on the illustrations. These, however, have been backed at some time by a Chinese text. Owing to the literary detective work of my colleague at Cornell University Professor Tsu-lin Mei, whose significant aid I wish to gratefully acknowledge, it has been possible to identify the text as the *Wen-hsüan* (*Anthology of Literature*), first compiled in the early sixth century. It seems to have no relation whatsoever to our drawings, but laborious tracing of what remains of the lines and comparison with a standard edition have established a definitive order for the ten fragments of the scroll.

By content and design, it appears that the drawings can be divided into two distinct sections: a group of deities individually depicted, and a narrative sequence. The unmistakable progression of the latter clearly indicates that the scroll is intended to be viewed from left to right. With the Chinese text on the other side as a guide to the order, it is evident that the group of deities comes first.

The figures in this section are distinguished from those of the narrative scenes by the presence of halos and by the slight colors often applied to their clothes. They include such common members of the Hindu pantheon as Indra (on the elephant) and Brahma (on

the bull). These deities were incorporated into the Buddhist pantheon as minor figures, but were often significant in the art, literature, and religious practices of border regions where the great traditions of Hinduism and Buddhism met. Other Buddhist figures are depicted, such as the fierce youth Kinkara (with the lion), who is conventionally seen elsewhere in East Asian Buddhist art as one of the eight youths in attendance on Acala. Also depicted is Vaishravana (the standing robed figure), around whom a major cult developed in Central and East Asia.

This particular sequence of deities is quite rare; I have not seen it elsewhere in Central Asian or East Asian art. It is likely to be a representation of the special guardian spirits of a particular oasis site, analogous to the eight guardian spirits of Khotan, as discussed in *The Prophecy of the Li Country*.

If this hypothesis is correct, it may also be that the narrative sequence depicts the mythic tale of a courageous hero-king, who meets with various trials and dangers. It begins with the standing figure of a guardian, most likely Vaishravana, who was considered by many of the Central Asian kings as their special patron spirit. Then comes a seated noble—the hero of the tale—who wears a three-lobed crown such as can be seen in fifth-century cave paintings at Tun-huang as well as sixth- to seventh-century murals from Kizil. Our hero seems to set forth on a journey, into a sea or lake with large fish. Next we find him standing beside a large amphora (cf. No. 6, from Khotan), apparently offering it and a necklace of jewels to a blacksmith, in payment for a fine knife that the smith is industriously forging at an anvil before a blazing hearth. Wielding the knife in his right hand, the hero strides purposefully away, enters once again into the waters, and apparently conquers a monstrous dragon. Many of the stories associated with the founding of Central Asian kingdoms include the conquest of malefic lake spirits; it is likely that our story fits this pattern.

Further episodes show the hero encountering fierce animals and venomous snakes and scorpions. He also meets (in a dream?) a man wearing the characteristic hat of Khotan, who holds a pair of scales before him, and in a later sequence he receives gifts from a gracious deity (note the halo) who is dressed in clothes similar to those seen in sixth-century wall paintings found at Tumshuk.

All the identifiable motifs point to a sixth- or seventh-century date for the model upon which this work was based. The artist seems to follow early T'ang traditions in his depiction of the figures; some of them are highly reminiscent of figures seen in those among the Japanese *zuzo* (iconographic images) that seek to preserve T'ang traditions. Works have been found at sites in Turfan which employ elements of the T'ang style and bear many stylistic similarities to our scroll. They are usually dated to the tenth and eleventh centuries, as provincial versions of an old style; it is among such works that this scroll should be placed.

R. B.

Fig. Q The Shronakotikarna Legend. Kizil, Cave of the Seafarers (after Gruñwedel)

APPENDIX

Two Buddhist Legends

To demonstrate how Buddhist legends have been illustrated in Central Asian art, we append a synopsis of two important and interesting ones found in Kizil, in the Cave of the Seafarers: the Shronakotikarna (Fig. Q) and the Maitrakanyaka Avadana (Fig. R).[1]

The Shronakotikarna Legend[2]

There once lived a merchant by the name of Shronakotikarna. He derived his Sanskrit name from the constellation Shravana (Shrona) and his surname, Kotikarna, from a costly earring that he wore from birth. The only son of a rich merchant, Shronakotikarna, following his father's footsteps, set off one day together with his companions on a trading voyage to the Island of Jewels, hoping for treasure. On his return he was separated from his companions and lost his way. Alone and confused, he had many strange adventures. Successively he arrived at two cities, identical in appearance, where, being hungry and thirsty, he cried for food at the first and drink at the second. For answer, spirits of the dead appeared at the city gates,

themselves crying out for food and drink—the ghosts of misers and swindlers who had been condemned to torments of hunger and thirst. Shronakotikarna passed on, and climbed into a tree to spend the night. There he was inadvertent witness to one man enjoying the pleasures of love with a woman by night, and another doing so by day. Thereupon the first man was devoured by dogs by day, and the other suffered horrible torments by night.

In the course of his travels Shronakotikarna comes to a lake, where he drinks and waters his donkey. On the shore he suddenly notices a palace, and though he is afraid to enter it, hunger gets the better of him. Inside, a beautiful woman offers him food. While they are eating, two hunger-spirits suddenly appear and crouch down beside them. Shronakotikarna tosses them some scraps, only to see these transformed into pus and blood. The woman explains to him that the two spirits are those of her husband and son, who once, when she gave food to a begging monk, were stingy enough to wish it changed into these horrid substances. Then two women approach the table, also asking to share in the repast; the first climbs into a big pot, cooks herself, and begins feeding on her own flesh, while the second transforms herself into a ram and goes out to pasture. From his hostess Shronakotikarna learns that the two women were once her daughter-in-law and maidservant; they had stolen food but denied it, saying that if they were guilty of the deed they would eat their own flesh or grass. These experiences obsess Shronakotikarna; having returned

1. As Waldschmidt points out, known depictions of the Shronakotikarna legend are not based, as Grünwedel assumed, on the version of the Divyavadana (no. 1) from the school of Mulasarvastivadin, but on the Sarvastivadin version (Chavannes 1910–35, no. 337). Thus we may conclude that the illustration of the Maitrakanyaka Avadana in the Cave of the Seafarers likewise goes back to a Sarvastivadin text.

2. After Waldschmidt 1952.

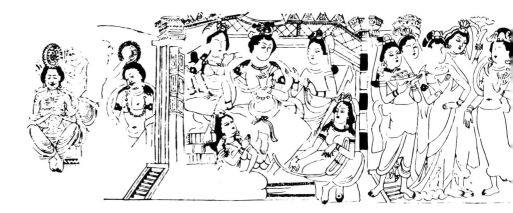

to his home city of Ujjain, he ponders incessantly on the terrible suffering that the cycle of birth and rebirth inflicts on human beings. Finally he knows that he must enter the Buddhist order.

The Maitrakanyaka Legend[3]

There once lived in Benares a rich merchant by the name of Mitra who had long desired a son, but in vain. In his need he prayed to various gods, among them Shiva and Varuna, and finally his wife gave birth to a boy. In order to ward off evil she gave him a girl's name—Maitra (son of Mitra) Kanyaka (little girl)—and a great celebration was held in honor of the child.

One day the boy's father sails out to sea and is never heard from again. The son, now grown, begins to ask questions about his father, but the mother, not wishing the same terrible fate to befall him, refuses to divulge his father's profession. The merchants of the town, however, jealous of the family's prosperity, are less scrupulous.

Despite his mother's pleas Maitrakanyaka prepares with the other merchants for a trading voyage. On the day of his departure his mother begs him for the last time to take up some less hazardous profession. In answer Maitrakanyaka, angered and scornful, aims a

kick at the prostrate woman's head. As he turns to leave he hears these words: "My son, may the fruit of this deed not fall back on thee."

Maitrakanyaka puts out to sea. Very soon, however, his ship is caught in a storm and sinks; he manages to save himself by clutching a timber, and the wind brings him to shore. Not far off he sees a city, but when he approaches it his way is blocked by four beautiful apsaras who ask him to go with them. He does so, and ends up in their clutches. Years pass before he manages to escape. The experience is repeated in the next city he comes to, this time with eight seductresses, and again with sixteen, then thirty-two.

Having finally succeeded in escaping, he comes to a city of iron. Hardly has he passed the gates when they slam shut behind him. Suddenly a man appears before him with a wheel of fire rotating on his head, feeding on the pus and blood of his own wounds. Horrified, Maitrakanyaka asks him the reason for this terrible torture, and the man replies: "I am one who insulted his own mother." On hearing these words Maitrakanyaka recalls his own deed of many years ago, and realizes that the time has come to do penance for it. At once he hears a voice saying: "Those who are bound shall be free, and those who are free, bound." In an instant the wheel of fire leaps from the man's head onto Maitrakanyaka's. In spite of the searing pain, Maitrakanyaka finds words of pity for other sinners: "For the good of all I shall bear this wheel on my head." As soon as these words are spoken the fiery wheel spins high into the air. And the bodhisattva Maitrakanyaka will be reborn among the gods in the Tushita heaven.

3. This legend is found in the Jatakas, nos. 82, 104, 369, and 439; in the Divyavadana (no. 1); the Avadanakalpalata (no. 24); in the Chinese Tripitaka (Chavannes 1910–35, no. 39); and in the Avadanashataka (Feer 1891, no. 36, pp. 131ff). In the Pali texts Mittavindaka (Maitrakanyaka) is described not as a bodhisattva but as a monk.

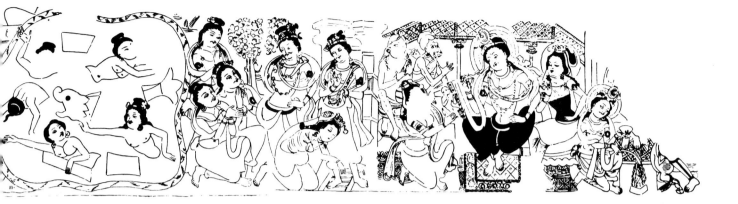

Fig. R The Maitrakanyaka Legend. Kizil, Cave of the Seafarers (after Grünwedel)

SELECTED BIBLIOGRAPHY

Shortened references are given for works cited in the text.

Bagchi, P. Ch. *India and China*. Bombay, 1950.

Banerjee 1970
Banerjee, P. "Hindu Trinity from Central Asia." *Bulletin*, National Museum, New Delhi, no. 2, 1970.

Bareau 1970
Bareau, André. *Recherches sur la biographie du Buddha dans les Sutrapitaka et les Vinayapitaka anciens*. Vol. 2. Publication de l'École Française d'Extrême-Orient (LXXVII). Paris, 1970.

Barrett 1967
Barrett, D. "An Ivory Diptych." *Lalit Kala*, no. 13 (1967), pp. 11–15.

Bhattacharya 1977
Bhattacharya, Chhaya. *Art of Central Asia (with Special Reference to Wooden Objects from the Northern Silk Route)*. Delhi, 1977.

Bussagli 1963
Bussagli, Mario. *Central Asian Painting*. Trans. by Lothian Small. Geneva, 1963; reprint 1979.

Chavannes 1910–35
Chavannes, Edouard. *Cinq Cents Contes et apologues: Extraits du Tripitaka chinois*. 4 vols. Paris, 1910–35.

Dutt 1947
Dutt, N., ed. *Gilgit Manuscripts*. Vol. III, part 1. Srinagar, 1947.

Feer 1891
Feer, Léon, trans. *Avadana-Çataka: Cent Légendes bouddhiques*. Paris, 1891; reprint Amsterdam, 1979.

Foucaux 1884
Foucaux, P.-E., trans. *Le Lalita Vistara*. 2 vols. Annales du Musée Guimet, VI. Paris, 1884.

Foucher 1905–23
Foucher, Alfred. *L'Art gréco-bouddhique du Gandhara*. 3 vols. Paris, 1905, 1918, 1923.

Foucher 1910
Foucher, Alfred. "La Madone bouddhique." Fondation Eugène Piot, *Monuments et Mémoires*, published by the Académie des Inscriptions et Belles-Lettres, Paris, vol. 17, part 2 (1910), pp. 225–275.

Foucher, Alfred. *The Beginnings of Buddhist Art and Other Essays on Indian and Central-Asian Archaeology*. Rev. ed., trans. by L. A. Thomas and F. W. Thomas. London, 1917.

Gabain 1973a
von Gabain, Anne-Marie. "Ksitigarbha-Kult in Zentralasien." *Indologentagung 1971*. Wiesbaden, 1973.

Gabain 1973b
von Gabain, Anne-Marie. *Das Leben in uigurischen Königreich von Qoco (850–1250)*. 2 vols. Wiesbaden, 1973.

Gaulier et al. 1976
Gaulier, Simone, Jera-Bezard, Robert, and Maillard, Monique. *Buddhism in Afghanistan and Central Asia*. 2 vols. Iconography of Religions XIII, 14. Leiden, 1976.

Ghirshman 1962
Ghirshman, Roman. *Persian Art: The Parthian and Sassanian Dynasties, 249 B.C.–A.D. 651*. New York, 1962.

Gropp, G. *Archäologische Funde aus Khotan Chinesisch-Ostturkestan*. Bremen, 1974.

Grünwedel 1893
Grünwedel, A. *Buddhistische Kunst in Indien*. Berlin, 1893. (In English: *Buddhist Art in India*, trans. by Agnes C. Gibson, rev. and enl. by J. Burgess, London, 1901. New German ed. by E. Waldschmidt, Berlin, 1932.)

Grünwedel 1906
Grünwedel, A. *Bericht über archäologische Arbeiten in Idikutschari und Umgebung im Winter 1902/03*. Munich, 1906.

Grünwedel 1912
Grünwedel, Albert. *Altbuddhistische Kultstätten in Chinesisch-Turkistan*. Berlin, 1912.

Grünwedel 1920
Grünwedel, A. *Alt-Kutscha*. Berlin, 1920.

Hambis, Louis, ed. *L'Asie centrale: Histoire et civilisation*. Paris, 1977. (The bibliography includes a listing of the various archaeological expeditions to the region and their publications.)

Härtel & Auboyer 1971
Härtel, Herbert, and Auboyer, Jeannine. *Indien und Südostasien*. Propyläen Kunstgeschichte, vol. 16. Berlin, 1971.

Henning 1936
Henning, W. *Ein manichäisches Bet- und Beichtbuch*. Abhandlungen der Berliner Akademie der Wissenschaften, Phil.-Hist. Klasse, no. 10, 1936.

Hopkirk, Peter. *Foreign Devils on the Silk Road: The Search for the Lost Cities and Treasures of Chinese Central Asia*. London, 1980.

Hulsewé, A. F. P. *China in Central Asia: The Early Stage, 125 B.C.–A.D. 23*. Leiden, 1979.

Indische Kunst 1971, 1976
Härtel, H., Moeller, V., and Bhattacharya, G. *Katalog: Ausgestellte Werke*. Museum für Indische Kunst. Berlin, 1971, 1976.

Indische Kunst 1978
Museum für Indische Kunst. *Museum*. Westermann Verlag, Brunswick, 1978.

Indische Kunst 1980
Museum für Indische Kunst. Kunst der Welt in den Berliner Museen. Belser Verlag, Stuttgart and Zurich, 1980.

Ingholt 1957
Ingholt, Harald. *Gandharan Art in Pakistan*. New York, 1957.

Jones 1949–56
Jones, J. J., trans. *The Mahavastu*. 3 vols. London, 1949–56.

Klimburg, M. "Die Entwicklung des 2. indo-iranischen Stils von Kutscha" (diss.). Vienna, 1969.

Klimkeit 1980
Klimkeit, H.-J. "Hindu Deities in Manichean Art." *Zentralasiatische Studien*, 14/2 (1980).

Le Coq 1913
von Le Coq, A. *Chotscho: Facsimile-Wiedergaben der wichtigeren Funde der ersten königlich preussischen Expedition nach Turfan in Ost-turkistan*. Berlin, 1913; reprint Graz, 1979.

Le Coq 1922–26
von Le Coq, A. *Die buddhistische Spätantike in Mittelasien*. Vols. 1–5. I. *Die Plastik*. Berlin, 1922; reprint Graz, 1973. II. *Die Manichäischen Miniaturen*. Berlin, 1923; reprint Graz, 1973. III. *Die Wandmalereien*. Berlin, 1924; reprint Graz, 1974. IV. *Atlas zu den Wandmalerein*. Berlin, 1924; reprint Graz, 1974. V. *Neue Bildwerke*. Berlin, 1926; reprint Graz, 1975. (See Le Coq & Waldschmidt 1928–33 for the last two volumes of this series.)

Le Coq 1925a
von Le Coq, A. *Bilderatlas zur Kunst und Kulturgeschichte Mittelasiens*. Berlin, 1925; reprint Graz, 1977.

Le Coq 1925b
von Le Coq, A. "Zwei Bruchstücke alt-buddhistischer Wandgemälde aus Chinesisch-Turkistan." *Jahrbuch der asiatischen Kunst*. Leipzig, 1925.

Le Coq 1926
von Le Coq, A. *Auf Hellas Spuren in Ostturkistan: Berichte und Abenteuer der II. and III. deutschen Turfan Expeditionem*. Leipzig, 1926; reprint Graz, 1974. (Trans. by Anna Barwell as *Buried Treasures of Chinese Turkestan: An Account of the Activities and Adventures of the Second and Third German Turfan Expeditions*, London, 1928.)

Le Coq 1928
von Le Coq, Albert. *Von Land und Leuten in Ostturkistan: Berichte und Abenteuer der 4. deutschen Turfanexpedition*. Leipzig, 1928.

Le Coq & Waldschmidt 1928–33
von Le Coq, A., and Waldschmidt, E. *Die buddhistische Spätantike in Mittelasien*. Vols. 6, 7. VI. *Neue Bildwerke II*. Berlin, 1928; reprint Graz, 1975. VII. *Neue Bildwerke III*. Berlin, 1933; reprint Graz, 1975.

Lee 1955
Lee, Sherman E. "The Golden Image of the New-born Buddha." *Artibus Asiae*, vol. 18, no. 3/4 (1955), pp. 225–237.

Lienhard 1980
Lienhard, Siegfried. *Die Legende vom Prinzen Visvantara*. Museum für Indische Kunst, Berlin, 1980. (Includes a comprehensive bibliography.)

Liu Mau-tsai 1969
Liu Mau-tsai. *Kutscha und seine Beziehungen zu China von 2 jh. v. bis zum 6 jh.*, pp. 100ff. and 201ff. Asiatische Forschungen, vol. 27. Wiesbaden, 1969.

Mallmann 1948
de Mallmann, Marie-Thérèse. *Introduction à l'étude d'Avalokiteçvara*. Paris, 1948.

Matsumoto Eiichi 1937
Matsumoto Eiichi. *Tonkôga no kenkyû*. Tokyo, 1937.

Munsterberg 1967
Munsterberg, Hugo. *Chinese Buddhist Bronzes*. Tokyo, 1967.

Nara 1978
Sources of Japanese Buddhist Art. Special exhibition, Nara National Museum, Japan, 1978.

Rao 1914
Rao, T. A. Gapinatha. *Elements of Hindu Iconography*. 1914; reprint Delhi, 1968.

Rowland 1974
Rowland, Benjamin. *The Art of Central Asia*. Art of the World. New York: Crown Publishers, 1974. (In German: *Zentralasien*. Kunst der Welt. Baden-Baden: Holle Verlag, 1970.)

Schneider 1980
Schneider, U. *Einführung in den Buddhismus*. Darmstadt, 1980.

Seidenstücker 1923
Seidenstücker, K. *Pali-Buddhismus in Übersetzungen*. Munich, 1923.

Soper 1958
Soper, Alexander C. "Northern Liang and Northern Wei in Kansu." *Artibus Asiae*, vol. 21, no. 2 (1958), pp. 131–164.

Stein 1907
Stein, M. A. *Ancient Khotan*. 2 vols. Oxford, 1907.

Stein 1921
Stein, M. A. *Serindia*. 5 vols. Oxford, 1921.

Stein, Sir Aurel. *Innermost Asia*. 4 vols. Oxford, 1928.

Talbot Rice, Tamara. *Ancient Arts of Central Asia*. New York, 1965.

[Tokyo]. *Illustrated Catalogues of the Tokyo National Museum*. Tokyo, 1971.

Tokyo 1978
L'Exposition André Malraux et le Japon éternel. Tokyo, 1978.

Uhlig 1979
Uhlig, Helmut. *Das Bild des Buddha*. Berlin, 1979.

Waldschmidt 1925
Waldschmidt, Ernst. *Gandhara, Kutscha, Turfan*. Leipzig, 1925.

Waldschmidt 1929
Waldschmidt, E. *Die Legende vom Leben des Buddha*. Berlin, 1929.

Waldschmidt 1948
Waldschmidt, E. *Die Überlieferung vom Lebensende des Buddha*. Abhandlungen der Akademie der Wissenschaften in Göttingen, Phil.-Hist. Klasse, part 2, 1948.

Waldschmidt 1952
Waldschmidt, E. *Zur Sronakotikarna-Legende*. Nachrichten der Akademie der Wissenschaften in Göttingen, Phil.-Hist. Klasse, no. 6, 1952.

Williams 1973
Williams, Joanna. "The Iconography of Khotanese Painting." *East and West*, n.s. 23 (March–June 1973), pp. 109–154.